JOHN PAUL II

JOHN PAUL II

A Light for

ALL PHOTOGRAPHS FROM *L'OSSERVATORE ROMANO*, THE OFFICIAL NEWSPAPER OF THE VATICAN

WITH SELECTIONS FROM THE WRITINGS AND SPEECHES OF POPE JOHN PAUL II

EDITOR, SISTER MARY ANN WALSH, RSM
DEPUTY DIRECTOR FOR MEDIA RELATIONS,
UNITED STATES CONFERENCE OF CATHOLIC BISHOPS

ESSAYS AND REFLECTIONS ON THE PAPACY OF JOHN PAUL II

the World

Greeting from the Vatican
ANGELO CARDINAL SODANO
SECRETARY OF STATE

Foreword by
KOFI ANNAN
SECRETARY-GENERAL OF THE UNITED NATIONS

Introduction by
BISHOP WILTON D. GREGORY
PRESIDENT, UNITED STATES CONFERENCE
OF CATHOLIC BISHOPS

Pope John Paul II: A Light for the World
JOHN THAVIS
ROME BUREAU CHIEF, *CATHOLIC NEWS SERVICE*

SHEED & WARD

Lanham, Chicago, New York,
Toronto, and Oxford

EX
LIBRIS
Teresa Franceschini

The Pope takes some time
to walk and pray in the
woods during his 12-day
visit to Canada in 1984.

Published by Sheed & Ward
An imprint of Rowman & Littlefield Publishers, Inc.
A wholly owned subsidary of The Rowman & Littlefield Publishing Group, Inc.
4501 Forbes Boulevard, Suite 200
Lanham, MD 20706

PO Box 317
Oxford
OX2 9RU, UK

Distributed by National Book Network

Library of Congress Control Number: 2003106091
ISBN 1-58051-142-2 (cloth : alk. paper)

Printed in the United States of America.

The paper used in this publication meets the minimum requirements
of American National Standard for Information Sciences—Permanence
of Paper for Printed Library Materials, ANSI/NISO Z39.48-1992.

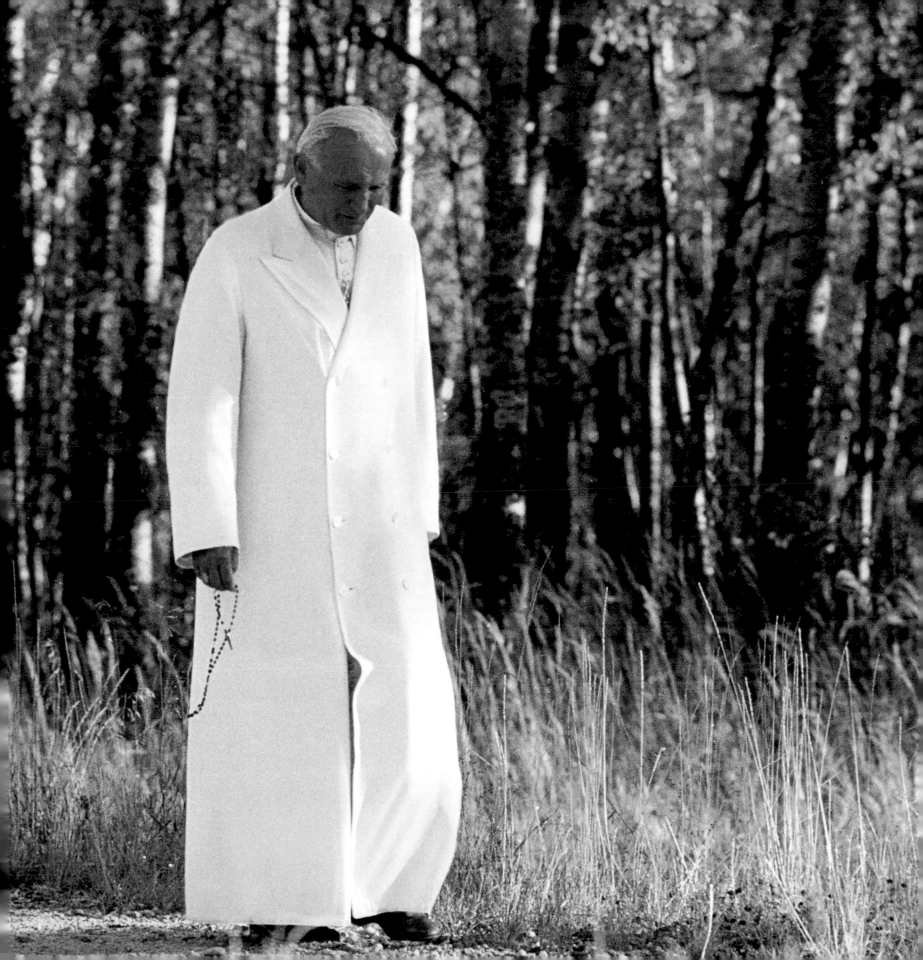

ONTENTS

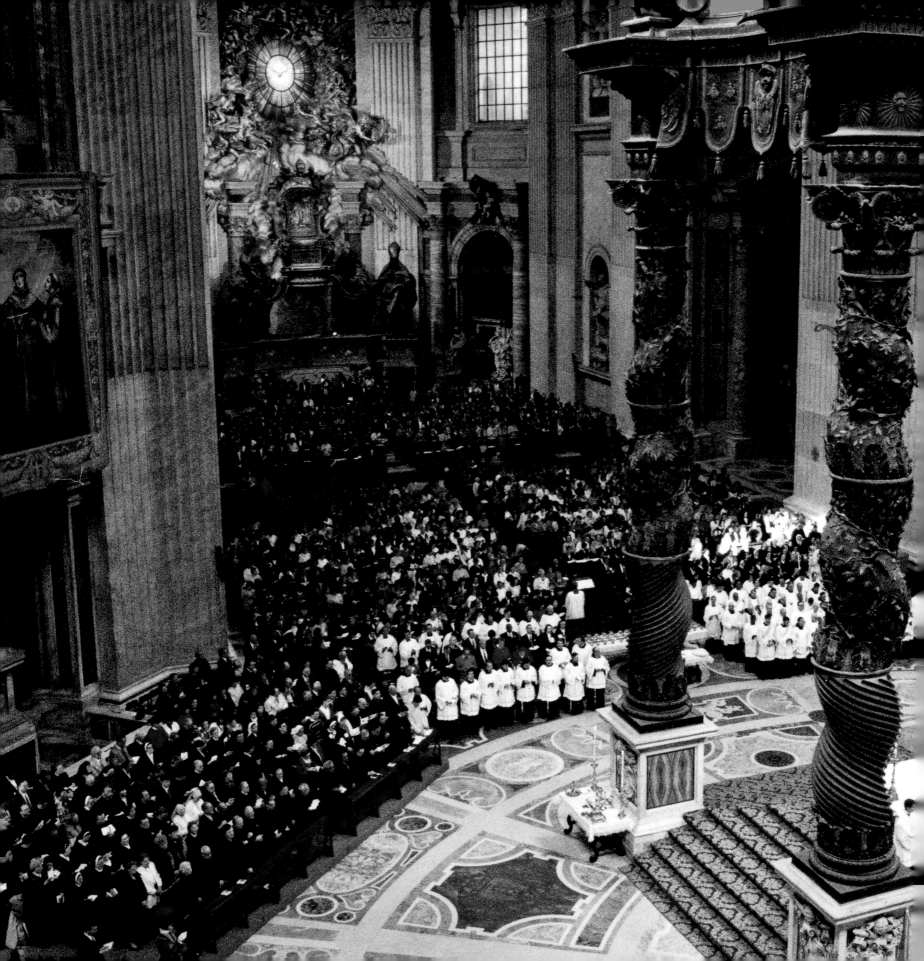

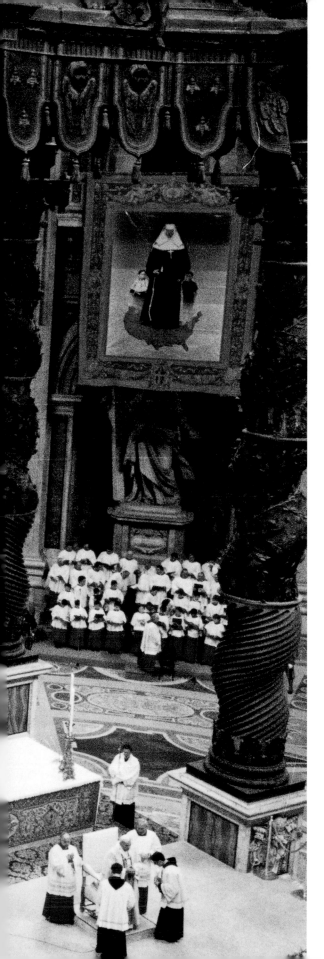

Greeting from the Vatican

Dear Brothers and Sisters in Christ,

I am pleased to introduce the commemorative book which the United States Conference of Catholic Bishops has issued to mark the twenty-fifth anniversary of the pontificate of His Holiness Pope John Paul II.

As the Successor of Peter, the Holy Father is the perpetual and visible source and foundation of unity both of the bishops and of the whole company of the faithful. Throughout the course of his Petrine Ministry, Pope John Paul II has indefatigably traveled the world, proclaiming the Good News of Jesus Christ and encouraging men and women to "encounter the Living Jesus Christ" (*Ecclesia in America*, 3) in the diverse situations in which they find themselves.

It is my fervent hope that the words and images of this book may assist its readers to heed the invitation of the Holy Father to "launch out into the deep" (*Novo Millennio Ineunte*, 1) and to come to follow ever more closely the Lord Jesus, who is "the way, and the truth, and the life" (Jn 14:6).

With my cordial best wishes to all,

+ Angelo Card. Sodano

ANGELO CARDINAL SODANO, Secretary of State
Holy Week, 2003

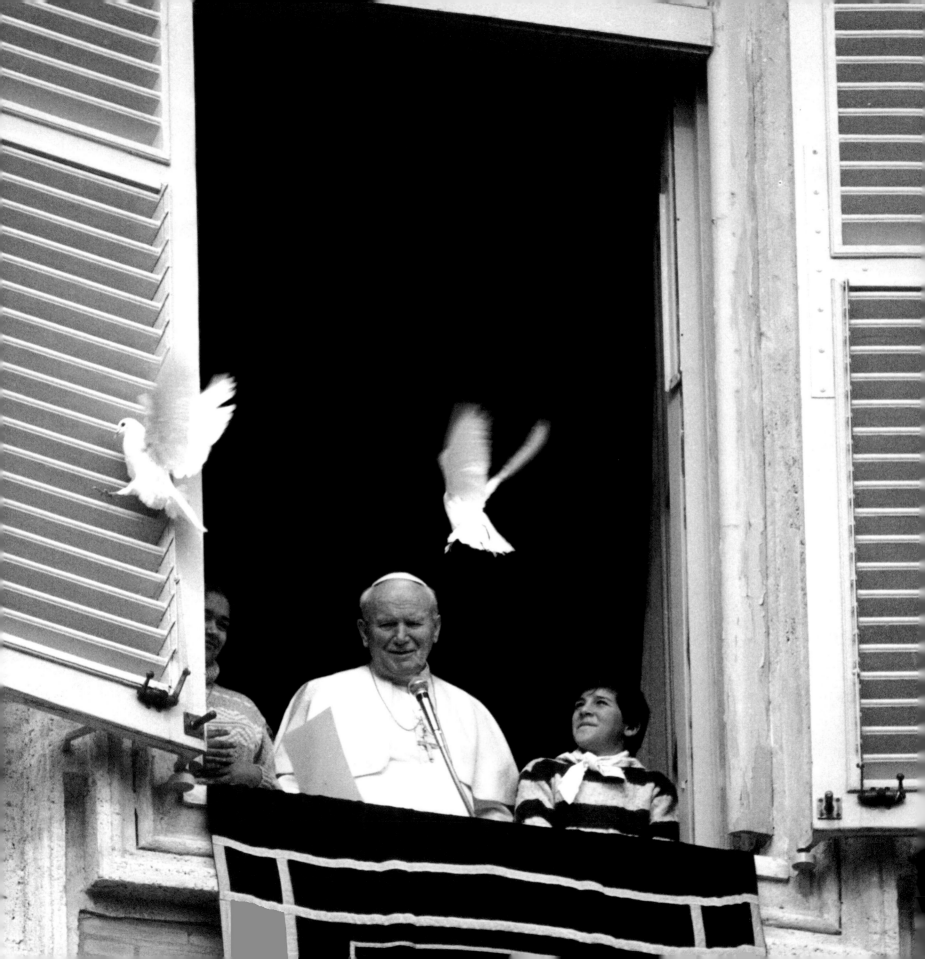

THE POPE OF PEACE

I am happy to participate in this commemoration of the 25th anniversary of the election of His Holiness Pope John Paul II. In June 2000, I had the honor to be the recipient of the Path to Peace Award, and on that occasion I had the opportunity to reflect at some length on the significance of the teaching of Pope John Paul II. At that time I said:

The teachings of His Holiness Pope John Paul II resound with people in all continents as the fundamental tenets of peace. In those teachings, His Holiness has asked us to heed the warning bequeathed to us by the previous century: that war is often the cause of further wars because it fuels hatred, creates injustice and tramples upon human dignity and rights.

He has reminded us of our obligations under humanitarian law; of our duty to provide humanitarian aid to suffering civilians and refugees; of the need to make the fullest and the best use of the United Nations Charter in defining instruments of intervention within the framework of international law.

He has reminded us that lasting peace means more than the absence of war, and depends on two indivisible and interdependent rights: the right to peace and the right to development. That to face today's problems, most of which are assuming a global dimension, we must foster a consciousness of universal moral values among all sectors of the international community, whether governments, civil society or the private sector.

He has explained how we can give our globalizing world a soul, a meaning and a direction. How globalization, for all its risks, also offers exceptional and promising opportunities—for he has given us an alternative concept: the globalization of solidarity, whereby the benefits of our new age can be spread more equally among the world's peoples.

He has spelt out that there will be peace only if humankind rediscovers itself as one human family, a family in which the equal dignity and rights of individuals—whatever our status, race or religion— are recognized as more important than any difference or distinction between us.

That is why, for millions around the globe, Pope John Paul has become the most powerful voice of peace, hope and justice they know. I am particularly grateful that in my meetings with him, I have been fortunate enough to be inspired by that voice firsthand.

KOFI ANNAN, Secretary-General of the United Nations

Previous: The Pope presides at the canonization of Mother Katharine Drexel, St. Peter's, Rome, 2000.

Opposite: During the Sunday Angelus from the window of his residence overlooking St. Peter's Square, the Pope and two children release doves into the air in celebration of "Peace Day," January 18, 1996.

A FRIEND TO ALL HUMANITY

GOD HAS GRANTED POPE JOHN PAUL II AN ABUNDANCE OF YEARS AS WELL AS GRACE AS THE CHURCH'S UNIVERSAL PASTOR. THIS VOLUME IS OFFERED BY THE UNITED STATES CONFERENCE OF CATHOLIC BISHOPS IN CELEBRATION OF THE REMARKABLE PONTIFICATE OF JOHN PAUL II, WHOSE ACHIEVEMENTS HAVE FILLED THE CHURCH WITH JOY, ADMIRATION, AND A DEEP SPIRITUAL SATISFACTION.

First and foremost among these achievements has been Pope John Paul's leadership in implementing the work of the Second Vatican Council. In taking the name "John Paul II," he honored not only his immediate predecessor but also the two popes who gave us the Council: Blessed John XXIII who convoked and opened it and Paul VI who brought its work to a fruitful conclusion and was the first to implement its decrees.

Pope John Paul II has continued that implementation, and he has led the Church to a deeper appreciation of the spiritual essence of the Council.

An outstanding bishop of his local Church when he was called to the See of Peter, Pope John Paul II has offered exemplary leadership to and with his fellow bishops. His reliance on the Synod of Bishops, in its ordinary and its special assemblies—such as those which dealt with the experience of the Church on each continent—demonstrates his desire to hear from his fellow

bishops. As Peter's successor, he, in turn, has sought to "strengthen his brethren." His 1998 Apostolic Letter *Apostolos Suos* (On the Theological and Juridical Nature of Episcopal Conferences) showed his solicitude for conferences of bishops, confirmed their teaching role under certain conditions, and reaffirmed their contribution to the life of the Church.

The Pope's deep pastoral care for his people is seen in his visits around the world. We in the United States remember in particular his extended visits here in 1979, 1987, 1993 for World Youth Day in Denver, 1995, and in 1999 to the Archdiocese of St. Louis. This worldwide pastoral care is mirrored in his visitation of the parishes of his own Diocese of Rome, which has been the source of a spiritual renewal. Internationally and locally, John Paul is an ardent shepherd of souls, carefully watching over his flock.

His interest in young people has been expressed

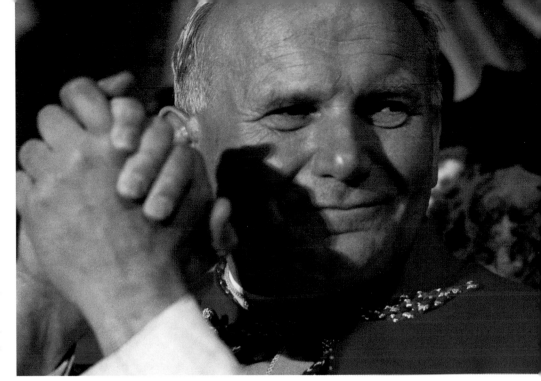

most noticeably through the World Youth Days which he established and attended. On these occasions, his call to discipleship of Christ has been received by the young people with tremendous enthusiasm and invariably awakened in their hearts a desire for continuing service to the Church in a variety of ways.

A commitment to ecumenical and interreligious dialogue has been another hallmark of the Holy Father's pontificate. In a unique way, the Jewish people have found in him a good friend. He tremendously accelerated the improvement in the relationship between Catholics and Jews which the Second Vatican Council began. Of special note in this regard is his Jubilee Year visit to Israel. Pope John Paul has also sought a greater understanding with the world of Islam and Buddhism. He, in turn, has received a heartfelt response from peoples of all faiths.

Pope John Paul's championship of human rights, in particular his willingness to lend his voice to the vulnerable—the poorest of the poor, the unborn, the elderly and ailing, and those condemned to death on account of their crimes—has placed him at the forefront of world leaders. His witness to the dignity of every person and every people was a source of the rebirth of freedom in his beloved homeland of Poland and the rest of Eastern and Central Europe. His desire to be an instrument for peace has been seen in his annual World Day of Peace messages and the extraordinary gatherings of religious leaders held in Assisi in 1986 and 2002 at his request. He is unceasing

in urging peaceful solutions to conflicts in numerous troubled areas of the world.

Pope John Paul has been a teacher par excellence. His impressive encyclicals are firmly rooted in the word of God, and are now among the Church's permanent treasures, as is the *Catechism of the Catholic Church*, whose development Pope John Paul approved and which he saw brought to completion as a "sure norm for teaching the faith."

Among his many gifts is his understanding of and exceptional talent for the media through which he has brought the papacy close to Catholics and to all people in a way never before possible. He has put his linguistic skill—his "gift of tongues"—at the disposal of his pastoral zeal, knowing that someone who chooses to speak to people in their own tongue comes not as a stranger but as a friend.

Pope John Paul II is a friend to all humanity.

BISHOP WILTON D. GREGORY
President of the United States Conference of Catholic Bishops

The Pope in 1979 enjoys his first trip home to Krakow, Poland, after his 1978 election to the papacy.

A LIGHT FOR THE WORLD

JOHN THAVIS, Rome Bureau Chief, *Catholic News Service*

TO CATHOLICS, HE IS UNIVERSAL SHEPHERD. TO WORLD LEADERS, HE CAN BRING MORAL SUPPORT OR STINGING CRITICISM. NON-CHRISTIANS AROUND THE GLOBE HAVE WELCOMED HIM AS A HOLY GUEST. POOR NATIONS CONSIDER HIM THEIR ADVOCATE IN THE HALLS OF POWER. AND FOR NEARLY EVERYONE, HE'S BEEN A VOICE OF CONSCIENCE ON ISSUES LIKE WAR, ABORTION AND THE DEATH PENALTY.

 he world knows Pope John Paul II in different dimensions: manager, missionary, statesman and prophet. His message is not always easy and his words are not always welcome. But it's hard to imagine a more influential figure on the global scene over the last twenty-five years.

If his pontificate seems a perfect match for our age, perhaps it's because he experienced its joys and trials firsthand—as no previous Pontiff has.

The path to the papacy was not a simple one for Karol Wojtyla. As a youth in southern Poland, he studied at the university, acted in a clandestine theater, wrote poetry and read philosophy, played goalie on his soccer team, split stone at a quarry and worked in a chemical factory. Only then did his vocation to the priesthood come into focus.

"I had positive experiences in many settings and from many people, and God's voice reached me through them," the Pope said in his 1996 book, *Gift and Mystery.*

The Pope's early life was marked by personal hardships and shadowed by national tragedies.

Born May 18, 1920, in the small town of Wadowice south of Krakow, he lost his mother, Emilia, at age nine. Her death was an event that stayed with him, and acquaintances say it prompted his lifelong spiritual devotion to the Virgin Mary. One of his first youthful poems, "Over This, Your White Grave," was dedicated to his mother's memory.

Three years later his only brother, Edmund, a physician, died of scarlet fever. And at age twenty he lost his father, a military officer who had raised his son with love and firmness. The future

Ireland shows a warm welcome to the Pope on the third foreign trip of his pontificate in 1979.

Pope would sometimes wake in the middle of the night and find his father praying on his knees. At his death, friends say Karol knelt for twelve hours in prayer at his father's bedside.

The Pope's former schoolmates describe him as friendly but pensive, an athletic youth who excelled in academics and spent a lot of time in church. They noticed the intense way he prayed—a habit of deep meditation that remained with him for life. One companion good-naturedly called him an "apprentice saint."

"Even as a boy he was exceptional," said Rafat Tatka, a neighbor who knew the young boy as Lolek, a nickname that translates as Chuck. Growing up, the Pope was especially protective of his Jewish friends.

As a teenager, he was already showing an appetite for philosophy and an amazing talent for languages. In 1938, he began working toward a philosophy degree at the University of Krakow, and was an active member of speech and drama clubs.

All that was interrupted by the Nazi invasion of Poland on September 1, 1939, which devastated the country and left an indelible impression on nineteen-year-old Karol Wojtyla. A priest later described how Wojtyla arrived at the cathedral when the first German bombs started to fall and served Mass amid the howl of sirens and the blasts of explosions.

With official schools closed during the German occupation, he helped set up an underground university and the clandestine "Rhapsodic Theater," which met in members' apartments. To make ends meet, he also took a job at the local Solvay quarry and chemical factory. More than fifty years later, he described how a fellow laborer was killed by flying rock, a "sense of injustice" emanating from his lifeless body. The Pope himself was nearly killed when he was hit by a truck near the plant and remained unconscious for several hours.

Karol Wojtyla had women friends, especially in the theater circles. Some thought that's why his vocation came relatively late in life.

But as he once explained it, a girlfriend "wasn't the problem." What delayed his entry to the priesthood was his great passion for literature, philosophy and drama—but the war helped change that, too.

He started noticing that some of his friends had disappeared, killed in war or seized in the night by Nazi troops. It haunted him.

"Any day I could have been picked up on the street, at the factory or at the stone quarry and sent to a concentration camp. Sometimes I asked myself: 'So many people at my age were losing their lives, why not me?'" he wrote on the fiftieth anniversary of his ordination.

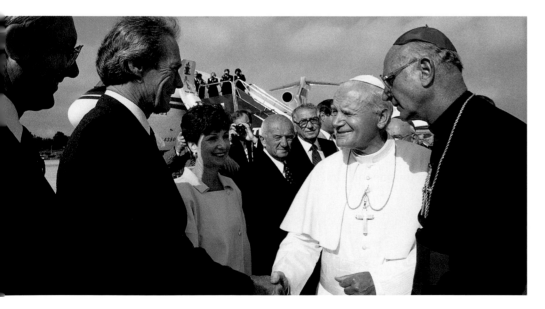

Pope John Paul II is greeted at the Monterey Airport by Carmel, California, mayor and actor Clint Eastwood on his 1987 visit to the United States.

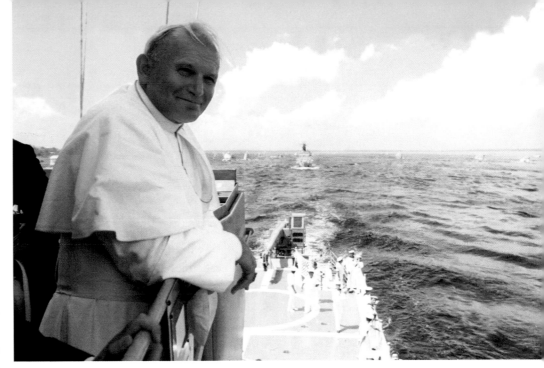

HE GRADUALLY CAME TO FEEL THAT HE WAS SPARED FOR A HIGHER REASON, PART OF A DIVINE PLAN TO BRING SOMETHING GOOD OUT OF WARTIME POLAND.

"I know it wasn't just chance," he said. If his Polish friends and neighbors were being sacrificed on the "altar of history," he would dedicate his life to God and the Church. The decision was a blow to his student companions, but he hoped they would understand in time.

He entered Krakow's clandestine theological seminary in 1942, a risky step under the Gestapo's watchful eyes. Always drawn to the mystical and contemplative, at one point he considered joining the local Carmelite order instead of the diocesan priesthood. But his cardinal told him: "Finish what you've begun," and the local Carmelite director is said to have turned him away with the words: "You are destined for greater things."

Four years later he was ordained, just as Poland was passing from the nightmare of Nazi occupation to the ideological vise-grip of a new Communist regime. Father Wojtyla was sent to study at Rome's Angelicum University, where he did coursework in ethics and wrote a thesis on Saint John of the Cross, a sixteenth-century mystic.

Back in Poland in 1948, the young priest got his first assignment to the rural village of Niegowic, twenty miles outside of Krakow. In what would become typical fashion, he walked there through the fields during harvesttime—and kissed the ground when he arrived. A year later, he became pastor at Saint Florian Parish in Krakow, devoting much of his ministry to young people. He taught them, played soccer, took them on hikes and invited them to his house for discussions.

Father Wojtyla turned to academics again, earning a second doctorate in moral theology. In 1953, he began commuting to Lublin University to teach. By the time he reached his mid-thirties, he had published dozens of articles and several books on ethics. But he also made time to write poems and plays.

Father Wojtyla was an outdoorsman, and he loved to take groups of students hiking, skiing, camping and canoeing in the hills of southern Poland. He took off his collar and told the youth to call him "uncle" because it was illegal for priests to sponsor such outings under Communism.

He was on a kayaking trip in 1958 when he was named an auxiliary bishop of Krakow—at age thirty-eight, he was the youngest bishop in Poland's history. He shunned the trappings of the new position, however, and left his humble apartment for the more comfortable bishops' residence only after friends moved his belongings one day when he was out of town.

The Pope travels by boat on the Amazon during his 12-day visit to Brazil in 1980.

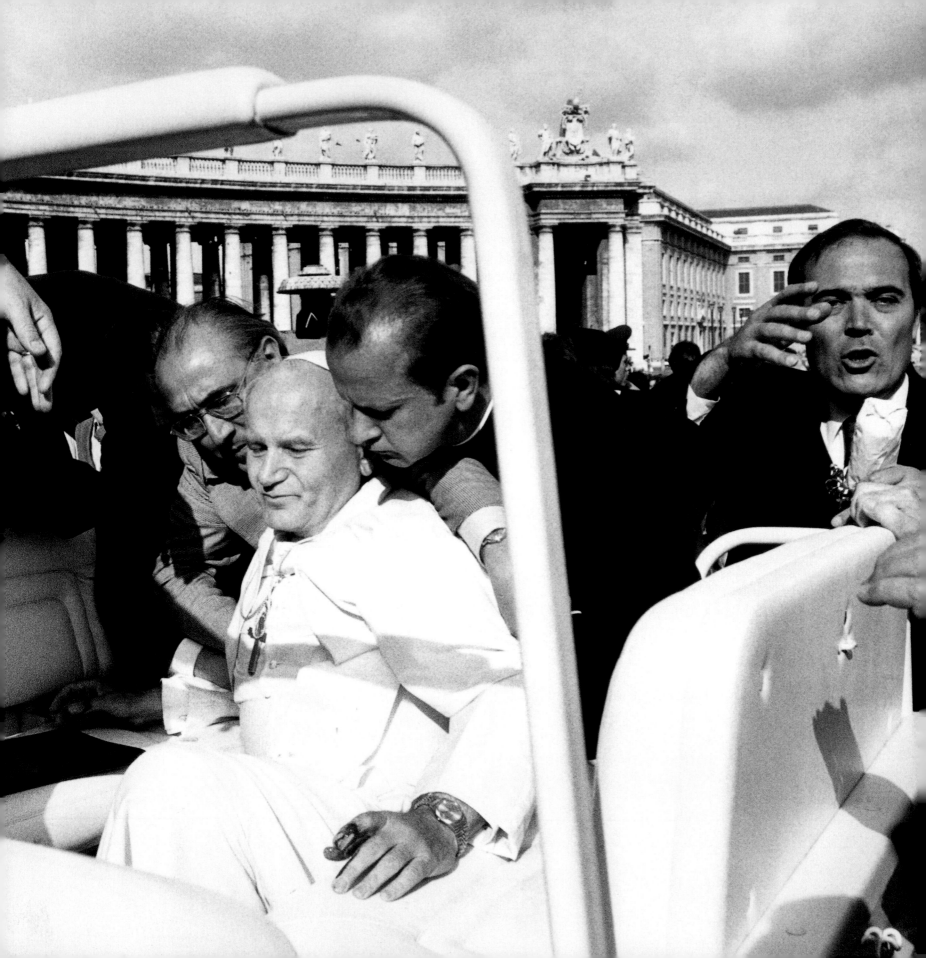

In 1964 he was named Archbishop of Krakow, and three years later he became a cardinal, one of the youngest in the Church. He spent much of his first two years in office commuting to Rome for the final session of the Second Vatican Council, where he helped draft the landmark document *Gaudium et Spes* (The Church in the Modern World).

CARDINAL WOJTYLA WAS VERY MUCH IN SYNC WITH THE COUNCIL'S PUSH TO TEAR DOWN THE WALLS BETWEEN THE CHURCH AND THE WORLD AND MAKE FAITH AN EVERYDAY EXPERIENCE. BUT THAT DID NOT MEAN TURNING HIS BACK ON THE CHURCH'S TRADITIONAL TEACHINGS— FAR FROM IT.

In the mid 1960's, he helped advise Pope Paul VI on sexual morality issues, and he eventually helped prepare the controversial encyclical *Humanae Vitae* (On Human Life), which upheld the Church's teaching against birth control.

Respected in the Vatican's inner circle but virtually unknown to the rest of the world, Cardinal Karol Wojtyla was elected Pope on October 16, 1978. He was the Church's first non-Italian Pontiff in 455 years, and most people didn't recognize his name when it was announced in Saint Peter's Square—they thought he was African.

But his fluency in Italian won the crowd over that night, and got his papacy off to a running start. Within months, he had taken trips around the globe, held airborne press conferences, issued an encyclical on redemption, met with world leaders and opened a new chapter in ecumenical dialogue with the Orthodox.

This hurricane pace was slowed by a would-be assassin's bullets on May 13, 1981. Mehmet Ali Agca, a Turkish terrorist, shot the Pope as he was riding in his jeep in Saint Peter's Square. The Pontiff was rushed to a Rome hospital and underwent hours of surgery; the Pope later deposited the bullet fragments in the crown of a statue of Our Lady of Fatima, whose feast day is May 13, and said he owed his life to Mary. Two and a half years after the shooting, he visited Agca in his Italian prison cell in a remarkable act of forgiveness and reconciliation.

The Pope was soon back in full swing, in a papacy that has rewritten the record books. He's logged more than 700,000 miles in trips to nearly

Opposite: The Pope, hit by a would-be assassin's bullets, falls in the popemobile, May 13, 1981.

The Pope brings his message of reconciliation to Mehmet Ali Agca, who shot him twice in a 1981 assassination attempt. Of the meeting the Pope remarked, "Today I was able to meet my would-be assassin, whom I again forgive." Rebibbia Prison, Rome, 1983.

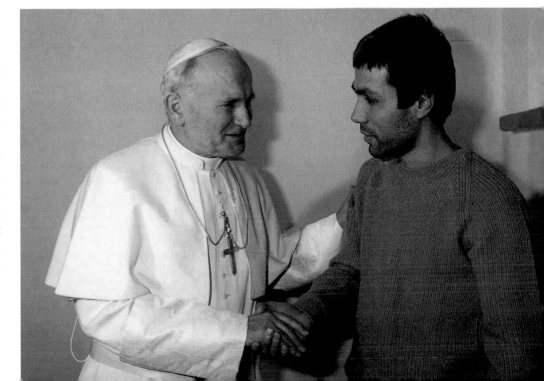

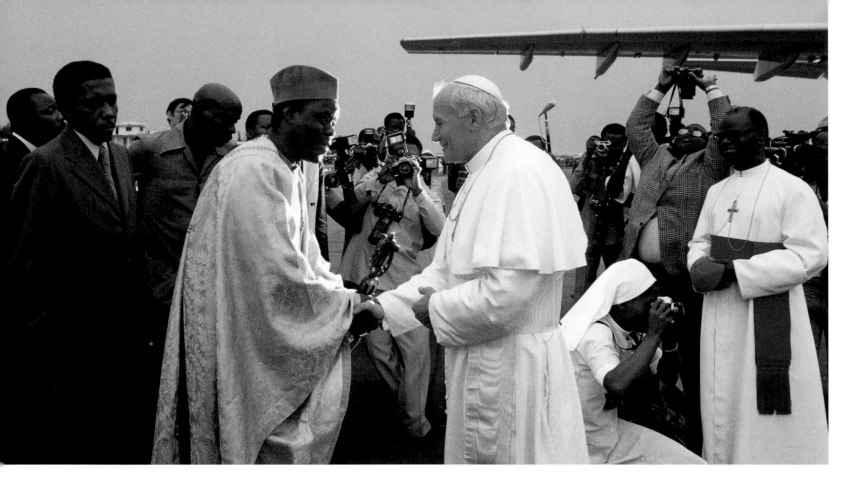

Pope John Paul II is greeted by officials in Cotonou, Benin, in 1982.

130 countries, including such remote spots as Azerbaijan, with a Catholic population of 120.

Many credit his political activism—and his morale-boosting trips to Poland—for helping to bring down European Communism in 1989. In a historic meeting with Soviet Premier Mikhail Gorbachev, the Pope nurtured the *glasnost* reform policy that would eventually lead to the break-up of the Soviet empire.

In other parts of the world, he prodded dictators and pleaded for human rights. At the same time, he lectured liberation theologians and warned bishops and priests against confusing the Gospel with political ideology. His social encyclicals challenged the architects of the globalized free-market economy to narrow the gap between rich and poor in the world.

Despite some people's misgivings about Church teachings like birth control and the all-

male priesthood, he received warm welcomes in his seven trips to the United States, where he was cheered by half a million young people in Denver in 1993.

Pope John Paul II has carried the pro-life banner proudly. Throughout the last decade he has urged bishops and lay Catholics to fight abortion and euthanasia, saying the "slaughter of the innocents" must be stopped. He's also argued that moral justification for the death penalty is practically non-existent in the modern age, and his interventions have sometimes helped save the lives of death-row inmates. Not everyone agrees with the Pope's public pronouncements, but popularity has never been his goal.

"The Pope becomes *persona non grata* when he tries to convince the world of human sin," he said with a dose of realism in 1994.

Yet more than any previous Church leader, he

has earned near-universal respect for highlighting moral and ethical values, and for speaking out on behalf of the millions of people who have little or no voice in global affairs.

Battling fatigue and illness in later years, the Pope has kept up a remarkable string of initiatives inside the Church as well. He used the Holy Year in 2000 to celebrate every aspect of the faith, apologize for Christians' historic misdeeds and map out a pastoral strategy for the new millennium.

He broke down interfaith barriers when he visited a Jewish synagogue and a Muslim mosque, and has made pilgrimages to Orthodox countries where no pope had ever set foot. He convened unprecedented "prayer summits" in the Italian hill town of Assisi, and orchestrated interreligious condemnations of terrorism.

INCREASINGLY, HE HAS EMPHASIZED TO HIS OWN FLOCK THAT PRAYER IS POWERFUL AND THAT PERSONAL HOLINESS CAN CHANGE THE WORLD.

In a typical blend of the traditional and the new, he recently reformed the praying of the rosary, formulating five new "mysteries of light." And he's canonized more than 470 new saints—including lay people from various walks of life—to illustrate his message that true faith is faith in action.

In ways big and small, he has left a lasting image on his Church: in written documents and dramatic gestures, in doctrinal firmness and heartfelt prayer, and by naming nearly all the cardinals who will one day choose his successor. Many young Catholics who have never known another pope call themselves part of the "John Paul II generation."

Despite his frailty, the Pope intends to keep bringing the light of the Gospel to the great issues of the twenty-first century. It's a ministry he carries out with the halting steps of an old man, and the determination of an Apostle.

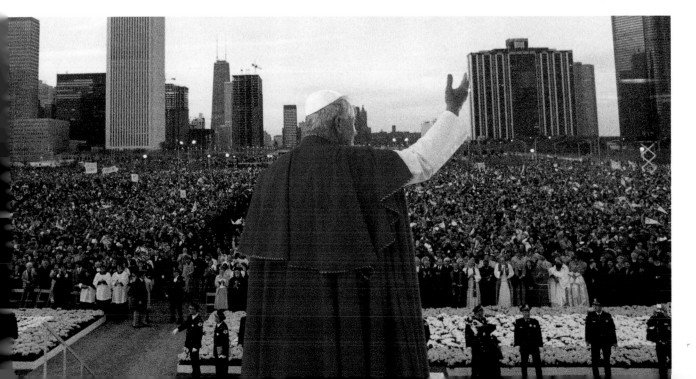

Above: Pope John Paul II greets the world from the balcony of St. Peter's, October 16, 1978, the day he was elected Pope.

Left: Before skyscrapers and a crowd of one million, Pope John Paul II greets Chicagoans during his 1979 visit there.

Following: John Paul II celebrates Palm Sunday Mass for over 30,000 youth who attended the eighteenth World Youth Day, April 13, 2003, in St. Peter's Square.

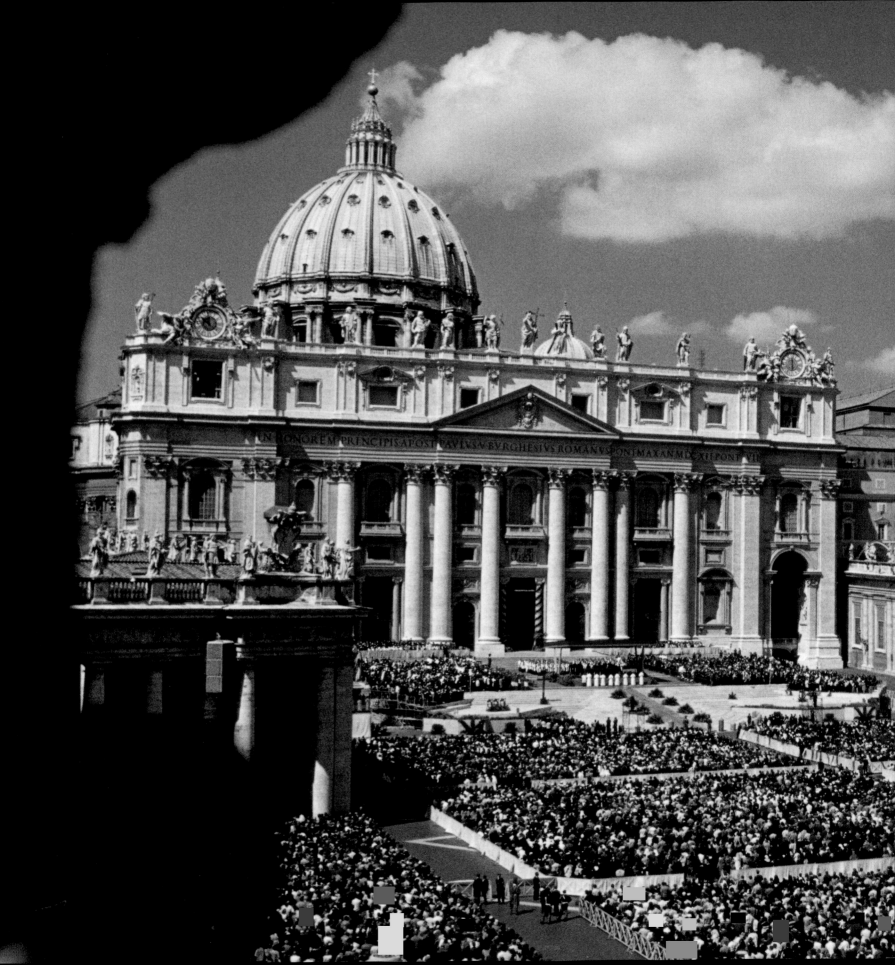

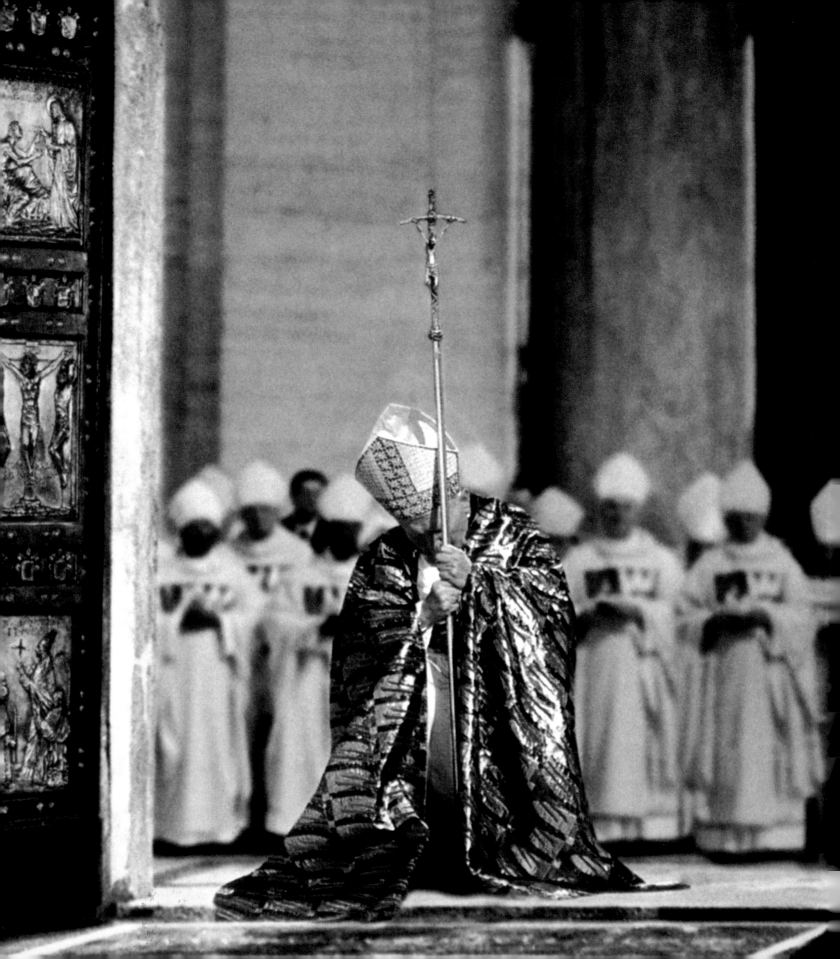

PASTOR

To be pastors after God's own heart (cf. Jer 3:15),
it is essential to adopt a mode of living which makes us like
the one who says of himself: "I am the good shepherd"
(Jn 10:11), and to whom St. Paul points when he writes:
"Imitate me as I imitate Christ" (1 Cor 11:1).

JOHN PAUL II, *ECCLESIA IN AMERICA*

A LIFE DEVOTED TO THE VIRGIN MARY

MONSIGNOR JOHN STRYNKOWSKI

ur Lady of Czestochowa has been a source of unity and continuity for the Polish people for over 600 years. It was not surprising, therefore, that from the beginning of his pontificate Pope John Paul II has demonstrated a profound veneration for the Blessed Virgin Mary. A strong and constant reminder of this is his coat of arms: blue in color with a large golden letter "M" inscribed upon it. The motto beneath the coat of arms reads in Latin *Totus tuus*, literally "Totally yours," expressing his total commitment to and confidence in the Blessed Virgin.

> *. . . the description of the Cana event outlines what is actually manifested as a new kind of motherhood according to the spirit and not just according to the flesh, that is to say Mary's solicitude for human beings, her coming to them in the wide variety of their wants and needs.*
>
> JOHN PAUL II, *REDEMPTORIS MATER*

As Pope he has visited the shrine of Our Lady of Czestochowa a number of times and similarly he has visited other Marian shrines during his trips to various countries, most especially Lourdes and Fatima. The attempt on his life in Saint Peter's Square took place on May 13, 1981, the anniversary of the first of the apparitions of the Blessed Virgin to three children in Fatima, Portugal, 1917. The Pope has constantly attributed to the intercession of the Blessed Virgin his survival and recovery from the assassination attempt.

In his writings and addresses the Pope almost always invokes the example and prayers of the Blessed Virgin, but in 1987 he dedicated an entire encyclical to her role in the life of Christians, *Redemptoris Mater*, or "The Mother of the Redeemer." In the first chapter he traces her presence in the life of her Son and in the second her presence in the Church. Building on the teaching of the Second Vatican Council, he writes that "Mary's faith . . . in some way continues to become the faith of the pilgrim People of God: the faith of individuals and communities, of places and gatherings, and of the various groups existing in the Church."

He rejoices because in ecumenical dialogue it is becoming clearer that churches and ecclesial communities of the West are demonstrating greater recognition of the role of Mary in salvation history and in the faith of Christians. In the third chapter he highlights the unique role of Mary in Christ's redeeming work.

Pope John Paul II declared a Marian Year from Pentecost 1987 to the Feast of the Assumption in 1988. In 2002, with his Apostolic Letter *Rosarium Virginis Mariae*, "The Rosary of the Virgin Mary," he encouraged the use of the Rosary and added the Mysteries of Light, which include five new mysteries—Baptism in the Jordan, Cana Wedding, Proclamation of the Kingdom, Transfiguration, and First Eucharist—to meditate on and pray over.

> *. . . I simply wish to note that the figure of Mary of Nazareth sheds light on womanhood as such by the very fact that God, in the sublime event of the Incarnation of his Son, entrusted himself to the ministry, the free and active ministry of a woman.*
>
> JOHN PAUL II, *REDEMPTORIS MATER*

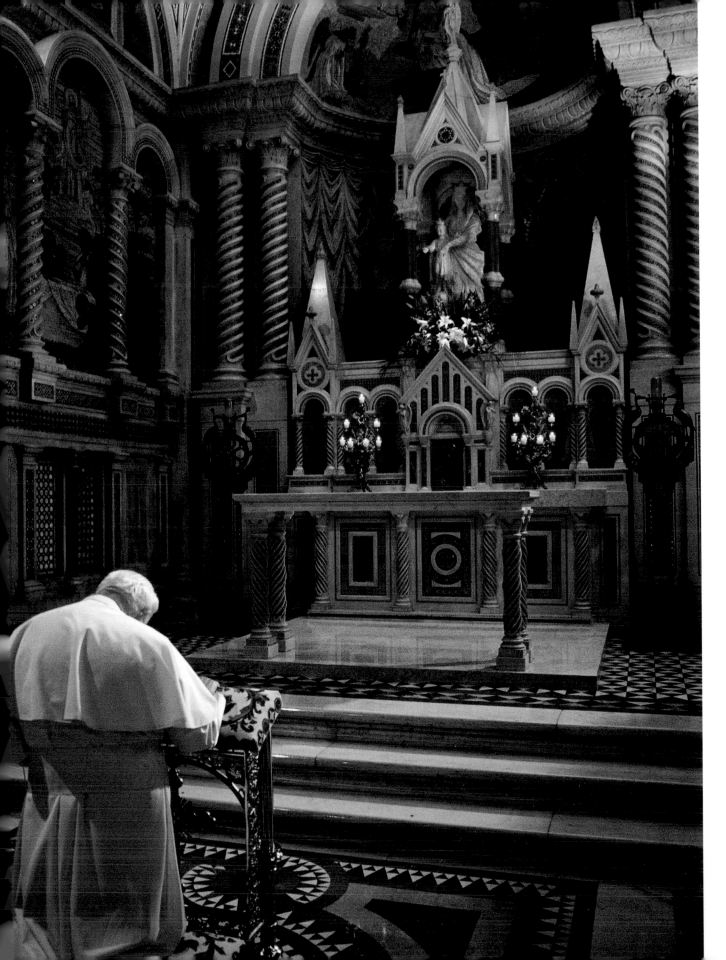

Previous: Kneeling at the threshold of the Vatican's holy door on Christmas Eve 1999, the Pope prays for the world as it enters a new millennium. He opened the doors with the words, "Open for me the door of justice."

Pope John Paul II prays in a side chapel in St. Louis Cathedral during his 1999 visit to the Archdiocese of St. Louis.

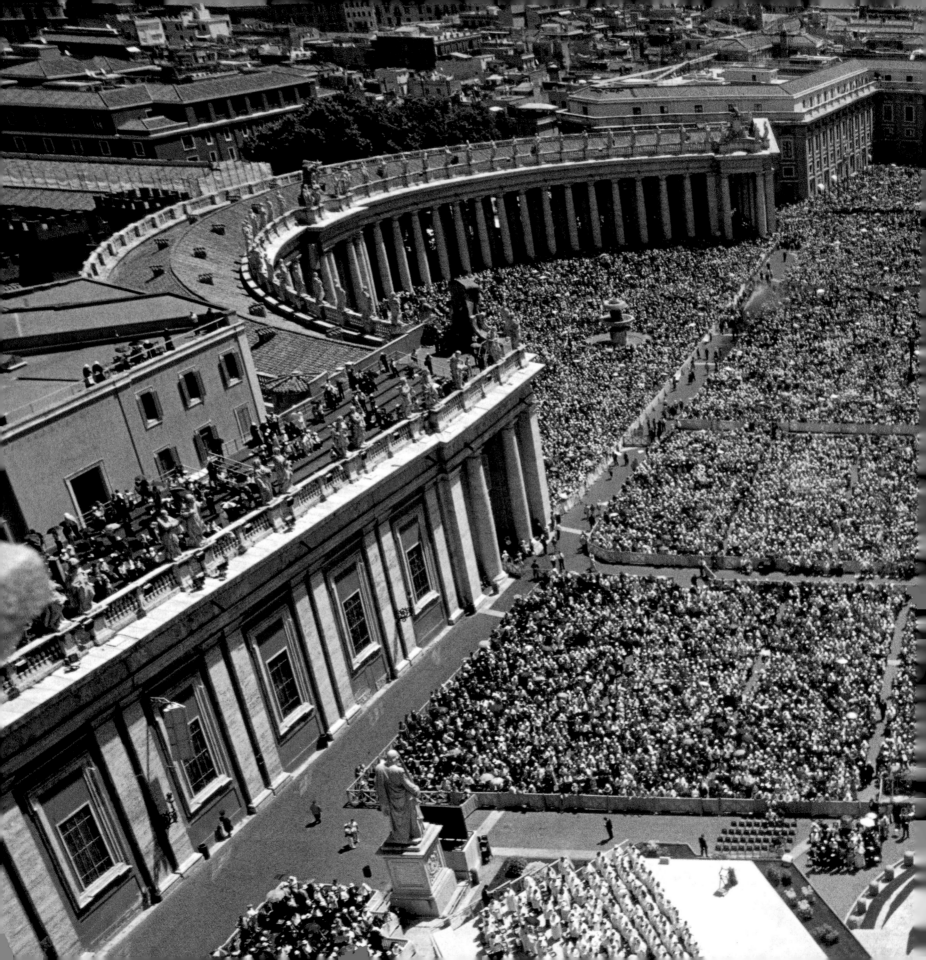

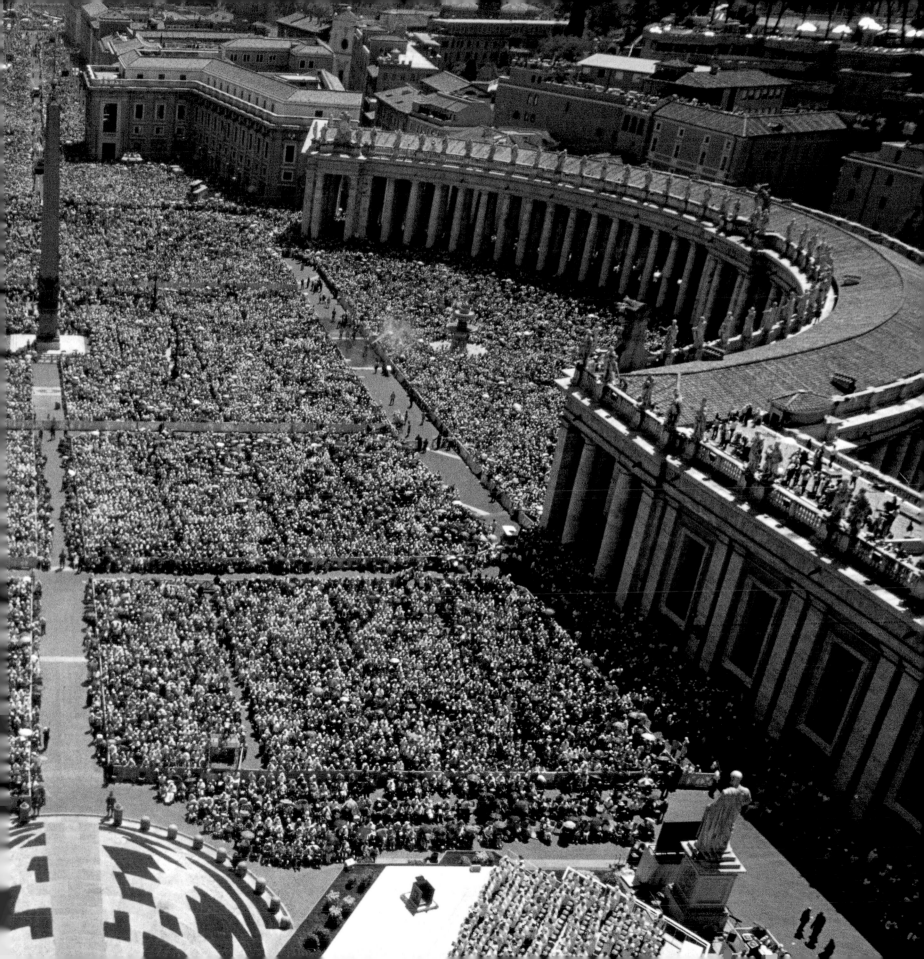

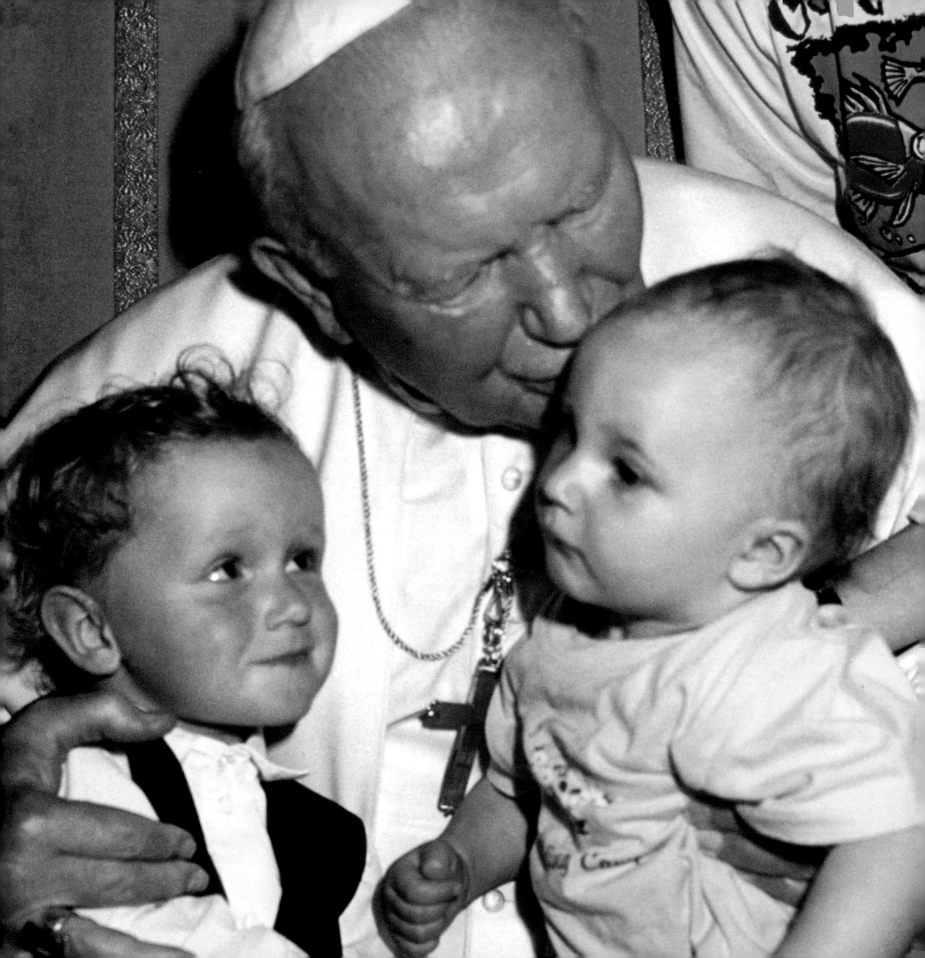

VALUING FAMILIES

H. RICHARD McCORD

hat pope ever sent a letter to your family and mine? Pope John Paul II did.

In 1994 he wrote a "Letter to Families" saying "Dear Families! The celebration of the Year of the Family gives me a welcome opportunity to knock at the door of your home, eager to greet you with deep affection and to spend time with you."

If you've ever watched how the Holy Father embraces children at public appearances, you appreciate how much he values families. If you've noticed how he reserves a place for newly married couples at his Wednesday audiences and greets them personally, you understand his words of affection are much more than nice rhetoric.

Pope John Paul II is a man who has never forgotten his family, his roots in Poland, and his experience as a priest working with young couples and families. And, from the beginning of his pontificate, he has continually emphasized that the family is the first and most fundamental community both of humankind and of the Church.

Among the first gatherings of the Synod of Bishops that he convened (1980) was one on the theme of family. This alone should tell us about the priority he places on marriage and family life. His Apostolic Exhortation at the conclusion of the synod, *Familiaris Consortio*, on the role of the "Family in the Modern World," displays the range and depth of his teaching. Its tone is positive and empowering. The Holy Father shows a pastoral awareness of the many situations and problems of modern family life. He wants to speak to the hearts of every family, no matter how difficult their circumstances.

The Exhortation begins with a stirring call: "Family, become what you are!" And what exactly is this? The Pope explains that every family, by God's design, is given four related tasks: (1) to become an intimate community of persons; (2) to give life and love; (3) to contribute to society; (4) to share in the life and mission of the Church. His is a sweeping, substantive vision. He expects great things of families.

Joys and sorrows, hopes and disappointments, births and birthday celebrations, wedding anniversaries of the parents, departures, separations and homecomings, important and far-reaching decisions, the death of those who are dear, and so forth—all of these mark God's loving intervention in the family's history.

JOHN PAUL II, *FAMILIARIS CONSORTIO*

But he doesn't leave it there—letting families fend for themselves. He devotes a large section of *Familiaris Consortio* to the Church's responsibility to accompany families on their journey. He asks for specific kinds of pastoral care and outreach, especially for those most on the margins. He counsels a gradual approach that begins with where people are and leads them patiently through a conversion process.

In the end, he says, the best way to love and value the family is "to give it back its reasons for confidence in itself, in the riches that it possesses by nature and grace, and in the mission God has entrusted to it."

This Pope, in his teaching and pastoring, has spent a lifetime doing exactly that.

Previous: An estimated 300,000 crowd St. Peter's Square in Rome for the canonization of 20th century mystic and monk Padre Pio, 2002.

Opposite: A deep affection for children characterizes John Paul II.

How'd He Know It Was His Day Off?

ARCHBISHOP TIMOTHY M. DOLAN OF MILWAUKEE

AS RECTOR of the North American College in Rome, I annually asked the privilege of a private audience with the Pope for the forty priests from home who were completing our sabbatical program.

It dawned on me one year at the last minute that I had forgotten to ask for an audience! Scared and embarrassed, I called then-Monsignor Dziwisz, the Holy Father's private secretary, and pleaded my cause, explaining that the men left Wednesday, and today was Monday, which only left tomorrow, Tuesday! Was there any chance they could see the Holy Father the next day? "But the Pope tries to take Tuesday as his day off," replied the exasperated secretary. After more pleading, he relented. "All right, bring the group tomorrow at noon."

The next day, up the *scala regia* (royal staircase) we climbed, to go through no less than five rooms, filled with pilgrims awaiting the Holy Father! Some day off, I thought! This man never stops giving! It is such indefatigable self-giving that inspires me about Pope John Paul II.

Here in Spain in 1997, as in other nations, the Pope takes time out to enjoy the mountains which have always revitalized him.

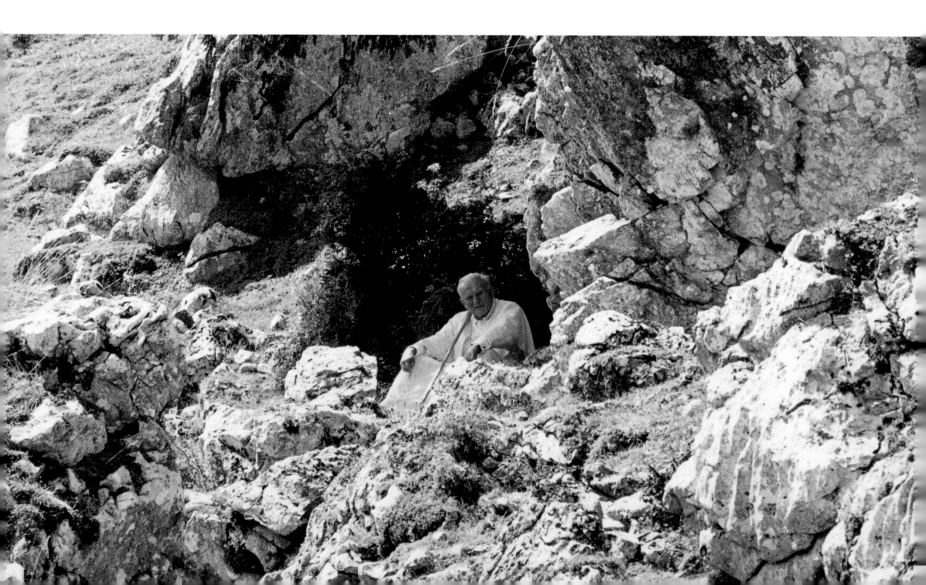

A Pontifical Quiz

CARDINAL EDWARD EGAN, ARCHBISHOP OF NEW YORK

SHORTLY after being named Archbishop of New York, I was invited to a luncheon with the Holy Father and his two priest-secretaries. The Successor of Peter had a twinkle in his eye. He had brought to the table a copy of the *Annuario Pontificio*, the Vatican yearbook, opened it up as we awaited our meal, and proceeded to question me about the Archdiocese—how many parishes there were, how many priests, how many schools, how many religious, and so on. I fumbled with approximate answers until he finally closed the book and had a good laugh.

Rather quickly, however, he became quite serious and started telling me about New York. He spoke with extraordinary knowledge and insight, all the while punctuating his remarks with a promise of prayers for me and the flock I had been assigned to serve.

When my priest-secretary picked me up in the *Cortile San Damaso* (the inner courtyard) after the luncheon, he asked how things had gone. I replied that the Bishop of Rome prays regularly for the Archdiocese of New York and knows more about it than its new archbishop. Moreover, I noted that on future visits to the Eternal City we had better bring with us a copy of the *Annuario Pontificio*. "It will make it possible for me to do some preprandial preparation," I explained, "in case the Holy Father invites me to his table again and allows me to retake my examination."

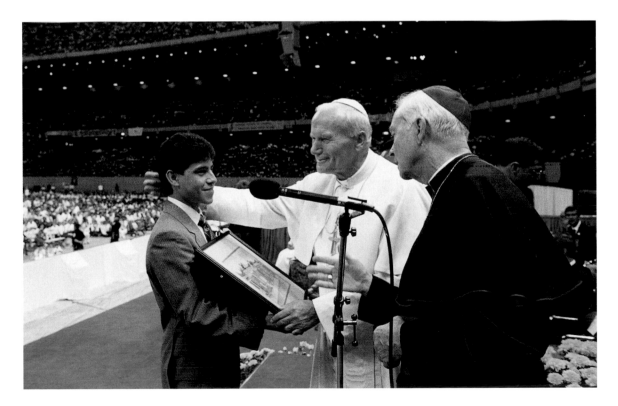

The Pope accepts a gift from one of the 88,000 youth gathered under the Superdome in New Orleans during his 1987 visit to the city.

CALLING ON THE YOUNG

SISTER MARY ANN WALSH, RSM

eaders of all stripes emerged in the twentieth century but only Pope John Paul II thought to convene the world's young people and offer a vision to the leaders of tomorrow.

Beginning in Rome in 1985 and continuing through to Toronto in 2002, John Paul has invited young people to join with him through a series of World Youth Days. By 2002, he had drawn millions of young people to international gatherings in Buenos Aires, Argentina (1987); Santiago de Compostela, Spain (1989); Czestochowa, Poland (1991); Denver, Colorado (1993); Manila, the Philippines (1995); Paris, France (1997); Rome, Italy (2000); and Toronto, Canada (2002).

Young people of America and of the world, listen to what Christ the Redeemer is saying to you! "To all who received him, who believed in his name, he gave power to become Children of God"(Jn 1:11–12). The World Youth Day challenges you to be fully conscious of who you are as God's dearly beloved sons and daughters.

JOHN PAUL II, WORLD YOUTH DAY, AUGUST **12, 1993**, MILE HIGH STADIUM, DENVER, COLORADO

The meetings showed the particular appeal of John Paul to young people. Speaking in the language of each of the countries where the events took place, he tapped into their idealism with a message that they are the ones to bring peace to the world. He bantered with them—to their chants of "John Paul II, we love you," he responded "John Paul II, he loves you too." He called them to be holy, bringing tears to their eyes; his words touched their hearts and souls.

He reminded them that there are no limits to what they can do with God.

World Youth Day is for the hardy. It involves hiking for miles to a site of an all-night vigil marked by prayer with the Pope, Scripture, community and song. The following day the young people participate in a Mass celebrated for them by the Pope himself. Some years it has rained, leaving young people coated in mud. Other years it has been chilly. Other years, hot. Always, the event has inspired participants and observers.

The Pope's visit to Denver in 1993 amazed even the cynical. It was like Woodstock, with all of the good and none of the bad, boasted a front-page story in a metropolitan daily newspaper. Viewers were amazed that hundreds of thousands of youth could gather for a lively five days of prayer and celebration of their faith.

Even as the Pope grew older, World Youth Day energized him. In 1993, organizers coined a new verb, "youthens," to describe a phenomenon they saw, as in, the Pope "youthens" when he meets young people. In Toronto, nine years later, a visibly aging Pope gathered energy from his first glimpse of youth from the plane. Given his increasing difficulty in walking, organizers had prepared a device to lift the Pope down when he had disembarked from Alitalia. To everyone's surprise, the Pope walked down the steps and headed for the microphones. His youth were calling him and he responded as always with the affection he feels especially for the young.

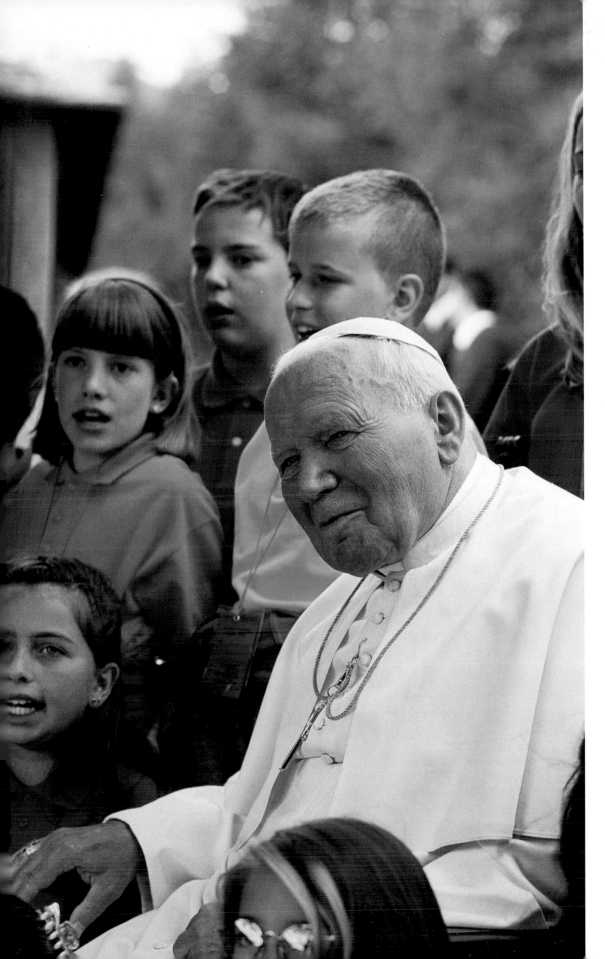

Only in Christ can men and women find answers to the ultimate questions that trouble them. Only in Christ can they fully understand their dignity as persons created and loved by God. Jesus Christ is "the only Son from the Father... full of grace and truth."

JOHN PAUL II, WORLD YOUTH DAY, AUGUST 14, 1993, McNICHOLS ARENA, DENVER, COLORADO

The Pope sings with children during his holiday in the Val d'Aosta region of northern Italy, July 16, 2000.

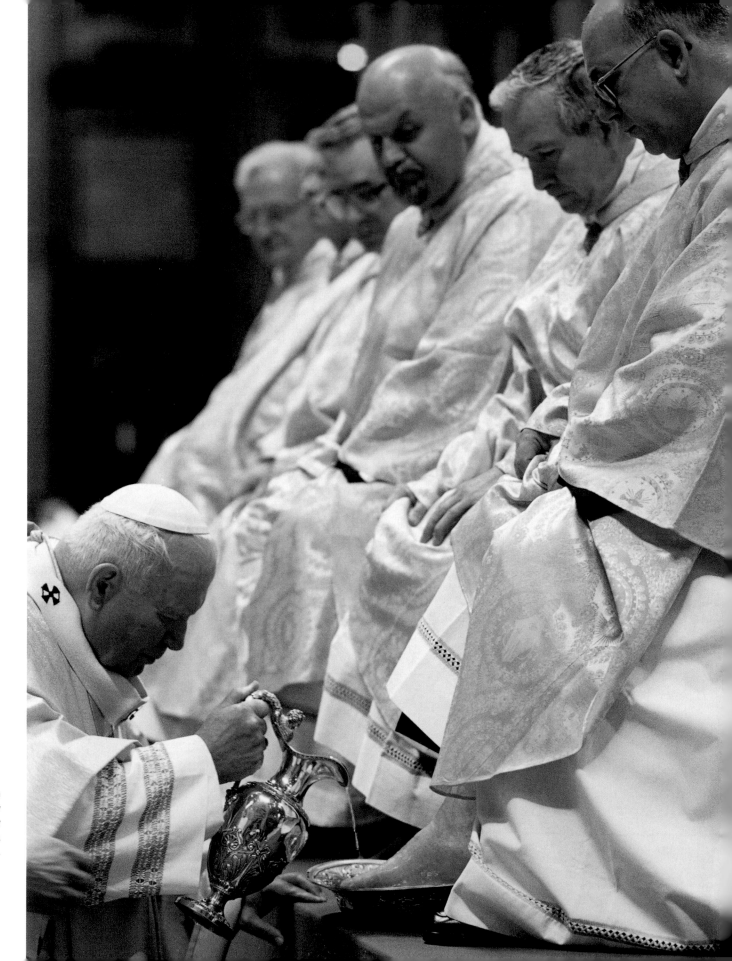

The Pope stoops to wash
the feet of his fellow
priests on Holy Thursday
during the Jubilee Year,
St. Peter's Basilica, 2000.

CARE FOR PRIESTS

FATHER J. CLETUS KILEY

ope John Paul II has shown an extraordinary solicitude for priests. One of the treasured contributions he has made to priests has been the annual letter he has sent to them on Holy Thursday of each year of his pontificate. In his first Holy Thursday Letter to Priests on April 18, 1979, the Holy Father wrote these powerful words of support to priests in their various situations around the globe: "At the beginning of my new ministry I feel the need to speak to all priests," he said. "I think of you all the time, I pray for you; with you I seek spiritual union because by virtue of the Sacrament of Orders you are my brothers. For you I am a bishop, with you I am a priest."

In each succeeding year of his pontificate, John Paul II reached out to priests through these annual letters and through many other forms of solicitude and encouragement.

Perhaps the greatest contribution of his pontificate regarding the priesthood will be his 1992 Apostolic Exhortation *Pastores Dabo Vobis* (I Will Give You Shepherds). In this document he laid out the foundations for the formation of future priests. He strengthened the identity of the priest and he issued a new call to spiritual holiness. He spoke of the priest as a full human person needing initial and ongoing formation as a person, and emphasized his intellectual, pastoral, and spiritual dimensions as well. Finally, he reminded all priests that the "priesthood has a radical communitarian nature" (*PDV*, 17). This reiterated his strong belief in his own sense of *communio* with priests throughout the world.

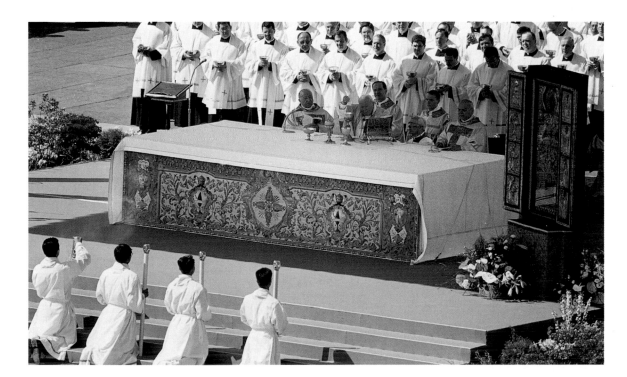

The Pope celebrates Easter Mass at St. Peter's Square, Vatican City, 2000.

Following: Pope John Paul II ordains men to the priesthood in St. Peter's Square, 2000.

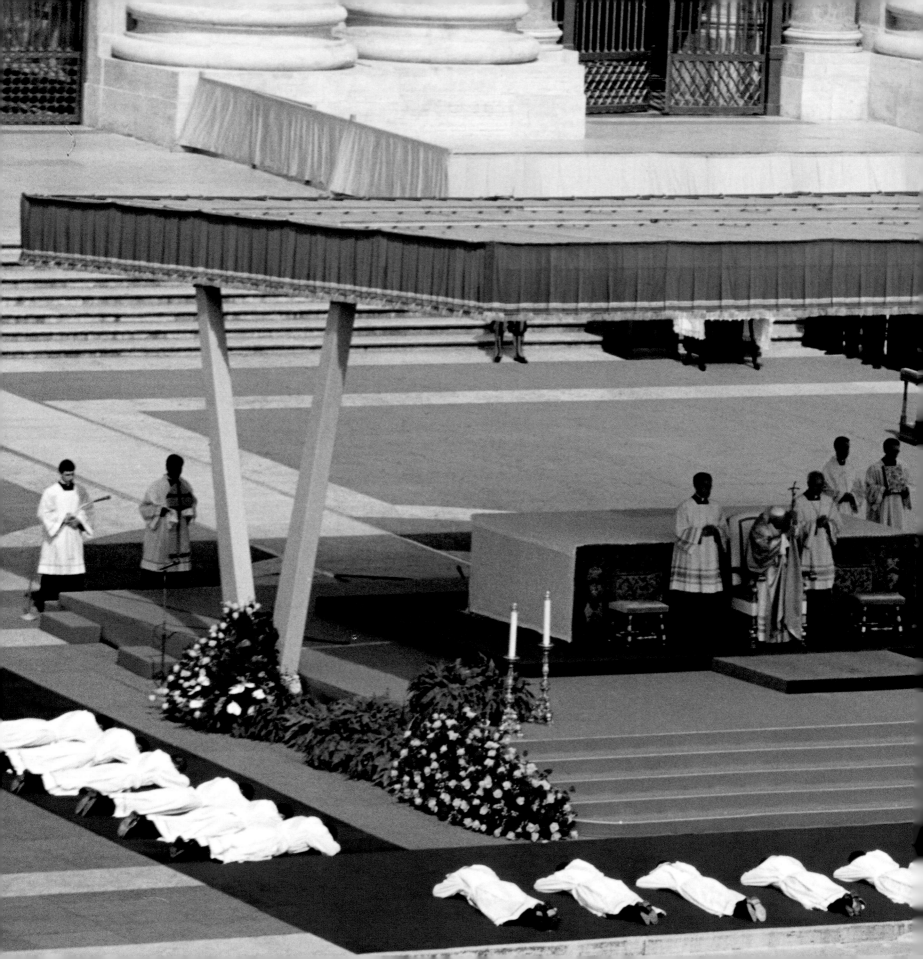

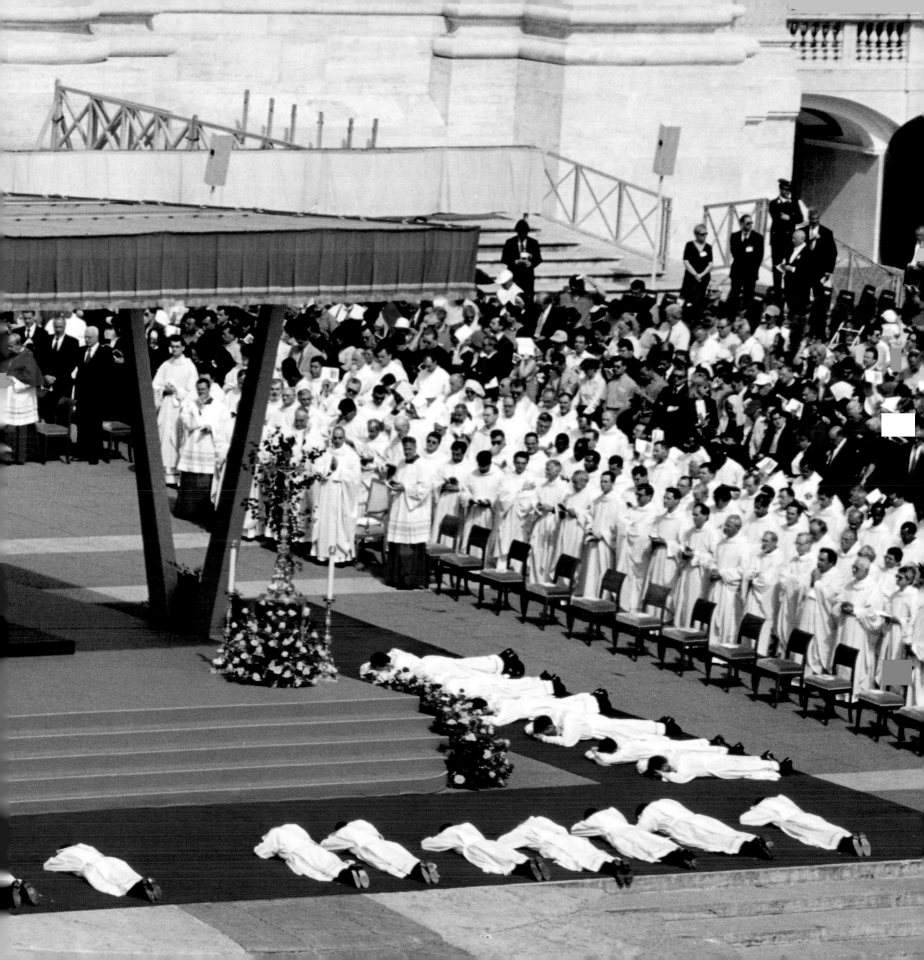

VOCATIONS TO SERVE AS PRIESTS AND RELIGIOUS

FATHER EDWARD J. BURNS

n a time when many in society seem to avoid the responsibilities of commitment, Pope John Paul II has repeatedly asked young people to courageously consider committing themselves to service within the Church and to be open to a life-long commitment as a priest, brother, or sister. He has identified the promotion of vocations to ordained ministry and consecrated life as a priority and an urgent mission for the Church.

To modern men and women, often dissatisfied with a shallow and ephemeral existence, and in search of authentic happiness and love, Christ offers his own example and issues the invitation to follow Him. He asks those who hear his voice to give their lives for others. This sacrifice is a source of self-fulfillment and joy, as is seen in the eloquent example of those men and women who, leaving all security behind, have not hesitated to risk their lives as missionaries in different parts of the world. It can also be seen in the response of those young people who, prompted by faith, have embraced a vocation to the priesthood or the religious life in order to serve God's plan of salvation.

JOHN PAUL II, HOLY FATHER'S MESSAGE FOR LENT, 2003

His ability to challenge young people to consider such vocations can be seen during World Youth Days, as well as in his messages for the World Day of Prayer for Vocations. He reiterates that all members in the Church need to recognize their responsibility to stir within the hearts of young people the possibility that the Lord of the harvest may be calling them to ordination or consecrated life.

L'Osservatore Romano, the Vatican daily newspaper, has reported that during his pontificate seminarians throughout the world have increased. Despite society's emphasis on consumerism, individualism and materialism, the Pope continues to speak about service to others, the spirit of the Gospel, and living out the paschal mystery. Such words of truth are evident in his teaching, his messages, and in his writings.

Pope John Paul II has also established opportunities for the Church to conduct Continental Congresses in order to highlight the necessity of promoting vocations to the ordained ministry and consecrated life. The first congress occurred for Latin America in Brazil in 1994. The second took place for Europe in 1997. In 2002, his Third Continental Congress on Vocations, this time in North America, was a huge success as 1,136 delegates from across Canada and the United States gathered that April to embrace the urgent mission to promote such vocations.

The Holy Father's messages on vocations have always included a challenge to parents, priests, bishops, religious, educators; indeed to the entire Church, that we all have a role and a responsibility in inviting young men and women to courageously consider vocations to ordained ministry and consecrated life.

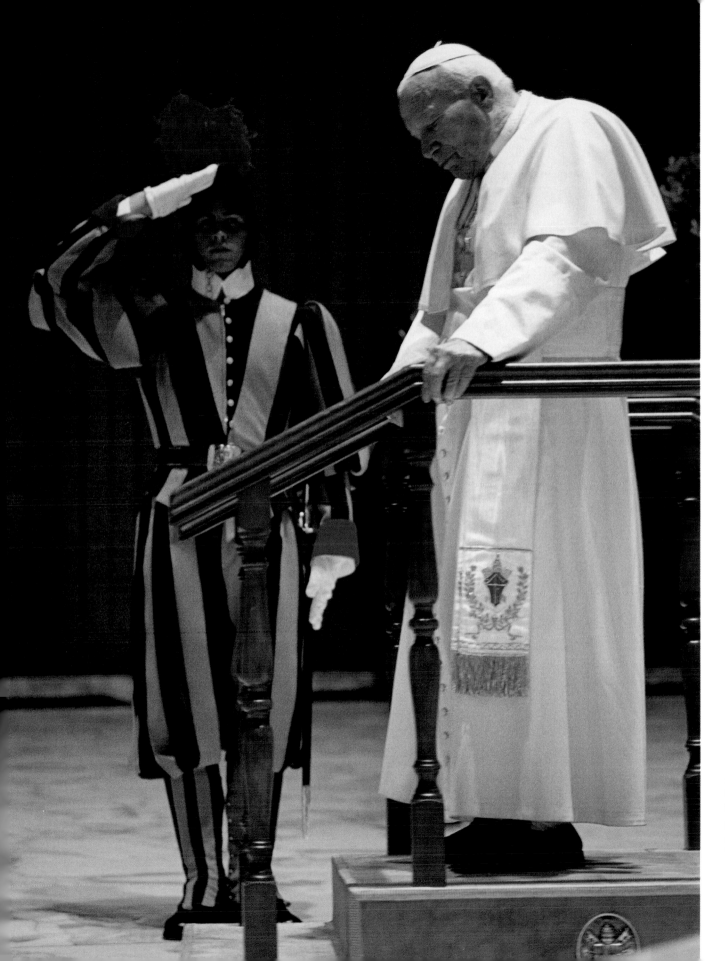

A Swiss Guard salutes Pope John Paul II as he arrives on his mobile platform in the Paul VI Audience Hall, Vatican City, 2002.

LITURGY FROM THE HEART

MONSIGNOR JAMES P. MORONEY

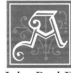 retrospective of the liturgical contributions of a pontiff usually begins with a list of impressive documents. Yet the perduring image of Pope John Paul II is his personal devotion as he stands at the altar, his head bowed, now in frailty and always in humility.

His very posture proclaims that this moment at the altar is the center of life, the act which gives meaning to everything else. It is a point stressed in the recently revised *Roman Missal* that says of every priest: "by his bearing and by the way he speaks the words of the Liturgy he conveys to the faithful the living presence of Christ" (*General Instruction of the Roman Missal*, 93).

When the Pope celebrates Mass, he moves people beyond the solemnity and pomp of pontifical rites, and into the heart of the matter. He has promoted a liturgical reform meant to transform those at worship from the inside out. He has emphasized that the Mass, the Divine Office and personal prayer are the most important aspects of a parish priest's life. He emphasized that point in 1998 when he told a group of United States bishops that "prayer for the needs of the Church and the individual faithful is so important that serious thought should be given to reorganizing priestly and parish life to ensure that priests have time to devote to this essential task, individually and in common. Liturgical and personal prayer, not the tasks of management, must define the rhythms of a priest's life, even in the busiest of parishes" (Pope John Paul II to the Bishops of Michigan and Ohio during their *ad limina* visit, May 21, 1998).

The Pope has urged parish priests to draw people to the liturgy and to make it meaningful to them whatever their background. He has completed and refined the reform of the liturgical books begun forty years ago and has urged that the Liturgy must be authentically translated into the voice of every culture and language, while preserving the identity and immemorial voice of the Roman Rite. Indeed, the revised *Roman Missal* could have been speaking of this Bishop of Rome when it concludes a long list of liturgical responsibilities by noting that it is "his primary task to foster the spirit of the Sacred Liturgy in priests, deacons, and the faithful."

Below: The Pope signs the encyclical *Evangelium Vitae* on the Value and Inviolability of Human Life, Rome, 1995.

Opposite: Pope John Paul II greets a record crowd at the America's Center in St. Louis in 1999.

The celebrants and leaders must help the assembly enter into a liturgical celebration which is not merely their own production but is an act of the whole Church. Priority must therefore be given to the words and actions of Christ to what has been called "God's surprise." The role of guidance is not to express everything or prescribe everything, it will respect a certain spiritual freedom for each person in his relationship with the word of God and with the sacramental signs. A liturgical act is an event of grace whose effect exceeds the will or expertise of the agents who are called to be humble instruments in the Lord's hands. It is they who have the task of making it possible to see what God is for us, what he does for us, and of making the faithful today realize that they are entering into the history of creation sanctified by the Redeemer, in the mystery of universal salvation.

JOHN PAUL II, TO THE BISHOPS OF FRANCE, MARCH 8, 1997

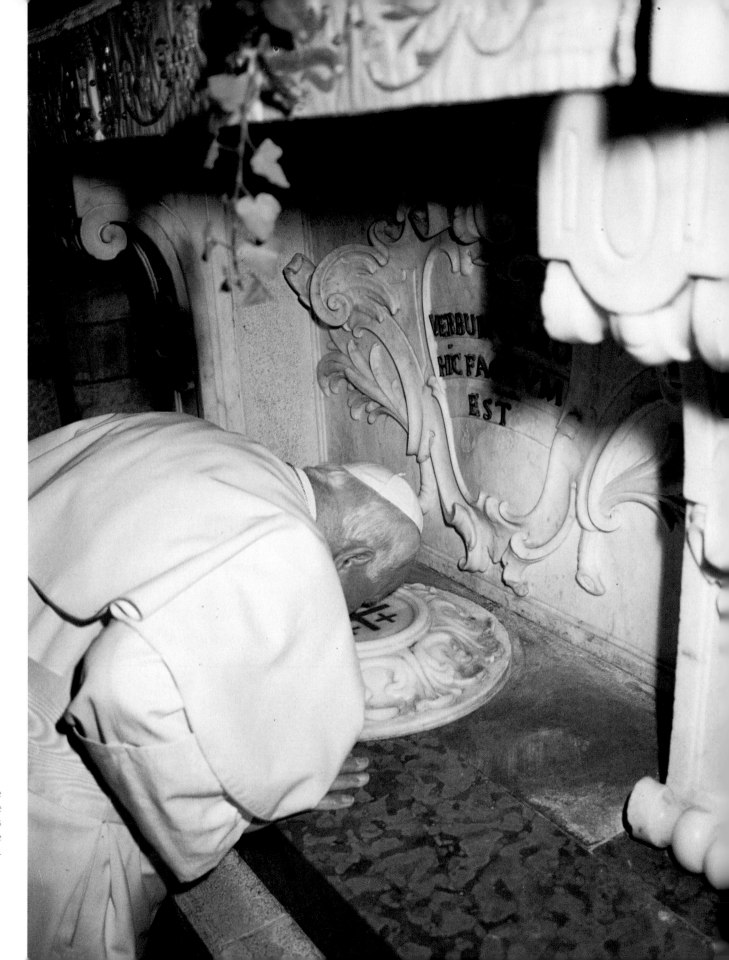

During his 2000 Jubilee
Year pilgrimage to the
Holy Land, the Pope prays
at the Basilica of the
Annunciation in Nazareth.

Lost in Prayer

BISHOP JOSEPH A. GALANTE, Coadjutor Bishop of Dallas

DURING the six years that I served as Undersecretary at the Congregation for Religious in Rome, it was my privilege to have lunch with the Pope once or twice each year. They were memorable occasions providing opportunities to experience the Pope's sense of humor, his ease in conversing and his interpersonal skills. But for me the most profound experiences that I had were during the visits to his private chapel after the meal. I was very much struck by the profound sense of prayerfulness of the Holy Father. Pope John Paul II is able to so focus on his relationship with God that all other people and sounds and settings are blotted out.

I came away from those times with a conviction that our Holy Father is truly a mystic. His relationship with the Lord is so total and consuming that to be in his presence when he is at prayer enables one to experience the presence of God.

And so, I continue this enduring conviction and I seek to imitate in my own poor way the example of a man of profound prayer. A true mystic in our day.

Pope John Paul II prays at the Church of the Agony near Jerusalem's Garden of Gethsemane during his 2000 visit to the Holy Land.

THE ERA OF THE LAITY

ANA M. VILLAMIL

ou go into the vineyard too" (Mt 20:3–4). These simple words from Matthew's Gospel have been often quoted by Pope John Paul II when speaking to the laity. The workplace, the home, the political arena, the school, the local parish . . . all of these are places where lay people belong. In fact, the Pope puts it even more strongly. These are places where people must have a commitment to be active, to live out their faith in a visible way. As he challenged the laity in his Apostolic Exhortation, *Christifideles Laici*, "It is not permissible for anyone to remain idle."

It is not surprising that during these past twenty-five years, participation of the laity in the mission of the church in the world has risen dramatically. The Pope has helped to create many new opportunities for lay ministers. He has challenged the laity to learn more about their faith and many have responded by pursuing graduate degrees in the fields of ministry and theology. During his entire tenure, the Pope has been calling the laity to be active Christians.

In his Apostolic Letter for the Jubilee Year 2000, *Novo Millennio Inuente* (At the Beginning of the New Millennium), he challenged, "Now we must look ahead, we must 'put out into the deep,' trusting in Christ's words: *Duc in altum*! What we have done this year cannot justify a sense of complacency, and still less should it lead us to relax our commitment. On the contrary, the experiences we have had should *inspire in us new energy*, and impel us to invest in concrete initiatives the enthusiasm which we have felt. Jesus himself warns us: 'No one who puts his hand to the plough and looks back is fit for the kingdom of God' (Lk 9:62). In the cause of the Kingdom there is no time for looking back, even less for settling into laziness. Much needs to be done . . ." (15). This is our faith. We need to be serious about it. We need to understand what we believe and then act on it.

This shift in perspective which the Pope calls for is both an exciting one and sometimes a frightening one. The Second Vatican Council started the shift by reminding the laity that baptism means something. It means that we have become a part of a community of believers. And this is not a community that allows passive membership! The Pope notes that this is a community that calls for full and active participation by *every* individual. We can no longer be passive about our faith. What we believe needs to permeate how we live our lives in every aspect. We need to take on the responsibilities that come with being called Catholic.

Unceasingly, Pope John Paul II reminds us about this. "The collaboration of the laity is becoming more and more indispensable. This is not only a practical need occasioned by a reduction in religious personnel, but it is a new, unprecedented opportunity that God is offering us. Our era could in some ways be called the era of the laity" (Pope John Paul II, Address to the Oblates of Saint Joseph, February 17, 2000, *L'Osservatore Romano*, March 8, 2000, p. 6).

These are sobering words, reiterating Christ's message, go into the vineyard too.

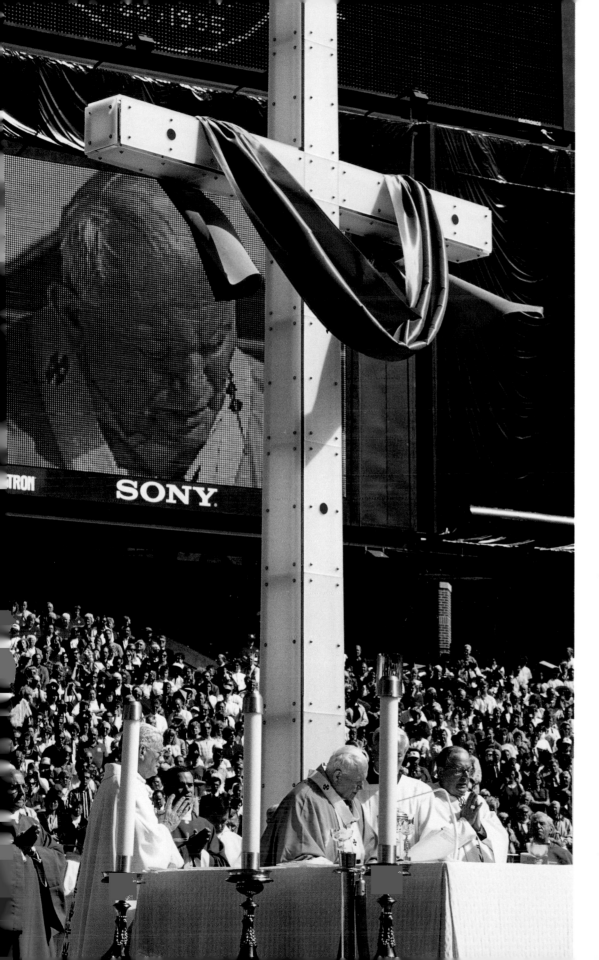

A new state of affairs today both in the Church and in social, economic, political and cultural life calls with a particular urgency for the action of the lay faithful. If lack of commitment is always unacceptable, the present time renders it even more so. It is not permissible for anyone to remain idle.

JOHN PAUL II, *CHRISTIFIDELES LAICI*

The Pope celebrates Mass at Oriole Park, Camden Yards, during his 1995 visit to Baltimore.

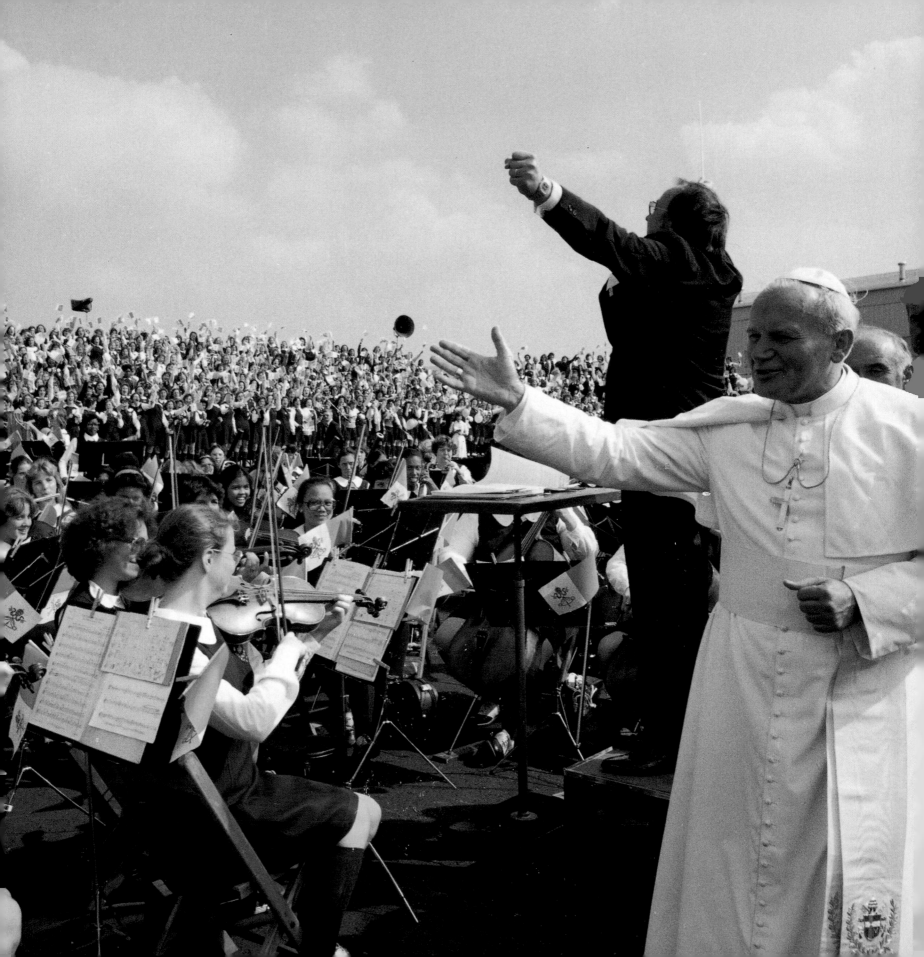

The Mention of a Special Name

THOMAS N. LORSUNG, Editor-in-Chief, *Catholic News Service*

"WHEN was that picture of the Pope taken?" people ask me about the framed image in my office.

It was March 1, 2002, and the Pontifical Council for Social Communications had its audience with the Holy Father. As a consultor to the group, I was pleased to be there and, frankly, curious to see for myself just how well he was getting along because video and still photos showed him having great difficulty. Even his facial expressions were limited by his neurological illness. But that changed before my eyes when my wife and I were introduced. When Pope John Paul II heard her name, Mary, he gained some special strength, looked up and smiled in a way I had not seen in many recent photos. I can only guess that for him any reminder of the name of the Mother of God is a special inspiration. I know that something beautiful and unexpected happened in that moment, creating an enduring memory for me and, of course, for Mary.

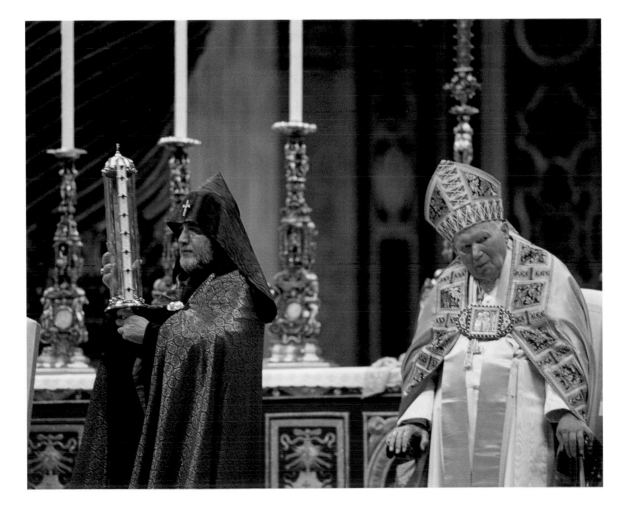

Opposite: The Pope greets members of a youth orchestra in Philadelphia in 1979.

Left: The Pope prays together with the head of the Armenian Apostolic Church, Catholicos Karekin II of Etchmiadzin, at St. Peter's Basilica, 2000.

Following: Pope John Paul II greets musicians in Nairobi, Kenya, September 18, 1985, during his visit to Cameroon South Africa and Kenya.

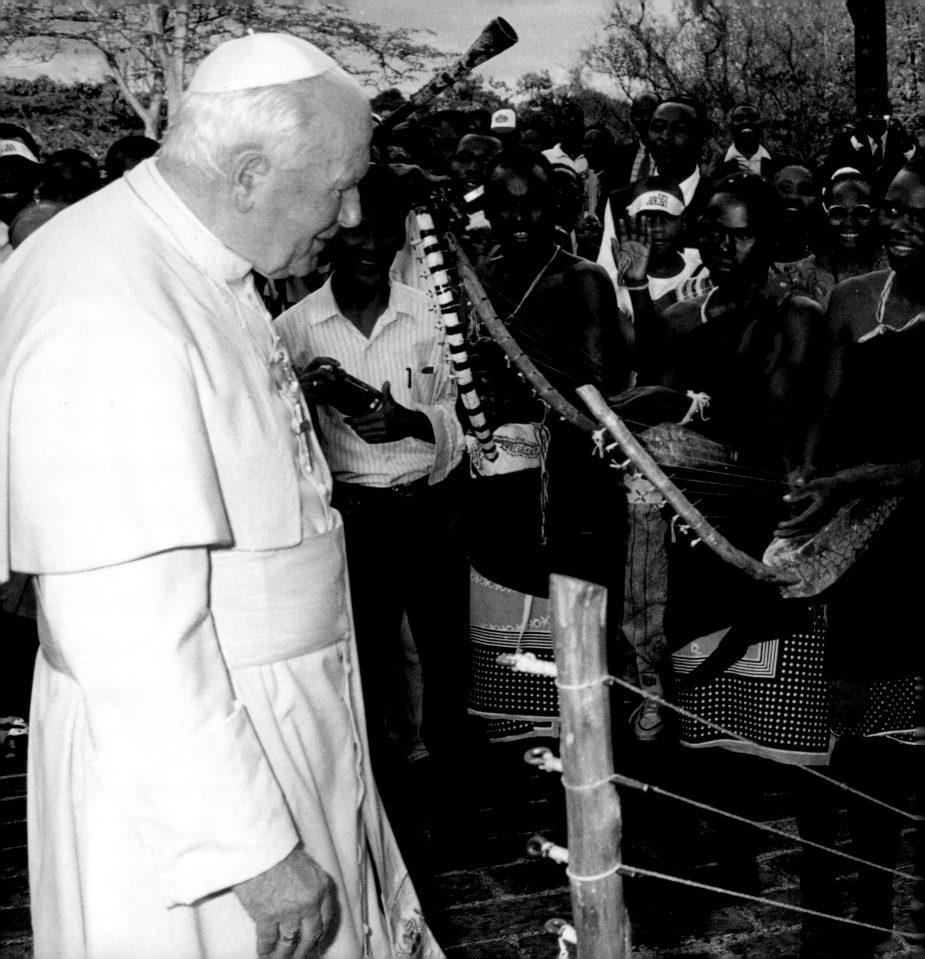

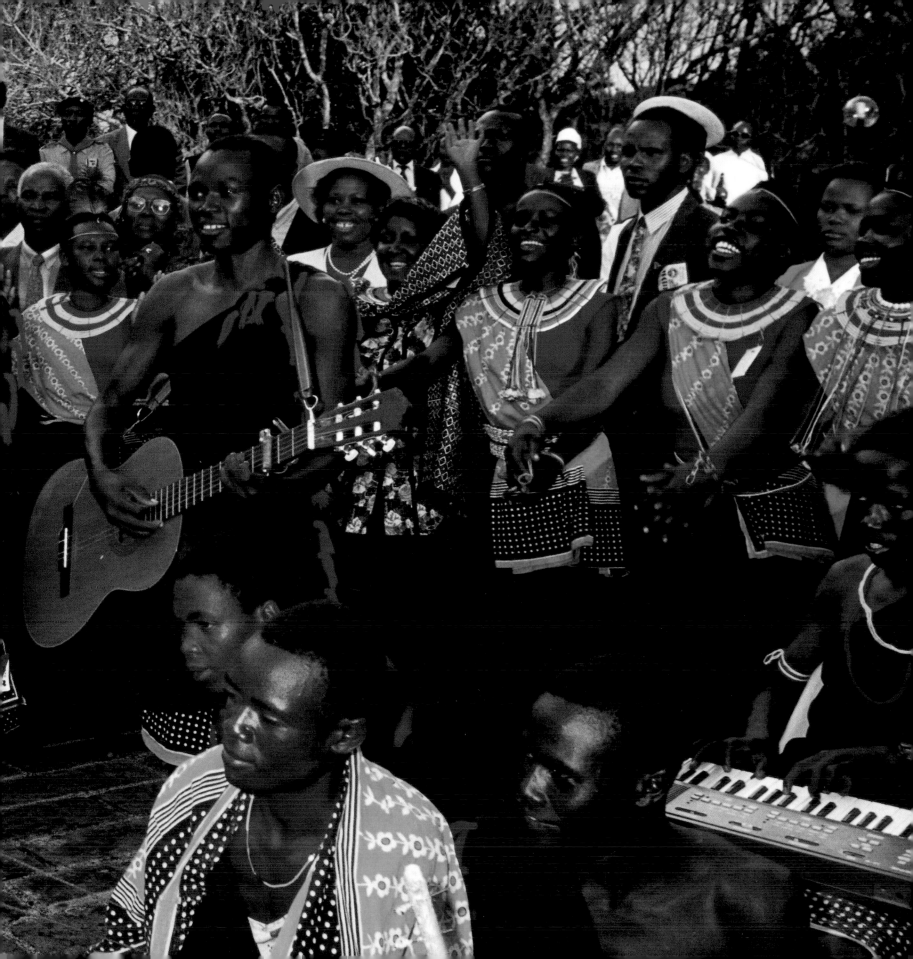

THE MAKING OF SAINTS

MONSIGNOR JOHN STRYNKOWSKI

hrough *Lumen Gentium* (Dogmatic Constitution on the Church), the Second Vatican Council reminded Christians that through the saints "God shows, vividly, to humanity his presence and his face." As no other before him, Pope John Paul II has allowed this divine presence and face to be seen through the number of men and women he has canonized and beatified. During his papacy he has canonized more than 460 saints and declared more than 1,250 men and women blessed. He has done this not only in Rome, but also in other places around the world during his many pastoral visits in order to demonstrate the universality of the call to holiness and allow more

people to witness the recognition of the sanctity of those who lived among them.

With his apostolic constitution *Divinus Perfectionis Magister* (The Teacher of Divine Perfection) of 1983, the Pope simplified the procedures for beatification and canonization, thus making possible the larger numbers during his pontificate. The Pope has encouraged for consideration as candidates for beatification and canonization men and women in recent decades who have died as martyrs in the face of persecution from atheistic totalitarian regimes. Among these is Saint Maximilian Kolbe, a Conventual Franciscan, who died a victim of the Nazis in Auschwitz.

Each of the saints reveals a particular aspect of the mystery of Christ and its implications for living according to the Gospel. One of the best-attended canonizations was that of Padre Pio on June 16, 2002. Concerning the life and example of Saint Padre Pio, the Pope noted: "Throughout his life, he always sought greater conformity with the Crucified, since he was very conscious of having been called to collaborate in a special way in the work of redemption. His holiness cannot be understood without this constant reference to the Cross."

Thus the presence and face of God continue to be made present through Saint Padre Pio and countless other saints and blesseds.

Everyone remembers the image of Pope John's smiling face and two outstretched arms embracing the whole world. How many people were won over by his simplicity of heart, combined with a broad experience of people and things! The breath of newness he brought certainly did not concern doctrine, but rather the way to explain it; his style of speaking and acting was new, as was his friendly approach to ordinary people and the powerful of the world.

JOHN PAUL II, HOMILY AT THE BEATIFICATION OF
POPE JOHN XXIII, SEPTEMBER 3, 2000

The Apostolic See... offers for imitation, veneration and invocation by the faithful those men and women who are renowned for the splendor of their love as well as all the other evangelical virtues and, after conducting the appropriate investigations, declares with a solemn act of canonization that they are saints.

JOHN PAUL II, APOSTOLIC CONSTITUTION, *DIVINUS PERFECTIONIS MAGISTER*

Pope John Paul II declares Mother Katharine Drexel a Saint, St. Peter's, Rome, 2000.

The Christmas Soloist after Dinner

CARDINAL ADAM MAIDA, Archbishop of Detroit

BY GOD'S providence, I have had many opportunities to spend time with our Holy Father—both on pilgrimages in Poland and when I am in the Vatican for various projects.

My most vivid memories of being with him center around dinner at his table—sometimes with a whole group of other bishops, and at other times, just with our Holy Father and his very immediate staff. At every one of those meals, our Holy Father is always relaxed and attentive, engaging in quick repartee, asking challenging questions and waiting for answers with eager respect. He always has a wonderful sense of humor and loves to make little jokes with different words from Polish, English, and Italian.

Among the most special dinners I attended were those which occurred during the Christmas Season which, in the papal household, runs to the feast of the Purification on February 2. Dinners on these occasions sometimes concluded with our Holy Father singing, solo, a few of his favorite Polish Christmas carols. When he sang these carols, I knew he was in deep prayer. In every setting in which I have had the privilege of being in the presence of our Holy Father, I am always struck by his deep peace and humble openness to others.

During his visit to Krakow, Poland, in 2002, the Pope gathers with old friends for a meal.

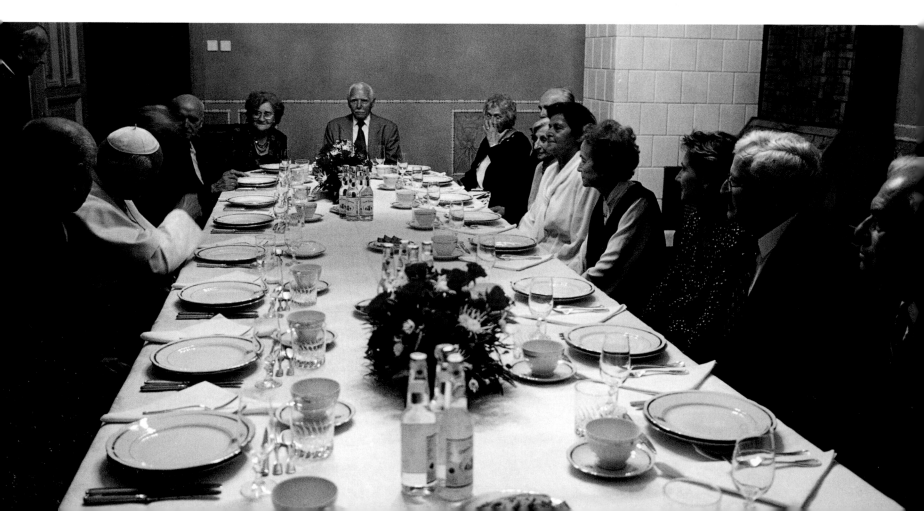

A Protest at the Dinner Table

ARCHBISHOP DANIEL E. PILARCZYK OF CINCINNATI

WHEN bishops make their *ad limina* visits to Rome every five years, a meal with the Holy Father is generally part of it.

On my last *ad limina* visit, as our group assembled around the Pope's dining table, I noticed the name had been misspelled on my place card. My mischievous streak was awakened, and, after the Pope had said the meal prayer and we were all sitting down, I announced in a solemn voice, "Holy Father, I wish to make a formal protest!" The bishops in the group were aghast. The Pope looked across the table at me and said, "A protest!" "Yes," I said. "At home in Cincinnati I am used to having my name misspelled because most of the people there are Germans or Irish. But here, at the table of the first Polish Pope, I presumed that my good Polish name would be properly treated! Instead, it is misspelled. I protest!"

The Pope smiled and said, "Archbishop, if you want to make a protest, you have to take it to the Secretary of State first. We all have to follow procedures."

He's a warm and friendly man who enjoys laughter. I treasure the memory of all of my contacts with him, this one most of all. I still have the place card—misspelling and all.

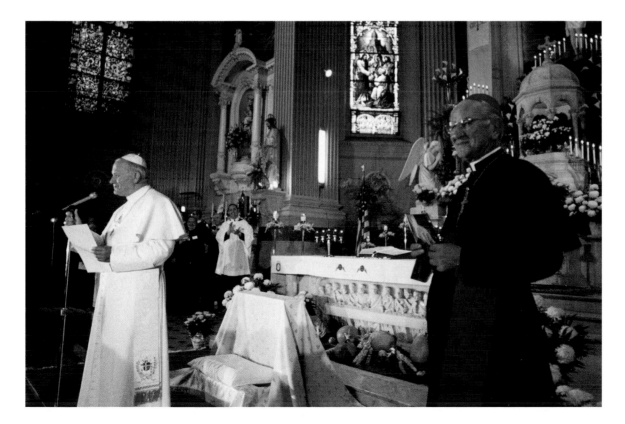

The Pope greets those in attendance at the Cathedral of Sts. Peter & Paul during his visit to Philadelphia in 1979.

The Pope incenses the altar at Sun Devil Stadium in Tempe, Arizona, during his 1987 visit to the United States.

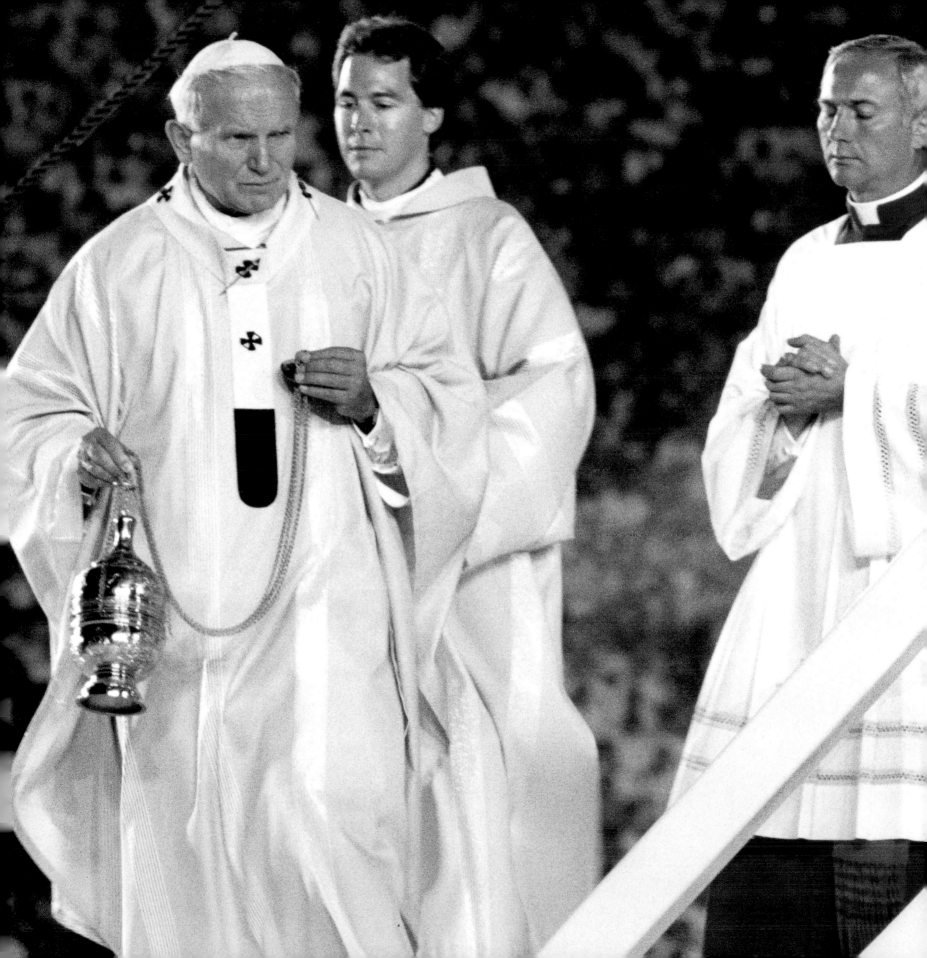

FORMING LIVES IN FAITH

SISTER MAUREEN SHAUGHNESSY, SC

rom the start of his pontificate, John Paul II has shown a great concern and love for the ministry of catechesis. In October 1979, he issued *Catechesi Tradendi* which has become a guiding light for all engaged in the ministry. In it he described catechesis as "an education of children, young people and adults in the faith, which includes especially the teaching of Christian doctrine imparted, generally speaking, in an organic and systematic way, with a view to initiating the hearers into the fullness of Christian life."

In this document, the work of catechesis is put in the context of the life experience and the living tradition upon which it draws. In the early 1990's he promulgated the *Catechism of the Catholic Church* so that there would be a sure guide for teaching the doctrine of the church. In 1997 he promulgated the *General Directory for Catechesis* to complement the catechism which gives the principles and guidelines that guide the ministry of catechesis.

In all his catechetical writings, John Paul II has consistently developed the theme of evangelization, understanding it as the fundamental mission of the Church. Paul VI urged the church to seriously examine its role in proclaiming and witnessing to the Gospel. Catechesis is seen as a unique moment within the process of evangelization. It is a dynamic work that assists persons of all ages to grow in the faith given to them at baptism. Catechesis seeks to make a person's faith living, explicit and fruitful. It is about a life journey that demands ongoing conversion, active participation in the community of faith and life lived as a disciple who witnesses to faith in every dimension of life.

In the twenty-five years of his pontificate, catechesis has seen a rich development in thought and practice. In the United States, much has happened. Adult faith formation has been given a strong emphasis; the Rite for the Christian Initiation of Adults has flourished; youth ministry has developed and attention is being given to the place of catechesis within that; and catechist formation and catechetical leadership formation have been increasingly topics of discussion and concern at all levels. The U.S. bishops are presently preparing both an adult catechism and a national directory for catechesis. These documents will assist bishops and all involved in catechetical ministry in improving and developing efforts in dioceses and parishes.

The new evangelization in which the whole continent is engaged means that faith cannot be taken for granted, but must be explicitly proposed in all its breadth and richness. This is the principal objective of catechesis, which by its very nature is an essential aspect of the new evangelization. "Catechesis is a process of formation in faith, hope and charity; it shapes the mind and touches the heart, leading the person to embrace Christ fully and completely. It introduces the believer more fully into the experience of the Christian life which involves the liturgical celebration of the mystery of redemption and the Christian service of others."

JOHN PAUL II, *ECCLESIA IN AMERICA*

The Pope offers Mass in Central Park, New York City, during his 1995 visit.

CATECHISM OF THE CATHOLIC CHURCH

FATHER DANIEL KUTYS

n 1985, bishops from around the world gathered with Pope John Paul II for a special synod marking the twentieth anniversary of the closing of the Second Vatican Council. Out of this extraordinary synod came a plan to develop what would become an extraordinary gift to the Church—the *Catechism of the Catholic Church*.

Catechetical efforts have two closely related dimensions: teaching the content of the Faith and forming in the practice of the Faith. The Fathers gathered at Vatican II judged that, at that time, the content of the Faith needed to be expressed in terms comprehensible today to enhance the practice of the Faith. As a result, they recommended the development of a catechetical directory to address this need. As a result, work began on the *General Catechetical Directory* which was released in 1971. By the time the bishops met for the special Synod of Bishops in 1985, the situation had changed dramatically. Therefore, the Synod Fathers recommended the development of a universal catechism or compendium of Catholic doctrine which could serve as a resource for the development of local catechetical material. The Holy Father recognized that the development of a new universal catechism would address a real need in the Church and so, in 1986, he established a commission of cardinals and bishops to whom he entrusted the development of such a text.

In late 1989, an initial draft of the *Catechism* was sent to bishops around the world for the purpose of consultation. The responses expressed positive support for a single text which could serve as a point of reference for catechetical material. The responses also contained a large number of suggestions for revisions. Many of them were implemented, and resulted in some significant changes to the text. In 1992, a definitive version of the text was released in French. The English edition of the *Catechism* was completed and released in 1994. In 1997, the Latin edition was completed, and some revisions were made to all the other language editions in use throughout the world. (The second English edition for the United Sates, in which these revisions were incorporated, was released in 2000.)

In the United States, the implementation of the *Catechism of the Catholic Church* has had a significant impact on many aspects of the Church's life. In particular, catechetical publishers are working with the United States bishops to ensure that materials produced for religious instruction completely and accurately reflect the content of the Catechism, a goal which first prompted the development of such a text.

In developing this catechism, Pope John Paul II showed his realization that those who bring the Catholic faith into the modern world must be grounded in their understanding of the Church. As he said in *Fidei Depositum*, the 1992 Apostolic Constitution on the publication of the *Catechism of the Catholic Church*, "[F]ollowing the renewal of the Liturgy and the new codification of the Canon Law of the Latin Church and that of the Oriental Catholic Churches, this catechism will make a very important contribution to that work of renewing the whole life of the Church, as desired and begun by the Second Vatican Council."

The Shepherd's Best Place Is with the Flock

BISHOP DENNIS M. SCHNURR OF DULUTH

SEMI-ANNUALLY the General Secretary of the Bishops' Conference has the opportunity to accompany its President and Vice-President when they visit the various offices of the Holy See. Always the highlight of those occasions, of course, is the private audience with the Holy Father. Because of my association with World Youth Day in Denver, I began to accompany the officers in 1992 and continued until I completed my term as General Secretary in 2001. On my last visit as General Secretary, the officers mentioned to the Holy Father that I was completing my term and kindly added, "We will miss him!" The Holy Father looked at me and asked what I would do when I returned to my diocese. I stated that I would be a pastor. Nodding to the officers and with a smile, the Holy Father then looked toward me and said, "You will not miss the Conference!" I was amused, but I also realized that it expressed the Holy Father's joy in being with his flock.

Pope John Paul II cuts into the cake at a lunch for the needy which he hosted in St. Martha's House in the Vatican, January 3, 1988.

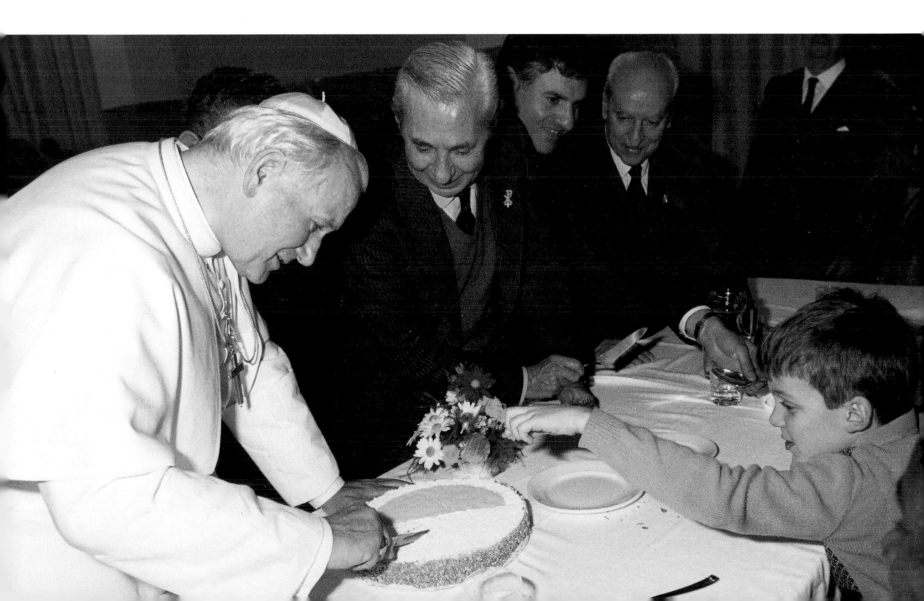

THE CRIME OF SEXUAL ABUSE

SISTER MARY ANN WALSH, RSM

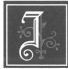nteractions with youth have high-lighted every trip abroad made by Pope John Paul II. The encounters with youngsters at airports and at Masses or with tens of thousands of teenagers at stadium rallies enliven him.

Thus it is no surprise that the Pope has had his harshest words for those who would intentionally hurt children through sexual abuse.

"People need to know that there is no place in the priesthood and religious life for those who would harm the young," the Pope said in an address to United States cardinals and other top church officials at a special Vatican summit on sexual abuse by priests, April 23, 2002.

> *People need to know that there is no place in the priesthood and religious life for those who would harm the young.*
>
> JOHN PAUL II, ADDRESS TO VATICAN MEETING WITH UNITED STATES CARDINALS AND BISHOPS' CONFERENCE OFFICIALS, APRIL 23, 2002

He said people took offense at how they perceived church leaders had acted in the face of this problem. His words were strong and clear.

"The abuse which has caused this crisis is by every standard wrong and rightly considered a crime by society; it is also an appalling sin in the eyes of God. To the victims and their families, wherever they may be, I express my profound sense of solidarity and concern."

He took personal offense.

"I too have been deeply grieved by the fact that priests and religious, whose vocation it is to help people live holy lives in the sight of God, have themselves caused such suffering and scandal to the young," he told summit attendees.

Nine years previously, in 1993, John Paul

speaking of abusers invoked one of the Gospel's severest condemnations, citing from Matthew, "For him who gives scandal (to children) it would be better to have a great millstone hung around his neck and to be drowned in the depths of the sea" (Mt 18:6).

To address the problem, the Pope changed universal Church law. In 1994, he extended Canon Law's age of majority from sixteen to eighteen years of age and its statute of limitations to ten years from the victim's eighteenth birthday. The Church's general law says prosecution for most ecclesiastical crimes cannot begin more than three years after the last offense but raises the limit to five years for certain crimes including clerical sex offenses against minors.

The change in rules initially was to bring Church law and United States law into closer agreement but eventually the Pope changed the Canon Law for the entire Church. Later, in 2002, at the request of the United States Conference of Catholic Bishops, the Pope approved norms drafted by the Bishops' Conference to enable them to deal strongly and expeditiously with sexual abusers.

The Pope also addressed the issue of sexual abuse in *Ecclesia in Oceania*, his Apostolic Exhortation following the Special Assembly of the Synod of Bishops in Oceania, signed November 22, 2001. The Synod, which had taken place in late 1998, found, he said, that sexual abuse "has been very damaging to the life of the Church and has become an obstacle to the proclamation of the Gospel." Added the Holy Father: "Sexual abuse within the Church is a profound contradiction of the teachings and witness of Jesus Christ. The Synod Fathers wish to apologize unreservedly to the victims for the pain and disillusionment caused to them."

The Pope celebrates Mass in New York City's Central Park in 1995.

Like you, I too have been deeply grieved by the fact that priests and religious, whose vocation it is to help people live holy lives in the sight of God, have themselves caused such suffering and scandal to the young. Because of the great harm done by some priests and religious, the Church herself is viewed with distrust, and many are offended at the way in which the Church's leaders are perceived to have acted in this matter. The abuse which has caused this crisis is by every standard wrong and rightly considered a crime by society; it is also an appalling sin in the eyes of God. To the victims and their families, wherever they may be, I express my profound sense of solidarity and concern.

JOHN PAUL II, ADDRESS TO VATICAN MEETING
WITH UNITED STATES CARDINALS AND BISHOPS'
CONFERENCE OFFICIALS, APRIL 23, 2002

Tell It to Me Straight

MONSIGNOR WILLIAM P. FAY, General Secretary, USCCB

AMONG the things that endear so many people to the person of Pope John Paul II is the profound solicitude that he has for their local Church. I had the privilege of witnessing this firsthand as I accompanied Bishop Wilton Gregory to lunch in the Holy Father's apartment in April 2002. At the time of the visit, the Church in the United States was in the midst of a crisis caused by the sexual abuse of children by priests. After the Holy Father had greeted us and we were seated, he looked Bishop Gregory directly in the eye and said, "Tell me the situation." And Bishop Gregory did: forthrightly, completely and with detail. The Holy Father listened, but there was more. He was completely engaged, as if this were the only conversation that mattered. When Bishop Gregory finished, the Pope asked insightful questions and sought to have his intuitions confirmed or corrected. He concluded by asking Bishop Gregory to tell the bishops and the faithful of the United States that the Pope was completely united with them in their hour of need. The weeks and months that followed proved how true that promise was.

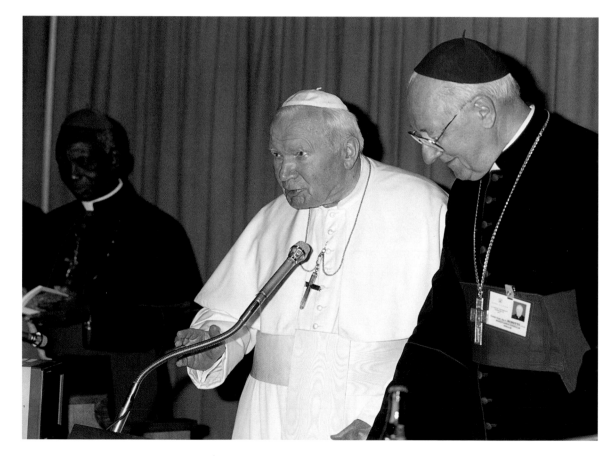

The Pope addresses bishops from around the world at the 2001 Synod of Bishops, Rome.

Opposite: Representatives from every parish in the archdiocese of New York gathers with the Pope for the Rosary and a reflection at St. Patrick's Cathedral in 1995.

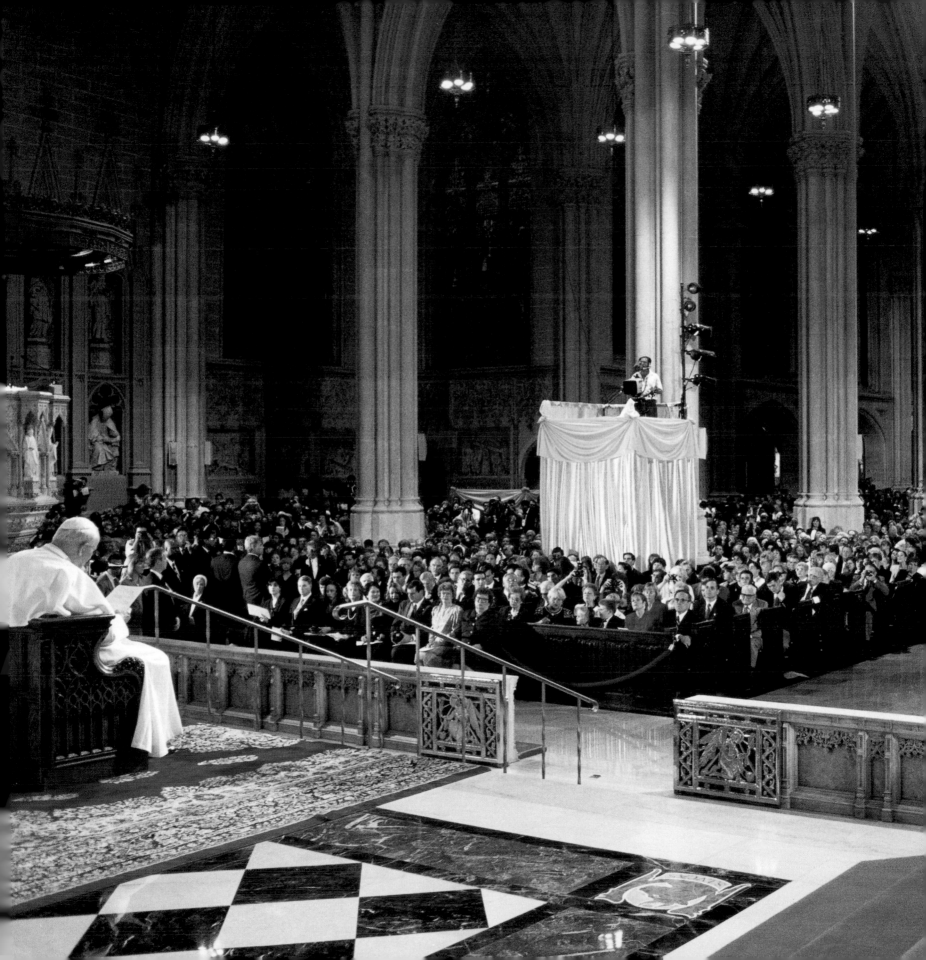

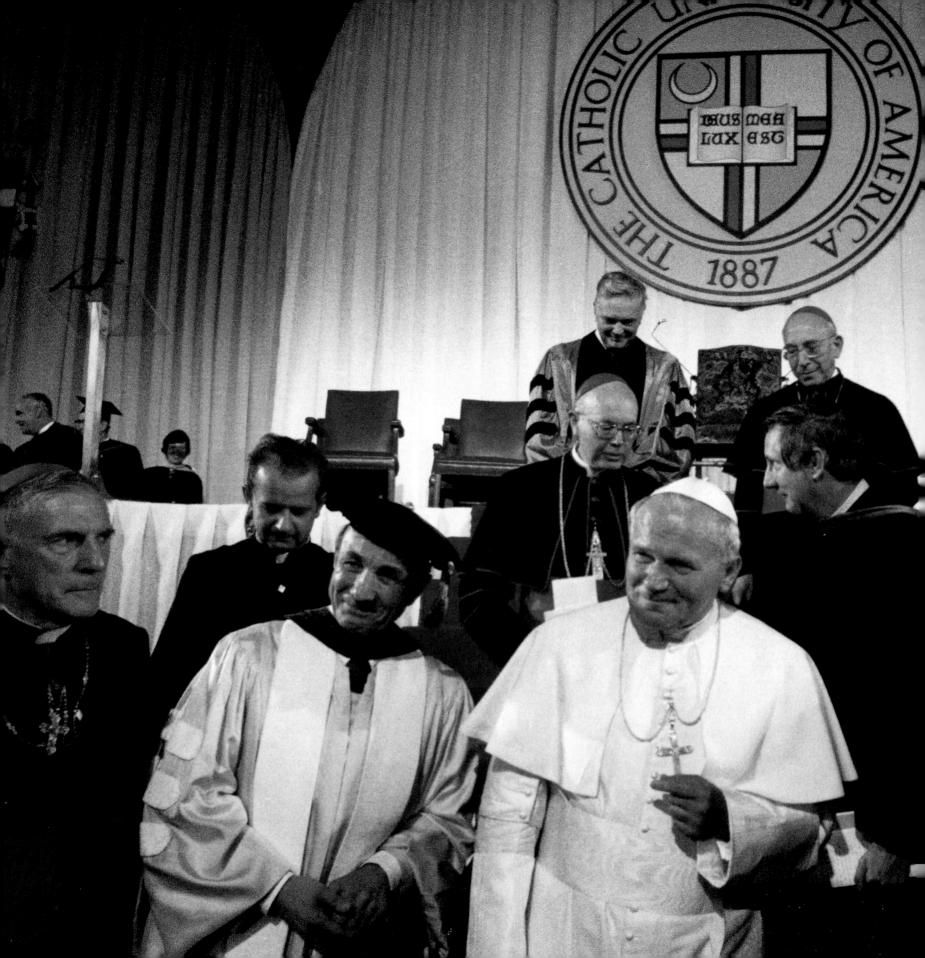

CATHOLIC IDENTITY IN HIGHER EDUCATION

SISTER GLENN ANNE McPHEE, OP

ope John Paul II as a young priest had a deep commitment to university students. His warm and generous spirit touched hearts and reflected Jesus in his many encounters with them. From hiking and skiing with young friends, to opportunities to offer pastoral guidance in parish settings, to actual classroom teaching, he used every encounter to intensify students' relationships with God. As a chaplain and teacher he was beloved. His times teaching at the Catholic University of Lublin were treasured years.

Years later as Pope, John Paul II continued his love of colleges and universities. From the earliest years of his papacy he spoke of the deep bond that exists between the Church and the university as well as the mutual needs between the two.

Key areas of his focus and dialogue include the relationships between faith and the areas of reason, culture, and scientific progress. He also focuses on colleges and universities as evangelizing communities. Throughout his many addresses he frequently speaks of the university's primary vocation as the true search for wisdom. He emphasizes the central focus of higher educa-

tion's apostolic effort for young adults—to meet Christ personally. He calls faculties to be true educators who not only teach knowledge but model Christian living.

His concern for higher education has been expressed in two Apostolic Constitutions: *Sapientia Christiana*, on pontifical institutes of higher learning, and *Ex Corde Ecclesiae*, for other such Catholic institutions.

Throughout Pope John Paul's reflections on Catholicity and higher education a dominant theme permeates his thoughts. He stresses the need for well-developed and coordinated campus ministry programs on all campuses that are characterized by coordination and collaboration of chaplains and staff. Chaplains are called to be the driving force of formation and evangelization. Campus Ministry must call all members of the university community to personal encounters with Christ.

He has stressed throughout these twenty-five years of addressing the college and university communities worldwide that Christ is in the midst of these communities, journeying with them as they seek to proclaim Him and bear witness to Him to one another throughout the world.

The Catholic universities are of great value for the Church. They fulfill a mission in the service of the understanding of the faith and the development of understanding; they tirelessly create bridges between scientists in all the disciplines. They are called ever more to be places of dialogue with the whole of the university world, so that cultural formation and research may be at the service of the common good and of the human person, who cannot be considered a mere object of research.

JOHN PAUL II, INTERNATIONAL CONGRESS ON GLOBALIZATION AND THE CATHOLIC UNIVERSITY, ROME, DECEMBER 5, 2002

The Pope visits the Catholic University of America, Washington, during his 1979 visit to the United States.

Following: The Pope lifts his hands in prayer during a Mass at Sao Sebastiao Cathedral, Rio de Janeiro.

The Pope lifts
his hands in prayer
during a Mass at
Sáo Sebastiao Cathedral,
Rio de Janeiro.

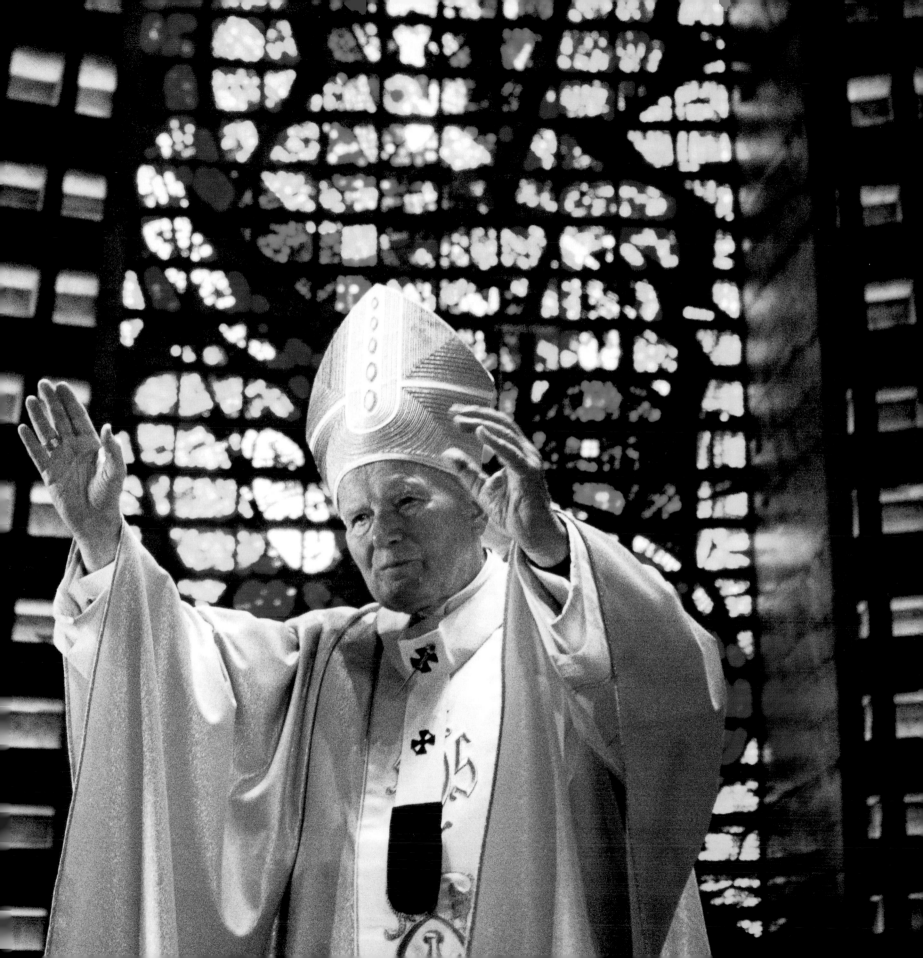

An Interest in Native Americans

ARCHBISHOP MICHAEL J. SHEEHAN OF SANTA FE

AT THE last *ad limina* visit at the Vatican, the bishops of our region of bishops were at the Pope's table for lunch. There were about a dozen bishops with the Holy Father. I recall that he took such personal interest in each one of us. He showed exquisite hospitality and the food and drink were delicious and well served.

As the Chairman of our region, I was seated directly across from the Holy Father. In the course of our discussion I asked him about when Kateri Tekakwitha might be canonized. He said, "She needs another miracle before canonization will be possible." We bishops then began to share with the Holy Father the great importance of Kateri Tekakwitha to the Native American population of our dioceses located in the Southwest.

He wanted to know about the Native Americans in each of our dioceses and how many of them were Catholic. He spoke of his visit to Phoenix where he met a number of Native Americans and expressed such love and reverence for them and their culture and traditions.

One of the bishops suggested that perhaps the Holy Father himself could be her miracle for canonization. He replied with a smile that he had been the necessary miracle for her beatification but now it was up to her, through her intercession, to have a miracle for canonization!

John Paul showed such pastoral interest in the ministry of the Church to Native Americans. His pastoral care and love for the Native Americans and all the people of our region moved me deeply. The Native Americans in Santa Fe that I shared the story with were proud and grateful to our Holy Father for his interest.

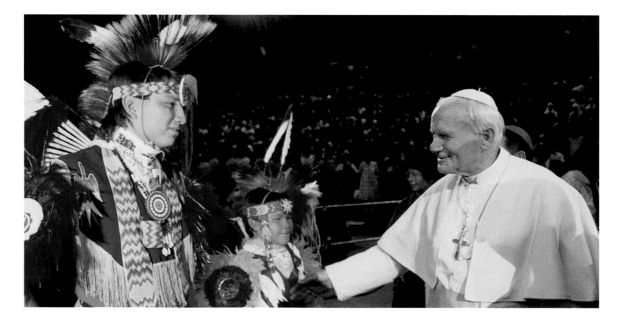

The Pope greets a delegation of Native Americans in San Antonio in 1987.

Opposite: The Pope prepares for Mass with Native people during a visit to Yellow Knife, Canada, in 1984.

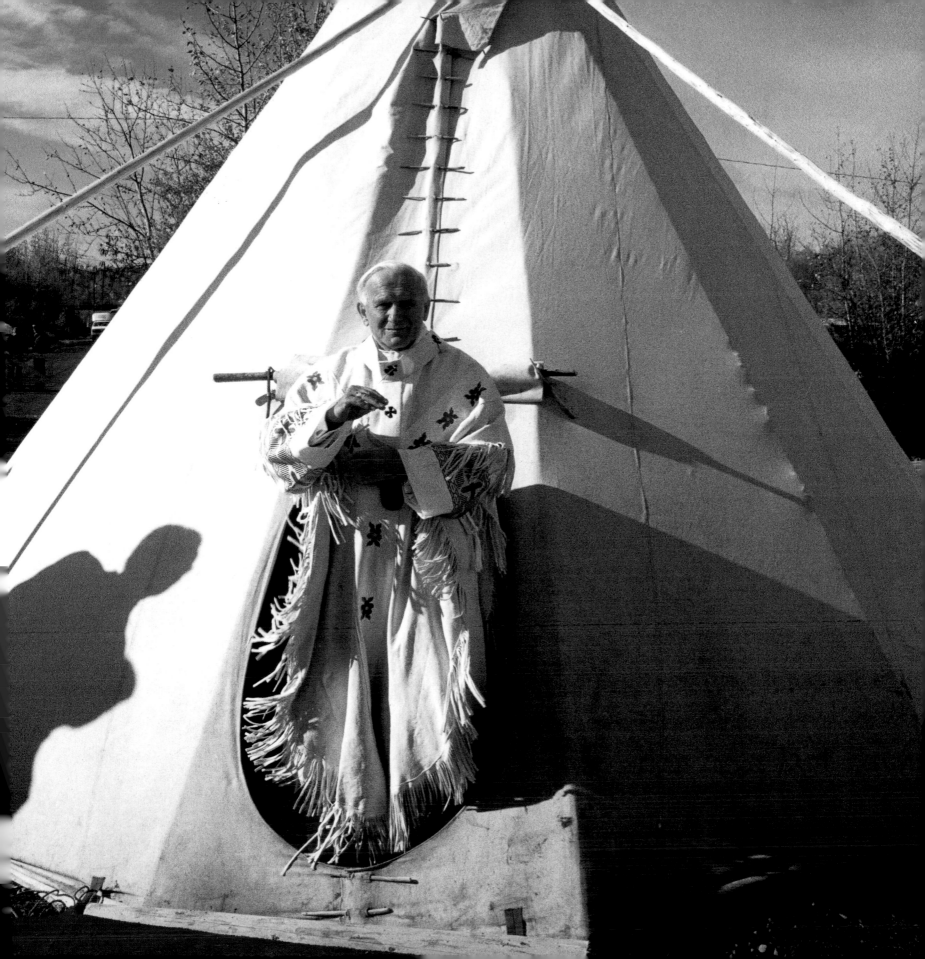

CONFERENCES OF BISHOPS

MONSIGNOR FRANCIS J. MANISCALCO

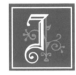 n *Christus Dominus* (Decree on the Pastoral Office of Bishops in the Church), the Second Vatican Council stated that "it would be in the highest degree helpful if in all parts of the world the bishops of each country or region would meet regularly, so that by sharing their wisdom and experience and exchanging views they may jointly formulate a program for the common good of the Church."·

In 1966, Pope Paul VI issued his *Motu Proprio* entitled *Ecclesiae Sanctae* (Holy Church) which put this wish of the Council into effect. Bishops' conferences were to be established, and their statutes drawn up, and approval given by the Holy See.

In 1983, the revised *Code of Canon Law* included national and territorial bishops' conferences in the Church's body of universal law: "A conference of bishops, a permanent institution, is a group of bishops of some nation or certain territory who jointly exercise certain pastoral functions for the Christian faithful of their territory in order to promote the greater good which the Church offers humanity, especially through forms and programs of the apostolate fittingly adapted to the circumstances of time and place, according to the norm of law." In this revised Code, there are eighty-four canons which deal with the action by the bishops' conferences to implement universal Church law in their territories. In addition, liturgical adaptations and translations must be adopted by

The Pope leads 200 bishops from around the world in the Synod Hall at the Vatican, 2001.

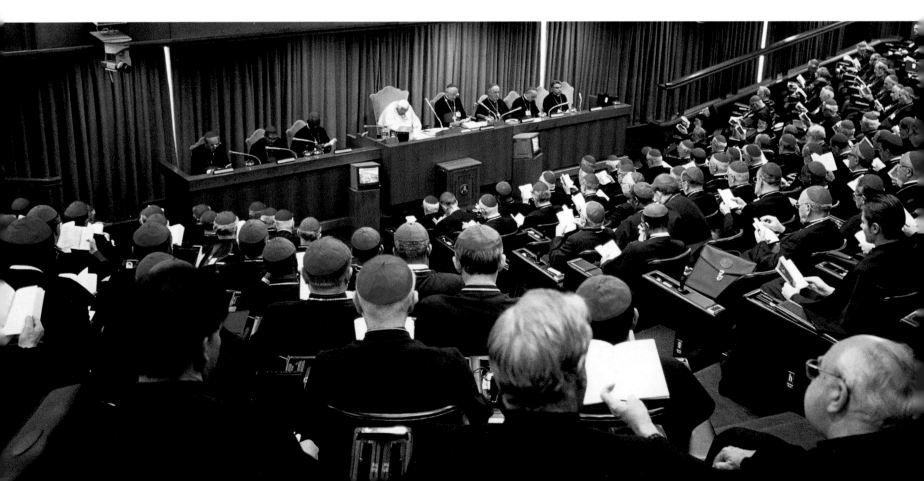

bishops' conferences, before they are given the Holy See's approval.

Though with precedents in the many regional councils and synods held throughout the Church's history, these permanent bodies were a recent development in the life of the Church. While clearly pastoral in purpose, their establishment gave rise to vigorous discussion, especially concerning their authority with regard to individual bishops and their possible participation in the Church's teaching authority.

In 1985, Pope John Paul II convened an Extraordinary Assembly of the Synod of Bishops on the occasion of the twentieth anniversary of the conclusion of the Second Vatican Council. It called for a clarification of the juridical status and the teaching authority of conferences of bishops.

Pope John Paul II, in his *Motu Proprio* entitled *Apostolos Suos* (1998), confirmed that a bishops' conference exercises the Church's teaching authority when teaching with unanimity "in communion with the head of the college [of bishops] and its members." Otherwise a "substantial" majority—never less than two-thirds—with the subsequent approval or *recognitio* of the Holy See is necessary for a declaration to be considered "authentic teaching to which all the faithful of the territory" must adhere also.

The "collegial spirit" is present in the joint exercise of "certain pastoral functions for the good of the faithful." Such action, however, does not have the "collegial nature" which properly belongs only to the entire college of bishops throughout the world acting in union with the pope as its head. Given their relative newness, bishops' conferences have quickly assumed a significant role in the Church's life, a development

much encouraged by Pope John Paul II who, through his Curia, will sometimes authorize action by conferences even beyond what is specifically spelled out in Canon Law.

In addition, Pope John Paul has called upon the presidents of these bodies for consultation on matters affecting the whole Church. Thus, with his encouragement and under his direction, these conferences have become the means of deepening the spirit of unity within the universal Church as well as among the dioceses of a nation or region.

Above: The Pope celebrates Mass at the Aqueduct Racetrack in the Diocese of Brooklyn during his October 1995 visit to the United States.

Following: Crowds stand in Assisi to hear the Pope speak of peace in 2002.

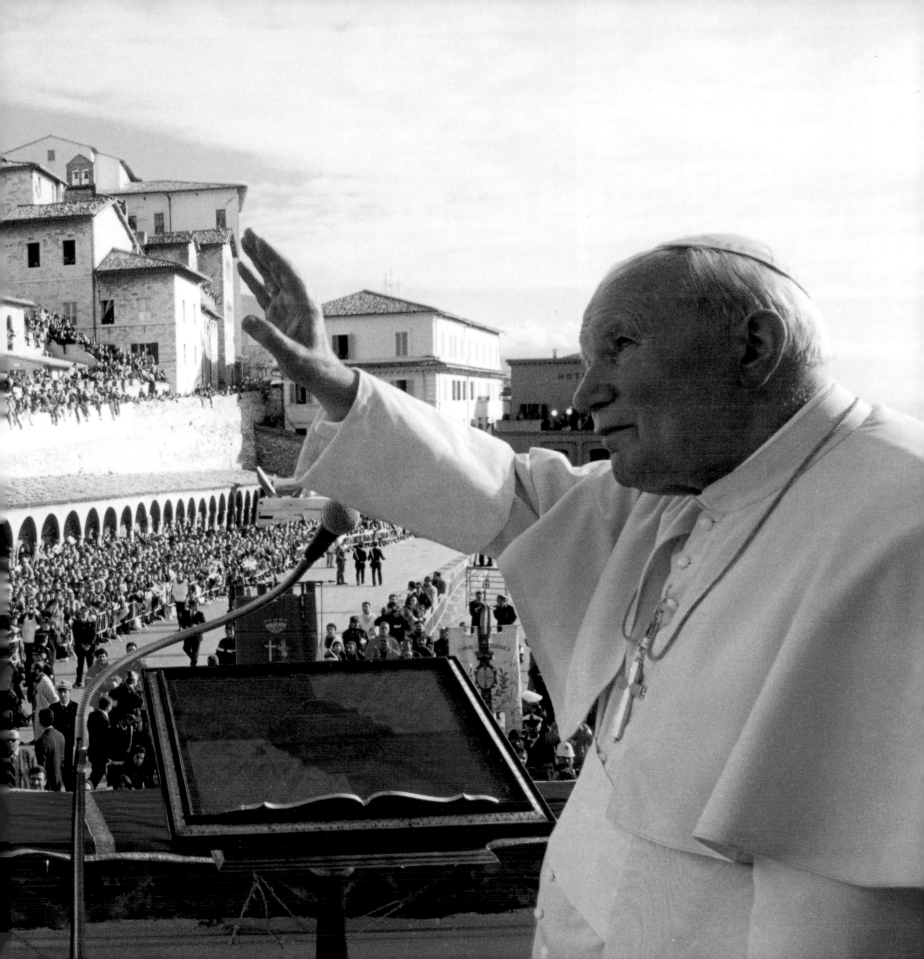

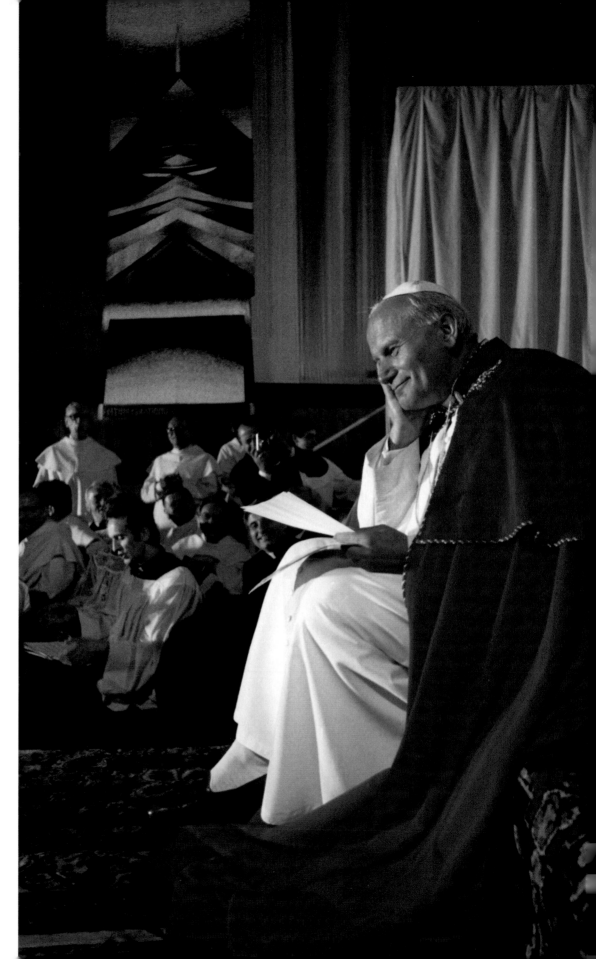

Like the whole of Christian life, the call to the consecrated life is closely linked to the working of the Holy Spirit. In every age, the Spirit enables new men and women to recognize the appeal of such a demanding choice. Through His power, they relive, in a way, the experience of the Prophet Jeremiah: "You have seduced me, Lord, and I have let myself be seduced" (Jer 20:7).

JOHN PAUL II, *VITA CONSECRATA*

In his native Poland for the first time as pope in 1979, Pope John Paul II listens fondly to a musical number.

CONSECRATED LIFE

SISTER AMY HOEY, RSM

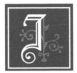n *Vita Consecrata*, the document written after the 1994 Synod of Bishops on "The Consecrated Life and Its Role in the Church and in the World," Pope John Paul II repeats the questions which he said many people today ask: "What is the point of consecrated life? Why embrace this kind of life, when there are so many urgent needs in the areas of charity and of evangelization itself, to which one can respond even without assuming the particular commitments of the consecrated life?"

During the twenty-five years of his pontificate, the Pope has answered those questions in letters, homilies, and addresses occasioned by meetings with individual religious orders, bishops, and gatherings of the leadership of many congregations. The length and tone of his responses vary with the occasion, but there are three themes to which the Pope returns over and over again.

Consecrated Life embraces a wide variety of forms. Tracing its history from the earliest days of the Church, consecrated life includes men and women who are members of monastic communities, hermits, contemplatives, apostolic religious, and members of secular and clerical institutes. The Pope also acknowledges that there are new forms of consecrated life emerging which "bear witness to the constant attraction which the total gift of self to the Lord, the ideal of apostolic community and the founding charism continue to exert, even on the present generation."

Consecrated Life is a gift and a challenge to those called to live it. The call to consecrated life is one form of the universal call to holiness. It is a call to make one's "friendship with God" the center of a life of vowed poverty, obedience, and celibate chastity, lived in community with others who profess similar vows.

The Consecrated Life, deeply rooted in the example and teaching of Christ the Lord, is a gift of God the Father to his Church through the Holy Spirit. By the profession of the evangelical counsels the characteristic features of Jesus—the chaste, poor and obedient one—are made constantly "visible" in the midst of the world and the eyes of the faithful are directed towards the mystery of the Kingdom of God already at work in history, even as it awaits its full realization in heaven.

JOHN PAUL II, *VITA CONSECRATA*

Consecrated life is a gift to the ecclesial community and to the world. "It is not something isolated and marginal, but a reality which affects the whole Church." Later in the document, the Pope looks beyond the Church and repeats Saint Teresa of Avila's question: "What would become of the world if there were no Religious?" Rather than spend much time trying to answer that question, the Pope calls us to be grateful (gratitude for consecrated life is an ever-recurring theme for him) and to consider the impact of individuals like Elizabeth Ann Seton, who founded the Sisters of Charity; the Jesuit martyr Isaac Jogues; Catherine McAuley, who founded the Sisters of Mercy; Isaac Hecker, who founded the Paulists; and the hundreds of thousands of their followers in the United States as we know it today.

A Snub for the Pope

JOHN THAVIS, ROME BUREAU CHIEF, *Catholic News Service*

IT WAS the end of a long day in Mexico City. The Pope was running late, and when he trudged into a crowded hospital he seemed exhausted. Then a little baby caught his eye, and he lit up.

I've seen it so many times over the years, but it's always amazing how small children and John Paul II connect in a special way. In this run-down clinic, he reached out and caressed the soft cheek, then traced a cross on the child's forehead. A blissful moment.

In Rome, I've watched over the Pope's shoulder as babies are passed up to him for a blessing. He lifts each one with extra care and a watchful eye. But not all kids react the same way to a papal embrace. Some smile, some coo and a few burst into tears.

On a summer's day many years ago at his villa outside Rome, the Pope reached out for our own baby daughter. It's all captured in our family photo album: The white-robed Pontiff approaching, ready to plant a kiss on her cheek. The proud parents beaming. Then our three-year-old bailing out with a stiff-armed refusal. He took the snub in stride, still smiling.

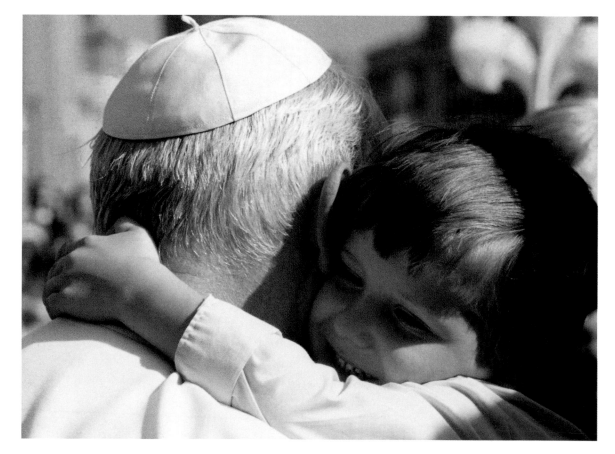

The Pope's affection for children is often on display in St. Peter's Square, the Vatican.

Right: The Pope calls for forgiveness and reconciliation during a snowy Mass on his visit to Sarajevo, April 12, 1997.

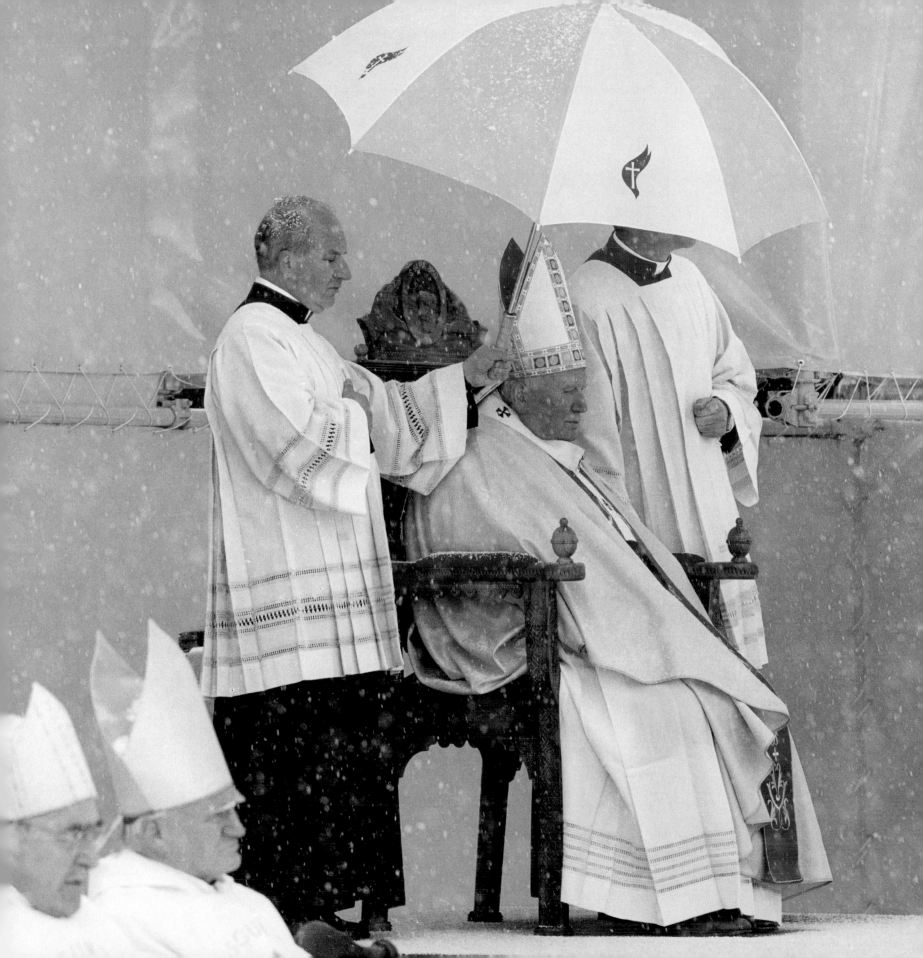

REFORM OF CHURCH STRUCTURES

MONSIGNOR JOHN STRYNKOWSKI

he period after the Second Vatican Council saw the birth of new structures on every level of Church life for the purposes of consultation and collaboration. On the universal level there were the synods of bishops, bringing together representatives of episcopal conferences from around the world. On the national level there were the episcopal conferences themselves. On the diocesan level there were presbyteral and pastoral councils. On the parish level there were also councils.

A spirituality of communion implies also the ability to see what is positive in others, to welcome it and prize it as a gift from God ...

JOHN PAUL II, APOSTOLIC LETTER
NOVO MILLENNIO INEUNTE, JANUARY 6, 2001

With the promulgation of a new *Code of Canon Law* by Pope John Paul II in 1983, these structures were given further encouragement by receiving juridical recognition. The Pope himself has used the synods of bishops to focus on specific areas and needs of the Church. He listens to the many presentations made by bishops and receives from them a list of propositions, on the basis of which he prepares an Apostolic Exhortation. These documents have proven most significant in giving direction to the Church in such matters as vocations, consecrated life, priestly ministry, the role of the laity, marriage, reconciliation and many other issues as well. The Pope has also convoked regional synods of bishops to address pastoral needs that have arisen in specific areas of the world.

In 1988, the Pope issued an Apostolic Constitution by which he reorganized the Roman Curia. He has continued the practice of his predecessor, Pope Paul VI, in ensuring that the officials of the Curia be drawn from around the world. He has used the visits of bishops to Rome every five years (known as the *ad limina* visits) to engage them in conversation about the situation of their particular churches.

In his Apostolic Letter for the close of the Jubilee Year 2000, *Novo Millennio Ineunte*, he called upon local churches to initiate a process of pastoral planning. He also urged that all relationships in the Church and structures be based on the spirituality of communion. He writes: "...the structures of participation envisaged by canon law, such as the council of priests and the pastoral council, must be ever more highly valued...The theology and spirituality of communion encourage a fruitful dialogue between pastors and faithful... To this end, we need to make our own the ancient pastoral wisdom which, without prejudice to their authority, encouraged pastors to listen more widely to the entire people of God."

The Holy Father also issued norms for the governance of the Church after the death of a pope and for the election of a new pope with the Apostolic Constitution *Universi Dominici Gregis* (Of the Lord's Whole Flock). Major changes from previous norms included where the cardinals are to be housed during the conclave (in a guest house in the Vatican rather than the Vatican Palace) and the possibility of election by absolute majority if no one has been elected by two-thirds majority after thirty ballots.

Tell Me about the Grandchildren

BISHOP DONALD W. WUERL, STD, OF PITTSBURGH

ONE OF the beautiful privileges that many, many have shared is the opportunity to participate in the Holy Father's morning Mass in his private chapel and even to concelebrate with him. On one such occasion a couple, traveling with me, was also invited to the Mass. Following the Mass, as was the custom, we all lined up in the Papal Library where eventually the Pope arrived and proceeded to greet each one of us.

When it was my turn, after reverencing his ring, I asked him if I could carry back his blessing to a very special event at our cathedral church to be held the following Sunday. Smiling, he replied, "Tell them I bless them abundantly." He then turned to the couple who, while greatly in awe, managed to hold up a photo of their six grandchildren to show the Pope. They nervously whispered with great excitement, "Our grandchildren."

The Pope, with everything else on his mind and all the other preoccupations facing him, stopped, turned to this couple and said to them, "Tell me their names." The proud grandparents named each one and the Pope said, "I bless them all." He then continued making his way around the room greeting and blessing everyone else. Just as he reached the doorway to leave all of us, he took another step in my direction and said, "Tell them the Pope sends his blessing and his love!"

During his trip to Angola, São Tomé, and Principe (June 4–10, 1992), the Pope paid a visit to a family in the town of M'Banza-Congo in Angola, June 4.

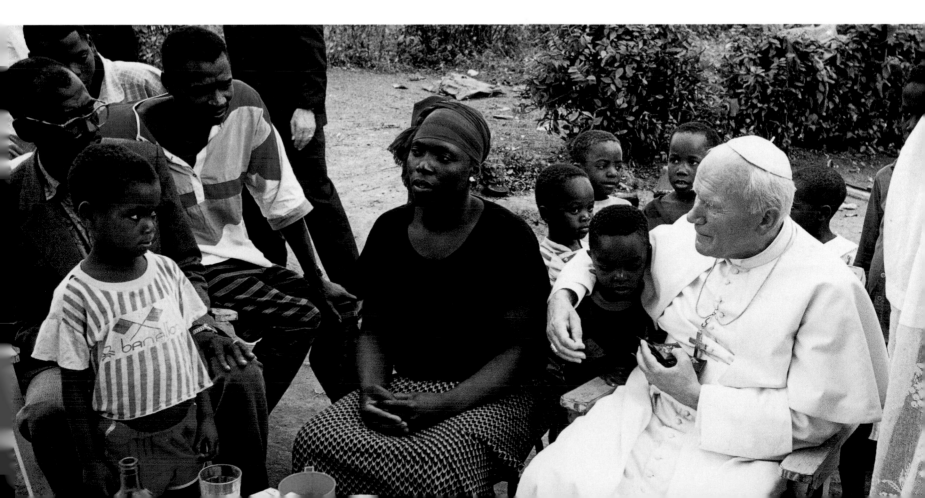

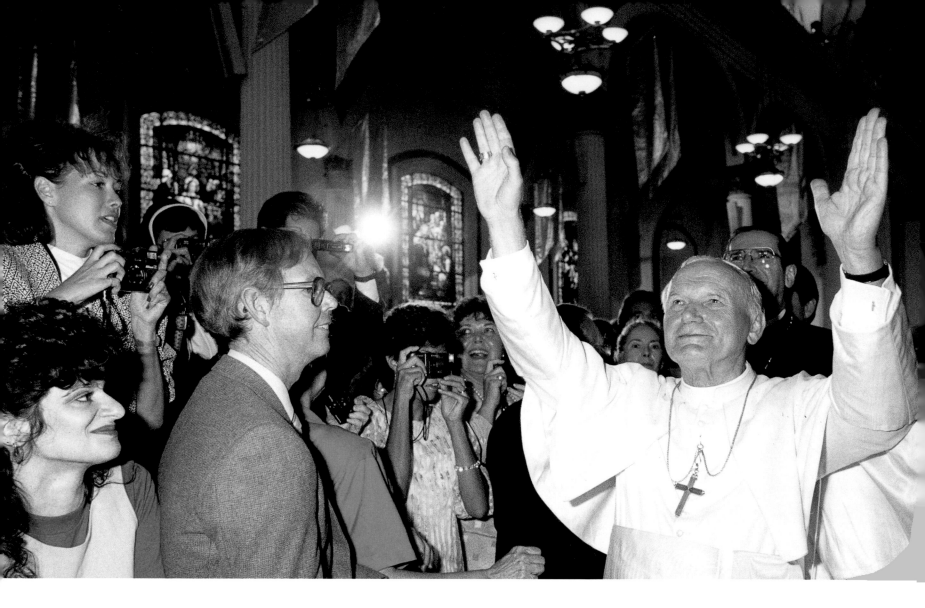

The exercise of the diaconal ministry—like that of other ministries in the Church— requires per se of all deacons, celibate or married, a spiritual attitude of total dedication. Although in certain cases it is necessary to make the ministry of the diaconate compatible with other obligations, to think of oneself and to act in practice as a "part-time deacon" would make no sense. The deacon is not a part-time employee or ecclesiastical official, but a minister of the Church. His is not a profession, but a mission! It is the circumstances of his life—prudently evaluated by the candidate himself and by the bishop, before ordination—which should, if necessary, be adapted to the exercise of his ministry by facilitating it in every way.

JOHN PAUL II, FROM "DEACONS ARE CONFIGURED TO CHRIST THE SERVANT,"
AN ADDRESS TO THOSE TAKING PART IN THE PLENARY ASSEMBLY
OF THE CONGREGATION OF THE CLERGY, NOVEMBER 30, 1995

THE SPECIAL ROLE OF DEACONS

WILLIAM T. DITEWIG, PH.D.

hen Karol Wojtyla was elected to the papacy in 1978, the diaconate renewed by the Second Vatican Council had been implemented for little more than a decade, with several thousand deacons serving in widely scattered locations around the world. During the time of this papacy, the diaconate has grown and matured, with nearly 30,000 deacons serving in hundreds of dioceses in more than 125 countries.

Pope John Paul II has addressed the theology, ministry and life of the diaconate in many ways. Five of the most significant include 1) his address to the deacons of the United States in 1987; 2) his three catecheses on the diaconate given at audiences in 1993; 3) his speech to a Joint Plenarium of the Congregations of Clergy and Catholic Education in 1995; 4) two documents published by these two dicasteries in 1998; and 5) his address to the permanent deacons of the world during the Jubilee for Deacons in 2000.

The teachings of Pope John Paul II might best be summarized through several key passages. During his 1987 address to the diaconate community gathered in Detroit the Pope made the following observation:

> The service of the deacon is the Church's service sacramentalized. Yours is not just one ministry among others, but it is truly meant to be, as Paul VI described it, a "driving force" for the Church's diakonia. You are meant to be living signs of the servanthood of Christ's Church.

The 1998 *Directory for the Ministry and Life of Permanent Deacons* recalls *Gaudium et Spes*: "The deacon should be conversant with contemporary cultures and with the aspirations and problems of his times… In this context, indeed, he is called to be a living sign of Christ the Servant and to assume the Church's responsibility of 'reading the signs of the time' and of interpreting them in the light of the Gospel."

Lastly, during the 1995 joint plenarium of the Congregations for Clergy and Catholic Education, the Pope stated that as a result of ordination, "the deacon receives a particular configuration to Christ, the head and shepherd of the church, who for love of the Father made himself the least and the servant of all."

A deeply felt need in the decision to reestablish the permanent diaconate was and is that of a greater and more direct presence of Church ministers in the various spheres of the family, work, school, etc., in addition to existing pastoral structures.

JOHN PAUL II, "DEACONS SERVE THE KINGDOM OF GOD," A CATECHESIS DURING THE GENERAL AUDIENCE OF OCTOBER 6, 1993

Several themes emerge from the teachings of the current Pope. First, the diaconate is described as a full-time ministry, even though that ministry is not always exercised in ecclesiastical settings. In fact, a particular reason to restore the diaconate as a permanent order was to provide a sacramental presence of Christ the Servant in extra-ecclesial spheres. Second, the deacon is presented clearly as a leader in service, with the Pope repeatedly echoing his predecessor Paul VI's description that the deacon is to be the driving force and sacramental sign of the Church's own diaconal identity. Third, and most fundamental of all, the Pope consistently teaches that all that the deacon does flows from his ordination and sacramental configuration to Christ the Servant.

The Pope waves to onlookers during a visit to St. Vibiana's Cathedral in Los Angeles during his 1987 visit.

EMPOWERING AFRICAN AMERICANS

BEVERLY CARROLL

n his address to Black Catholic leaders in New Orleans in 1987, Pope John Paul II made special mention of the importance of Black Catholic leadership in the Church, noting: "The Church needs you, and you need the Church." The African American Bishops echoed the same message in their 1984 Pastoral Letter on evangelization, *What We Have Seen and Heard.* The Bishops insisted "as Black Catholics we have the solemn responsibility to take the lead in the Church's work within the Black community."

In embracing Pope John Paul II's challenge for a new evangelization, Black Catholic History and Identity have become central themes in the retelling of the story of their past. The possession of one's history is the first step in an appreciation of one's culture, something Pope John Paul II reminded the world of in his 1989 World Day of Peace Message when he stated that a "right which must be safeguarded is the right of minorities to preserve and develop their own culture."

Inspired by him, African American Catholics recognize that all of us have a part to play in the Spreading of the Good News. A variety of formation programs have been established to support the work of a new evangelization. The Institute for Black Catholic Studies at Xavier University in New Orleans, the Augustus Tolton Program at Catholic Theological Union in Chicago, and advanced degree programs in the Archdiocese of Louisville and Philadelphia have raised a cadre of Black Catholic theologians and scholars prepared to dialogue with their counterparts in the Catholic Church. The National Black Catholic Congress is having a strong, positive effect on ministry in Black Communities, noting that African Americans are "no longer a missionary field but mature Christians with the responsibility of evangelizing themselves."

Pope John Paul II teaches that not only individuals but whole cultures need to be transformed by influence of the Gospel. In her missionary activity the Church encounters different cultures and becomes involved in the process of inculturation. By inculturation the Pope means "the intimate transformation of authentic cultural values through the integration in Christianity and the insertion of Christianity into the various human cultures" (*Redemptoris Missio, 21*).

Today the Black Catholic community is a vibrant, faith-filled component of the Catholic Church. The music and the liturgical celebrations of African American Catholics have added a different dimension to worship in the Catholic Church, catechetical programs are based on the old, old stories on how we came through the storm, and rites of passage embedded in youth ministry programs are based on seven key African-centered values. Black Catholics are marching into the new millennium, "fully functioning, bringing their whole history, traditions, experiences, and culture," as the late Sister Thea Bowman said. They are impelled onward by the leadership of John Paul II.

The Pope's visit to Balitmore includes this moment with a young girl, October 8, 1995.

Following: The Pope greets well-wishers upon his arrival at Newark International Airport on his 1995 pastoral visit to the United States.

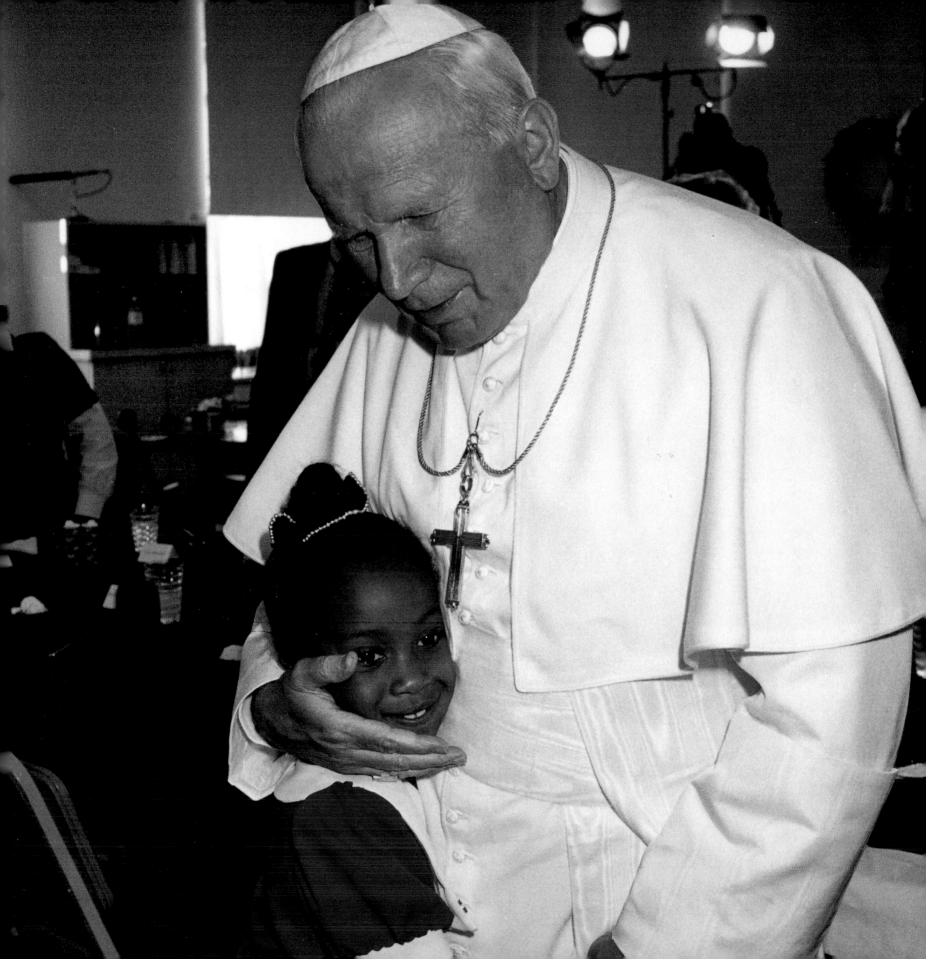

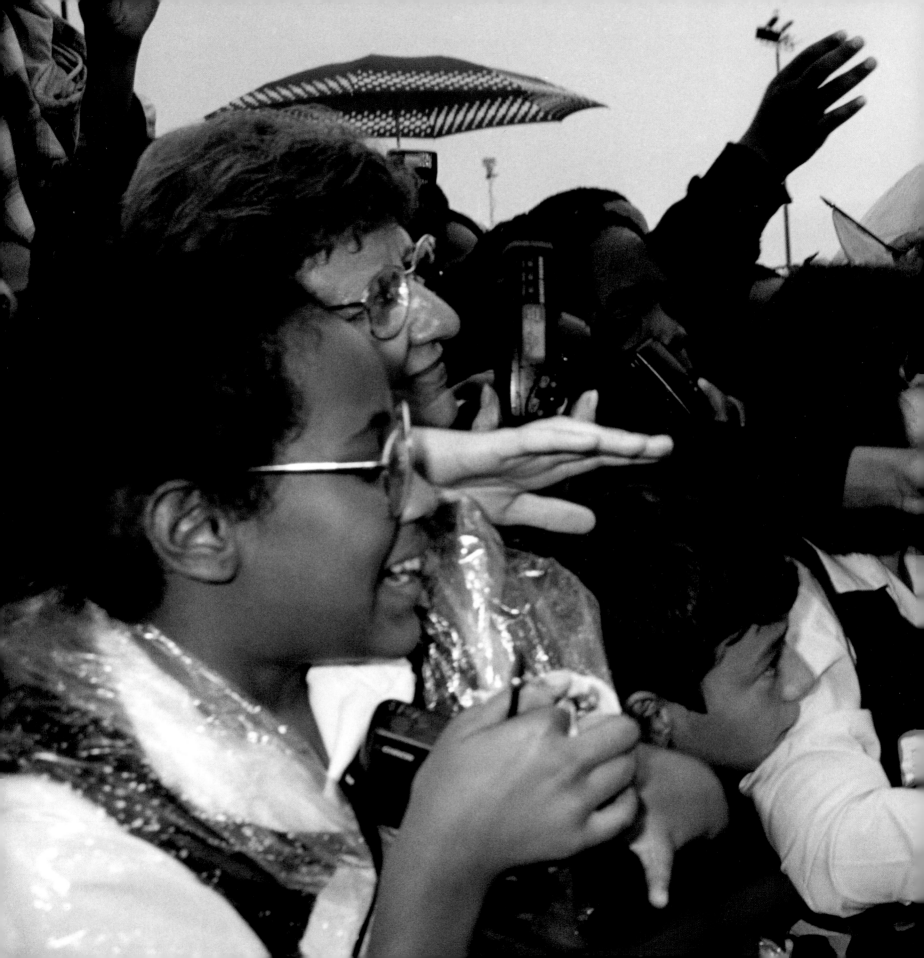

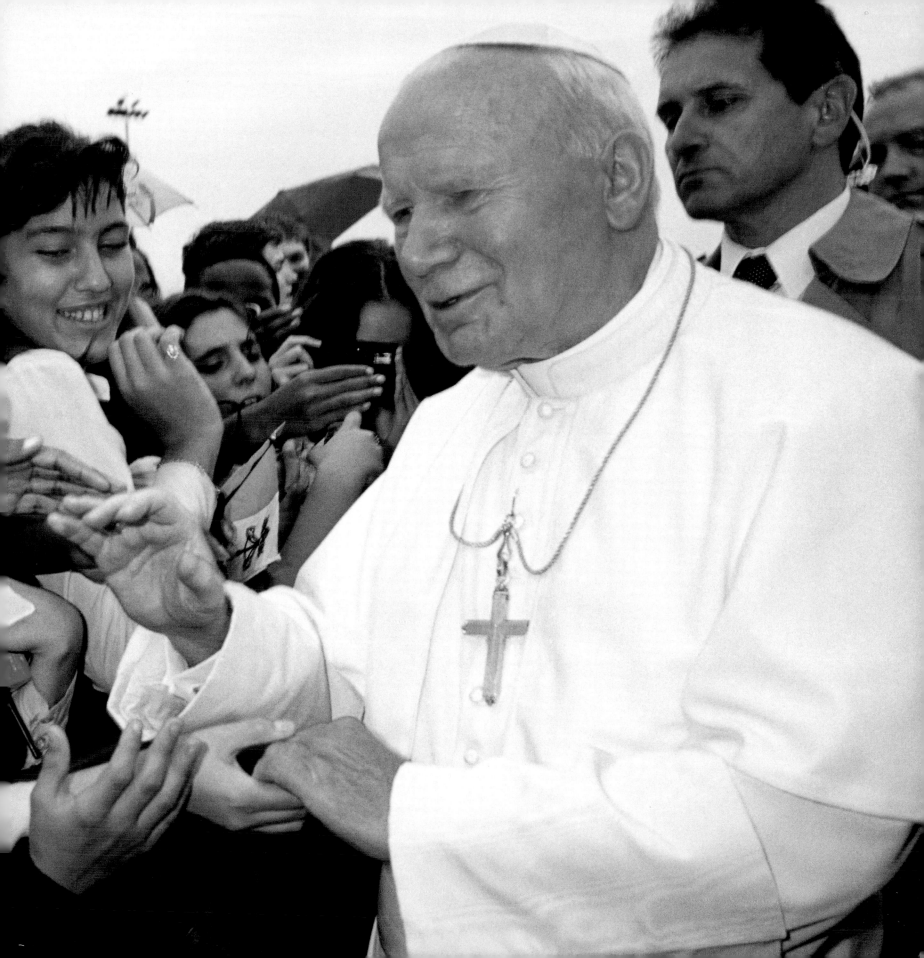

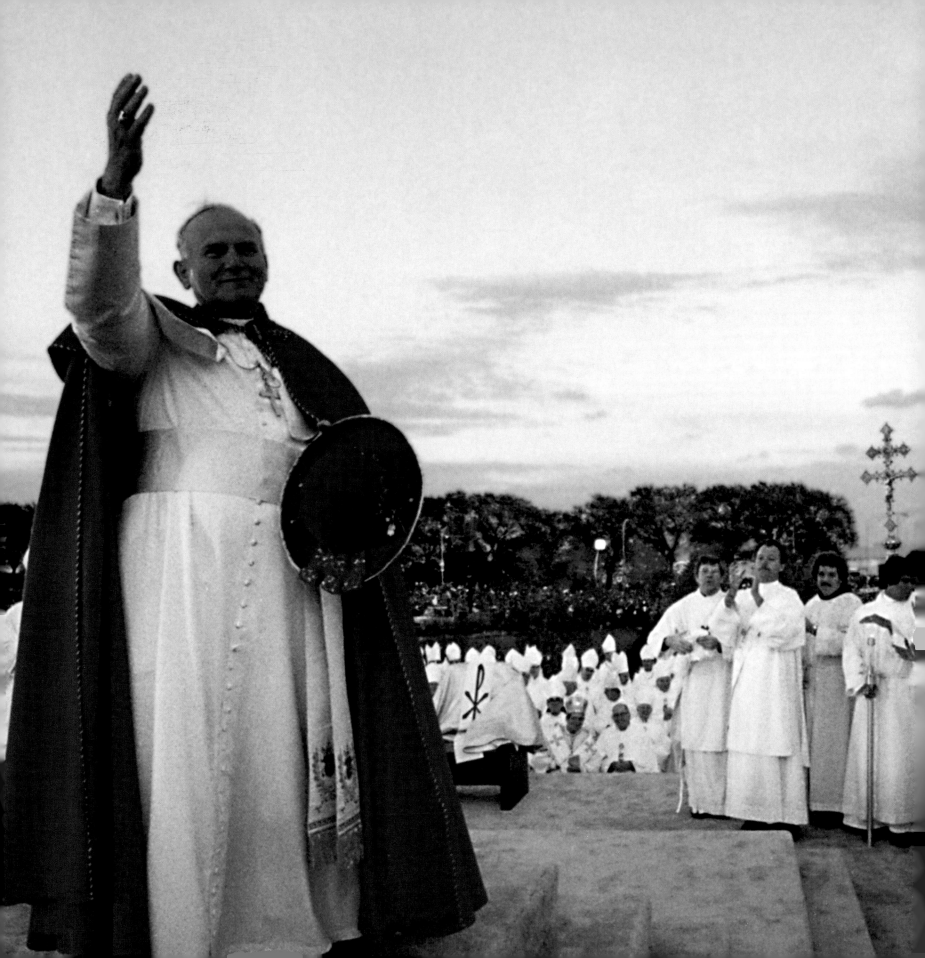

PILGRIM

---◆---

I come as a pilgrim of peace and understanding among peoples.

POPE JOHN PAUL II ARRIVAL SPEECH, NEWARK, OCTOBER 4, 1995

WITNESS FOR PEACE

GERARD POWERS

 ew popes have made Jesus' words— "blessed are the peacemakers"— so central to their pontificate as John Paul II.

True peacemaking can be a matter of policy only if it is first a matter of the heart. "The goal of peace, so desired by everyone," as Pope John Paul has written, "will certainly be achieved through the putting into effect of social and international justice, but also through the practice of the virtues which favor togetherness and which teach us to live in unity…" (*Sollicitudo Rei Socialis*, 39). In the absence of repentance and forgiveness, no peace can endure; without a spirit of courageous charity, justice cannot be won; without patience and perseverance, the building of a just peace out of the ruins of war will not succeed.

The Holy Father has been clear that a practical complement to the virtues of peacemaking is a clear vision of a peaceful world built on "truth, justice, love and freedom" (World Day of Peace Message, 2003). Peace is not the absence of war but the "tranquility of order." Peace will be the fruit of respect for human rights, efforts to promote integral human development, solidarity between peoples and nations, and new forms of political authority capable of promoting the universal common good.

Given this rich vision of peace, he has insisted that "war is not inevitable." In fact, it is "a defeat for humanity." The demise of the Soviet bloc came, he reminds us, not through war, but through "the nonviolent commitment of people who…succeeded time after time in finding effective ways of bearing witness to the truth" (*Centesimus Annus*, 23). Having lived through World War II and Communism, he has often warned about the great dangers of modern warfare as well as the "false peace of totalitarian regimes" and the need to defend against global terrorism and aggression. While recognizing that people have a right and even a duty to defend against unjust aggression, he was clear in addressing the crisis in Iraq that "war cannot be decided upon, even when it is a matter of ensuring the common good, except as the very last option and in accordance with very strict conditions" (Address to the Diplomatic Corps, January 13, 2003).

The Holy Father has not limited himself to teaching about peace, but has been an active advocate for peace around the world. Before the Gulf War in 1991 and the war with Iraq in 2003, he combined dozens of personal appeals with vigorous diplomatic efforts to persuade world leaders to find alternatives to war. He visited Bosnia-Herzegovina, Sudan, the Holy Land, Central America, Poland and other places torn by war and repression as personal acts of solidarity with those who were suffering. Such dramatic gestures of peace included his convening of the world's religious leaders on several occasions to pray together for peace in Assisi. In these and other ways, Pope John Paul II has made the Prayer of Saint Francis a legacy of his ministry.

Previous: A crowd of over one million are on hand to welcome the Pope to Chicago's Grant Park, where he offered Mass.

The Pope visits the Auschwitz concentration camp during his first return to Poland as Pope in 1979.

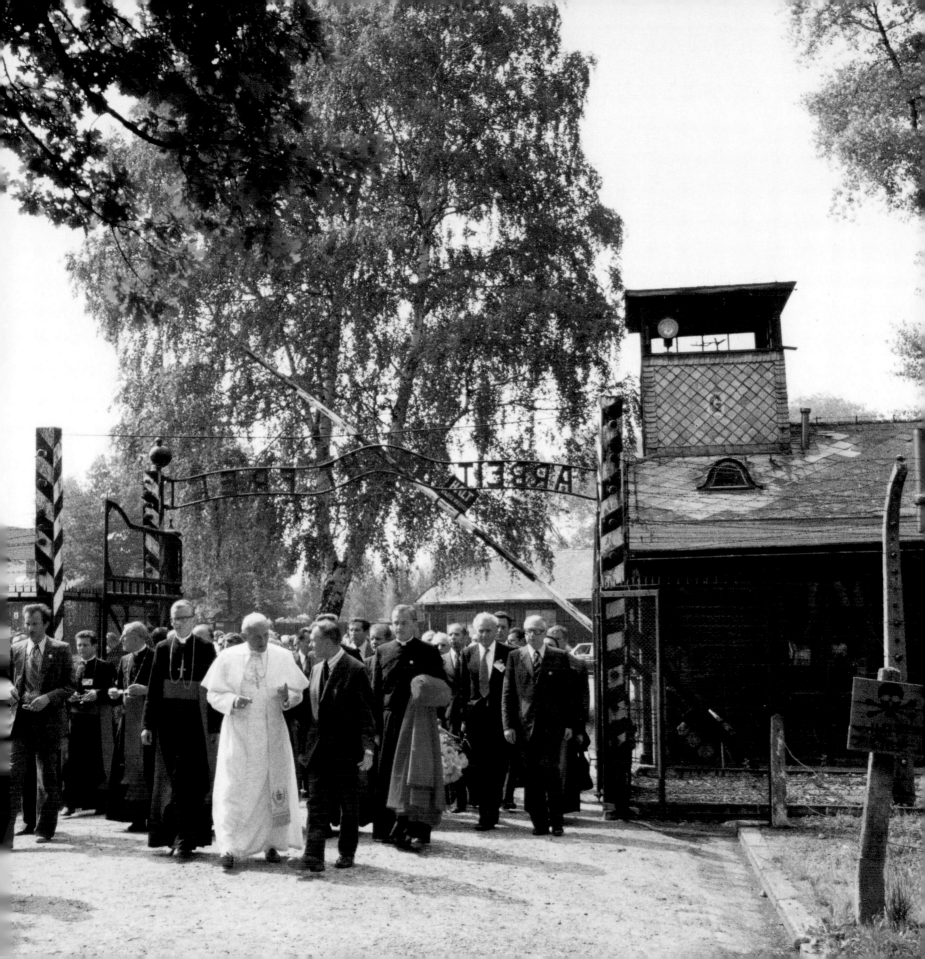

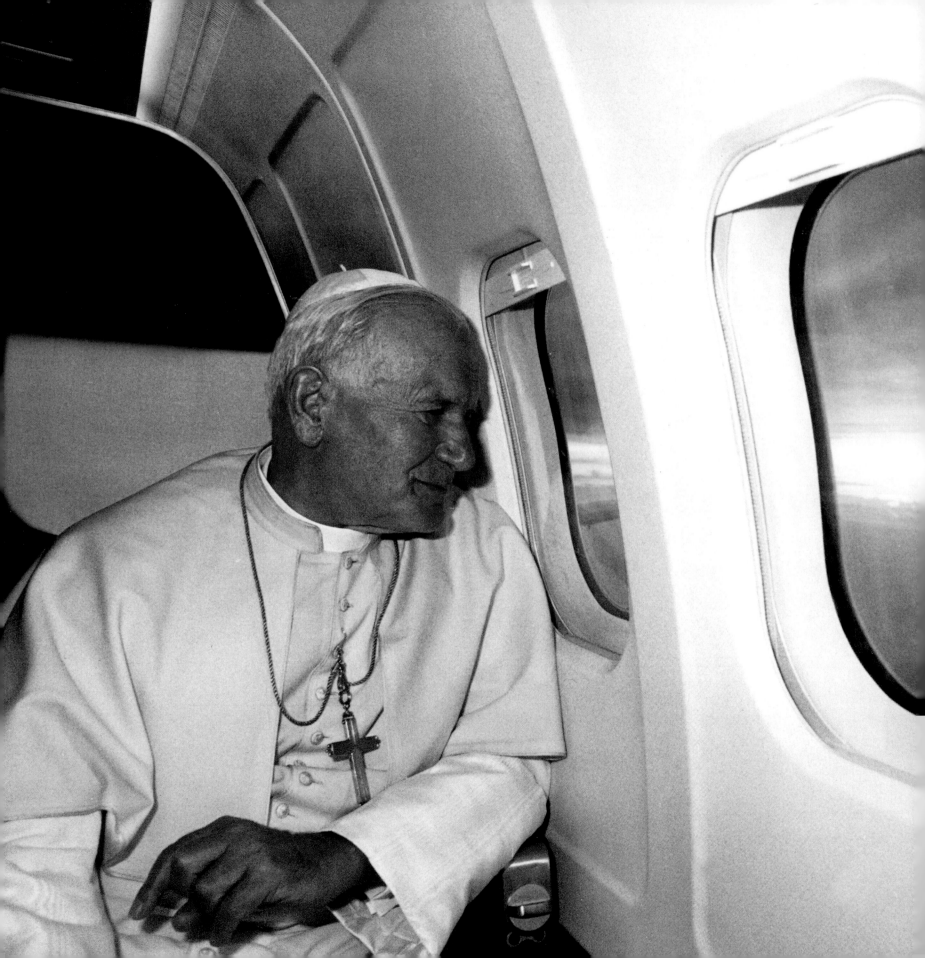

FREQUENT FLIER POPE

JOHN THAVIS, Rome Bureau Chief, *Catholic News Service*

or centuries, Roman pontiffs were carried on chairs at the Vatican. Pope John Paul II prefers the airplane.

Logging more than 700,000 miles during his first twenty-five years in office, the Pope has taken the universal church to such out-of-the-way places as Fiji, Botswana and Alaska. Along the way, he's changed the nature of the papacy and its once-stable ministry.

From the start, the travels were Pope John Paul's way of "globalizing" the church and its message. Cheering crowds sometimes gave his trips a rock-concert atmosphere, but popularity was never his purpose.

He travels as a missionary, preaching the faith in every corner of the world. He travels as a man of dialogue, reaching out to other religions and other cultures. And he travels as an Apostle, walking a pilgrim's path in places where the church was born and spread its roots.

Asked about his globe-trotting in 1983, he replied with a bit of irony: "Yes, I am convinced… that I am traveling too much, but sometimes it is necessary to do something of what is too much." On other occasions, he said simply, "I must visit my people."

The Pope put on his traveling shoes in 1979, with a planeful of aides and journalists in tow. Today his passport bears the stamps of nearly 130 countries.

From the mountains of Peru to the plains of India, he has spoken the local languages, delivered pep talks to pastoral workers and canonized native saints. In 1980, he underscored the Church's commitment to the poor by walking into a shack in a Rio de Janeiro slum and chatting with residents.

He's visited leprosy patients in Guinea-Bissau and blessed young AIDS sufferers in Uganda and the United States. His hugs for the sick were often front-page pictures in newspapers around the world.

The Pope's seven trips to the United States have featured festive celebrations and emotional highlights, like the time he embraced armless guitarist Tony Melendez—who strummed with his feet—in Los Angeles in 1987, or when he spoke movingly about young people's hopes and ideals to half a million World Youth Day pilgrims in Denver in 1993.

Whether in Muslim Morocco, Buddhist Japan or Catholic Spain, the Pope pushed a simple message through his words and presence: that the Gospel is not out of place in any country.

Opposite: In his nearly 25 years as Pope, John Paul II has logged more than 700,000 miles on more than 100 foreign trips.

Below: As his plane passes over Dublin, the Pope takes a moment to look over the countryside.

Following: Religious leaders gather with the Pope for the Interfaith Day of Prayer for Peace in the square in front of the Basilica of St. Francis, Assisi, 1986.

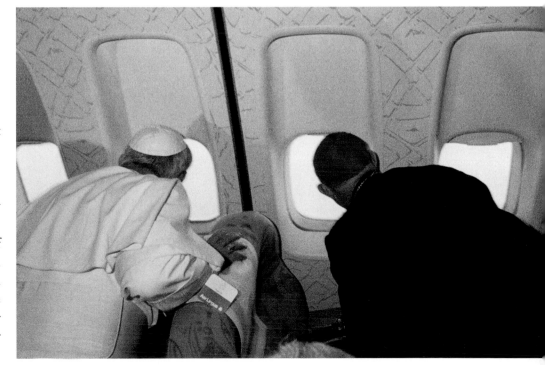

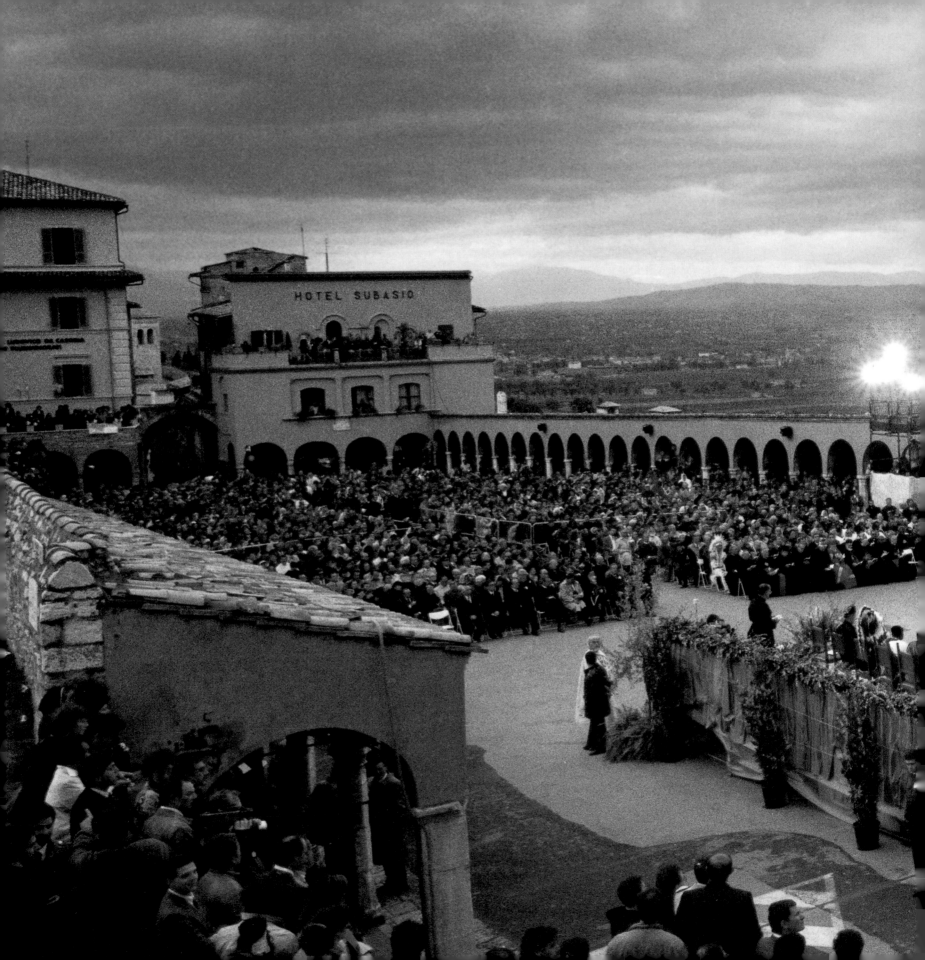

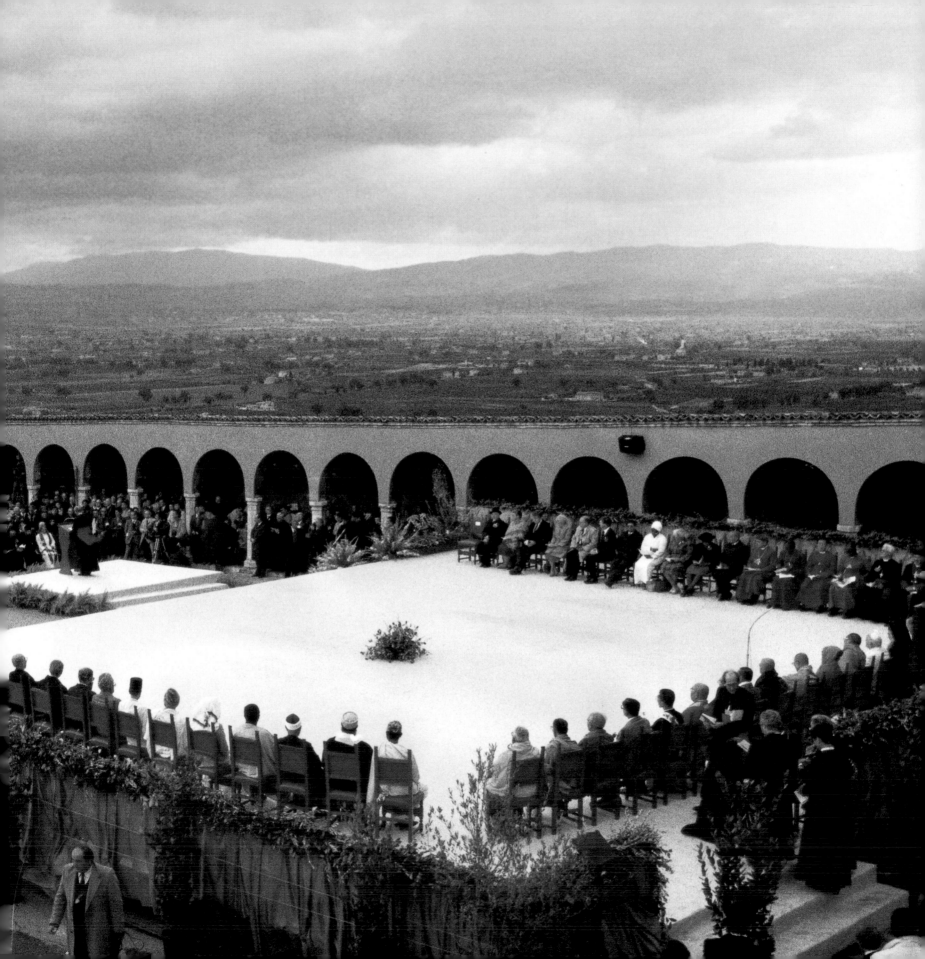

The Human Touch

CARDINAL ANTHONY BEVILACQUA, Archbishop of Philadelphia

A UNIQUE meeting with the Pope happened while I was Bishop of Pittsburgh. In June 1987, I was in Warsaw on a pilgrimage at the same time the Pope was in Warsaw as part of a visit to his homeland. I received an invitation to a luncheon honoring him, and in the large hall for the event found myself amidst a vast number of prelates. When the Holy Father arrived, he was besieged by bishops affectionately greeting him. It took him about twenty minutes to reach his chair.

After the luncheon, the Pope did not exit past the same bishops he had met upon his entrance. Instead, he walked down the opposite side of the room to greet the rest of us. As he approached where I and others awaited him, a group of Polish bishops rushed to him. This left me by myself directly behind the Pope's back and pressed against the wall. I did not think he noticed I was there. As these bishops held the Pope's attention he calmly listened, and suddenly, to my surprise, slowly reached back, took my right hand in his and firmly grasped it. And then he moved on. In that simple but personal gesture, he told me that he knew I was there and that he knew me. My reciprocal grasp of his hand was my response to him: "Thank you."

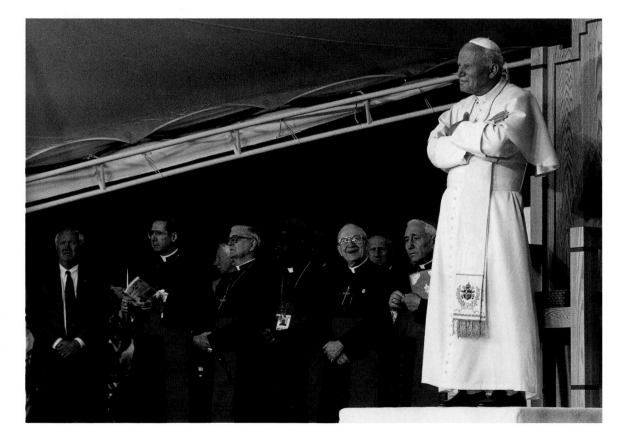

On the feast of the Assumption, August 15, John Paul II addresses hundreds of thousands of World Youth Day participants gathered at Denver's Cherry Creek State Park in 1993.

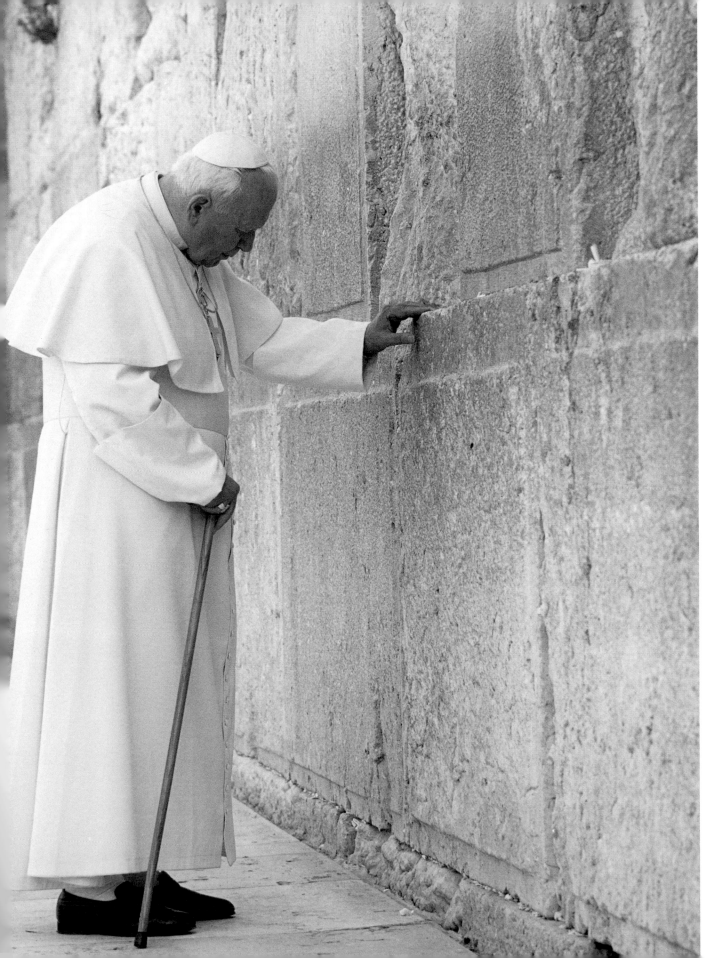

At the Western (Wailing) Wall, the Pope prays and places a note in its cracks which says, "God of our Fathers…We are deeply saddened by the behavior of those who in the course of history have caused these children of Yours to suffer and, asking Your forgiveness, we wish to commit ourselves to genuine brotherhood with the people of the Covenant," in 2000.

Following: Pope John Paul II tours the Living History Farms in suburban Des Moines, Iowa, where he later said his first Mass west of the Mississippi on his 1979 visit to the United States.

THE MESSAGE THROUGH THE MEDIA

MONSIGNOR FRANCIS J. MANISCALCO

he Vatican has long made use of all forms of media. The daily newspaper which it publishes, *L'Osservatore Romano*, goes back over 140 years. Shortly after the first public screenings of "pictures in motion" in Paris in 1895 by the Lumiere brothers, Pope Leo XIII was photographed in Rome with this new device. By 1936, an entire encyclical was devoted to the motion picture, so influential had this industry become in the eyes of the Church.

With the personal assistance of Guglielmo Marconi, Pius XI inaugurated the Vatican Radio Station in 1931, over which he and his successors have broadcast messages worldwide ever since. However, though church ceremonies would seem to be made for television, the Vatican, while always interested, did not establish a similar presence on television.

As with so much in the contemporary Church, the Second Vatican Council spurred new interest in the Church's relationship to the world of media. Its own document on the matter, *Inter Mirifica* (1963), was somewhat sketchy. However, the Pontifical Council for Social Communications to which it gave rise has issued several important documents on the media, starting with a pastoral instruction, *Communio et Progressio*, as requested by the Council Fathers.

Throughout his pontificate, Pope John Paul II has shown his grasp both of the issues raised by the power of the media and also a distinctly practical sense of how they can effectively extend the ministry of the pope as the Church's universal pastor.

While his pastoral visits across the globe and his sponsorship of large-scale events, such as World Youth Day, are intended to do more than provide "photo-ops," they are also photo-ops *in excelsis*. Through media coverage, Pope John Paul knows that he can be close even to the millions who cannot get to these events—or to Rome. Given his personal gifts as well, such as an astonishing facility with languages, he has added to the papacy the dimension of being a media ministry.

Pope John Paul II also understands that the influence of the media goes beyond simply the technical facts of transmitting content more quickly and efficiently over farther distances than ever before.

In his 1990 encyclical, *Redemptoris Missio*, Pope John Paul II writes that "the means of social communication have become so important as to be for many the chief means of information and education, of guidance and inspiration in their behavior as individuals, families and within society at large." After pointing out that the Church has somewhat neglected the world of communications in seeking to spread the Gospel, he adds that "there is a deeper reality" involved in the media than simply some more, extremely powerful tools for getting out the message. The Gospel message has to be "integrated" into the "new culture" created by modern communications—a culture that arises from "the very fact that there exist new ways of communicating, with new languages, new techniques and a new psychology."

This profound insight into the relationship between means and content allied with both his messages for World Communications Day each year for two and a half decades and his own practical example make the pontificate of John Paul II a turning point in the encounter of the Church with culture through the media.

The Pope gives a press conference en route to Kingston, Jamaica, August 9, 1993.

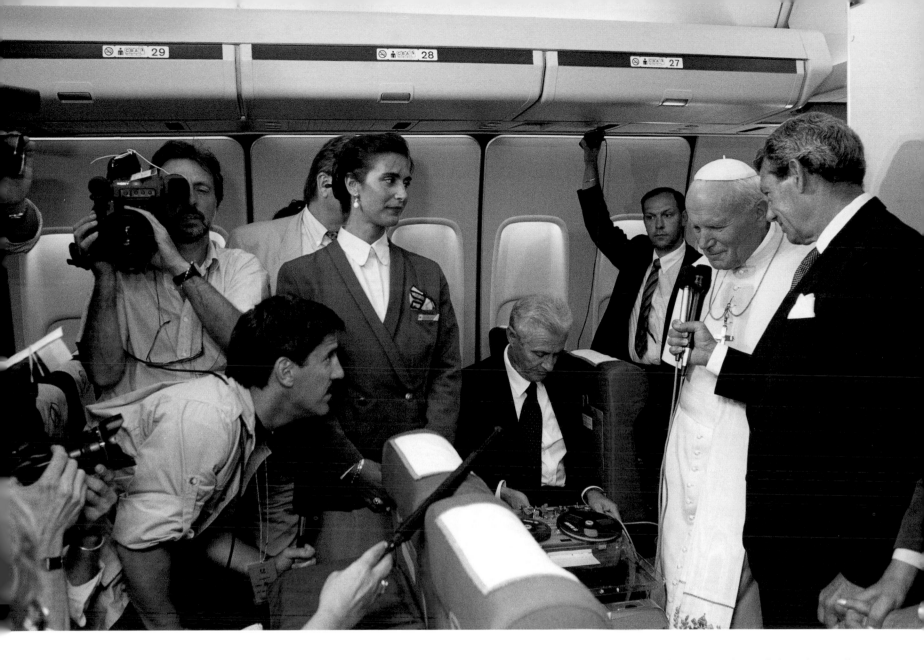

The Church tries and will try more and more to be a "glass house," where all may see what is happening, and how she accomplishes "her mission in fidelity to Christ and the evangelical message." But the Church expects that a similar effort of authenticity will be performed by those who are put in the position of observers and have to report the Church's life and doings to others—the readers of their newspapers or periodicals.

JOHN PAUL II, AT SPECIAL HOLY YEAR MEETING
WITH JOURNALISTS ON JANUARY 27, 1984

From Language to Language

ARCHBISHOP JOHN P. FOLEY, President, Pontifical Council for Social Communications

THE HOLY FATHER follows the work of the various departments of the Holy See by inviting the top officials of Vatican offices to lunch. On one such occasion, he asked: "What is the most difficult telecast you ever did?"

I responded, "Holy Father, it was your World Day of Peace Mass in the Philippines in 1995."

"Why?" he asked.

I said, "Chiefly because you were an hour and a half late, because of the crowds which made it impossible for you to arrive in your Popemobile."

He smiled and asked: "What did you talk about?"

I responded, "First, I gave the history of World Youth Day; then I gave the history of the Catholic Church in the Philippines; then I gave the history of the Church."

The Pope laughed, and then I said, "But that's not all. At the end of the Mass, you 'ad libbed'—first in English; then in Spanish, which had been the language in the Philippines, and I could translate that; then in Italian, because you saw a large group of Italians, and I could translate that. But then you saw the flag from Bosnia-Herzegovina, and you 'ad libbed' in Serbo-Croatian—and I was lost, until I heard the word *mir*, which I know means 'peace' in Slavic languages."

The Holy Father said, "It also means 'cosmos' or 'universe.'"

I responded, "I said on television that the Holy Father has seen the flag of Bosnia-Herzegovina and has assured the people of that war-torn country of his prayers for peace."

He smiled and replied: "That's exactly what I said."

And I heaved a sigh of relief and said a quiet prayer of thanks!

During a visit to Africa, the Pope enjoys a boat ride on Lake Togo in Lome, Togo, August 9, 1985.

Opposite: In his 79th foreign trip, Pope John Paul II celebrates World Youth Day in Paris, 1997.

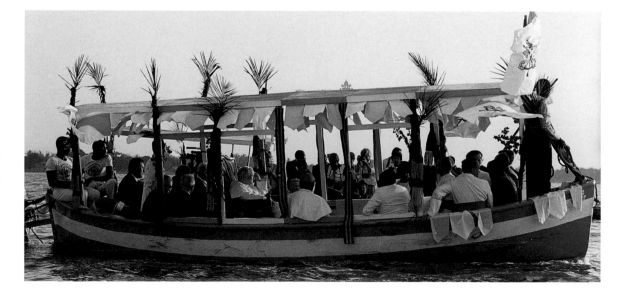

CHURCH AND STATE RELATIONS

MARK CHOPKO

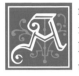mericans take for granted that freedom of religion is a part of their heritage. The Constitution separates the roles of religion from civil governance as a way of protecting that freedom. The Church's teaching regarding freedom of religion and the unique roles of Church and State was clarified in the Second Vatican Council. As one who experienced dictatorships first hand, John Paul II confirmed and expanded the Council teaching that freedom of religion is a basic human right and the foundation for other human rights.

Freedom of religion is an expression of personal conscience, a personal quest for the transcendent truth that animates all human life. It is both personal and communal and can flourish best when free of State-sponsored coercion. Pope John Paul in an address to the Cuban bishops, January 25, 1998, stated that religious freedom is an "inalienable human right…It is not simply a matter of a right belonging to the Church as an institution; it is also a matter of a right belonging to every person and every people."

Both Church and State have different and complementary roles. The State through its laws must protect the human rights of every person starting with freedom of religion. The Holy Father has often condemned those conditions and legal systems under which religion is persecuted and people are not free to express their religious beliefs openly, addressing both totalitarian and religiously intolerant regimes. The State has no legitimate business involving itself in religion, "nor can it substitute for the various Confessions in matters of organizing religious life," the Pope told the Vatican Diplomatic Corps in 1989. So too the "Church, immersed in civil society, does not seek any type of political power in order to carry out her mission; she wishes only to be the fruitful seed of everyone's good by her presence in the structures of society," he said in a homily in Santiago, Cuba, January 24, 1998.

Justice, wisdom, and realism all demand that the baneful positions of secularism be overcome, particularly the erroneous reduction of religion to the purely private sphere. Every person must be given the opportunity within the context of our life together to profess his or her faith and belief, alone or with others, in private and in public.

JOHN PAUL II, MESSAGE ON THE THIRTIETH ANNIVERSARY OF THE UNIVERSAL DECLARATION ON HUMAN RIGHTS, 1978

In his 1988 World Day of Peace message, the Pope also stressed that "The civil and social right to religious freedom…respect[s] the individual's most jealously guarded autonomy, thus making it possible to act according to the dictates of conscience both in private choices and in social life." Through the rule of civil law, the State must foster conditions where religious expression is not only possible but encouraged and protected, from the right to worship, to the formation of communities of believers, to the education of children, to access to the means of communication of religious ideas. These rights are under attack in our own country where secularization and growing regulatory powers do not always respect that the right of religious conscience is fundamental to our own liberty.

The Pope visits with President George H. W. Bush and his wife Barbara in 1991 at the Vatican.

The Church, immersed in civil society, does not seek any type of political power in order to carry out her mission; she wishes only to be the fruitful seed of everyone's good by her presence in the structures of society. Her first concern is for the human person and the community in which the individual lives; she is well aware that actual people with all their needs and aspirations constitute her primary path. All that she claims for herself she places at the service of people and society. For this reason Christ charged her to bring his message to all peoples, and for this she needs sufficient freedom and adequate means.

JOHN PAUL II, HOMILY IN SANTIAGO,
CUBA, JANUARY 24, 1998

The Pope greets Cuban
President Fidel Castro on
his visit to the Vatican,
November 9, 1996.

Following: The Pope
visits the Hiroshima
Memorial in 1981, a model
of the city after the
atomic bomb explosion
on August 6, 1945.

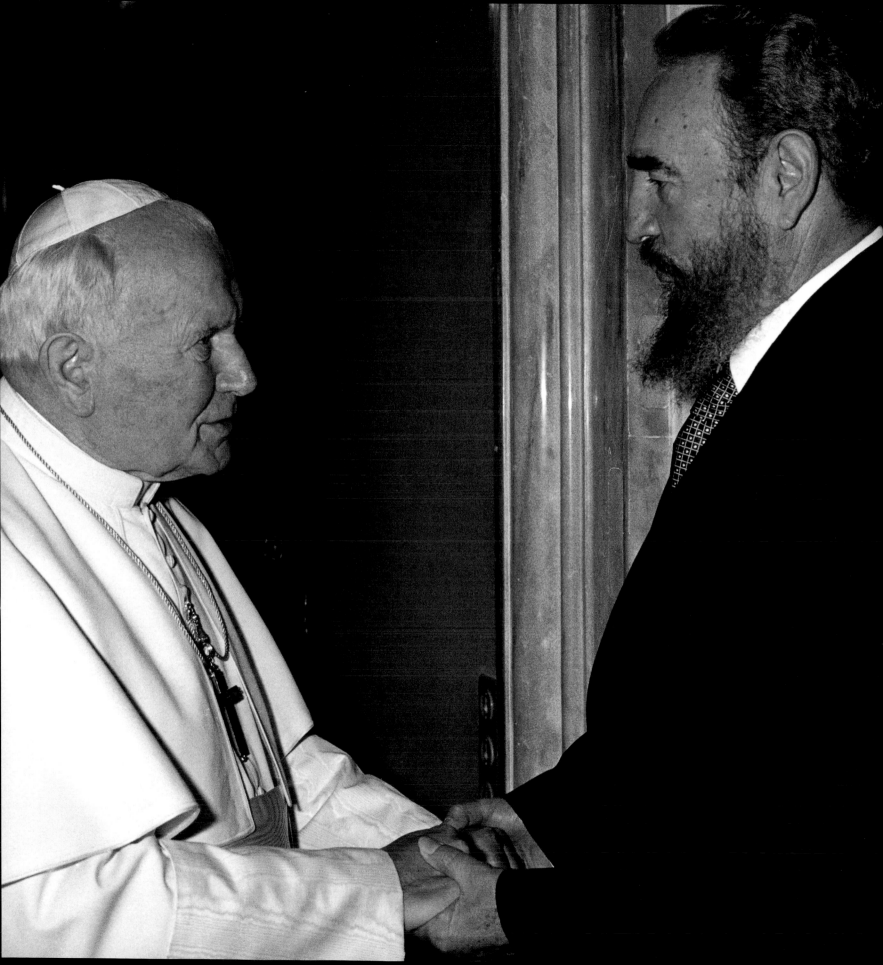

PROMOTER OF GLOBAL SOLIDARITY

FATHER ROBERT VITILLO

erhaps more than any of his predecessors, Pope John Paul II has made the "catholic," or universal, character of the Church a hallmark of his papal ministry. In both word and deed, through his pastoral visits to every corner of the globe and through his deeply reflective teachings on the social mission of the Church, he has expanded the horizons of the Catholic faithful. He tirelessly reminds everyone about the needs of their vulnerable sisters and brothers in other parts of the world and urges a response based on solidarity, communion, and justice.

Far from naive about trends in modern economics and business, Pope John Paul II recognized the positive potential of globalization. He noted in his 1991 encyclical *Centesimus Annus*, which marked the hundredth anniversary of the encyclical *Rerum Novarum*, for example, that "Today we are facing the so-called 'globalization' of the economy, a phenomenon which is not to be dismissed, since it can create unusual opportunities for greater prosperity (58)."

In similarly incisive fashion, he posed some haunting questions about the state of international development as he set the tone for the Third Christian Millennium. In the 2001 Apostolic Letter, *Novo Millennio Ineunte*, to close the Great Jubilee of the Year 2000, he noted that "our world is entering the new millennium burdened by the contradictions of an economic, cultural, and technological progress which offers immense possibilities to a fortunate few, while leaving millions of others not only on the margins of progress but in living conditions far below the minimum demanded by human dignity. How can it be that even today there are still people dying of hunger? Condemned to illiteracy? Lacking the most basic medical care? Without a roof over their heads?"(50).

One tangible and "close-to-home" action taken by Pope John Paul II to promote deeper solidarity among "haves" and "have-nots" could be observed in his decision to convene an extraordinary synod among bishops from the entire American hemisphere. He made it abundantly clear that, by talking of "one America," he had no intention of hearkening back to outdated concepts of the colonial era but rather was pleading for us to move beyond the barriers and differences that are obstacles to authentic human development on the American continent.

In his 1999 post-synodal Apostolic Exhortation, *Ecclesia in America* (On the Encounter with the Living Christ: The Way to Conversion, Communion and Solidarity in America), he wrote that "the decision to speak of 'America' in the singular was an attempt to express not only the unity which in some way already exists, but also to point to that closer bond which the peoples of the continent seek and which the Church wishes to foster as part of her own mission, as she works to promote the communion of all in the Lord."

Insisting that the "family of humanity" must hear the cry of the poor who simply are asking for "their sacrosanct right" and that "faith does not allow a Christian to be indifferent to questions of such world relevance," the Holy Father has urged that the process of globalization be "firmly governed by motives for the common good of citizens, based on the absolute demands of justice and charity" (*Angelus* Address, July 8, 2001).

At the Interfaith Day of Prayer for Peace at Assisi in 1986, the Pope stands with, from left, Orthodox Archbishop Methodios of Thyateira/Great Britain and representative of Ecumenical Patriarch of Constantinople, Anglican Archbishop of Canterbury Robert Runcie, and Lutheran World Federation Vice President Susannah Telewoda.

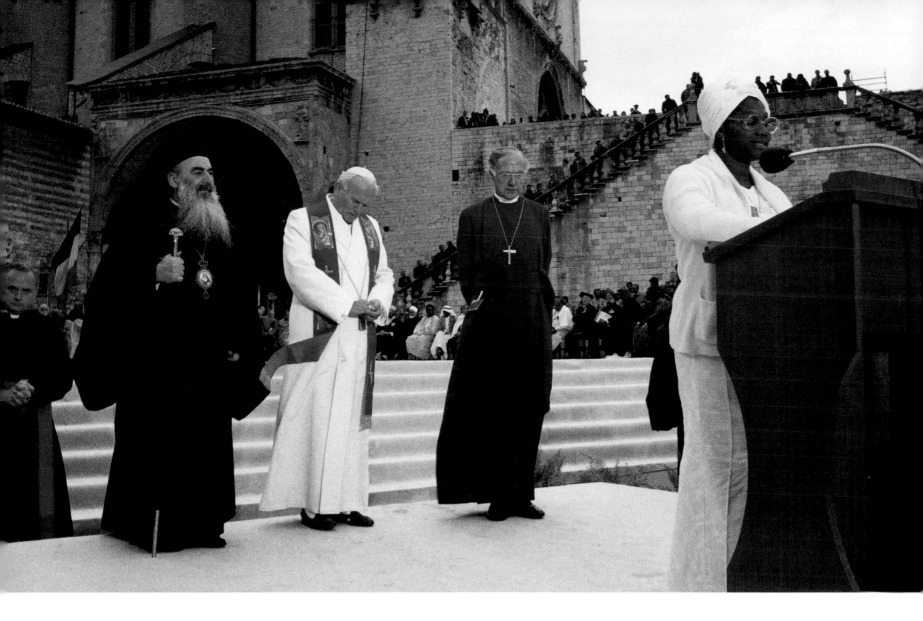

*Globalization will have many positive effects if it can be sustained by a strong
sense of the absoluteness and dignity of all human persons and of the principle
that earthly goods are meant for everyone. There is room in this direction to
operate in a fair and constructive way, even within a sector that is much subject
to speculation. For this it is not enough to respect local laws or national regulations;
what is necessary is a sense of global justice, equal to the responsibilities that are at
stake, while acknowledging the structural interdependence of the relations between
human beings over and above national boundaries.*

JOHN PAUL II, ADDRESS TO *CENTESIMUS ANNUS*—
PRO PONTIFICE FOUNDATION, SEPTEMBER 11, 1999

MAKING ONE AMERICA

RONALDO M. CRUZ

he Synod of Bishops for America, held in 1997, and *Ecclesia in America*, the Apostolic Exhortation promulgated by Pope John Paul II in January 1999 in Mexico City at the official closing of the Synod for America, were two key events that helped open an international dialogue among Catholics on the American continent. Though dialogue had been ongoing on a variety of issues before the Synod and the exhortation, the attention given to building solidarity in the one America grew and became more systematic and intentional.

It is most important that the Church throughout America be a living sign of reconciled communion, an enduring appeal to solidarity and a witness ever present in our political, economic and social systems.

JOHN PAUL II, *ECCLESIA IN AMERICA*

The theme Pope John Paul II selected for the Synod, "Encounter with the Living Christ: The way to Conversion, Communion, and Solidarity in America," was important to the focus required for follow-through after the actual event and to promoting the concept of one America in the Church. An international gathering took place in Dallas, Texas, in early February 1998. This catechetical *Encuentro* was conceived as a first step toward a closer collaboration in the field of catechesis between the North and South. At the closing of the *Encuentro*, the participating bishops wrote a letter to the presidents of the Latin American Episcopal Council (CELAM) and to the United States Conference of Catholic

Bishops to inform them of what had transpired at the international event. They asked their Conference leaders to convey to Pope John Paul II the success of the experience, as well as "our commitment to continue our efforts to build one Church in *one America*." The theme of this special gathering, "One Faith, One Church, and One America," was complimented with the importance of recognizing and affirming the reality of one multicultural America with diverse catechesis, united in faith. One of the recommendations was to include the Canadian Conference of Catholic Bishops in future events.

The concept of one America was also important to the vision, planning and implementation of the extremely successful national Jubilee event hosted by the Hispanic Catholic community and convened by the Catholic bishops of the United States in July 2000, in Los Angeles, California, *Encuentro 2000: Many Faces in God's House*. Today, the values and principles of *Encuentro 2000*, which are clearly stated in *Ecclesia in America*, are integrated into the planning processes initiated by the Church at all levels of ministries and gatherings. This is also evidenced in new documents of the bishops of the United States, such as *Welcoming the Stranger Among Us: Unity in Diversity, Encuentro and Mission: A Renewed Pastoral Framework for Hispanic Ministry*, and *Strangers No Longer: Together on the Journey of Hope*.

Several other international gatherings held since the Synod of Bishops for America promoted the concept of one America, such as a continental gathering of youth and young adults in Chile, a continental gathering on missions in Argentina, the North American Congress on Vocations held

The Pope celebrates Mass before a crowd of 175,000 on the National Mall during his 1979 visit to Washington.

in Montreal, and a continental gathering on African American Catholics in America. In late February 2003, Pope John Paul II's call for *one America* was given a major boost in the Continental Gathering sponsored by the bishops of Canada, Latin America, and the United States. Its theme, "New Evangelization and Catechesis: America Speaks of Its Experiences," marked the way the Church will continue to work collaboratively in sharing relevant experiences and in developing strategies to respond to a very mobile Catholic community faced with pastoral, economic, and global challenges.

John Paul II's Synod of Bishops for America and *Ecclesia in America* provide the parameters and motivation to make *one America* a potential reality, at least in the Church.

The parish is a privileged place where the faithful concretely experience the Church…The parish needs to be consistently renewed on the basis of the principle that "the parish must continue to be above all a Eucharistic community." This principle implies that "parishes are called to be welcoming and fraternal… attentive to the cultural diversity of the people…"

JOHN PAUL II, *ECCLESIA IN AMERICA*

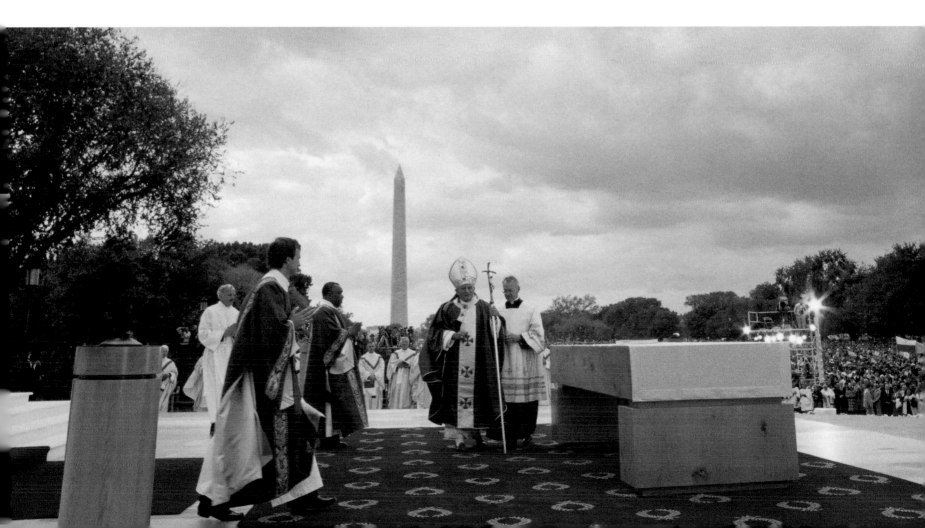

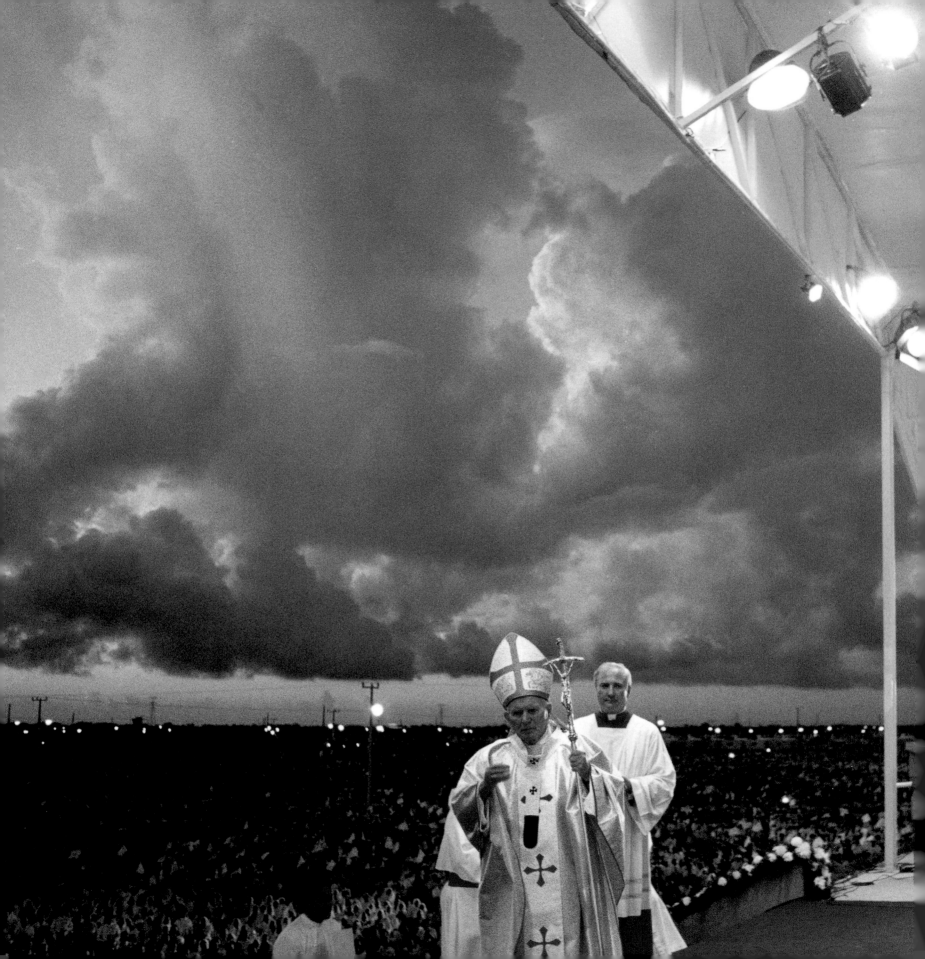

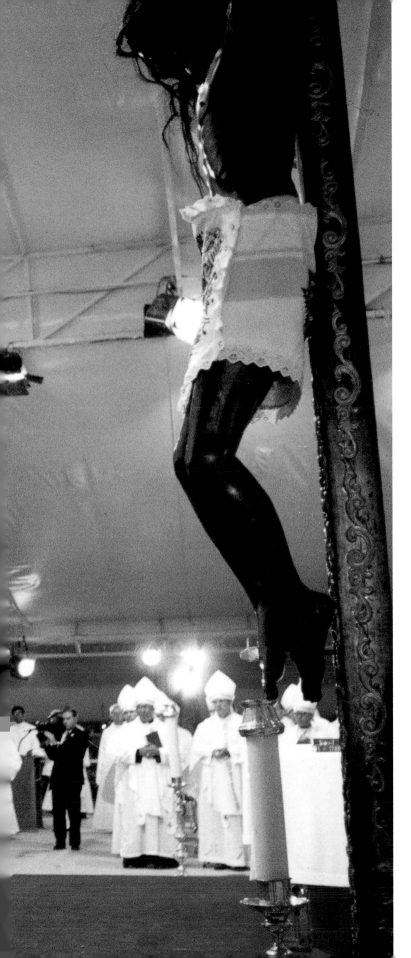

The tortured cry which these lands raise and which invokes peace, the end of war, and the end of violent death resounds with urgency in my spirit ... It is the pain of the peoples that I come to share, to try to understand more intimately, so as to leave them a word of encouragement and hope, founded on a necessary change of attitudes. Change is possible, if we accept the voice of Christ.

JOHN PAUL II, ARRIVAL SPEECH IN SAN JOSE,
COSTA RICA, MARCH 2, 1983, AT THE START
OF AN EIGHT-NATION CENTRAL AMERICAN VISIT

En route to World Youth
Day in Denver, the
Pope celebrates Mass
in Mérida, Mexico,
the capitol of the
state of Yucatán, on
August 11, 1993.

IN SOLIDARITY WITH MIGRANTS

MARK FRANKEN

e has been called the "migrant Pope." Some attribute this to his extensive world travels. After all, John Paul II has been to nearly 130 countries, making him the most migratory Pope in history. Perhaps the tone for the "migrant" dimension of his papacy was set during his installation twenty-five years ago as the new bishop of Rome when he described himself the day he was elected Pope as a traveler "from a distant land." It had been 455 years since the last "migrant pope" came to Rome.

Yet there is another essential aspect of his papacy that contributes to his reputation as the "migrant Pope." He has written and taught extensively on the contemporary issues of migration. Pope John Paul II has eloquently and compellingly framed his teachings to emphasize the human dimensions of migration. His voice has provided an essential counterbalance to the secular world's tendency to view migrants as objects, rather than as humans who enjoy God-given rights. He has been an outspoken promoter and defender of the human rights and human dignity of migrants.

With advancements in technology and transportation, our world has become ever smaller and is increasingly integrated through the globalization of economies. This has given rise to a huge surge in migration around the world. With around 175 million people currently residing in a country other than where they were born, the number of migrants in the world has more than doubled during John Paul II's tenure as Pope.

Being ever more deeply rooted in Christ, Christians must struggle to overcome any tendency to turn in on themselves, and learn to discern in people of other cultures the handiwork of God.

JOHN PAUL II, MESSAGE OF THE HOLY FATHER FOR THE 89TH WORLD DAY OF MIGRANTS AND REFUGEES, 2003

According to the Pontifical Council for the Pastoral Care of Migrants and Itinerant People, the Holy Father has issued seventeen Migration Day messages, espousing a welcoming and humane vision for our society's response to the migration phenomenon. Additionally, he has delivered thirty-seven messages dealing with refugees and twenty-one messages regarding migrants. The foundations for John Paul II's teachings on migrants, though, are found in the encyclicals, which contain the principles that guide the Church's response to the migrant. In these we hear the Holy Father speak of God's calling us all to journey to the Kingdom. We hear the Holy Father's impassioned plea for each human person to be treated with dignity and respect and to see in the migrant the face of Christ.

Below: The Pope greets those gathered for Mass in Delaney Park, Anchorage, Alaska, 1981.

Opposite: On October 5, 1995, Pope John Paul II celebrates Mass at Giants Stadium in the Newark Archdiocese before a record crowd of nearly 83,000.

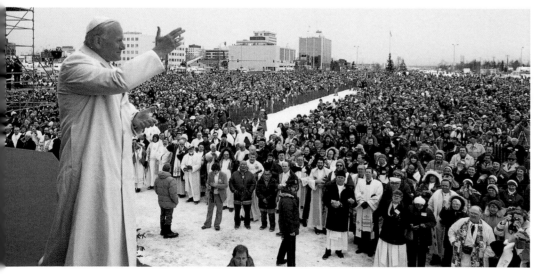

In the United States, a nation founded by refugees and largely inhabited by immigrants, attitudes toward immigrants, migrants, and refugees have become increasingly hostile, especially following the terrorist attacks in September 2001. In the year following those terrible events the number of refugees admitted to the United States for resettlement fell by more than 60 percent. In the current year, United States refugee admissions will probably amount to less than 30,000. This, at a time when there are more than 15 million refugees in the world, most of whom are in need of a durable solution, such as resettlement to a third country.

Pope John Paul II seems to have sensed the growing negativity in attitudes toward migrants when he visited the United States in 1995. Speaking at Giants Stadium, October 5, that year, within sight of the Statue of Liberty, he said:

Quite close to the shores of New Jersey, there rises a universally known landmark which stands as an enduring witness to the American tradition of welcoming the stranger, and which tells us something important about the kind of nation America has aspired to be.

Is present-day America becoming less sensitive, less caring toward the poor, the weak, the stranger, the needy? It must not! Today, as before, the United States is called to be a hospitable society, a welcoming culture. If America were to turn into itself, would this not be the beginning of the end of what constitutes the very essence of the "American experience"?

In John Paul II, the migrants and refugees find a friend, indeed.

The situation of the world's migrants and refugees seems ever more precarious. Violence sometimes obliges entire populations to leave their homeland to escape repeated atrocities; more frequently, it is poverty and the lack of prospects for development which spur individuals and families to go into exile, to seek ways to survive in distant lands, where it is not easy to find a suitable welcome.

JOHN PAUL II, MESSAGE FOR WORLD MIGRATION DAY, 1998

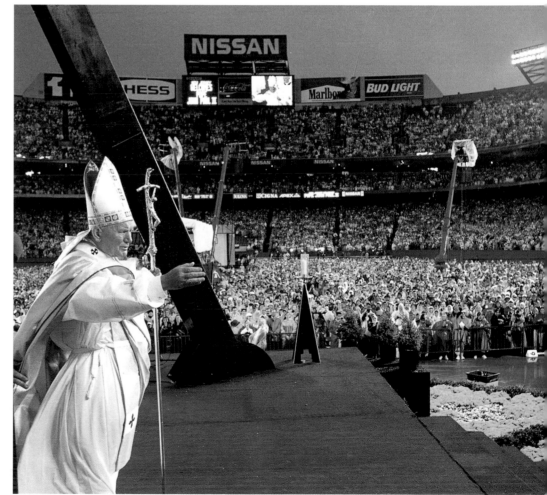

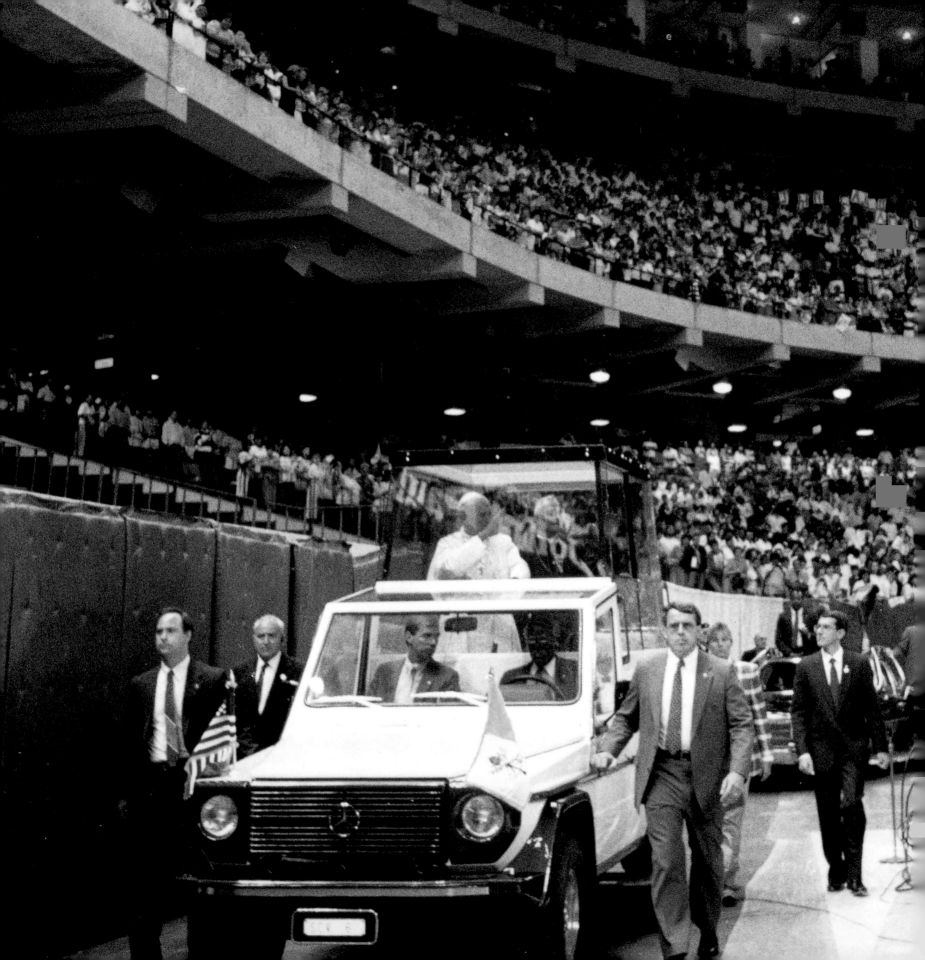

A Bible, A Belt?

MONSIGNOR DANIEL HOYE,
Pastor, St. John the Evangelist Parish, Attleboro, Massachusetts

POPE JOHN PAUL II'S ability to converse in many languages is well known. However, I recall one time when the use of an English idiom stumped him.

Prior to his 1987 visit to the United States, when I was USCCB General Secretary, Archbishop John May, then the President of the Bishops' Conference, was briefing the Pope on different aspects of the trip.

That time the Pope's visit was to include some southern states. The Archbishop told the Pope that he would be in the Bible Belt where the Catholic population was in the minority.

The Pope looked puzzled and asked, "Bible Belt? I know what is Bible and I know what is belt but what is Bible Belt?"

The Archbishop laughed and explained the term.

Opposite: The Pope waves to crowds gathered for a stadium Mass during his 1987 visit to the United States.

The Pope arrives at the Newark Cathedral Basilica of the Sacred Heart to pray Vespers in 1995.

He Calls Them Each by Name

ARCHBISHOP THOMAS C. KELLY, OP, of Louisville

EVERYONE likes to be remembered but to be remembered by the Pope is awesome. Since his first pastoral visit to the United States in 1979, the Holy Father has honored me by remembering me whenever we've meet.

The Holy Father's ability to recall individuals is a revelation of his humble respect toward his sisters and brothers in Christ. I don't know how his memory works—my face has changed a lot in these twenty-five years and not for the good—but I love him for it. He also rises when he is able to greet his visitors, a mark of respect dazzling in itself. This gesture illustrates the Thomistic-Aristotelian adage that honor exists in the one honoring rather than in the honoree.

Pope John Paul II is indeed a man of honor, a Holy Father who loves and respects all of his brothers and sisters. He calls to mind the tender words of Psalm 147: "He knows the number of the stars; he calls them each by name."

The Pope greets people at the first Mass of his 1987 pastoral visit, praying with a crowd of over 150,000 in Miami's Tamiama Park.

Opposite: The Pope embraces a woman with disabilities during the eighth annual World Youth Day in Denver, 1993.

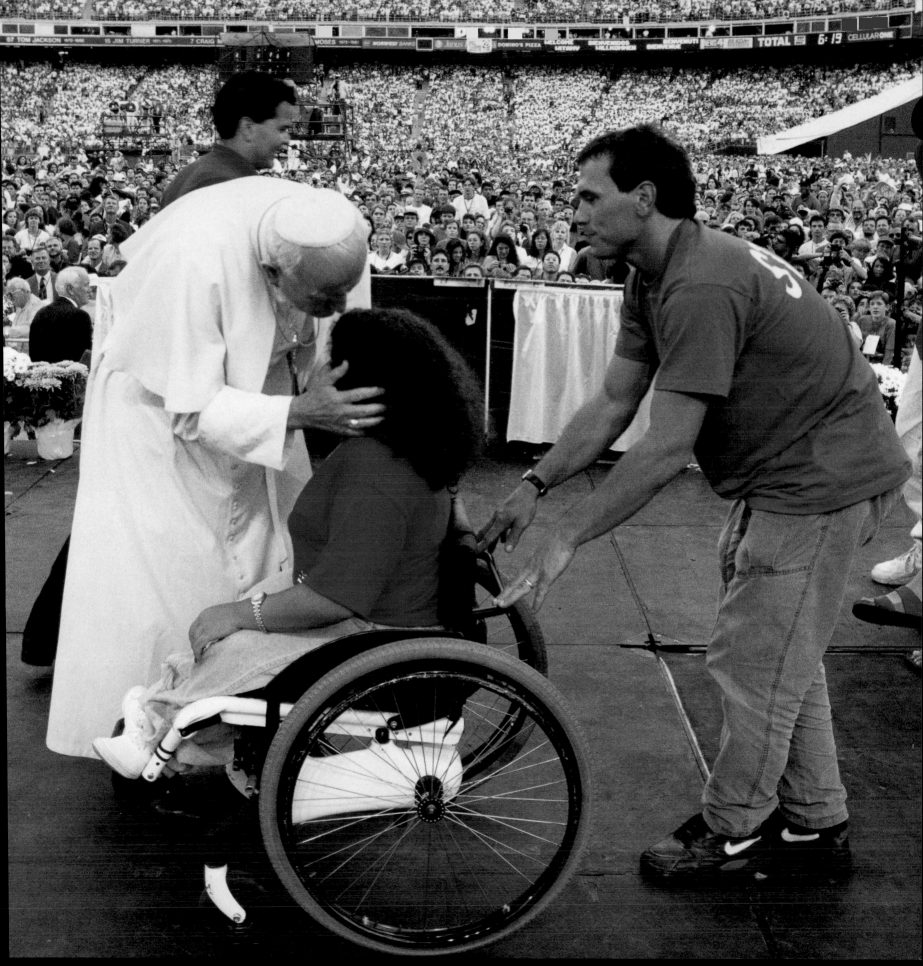

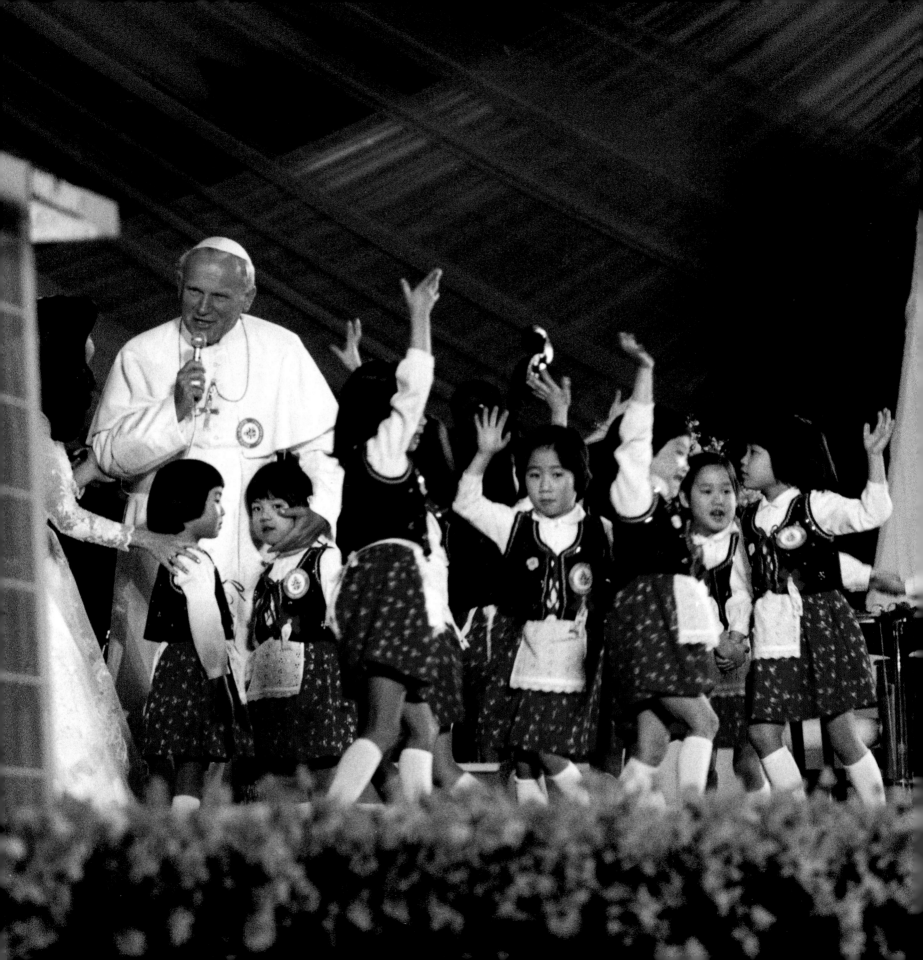

A MISSIONARY TO THE WORLD

FATHER JOHN E. HURLEY, CSP

oday, evangelization, the essential mission of the Church, is alive and well across the United States and around the world. However, evangelization was a difficult concept twenty-five years ago, let alone a word that easily rolled off Catholics' lips. When Pope John Paul II began his reign as Supreme Pontiff, many Catholics thought the focus of Pope Paul VI's Apostolic Exhortation, *Evangelii Nuntiandi*, released three years before the election of Pope John Paul, might fade away. This was not to be the case.

The 1974 Synod of Bishops on Evangelization convened by Pope Paul VI said, "We wish to confirm once more that the task of evangelizing all people constitutes the essential mission of the Church." Following the Synod, in his Apostolic Exhortation, *Evangelii Nuntiandi* (1975), Pope Paul VI said, "It is a task and mission which the vast and profound changes of present-day society make all the more urgent. Evangelizing is in fact the grace and vocation proper to the Church, her deepest identity. She exists to evangelize."

Cardinal Karol Wojtyla knew these words well as a participant at this Synod and they became the cornerstone of his papacy. Seven months after his election as Successor of Peter he said, "One who follows the work of evangelization is not above all a professor. He is a messenger. He acts like one to whom a great mystery has been entrusted and at the same time like one who has personally discovered the greatest treasure, like that hidden in a field in the parable of Matthew" (May 29, 1979).

The Pope's prophetic call for all members of the Church to be active disciples of Jesus Christ cannot be silenced. Whether in his ministry at Vatican City or every time he steps off a plane in another country, he is instant news through the media waves of the host country and around the world.

This renewed vision of evangelization inspired the United States bishops to issue in 1992 *Go and Make Disciples: A National Plan and Strategy for Catholic Evangelization in the United States*. Now, all dioceses have someone designated to coordinate the evangelization efforts within the local Church. As papal documents stress their context within the evangelizing mission of the Church, so do the United States bishops' documents. All of this continues to implement the framework handed on to Pope John Paul II in *Evangelii Nuntiandi*: The Church exists to evangelize.

The Pope's tireless efforts to announce the Good News of Jesus Christ continue to have an impact on the world twenty-five years later and will be a legacy for years to come.

Opposite: The Pope sings with Japanese children during his visit to Tokyo, Japan, in 1981.

Below: The Pope enters Yankee Stadium to celebrate Mass during his 1989 visit to the United States.

Following: In 1982, Pope John Paul II makes his first pastoral visit to Nigeria, the country with the largest Catholic population in Africa south of the Sahara, Onitsha, Nigeria.

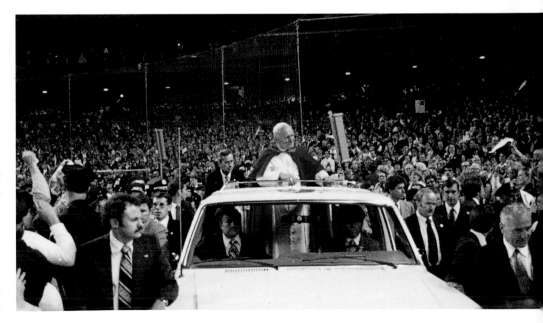

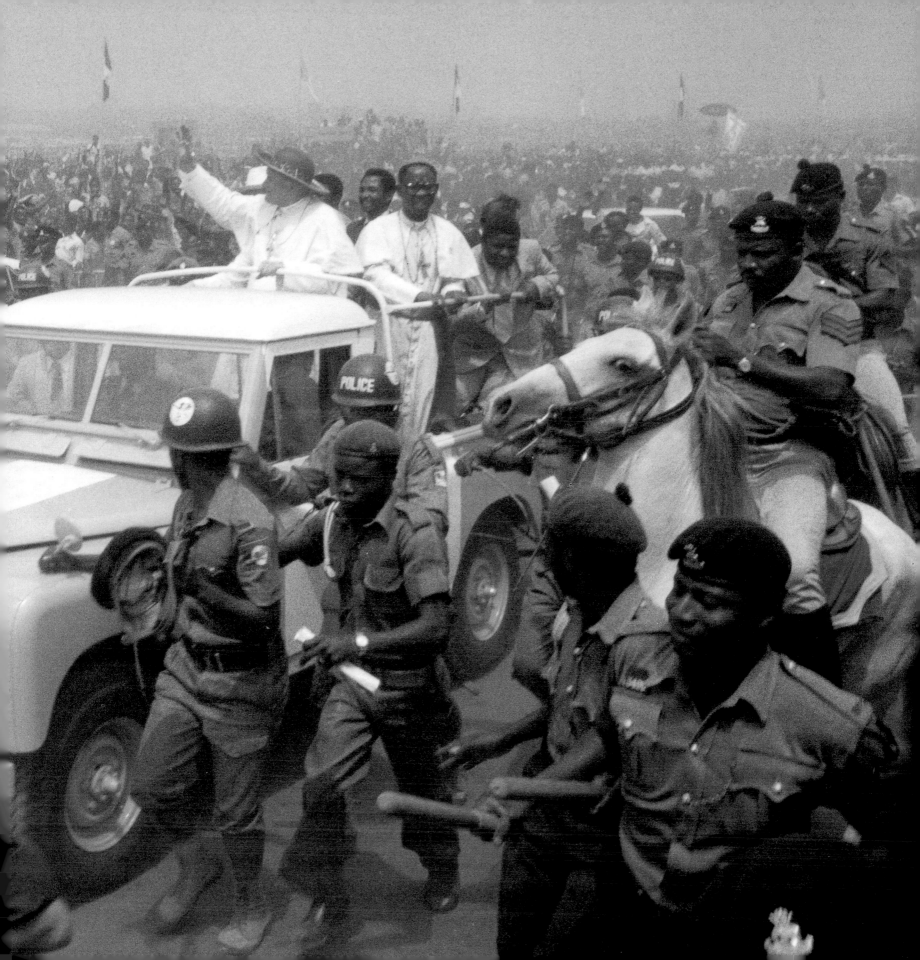

I've Lost the Holy Father!

CARDINAL ROGER M. MAHONY, Archbishop of Los Angeles

IN SEPTEMBER of 1987 Pope John Paul made an extensive pastoral visit to the United States beginning with stops in Miami and concluding in Detroit. Two of those memorable days were spent in Los Angeles.

On the first night of the Pope's stay in our cathedral residence, we had returned from a large public Mass in the Los Angeles Coliseum and the Holy Father was running a bit early on his schedule. It had been planned for him to have a late dinner in the small dining room on the third floor of the Residence.

When the Holy Father, then-Monsignor Stanislaw Dziwisz and his secretary, and I exited the elevator for the dinner, we could smell the food cooking in the kitchen but there were no cooks, waiters, or other personnel anywhere. Feeling that overwhelming sense of panic, I assured the Holy Father that the staff must be nearby somewhere, and invited him to be seated in the dining room while I searched for them.

It seems that the Secret Service had brought everyone down to the first floor as part of their security protocol, but failed to inform the cooks and waiters that they could return to the dining room area.

When I went back into the small dining room, the Pope and Monsignor Dziwisz were nowhere to be found. I heard voices in the kitchen, and upon entering, I saw the Holy Father lifting the lids on various pots and pans on the stove. Before I knew it, they were serving themselves a nice helping of soup!

The Pope seemed so relaxed, truly enjoyed his time in the kitchen, and made us all feel like mutual friends sharing a meal together.

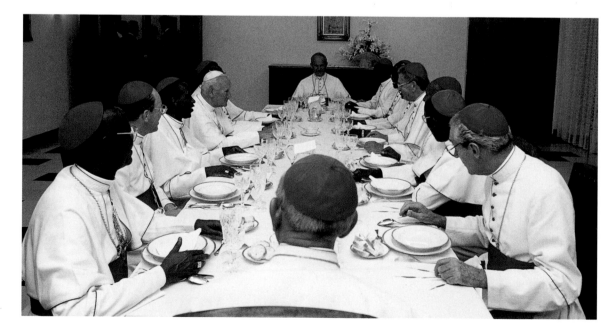

In his 49th pastoral visit outside Italy, the Pope visits Tanzania, where he met with local bishops, in 1990.

Opposite: During his 1985 pilgrimage to Venice, Italy, the Pope tours the Grand Canal.

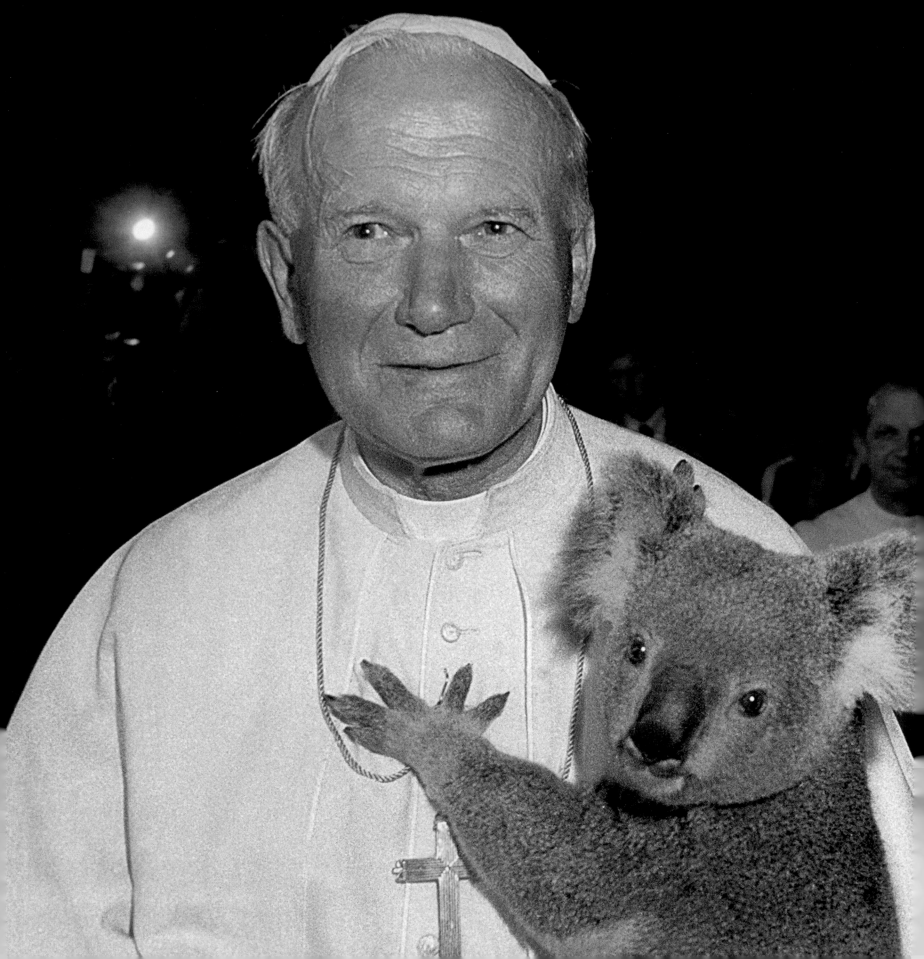

He Never Forgets a Joke

CARDINAL THEODORE McCARRICK, Archbishop of Washington

MY FIRST meeting with the Holy Father occurred before he became Pope, during the 1976 Eucharistic Congress. As the Archbishop of Krakow, he came to the United States with a group of Polish bishops, and spent time in New York as Cardinal Cooke's guest. I was asked to come back early from my vacation to help.

One morning at the breakfast table, before Cardinal Cooke came in from Mass, Monsignor Larry Kenney, the other secretary, and I were with the present Pope and his secretary, now Bishop Dziwisz. I joked about having to come back early from my vacation and complained in jest that Monsignor Kenney would never give me the time I sacrificed. I complained that there was no justice in that office. Cardinal Wojtyla, enjoying the joke and repartee, joined in for a few moments until Cardinal Cooke arrived and we turned to more serious subjects. I never thought of it again.

Not long after, we received thank you notes from Cardinal Wojtyla. On mine, he wrote, "I hope you get the vacation you lost because of my coming."

Two years later in Rome, at the first general audience of the new Holy Father, I was in a line of more than one hundred bishops who had come for that special occasion. Pope John Paul II stopped me, searched his memory, then turned and asked, "Did you ever get that vacation?"

I knew then that we had a Holy Father who not only had an extraordinary memory, but a very wonderful gift for people.

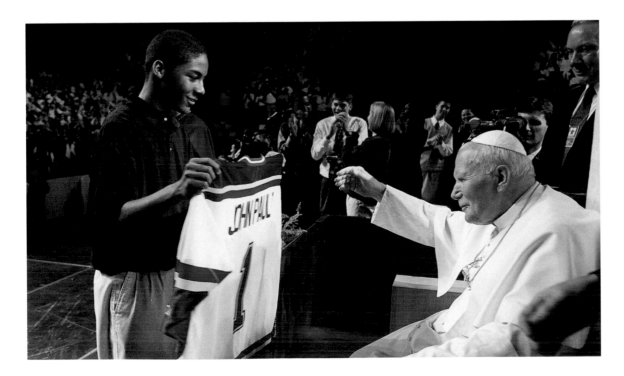

Opposite: The Pope enjoys a koala's company during his visit to Brisbane, Australia, November 25, 1986.

While in St. Louis in 1999 the Pope receives a hockey jersey during a meeting with young people.

ONE WITH THE POOR

JOHN L. CARR

 ohn Paul II is a champion of "the least of these" (Matthew 25: 31–46). Wherever he goes, whatever he says, he stands with the poor and vulnerable.

Two decades ago he stood in Yankee Stadium and told us that the poor of our country and of the world are our brothers and sisters in Christ. "You must never be content to leave them just the crumbs of the feast. You must take of your substance, and not just of your abundance, in order to help them. And you must treat them like guests at your family table" (Homily at Yankee Stadium, October 2, 1979, 4).

"When there is a question of defending the rights of individuals, the defenseless and the poor have a claim to special consideration. The richer class has many ways of shielding itself, and stands less in need of help from the State; whereas the mass of the poor have no resources of their own to fall back on, and must chiefly depend on the assistance of the State. It is for this reason that wage-earners, since they mostly belong to the latter class, should be specially cared for and protected by the Government" (Rerum Novarum) *... the more that individuals are defenseless within a given society, the more they require the care and concern of others, and in particular the intervention of governmental authority.*

JOHN PAUL II, *CENTESIMUS ANNUS*

Opposite: In Port Harcourt, Nigeria, the Pope embraces a young boy.

Following: At the Our Daily Bread soup kitchen in Baltimore in 1995, run by Catholic Charities, the Pope enjoys a light lunch with guests.

In the streets of Chicago he affirmed the option for the poor and the principle of participation that is at the heart of the United States Bishops' Catholic Campaign for Human Development.

The most prominent opponent of Communism is also the most persistent challenger of unrestrained capitalism. In *Centesimus Annus*, the encyclical commemorating the hundredth anniversary of modern Catholic Social Teaching, the Pope both criticized the socialist system as a form of state capitalism and called for a society that "demands that the market be appropriately controlled by the forces of society and by the state so as to guarantee that the basic needs of the whole of society are satisfied" (35).

In the face of economic globalization, he has called for the globalization of solidarity, insisting that believers look at globalization from the bottom up, how it touches the poor, families, vulnerable workers and immigrants.

He has been a decisive force for global debt relief and a persistent advocate of development assistance, asking insistently, "How can it be that even today there are still people dying of hunger? Condemned to illiteracy? Lacking the most basic medical care? Without a roof over their heads?... Christians must learn to make their act of faith in Christ by discerning His voice in the cry for help that rises from this world of poverty" (*Novo Millennio Ineunte*, 50).

For Pope John Paul II, the poor in our midst and around the world are not issues of abstraction, but a test of our faith. If we are disciples of Jesus, we will serve and stand with Him in "the least of these."

There has been no more central theme of his papacy, no more compelling call of his leadership. The moral measure of our lives, societies and world is how we treat the poor and weak, the vulnerable and the voiceless.

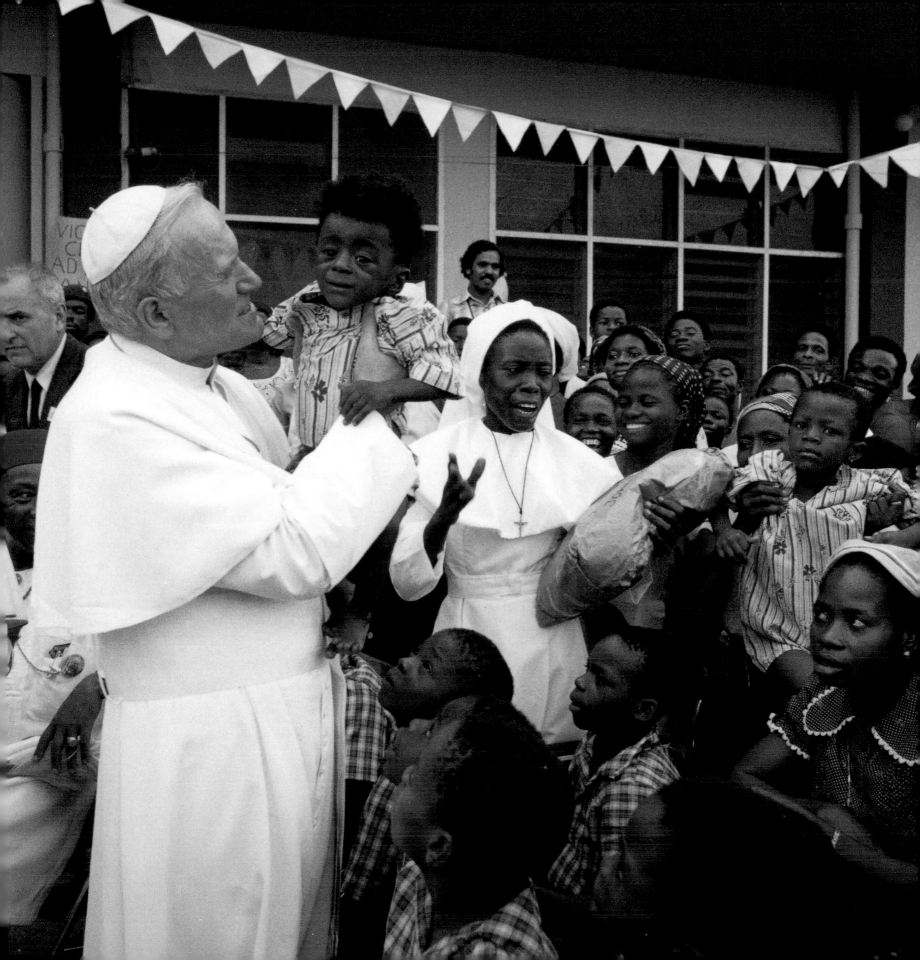

Starting with 100 Minutes of Prayer

ARCHBISHOP JUSTIN F. RIGALI OF ST. LOUIS

DURING the time of my service to the Holy See I had the opportunity to accompany Pope John Paul II on a number of his pastoral visits around the world. One thing that impressed me so deeply on all those occasions was the fact that the Holy Father always found time for prayer. It was also obvious during those visits that for him prayer was a source of strength, refreshment and joy.

After being with the Holy Father in so many different dioceses and countries, as Archbishop of St. Louis I finally had the opportunity in 1999 to welcome him to our local Church, and to observe him in prayer in my own residence.

On the morning of January 27th, the Holy Father came down to the chapel at 5:55 a.m. There he knelt in adoration before the Blessed Sacrament. An hour and forty minutes later, at 7:35 a.m., he emerged to begin a day of intense pastoral activity. This included the long Eucharistic celebration with 100,000 people in the America's Center. Then came Evening Prayer in the Cathedral, with extended ecumenical and interfaith contacts. Here he successfully appealed to the Governor of Missouri to commute the death penalty of a person on death row. After meeting with the Vice-President and hundreds of people at the airport, he was off to Rome. And all of this took place in one intense day of prayer!

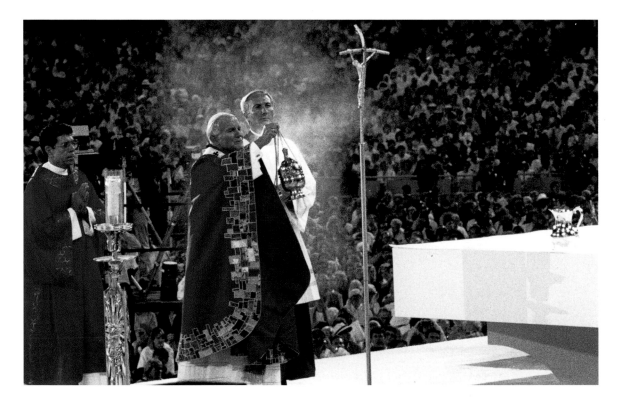

Right: A crowd of more than 100,000 fills the Coliseum in Los Angeles for Mass during the Pope's 10-day US tour in 1987.

Opposite: The Pope kneels in prayer at the Vatican.

Following: The Pope enjoys walking in the mountains of Spain.

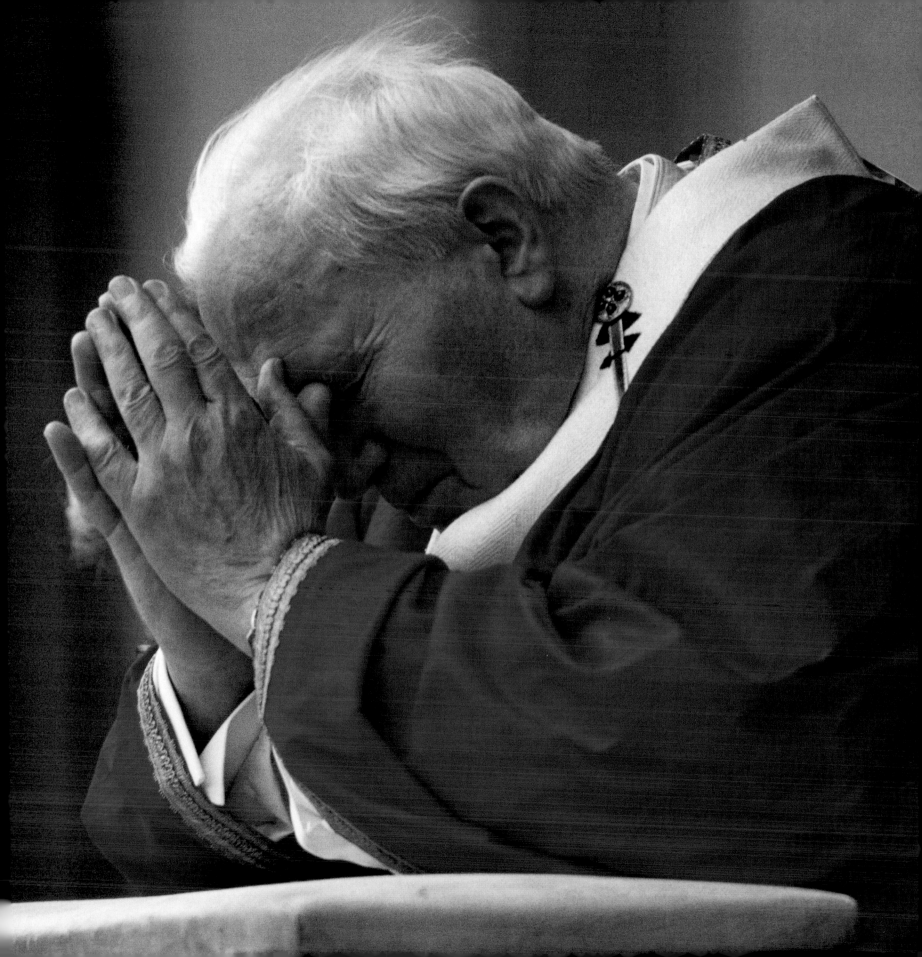

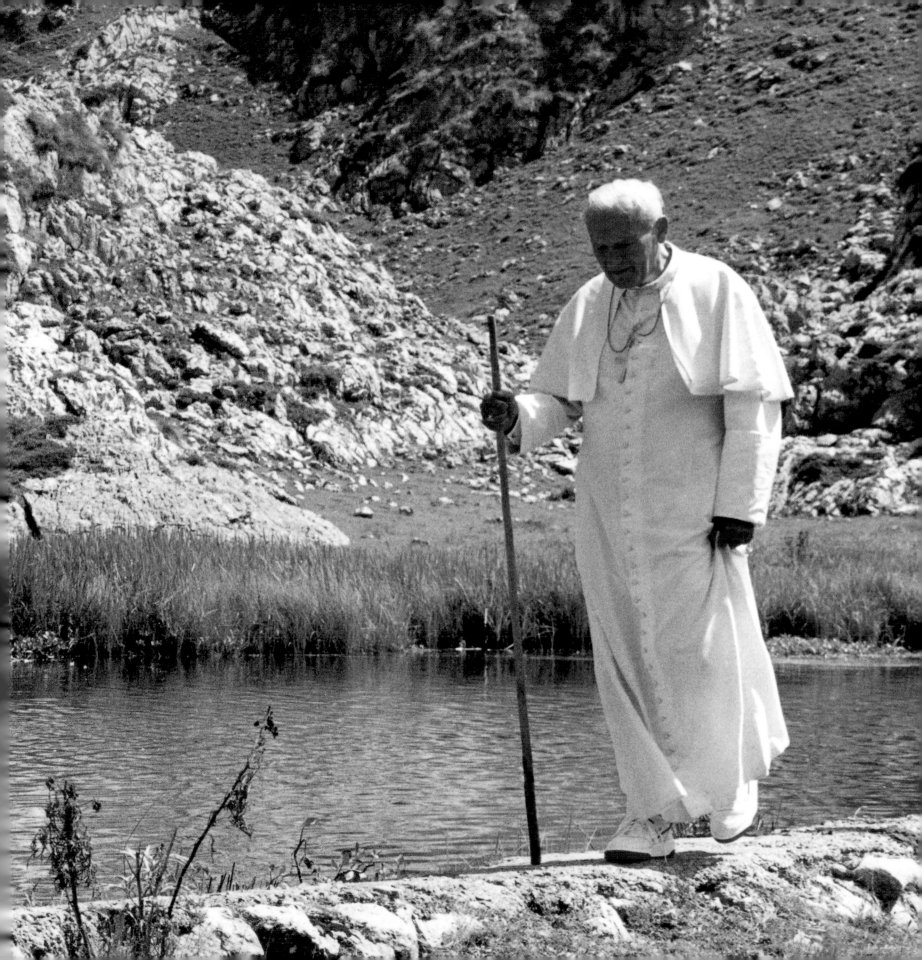

An Observation on Deacons

BISHOP WILLIAM A. SKYLSTAD OF SPOKANE

WHEN Pope John Paul II visited Detroit in September 1987, part of that visit was the historic meeting with deacons and their wives at Ford Auditorium. This was the first time after the restoration of the permanent diaconate that such a public affirmation of diaconal presence in the Church took place. At the time, as chair of the Bishops' Committee on the Permanent Diaconate, I was unexpectedly called backstage beforehand to visit alone with the Holy Father for about ten minutes. His great admiration for the diaconate came through very strongly as he commented on the rapid growth of the diaconal community here in the United States and on the great contribution they were making to the life of the Church. He also asked if most of the deacons were married. Their presence in the Church, he commented, is and certainly will be a great blessing, a sign of the movement of the Holy Spirit. Then he walked out onto the stage amidst the tremendous applause of the some two thousand deacons and their wives. It was truly an electrifying and exhilarating moment.

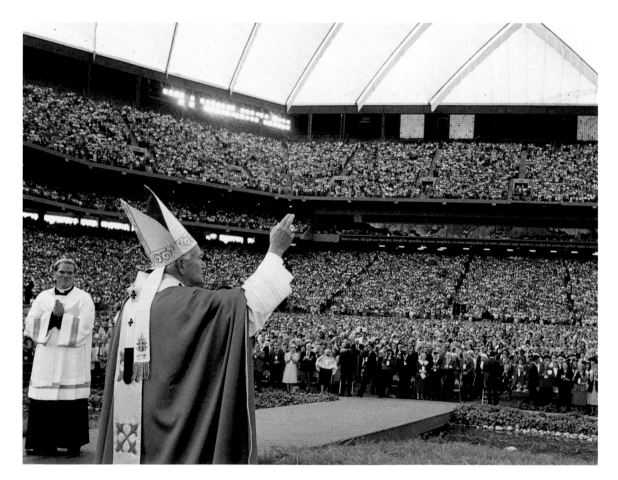

The Pope speaks on the dignity of the human person before a crowd of 90,000 at Detroit's Pontiac Silverdome Stadium, in 1987.

The Pope visits the satellite telecommunications organization of Italy (Telespaszio) in the town of Furcino, March 24, 1993.

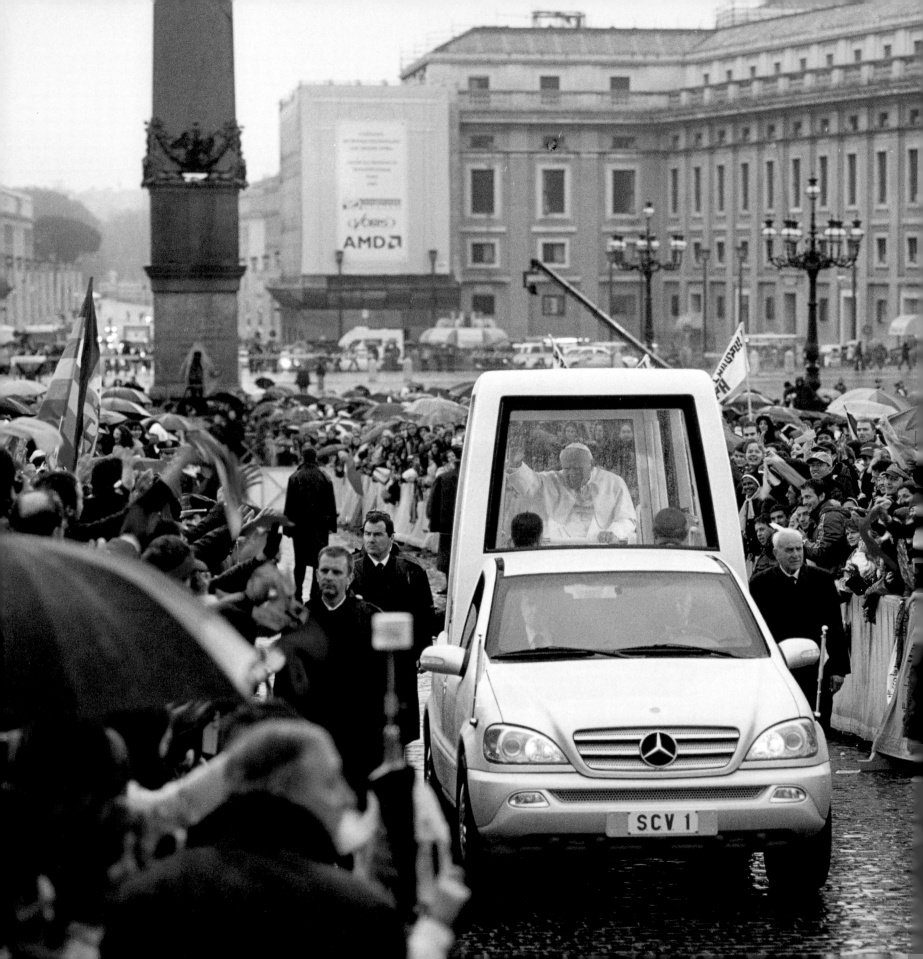

He Wants to Be with the People

CARDINAL EDMUND SZOKA, President, Pontifical Commission for Vatican City State

THE FIRST time I met Cardinal Karol Wojtyla was at the International Eucharistic Congress in Philadelphia in 1976. At the time I was Bishop of Gaylord, Michigan. Two weeks later, I participated in a Mass he celebrated in Detroit's oldest Polish parish. We had a brief conversation together while we waited in the rectory for the procession to begin.

The following year I made my first visit to Poland. I accidentally met Cardinal Wojtyla in Poznan. His first words to me, in English, were, "I remember you." It never occurred to me that in another year he would be Pope.

Our Holy Father is a genuine intellectual, a scholar. He has written great encyclicals and produced inspiring and influential documents. However, our appreciation of him would not be complete if we did not realize that he is, above all, a pastor. He loves people and he has a burning desire to minister to them as directly as possible. He has visited almost every parish in Rome. He has visited every part of Italy. He has made innumerable trips outside of Italy to every continent of the world. He wants to be with the people.

I have come to know the Holy Father well. I can sum up that knowledge by saying he is the holiest person I have ever met.

Opposite: The Pope waves to rain-soaked youth during the Diocese of Rome's annual gathering of young people, St. Peter's Square, April 10, 2003.

The Pope visits with youth in Sicily during a three-day trip there in May 1993.

REACHING OUT TO THOSE WITH HIV/AIDS

FATHER ROBERT VITILLO

Pope John Paul II was among the first leaders of major faith communities to urge a compassionate, non-judgmental response to people living with or otherwise affected by the pandemic of HIV/AIDS. During his visit to the United States in 1987, he revealed his fatherly care by embracing a child living with AIDS and countered the mistaken reasoning of some people who claimed that the HIV pandemic might represent God's displeasure with sinners.

Speaking September 17, at Mission Dolores in San Francisco, he said forcefully, "God loves you all, without distinction, without limit...He loves those of you who are sick, those suffering from AIDS...He loves all with an unconditional and everlasting love."

The Holy Father often has demonstrated his pastoral sensitivity to people affected by the pandemic by comforting them during his visits throughout the world. At the 2001 gathering of health care workers and volunteers in Vatican City, he declared, for example, "Dear brothers and sisters suffering from AIDS: Do not feel alone! The Pope is by your side and supports you with affection in your difficult path."

Equally strong has been Pope John Paul II's encouragement of a value-based approach to prevention of the further spread of HIV infection by urging observance of sexual abstinence outside marriage and life-long fidelity within it. Thus he called on young people during his visit to Uganda, February 7, 1993, "Do not let yourselves be led astray by those who ridicule your chastity or your power to control yourselves. The strength of your future married love depends on the strength of your present effort to learn about true love. Chastity is the only safe and virtuous means to put an end to the tragic plague of AIDS."

The Holy Father also has shown his keen insight that the pandemic reaches far beyond the problems of individual behavior and that both the root causes and the solutions of the pandemic must be approached from a global perspective. On a September 1, 1990, visit to Tanzania, he observed that "the drama of AIDS threatens not just some nations or societies, but the whole of humanity. It knows no frontiers or geography, race, age, or social condition... Only a response that takes into account both the medical aspects of the illness, as well as the human, cultural, ethical, and religious dimensions of life, can offer complete solidarity to its victims and raise the hope that the epidemic can be controlled and turned back."

Since the advent of combination, anti-retroviral medications that are capable of prolonging the life of people living with AIDS, the Holy Father, and his personal representatives at various international conferences, have been tireless in their advocacy to make such medications available to all people in the world. Not content with restricting the access of such medications to those in high income countries who could afford the prices imposed by pharmaceutical companies, the Pope has emphasized the Church's consistent teaching that there is a "social mortgage" on all private property, that this concept must be applied, as well, to "intellectual property," and that "the law of profit alone cannot be the norm of that which is essential in the struggle against hunger, sickness, and poverty" (Message to the Jubilee 2000 Debt Campaign, September 23, 1999).

Opposite: During his visit to San Francisco in 1987, the Pope hugs Brendan O'Rourke, a 4-year-old AIDS patient.

Following: Pope John Paul II leads the Stations of the Cross in the Colosseum on Good Friday, 2000.

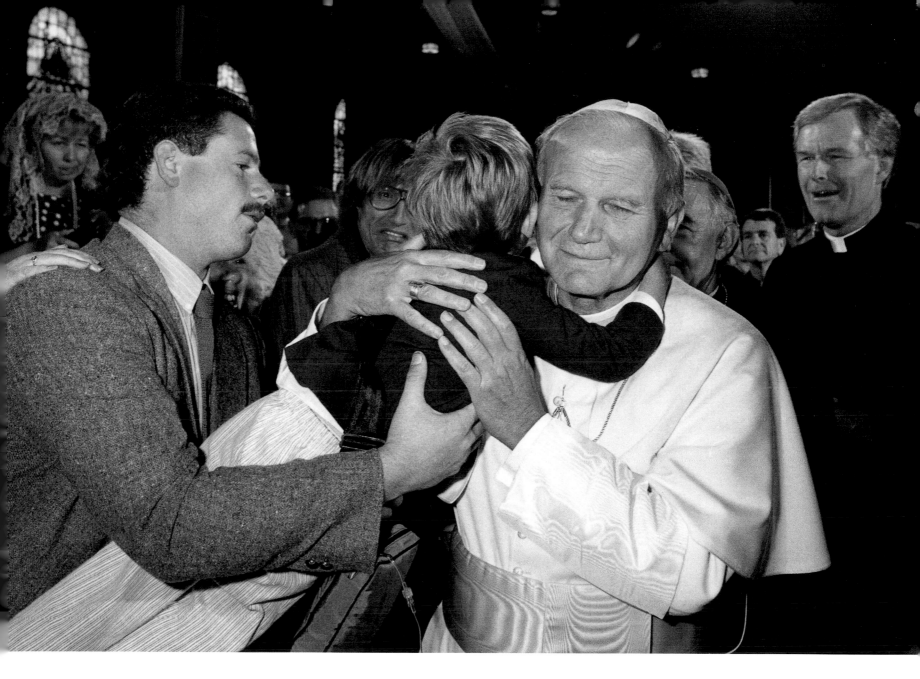

I invoke the comforting and strengthening gifts of God's unfailing love upon those who suffer from AIDS and upon all those who are generously engaged in caring for them. At the same time I appeal to those who are working to find an effective scientific response to this illness not to delay and above all not to allow commercial considerations to detract from their committed efforts.

JOHN PAUL II, MESSAGE IN UGANDA, FEBRUARY 7, 1993

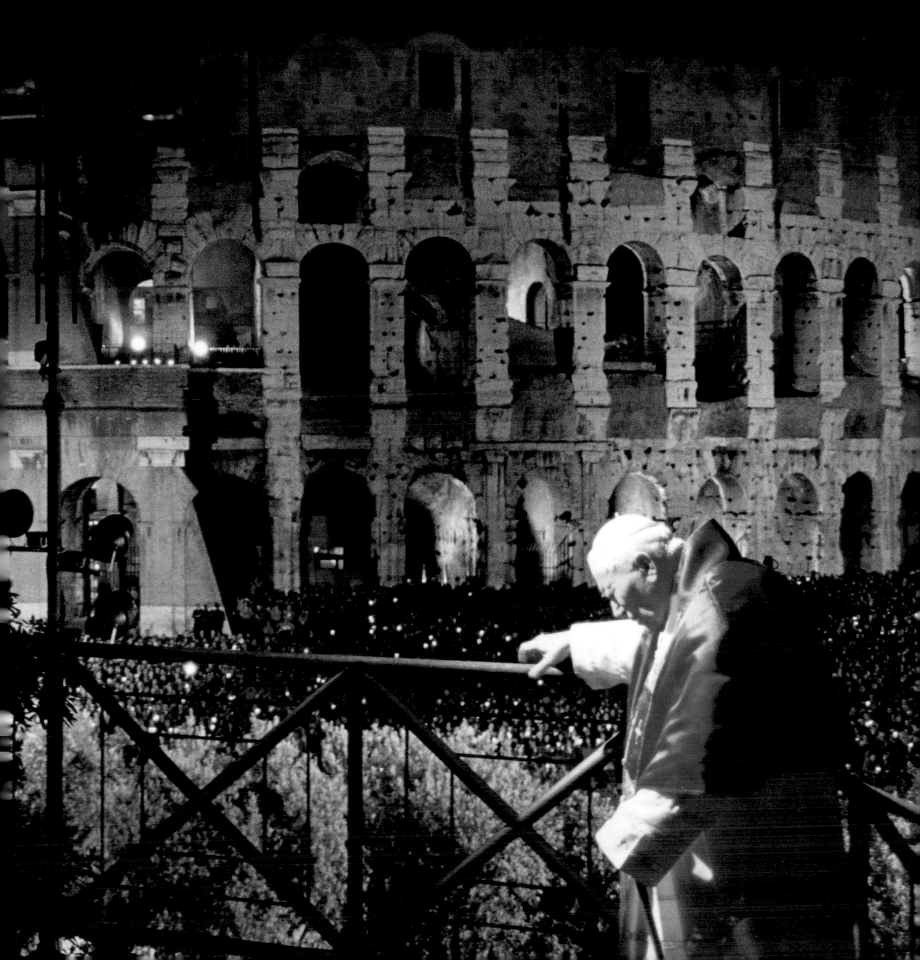

Kindness for a Bumbling Reporter

SISTER MARY ANN WALSH, RSM, Deputy Director for Media Relations, USCCB

ONE PRIVILEGE of the Vatican press corps is riding on the papal plane when the Pope goes outside Italy. Such a trip for a journalist can be nerve-racking. On one, a trip to the Netherlands, I took a middle seat towards the front. Custom was for the Pope to visit reporters near the end of the trip allowing each one a question. Everyone hoped for a few special words, maybe even a scoop. I was rapt in the preview text of his arrival remarks when a white sleeve—the Pope's—suddenly was before my face, reaching to shake hands. I moved quickly to rise only to be held back by my seatbelt. As I fumbled, the Pope surmised the situation. "Never mind, I'll come back," he said. Dejected, I watched my scoop disappear. Why would he remember with all he had on his mind? But he did. It was a sympathetic gesture towards a bumbling reporter and saved my day. I asked about the hostility preceding his trip to Holland and why he was still going. "Because they invited me," he said.

Protests marked the visit. About a week later, as he moved to his seat on the return flight, the Pope saw me and paused. "You were afraid for me a little," he said. "Now you see why it was indispensable that I go?"

Crowds line the streets to see the Pope during his trip to Cuba in 1998.

Opposite: Pope John Paul II is greeted at Boston's Logan International Airport on October 1, 1979, the first day of his 7-day pastoral visit to the United States.

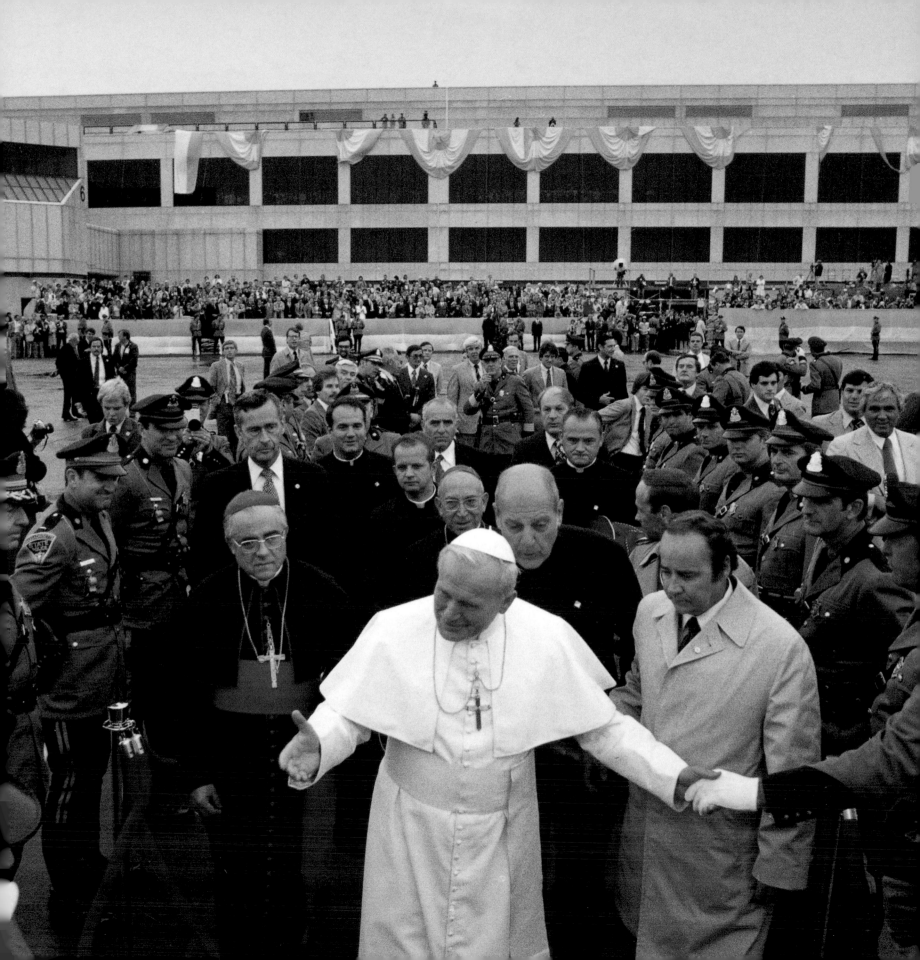

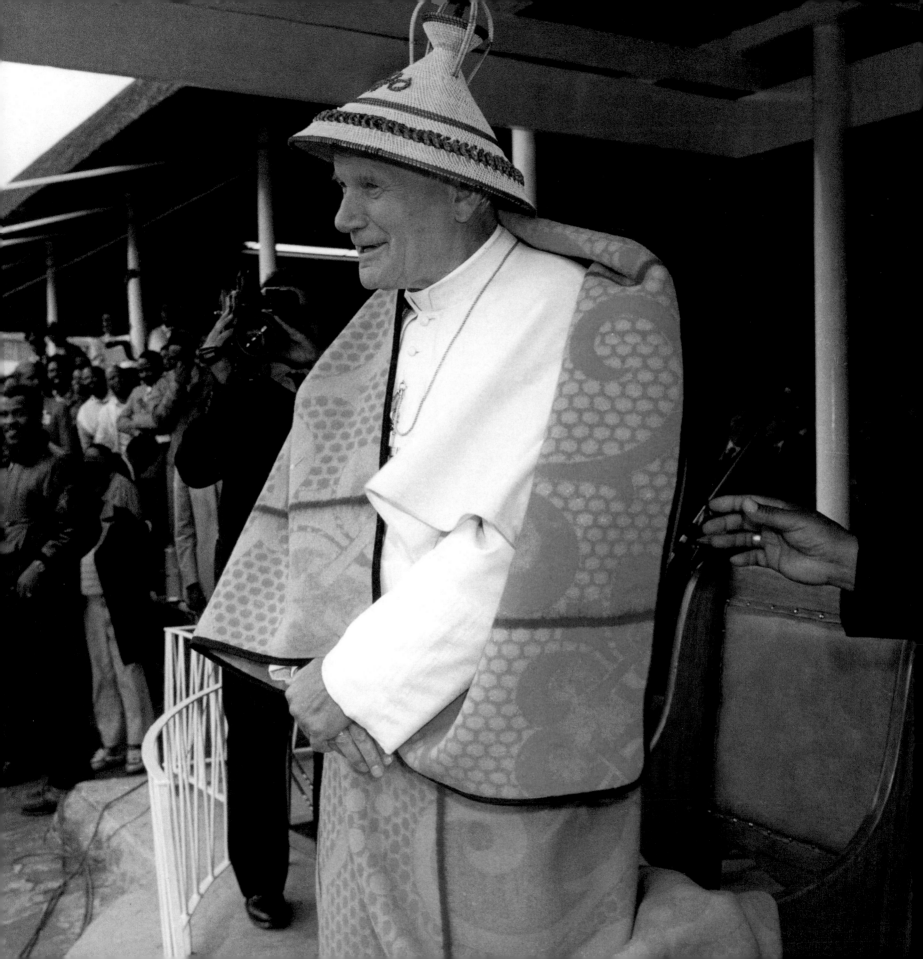

When Outside Rome …

CINDY WOODEN, Rome Senior Correspondent, *Catholic News Service*

WATCHING Pope John Paul II in Rome and around the world, one realizes that being pastor of the universal Church sometimes means being prepared for anything.

Vatican officials have discussed, debated and tried to legislate the extent to which local cultural expressions, including dance and music, should be allowed at Mass.

Yet Pope John Paul seems to accept and, most times, delight in the differences.

While the Pope was prepared for a choreographed offertory dance at the opening Mass for the Synod of Bishops for Africa, the sounds of joy were not scripted: Ululations sprang from the throats of African women, bouncing off the walls of Saint Peter's Basilica providing a totally natural "surround sound" effect.

Native American pipe-smokers and incense smoke rising from clay pots rather than thuribles bring attentive looks, not scowls from the Pope; he places Communion on the outstretched hands of the faithful with the same reverently serious gaze he has when he places Communion on someone's tongue; he did not hesitate leaving street shoes behind when visiting a mosque in Syria or a Hindu's tomb in India.

Even before physical limitations led Pope John Paul to shorten his speeches and hold fewer public meetings, what often attracted young and old, believers and non-believers to him was not just what the Pope said, but what he did.

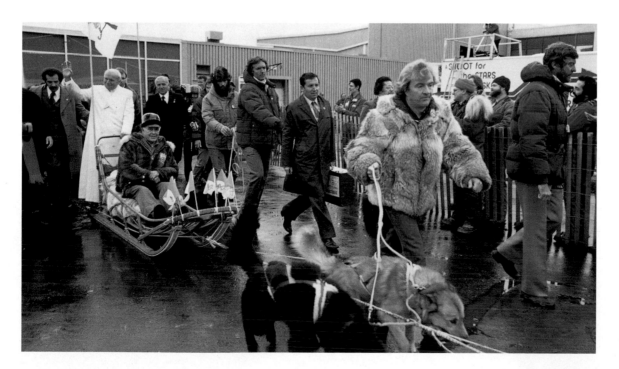

Opposite: John Paul II is vested in local dress at a youth meeting in Maseru, Lesotho, September 15, 1988, during his visit to five countries in southern Africa: Zimbabwe, Botswana, Lesotho, Swaziland, and Mozambique.

Left: The Pope is treated to a bobsled ride during his visit to Anchorage, Alaska, in 1981.

Following: The Pope is serenaded by a mariachi band in San Antonio, Texas, September 13, 1987.

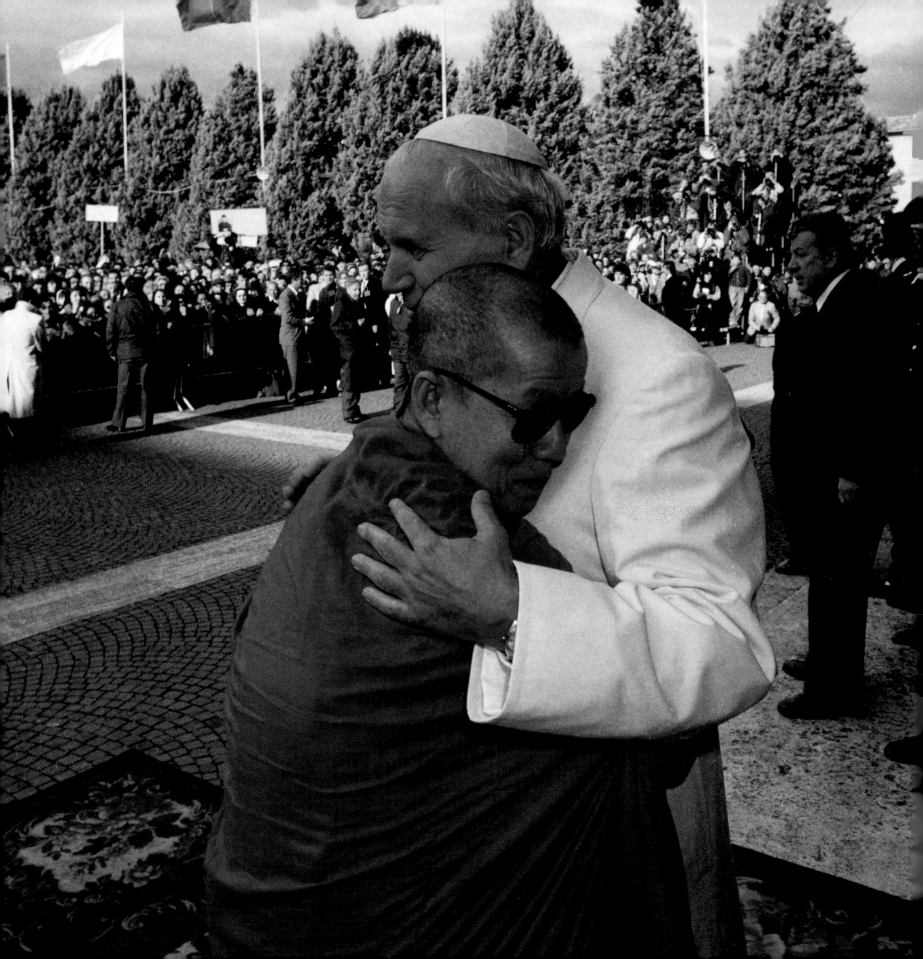

PROPHET

In a world which is too often forgetful of spiritual realities, you are called to bear prophetic witness to the primacy of God and to the transcendent human vocation which alone reveals life's meaning and purpose.

POPE JOHN PAUL II, OCTOBER 28, 1989
LETTER MARKING THE 200TH ANNIVERSARY OF THE ESTABLISHMENT OF THE
HIERARCHY OF UNITED STATES BISHOPS

CHAMPION OF HUMAN RIGHTS

FATHER JOHN LANGAN, SJ

he notion of human rights is one of the dominant themes in the political experience of the second half of the twentieth century and in the social teaching and practice of John Paul II. In *Centesimus Annus*, which commemorated the centenary of Pope Leo XIII's landmark encyclical, *Rerum Novarum*, on capital and labor, Pope John Paul attributes the "more lively sense of human rights" to a reaction against the horrors of World War II; but he also sees it as intensified by "the collapse of Communist totalitarianism and of many other totalitarian and national security regimes." On the level of political and pastoral practice, concern for human rights has caused him to challenge regimes in such different countries as Chile, South Africa, the Philippines, and his native Poland for their conspicuous violations of human rights. But his comprehensive understanding of human rights has also led him to criticize liberal democracies for their neglect of the right to life and for their tendency to subordinate the common good to particular interests. He affirms a very close connection between the protection of the "inviolable personal dignity of every human being" and the absolute character of moral prohibitions (*Veritatis Splendor*). No one, from the beginning of human life in conception, is excluded from this protection; and no one is permitted to violate it.

John Paul II shares the same broad understanding of the range of human rights which is found in John XXIII's *Pacem in Terris* (1963) so that the idea includes not merely civil and political rights but also social and economic rights to the goods necessary for survival and human dignity.

For him, human rights are not merely individualistic but are linked in such a way that "violation of the rights of man goes hand in hand with violation of the rights of the nation, with which man is united by organic links as with a larger family" (*Redemptor Hominis*). But, in contrast to many secular interpretations of the rights of the nation and of the common good, John Paul II insists that human rights are not to be sacrificed for the common good and for the demands of political authority. "The common good that authority in the State serves is brought to full realization only when all the citizens are sure of their rights."

From the very beginning of his pontificate, he affirmed with special energy the primacy of the right to religious freedom, a right which was under consistent attack in Marxist regimes but which continues to be at risk in many parts of the world. In affirming religious freedom, both for the Church and other religious communities and for the conscience of the individual, he continues the teaching of the Second Vatican Council's *Dignitatis Humanae*; and he opposes a "radical injustice with regard to what is particularly deep within man, what is authentically human."

Another right to which he gives special attention is "the right of economic initiative" (*Sollicitudo Rei Socialis*). "In the name of an alleged 'equality' of everyone in society," the denial of this right destroys "the creative subjectivity of the citizen." The "principle of human rights" has a privileged place in the social teaching of John Paul II since it "is of profound concern to the area of social justice and is the measure by which it can be tested in the life of political bodies." It gives the

Previous: The Pope embraces Cambodian Buddhist leader Maha Ghosananda during the Interfaith Day of Prayer for Peace, Assisi, 1986.

During his first visit as Pope to the United States, Pope John Paul II becomes the second pope to address the UN General Assembly in New York, October 2, 1979. His address, delivered in English, covered peace, justice, and human rights issues.

Following: The Pope and United Nations Secretary-General Kofi Annan discuss the importance of the United Nations during their visit at the Vatican on February 18, 2003.

Church and the human community a set of specific norms which can be used to assess political programs and performance. These norms are more concrete than such general political values as freedom, equality, and justice; and they direct our attention back to the dignity of the human person and to those movements in contemporary life which threaten that dignity. Such movements have no more consistent and more dedicated opponent than John Paul II.

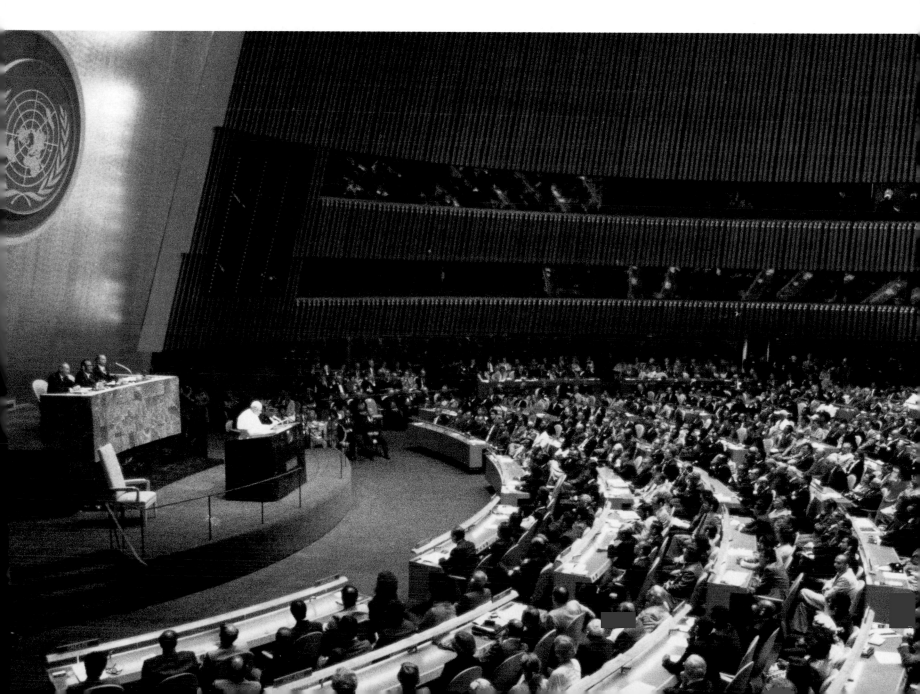

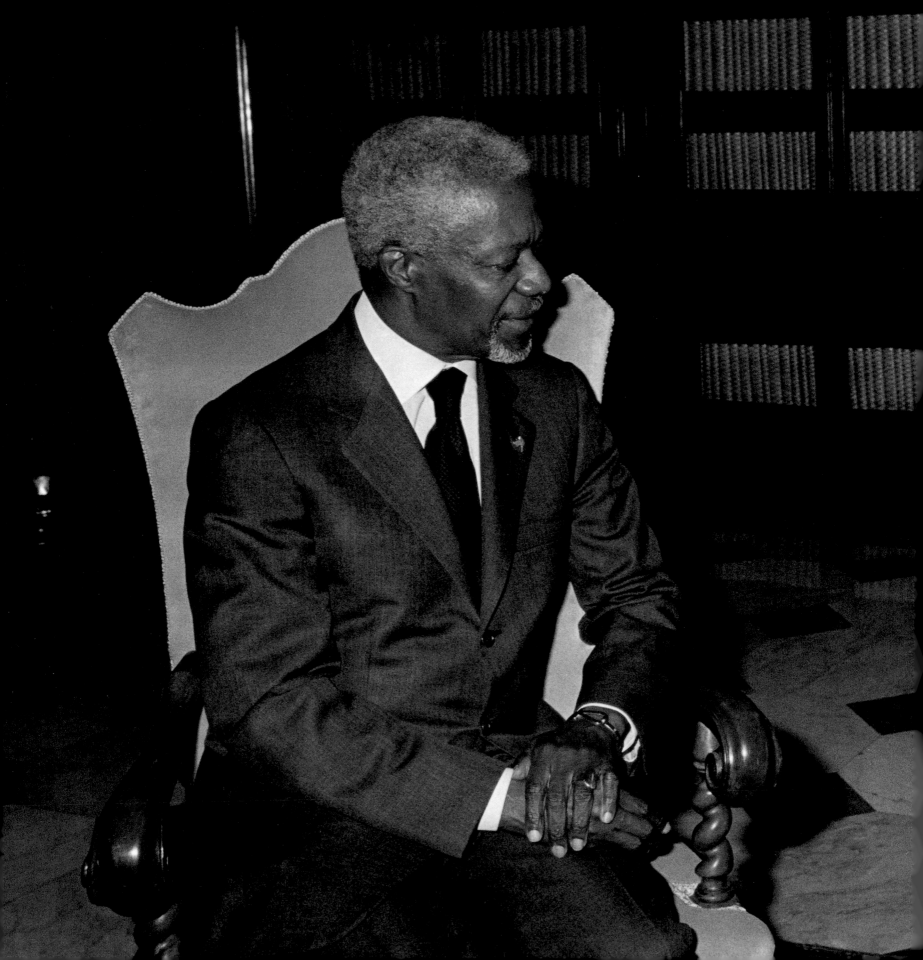

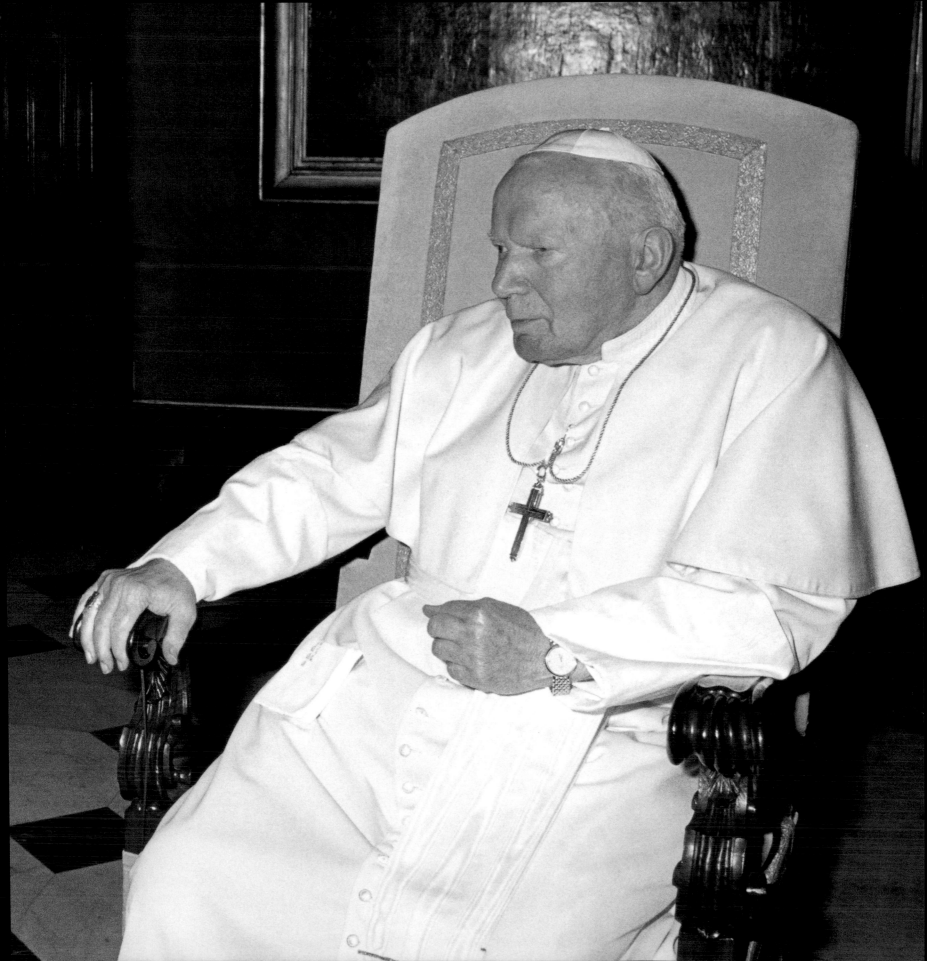

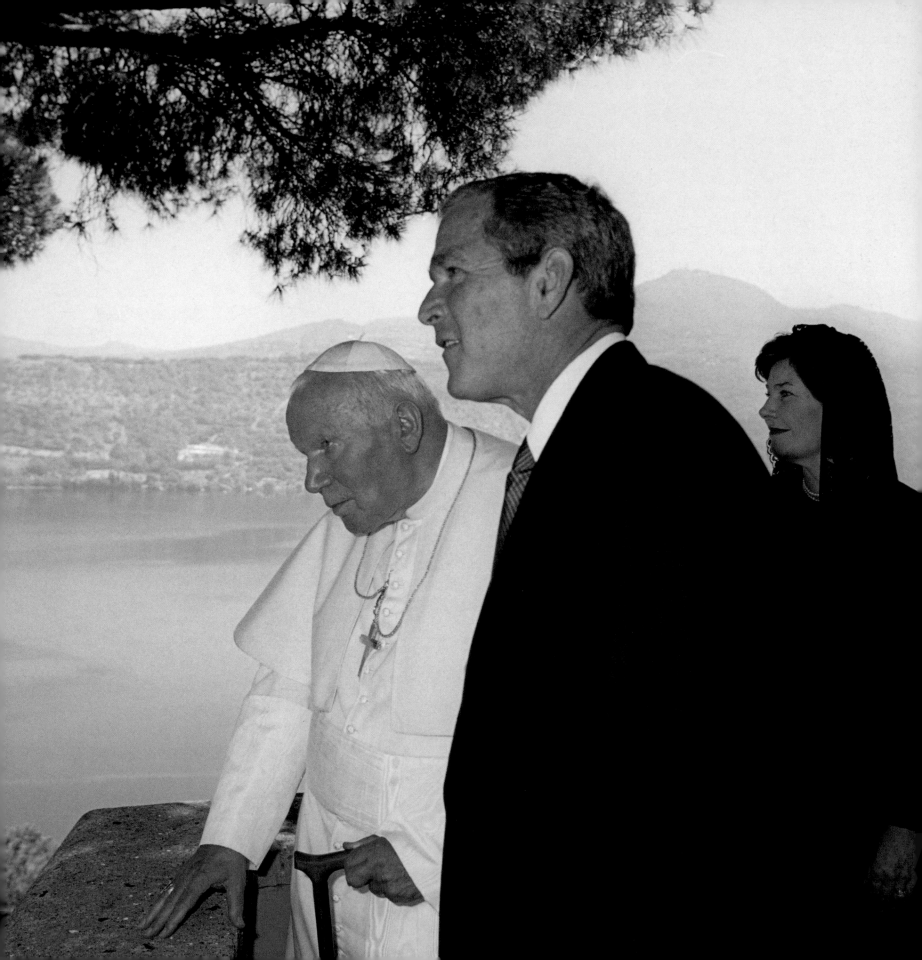

In Touch with America

BISHOP JOSEPH A. FIORENZA OF GALVESTON-HOUSTON

DURING the six years that I served as vice-president and then president of the United States Conference of Catholic Bishops, it was a special privilege to meet with the Holy Father twice every year to give him a brief report on the main activities of our episcopal conference. It also gave him the opportunity to ask us questions about the Church in the United States. Sometimes the Holy Father would invite us to lunch, which provided a much longer time to converse with him.

One of my vivid memories is the intense attention the Holy Father gave to what we were saying. His interest was obvious and his comments and questions indicated that he was familiar with the current issues discussed within our episcopal conference.

During the meals we shared, the conversation was broad-ranging. I was amazed that he knew Houston was the center for space exploration and that it was a large and important city. He offered the observation that Houston "is the modern capital of the United States." I said, "Holy Father, I don't know if Cardinal O'Connor would agree with you."

On another occasion we were discussing one of his visits to the United States and the overwhelming positive response to his message. However, he was aware of some of the criticism and knew the name of one of the most prominent critics. In a most sincere manner, he said, "If you see that person please express my regards." There was no hint of displeasure with the critic, but only the graciousness of a remarkable man.

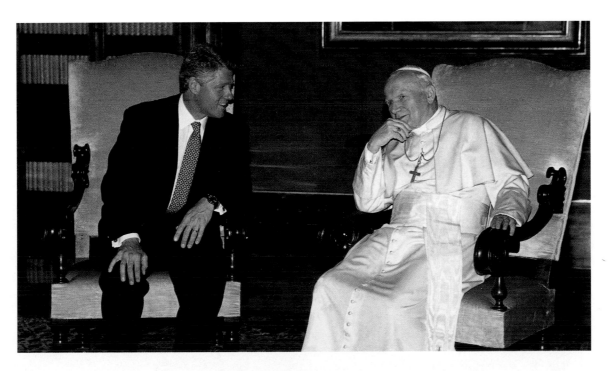

Opposite: The Pope visits with President George W. Bush and his wife Laura at the papal retreat, Castel Gandolfo, Rome, in 2001.

Left: The Pope discusses religious freedom, world population growth, and the role of family in society with President Clinton during a private audience at the Vatican in 1994.

THE GREAT LOVER OF LIFE

CATHLEEN A. CLEAVER

 hat the "culture of death" has had a firm grip on the last quarter of a century is seldom disputed. Elective abortion is the most common surgery performed on women in the United States, and "physician-assisted suicide" and euthanasia

It is therefore a service of love which we are committed to ensure to our neighbor, that his or her life may be always defended and promoted, especially when it is weak or threatened.

JOHN PAUL II, *EVANGELIUM VITAE*

Pope John Paul II celebrates Mass at Laguna Seca Raceway, Monterey Bay, where 50,000 people had gathered to see him in 1987.

receive less condemnation and greater consideration than ever before. Medical research, with its laudable goal of finding cures for disease, has embraced the death of human embryos as a source of research material. Thus, even the family and the medical profession, the great protectors of the weak and vulnerable, have been swept into service for the culture of death.

Against this great tide is set the Catholic Church, and at its helm is Pope John Paul II. It is difficult to imagine a man more suited to the task.

Pope John Paul II has inspired millions to embark upon a journey toward what he calls a "culture of life." He has led the world toward a culture of life by the example of his own life and by his writings, chief among them, his encyclical *Evangelium Vitae*, issued on the Solemnity of the Annunciation, March 25, 1995.

Evangelium Vitae unmasks the culture of death, revealing as its cause "a notion of freedom

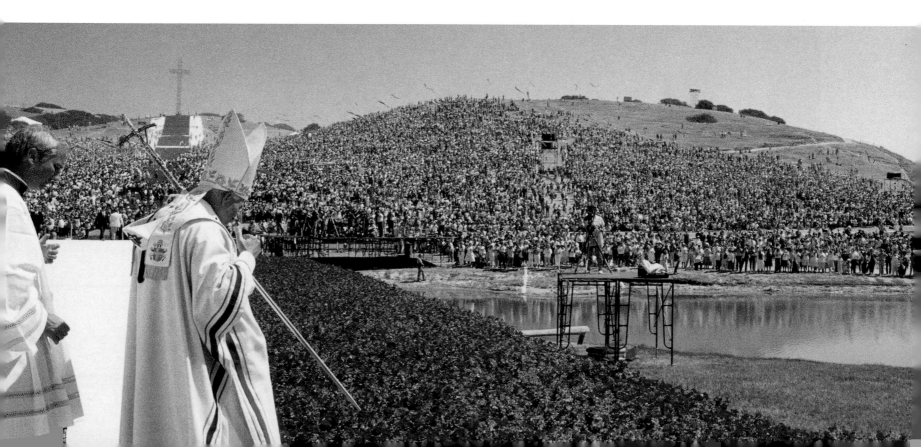

which exalts the isolated individual in an absolute way, and gives no place to solidarity, to openness to others and service of them." This false freedom "negates and destroys itself," and becomes "the freedom of 'the strong' against the weak" because it "no longer recognizes and respects its essential link with the truth."

Pope John Paul II in *Evangelium Vitae* calls for a "cultural change" which "demands from everyone the courage to adopt a new lifestyle." A lifestyle that recognizes "[t]here is no true freedom where life is not welcomed and loved, and there is no fullness of life except in freedom." And what links life and freedom? "[T]he vocation to love. Love, as a sincere gift of self, is what gives the life and freedom of the person their truest meaning."

What Pope John Paul II's greatest legacy to the world will be is hard to tell. There will be so many. That he speaks of love as our vocation against death is somewhat of a miracle, given the story of his own life. He is a man who survived the two great death machines of the twentieth century—Nazi Germany and Soviet Russia—and who personally escaped death from the bullet of a gun. There is no doubt he was saved to be a witness of love against the culture of death.

There can be no true democracy without a recognition of every person's dignity and without respect for his or her rights. Nor can there be true peace unless life is defended and promoted.

JOHN PAUL II, *EVANGELIUM VITAE*

The Pope visits with Prince Charles and Princess Diana at the Vatican, 1985.

AFFIRMING WOMEN'S GIFTS

SHEILA GARCIA

ohn Paul II's papacy has coincided with a period of tremendous gains for women in society and in the Church. In the United States, lay and religious women have moved into diocesan leadership positions, including those opened to them by the 1983 revision of the Code of Canon Law. By 1999, women held nearly half of diocesan administrative and professional positions. At the parish level, about 80 percent of the estimated 30,000 lay ministers are women.

Without the contribution of women, society is less alive, culture impoverished, and peace less stable. Situations where women are prevented from developing their full potential and from offering the wealth of their gifts should therefore be considered profoundly unjust, not only to women themselves but to society as a whole.

JOHN PAUL II, *ANGELUS* REFLECTION,
JULY 23, 1995, ON THE GENIUS OF WOMEN

The Pope recognizes and encourages the participation of women in the life of society and the Church. His 1988 Apostolic Letter, *Mulieris Dignitatem, On the Dignity and Vocation of Women*, reflected on women's dignity and equality with men that is the basis for such participation. He affirmed women's roles as wives and mothers, a recurrent theme in his papacy.

In 1995, as countries and non-governmental organizations prepared for the United Nations

The Pope meets with Sister Lucia dos Santos, one of the three "Seers of Fatima," before the beatification of her fellow seers, Francisco and Jacinta Marto, in Fatima, Portugal, May 13, 1991.

Fourth World Conference on Women in Beijing, the Pope seized the opportunity to speak out on women's behalf. Beginning with his World Day of Peace Message on January 1, and continuing with a series of *Angelus* reflections and the Letter to Women, the Holy Father affirmed women's gifts and leadership and praised the "genius of women." He even offered an apology for the times the Church has failed to acknowledge women's dignity and rights.

The Pope has challenged the church community "to foster feminine participation in every way in its internal life." He pointed out that Church law permits a lay and feminine presence in theological teaching, liturgical ministry, pastoral councils, and in many pastoral activities.

Turning to society, the Holy Father has lamented that history often ignores the contributions of women. He has urged equal opportunity in the workplace, including pay and career advancement. He has encouraged women to become involved in politics and challenged them to become peacemakers in their homes and in the global community.

The Pope capped preparations for the Beijing Conference by responding to the United Nations Secretary-General's request that nations make concrete commitments to improve the condition of women. He announced an option in favor of girls and young women, especially the poorest, and called all Catholic caring and educational institutions to make them a priority in the years ahead.

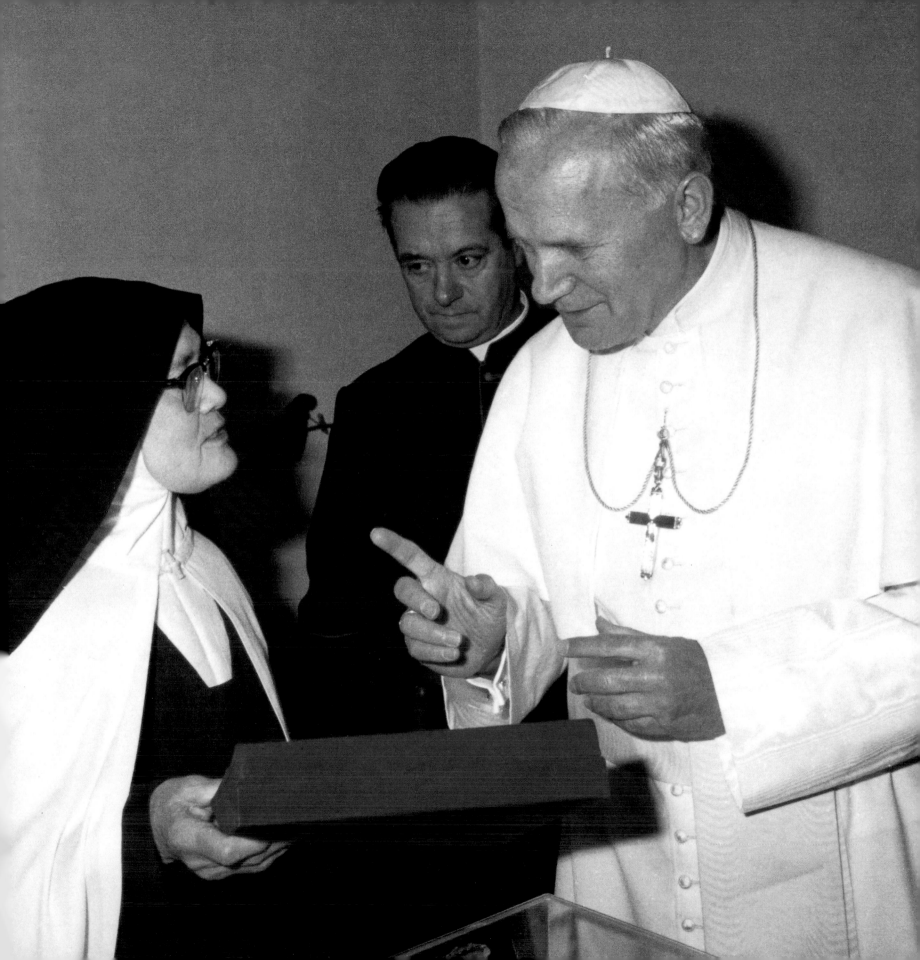

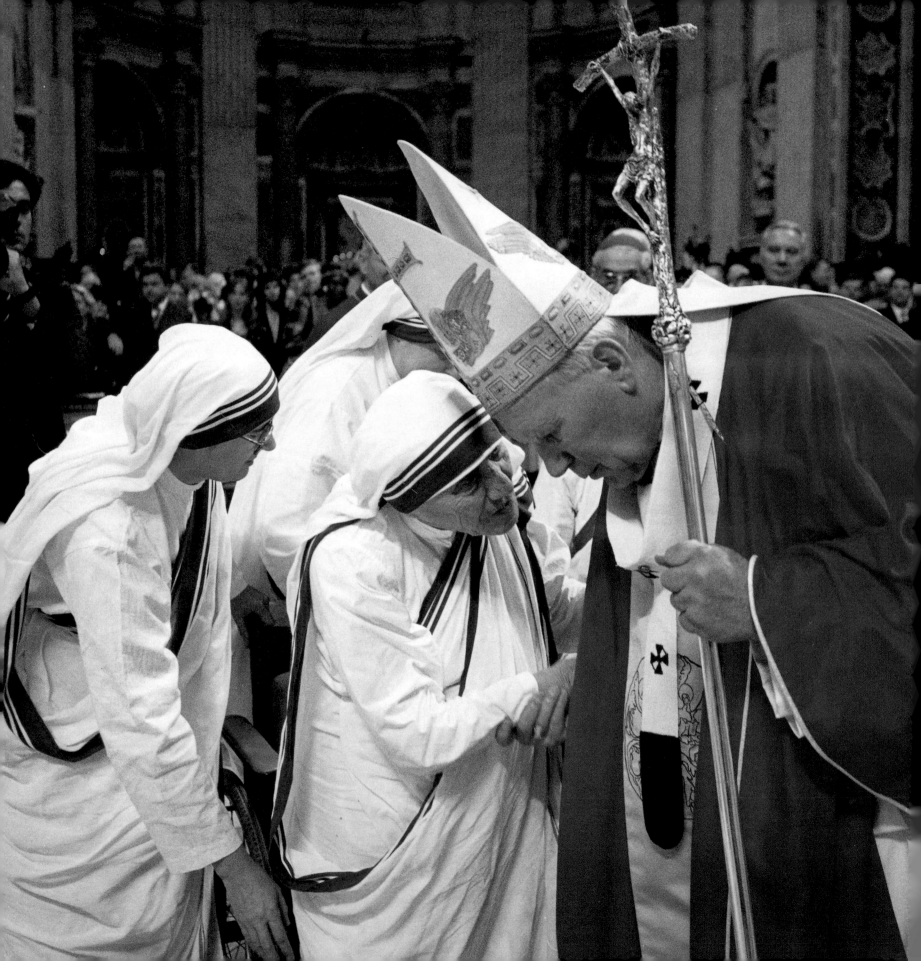

"Tell the Sisters That I Love Them"

SISTER LOURDES SHEEHAN, RSM, Associate General Secretary,
United States Conference of Catholic Bishops

IN THE SPRING of 2003, I accompanied Bishop Wilton D. Gregory, president; Bishop William S. Skylstad, vice president; and Monsignor William P. Fay, general secretary, on their semi-annual visit from the Bishops' Conference to the Vatican.

The trip involved visits to Vatican departments, meeting with folks I've known only through correspondence and enjoying the hospitality of seminarians at the North American College. Everyone was on a tight schedule, including the Holy Father. We were told that even a courtesy visit with him seemed unlikely.

Imagine my surprise when early Monday morning I learned that our group was invited to lunch.

The occasion was remarkable. Over pasta, wine and prosciutto, the Pope expressed great interest in every aspect of the Church in the United States. He spoke to each one of us individually and asked about everything from the sex abuse crisis and immigration to vocations to the priesthood and the war in Iraq. As he led the conversation from topic to topic I was struck by how focused he was amidst a day filled with meetings with government and church officials from all over the world.

He sensed each of our special concerns and surprised me even more when he turned to me and asked, "How are the Sisters in the United States?"

"Well, and working hard, but there just aren't enough of us," I said.

He smiled, nodded his head affectionately and asked me to deliver a message to women religious: "Tell the Sisters that I love them."

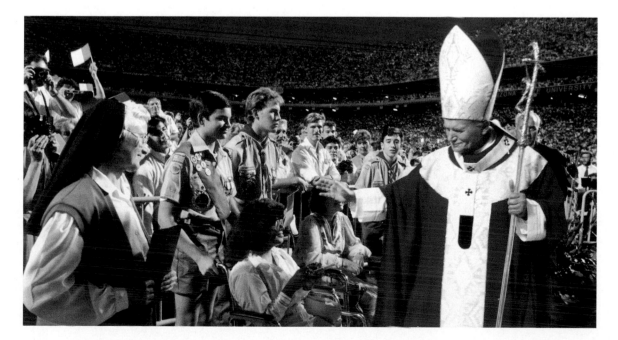

Opposite: The Pope greets Mother Teresa in St. Peter's Basilica in 1997.

At a Mass for 80,000 held at Arizona State University's Sun Devil Stadium in Tempe in September 1987, the Pope takes a moment to greet the physically impaired.

COLLAPSE OF THE SOVIET BLOC

FATHER ROBERT VITILLO

t least one papal biographer claims that Communist party ideologists in Pope John Paul II's native Poland had singled him out as a "pushover" for collaboration with the Communist state. After having vetoed seven candidates put forward by the Church for nomination as bishops, party official Zanon Kliszko reportedly stated, "I'm waiting for Wojtyla, and I'll continue to veto names until I get him," notes biographer George Weigel in his book *Witness to Hope*. Little did the party wags know how formidable an opponent Wojtyla would prove to be when, at the young age of thirty-eight years, he received one of the last episcopal appointments made under the papacy of Pius XII and then became Archbishop of Krakow a few years later.

Some authors have advanced the theory that Pope John Paul II and President Ronald Reagan teamed up to topple the Soviet Union. While these two leaders may have shared deep concerns about such a totalitarian political system, the role of the Pope was much more that of the teacher of revealed truth than that of political pundit.

In fact, Pope John Paul II clearly demonstrated his opposition to Communism long before he met President Reagan in 1982. As the first non-Italian pope in 455 years, he was uniquely qualified to confront the Soviet bloc through his own life experiences under both extremes of right-wing Nazism and left-wing Marxist-Leninism and through his deep, abiding faith in the God who called him to study clandestinely for the priesthood. Within months after his election as Pope, John Paul II traveled to his native Poland, in 1979, in order to issue the challenge to his countrymen—to uphold their faith in the one true Lord and to maintain their culture which he perceived as inextricably linked to the rich history of Christianity in this country.

During that first visit back to Poland, Pope John Paul II also lent support to the newly emerging labor union, Solidarity, which was beginning to challenge the oppressive political structures of the Communist state. During his second visit to Poland, in 1983, he was even bolder in his insistence on the pursuit of absolute truth by admonishing his compatriots to "call good and evil by name." In similar fashion, he encouraged believers in such countries as Czechoslovakia and Ukraine, where persecution was much more common and harsh than that in Poland. Thus, too, he persisted in appointing new bishops for the local churches in these lands, even though some of those bishops were forced to remain in exile and never were able to take possession of their dioceses.

Far from declaring victory when the last stone crumbled from the Berlin Wall or when the vestiges of the Soviet Union began to disappear, Pope John Paul II has persevered in his quest to re-awaken faith and culture in the former Soviet bloc. Thus he lamented to the bishops of Germany in 1996 that "a great void and a deep disorientation have remained with regard to knowledge of the faith and the meaning of Christian life, creating both privately and at the social and political level, considerable and tangible problems for people." His concern, in particular, was directed to young people living in former Soviet countries who, while not presently suffering the extremes of political oppression, still live with the heritage of past attempts to build a "godless" culture. So Pope John Paul II strongly

encouraged university students during a visit to Kazakhstan: "Here you sit side by side, in a spirit of friendship, not because you have forgotten the evil there has been in your history, but because you are rightly more interested in the good that you can build together. There is no true reconciliation which does not lead to generous shared commitment. Realize that each one of you is of unique worth, and be ready to accept one another with your respective convictions as you search together for the fullness of truth. Your country has experienced the deadly violence of ideology. Do not let yourselves fall prey now to the no less destructive violence of 'emptiness.'"

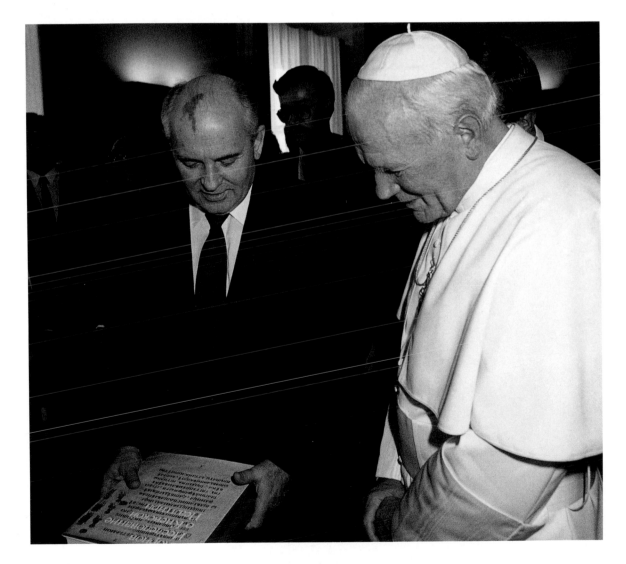

Previous: The Pope is greeted by President Jimmy Carter, his wife Rosalynn, daughter Amy, and Vice President Walter Mondale at the White House, October 6, 1979. President Carter called the Pope's visit a "milestone in the long intertwined history of our country and its faith in God."

Soviet General Secretary Mikhail Gorbachev visits with the Pope at the Vatican just weeks after the fall of the Berlin Wall and en route to a summit with President George H. W. Bush, in 1989.

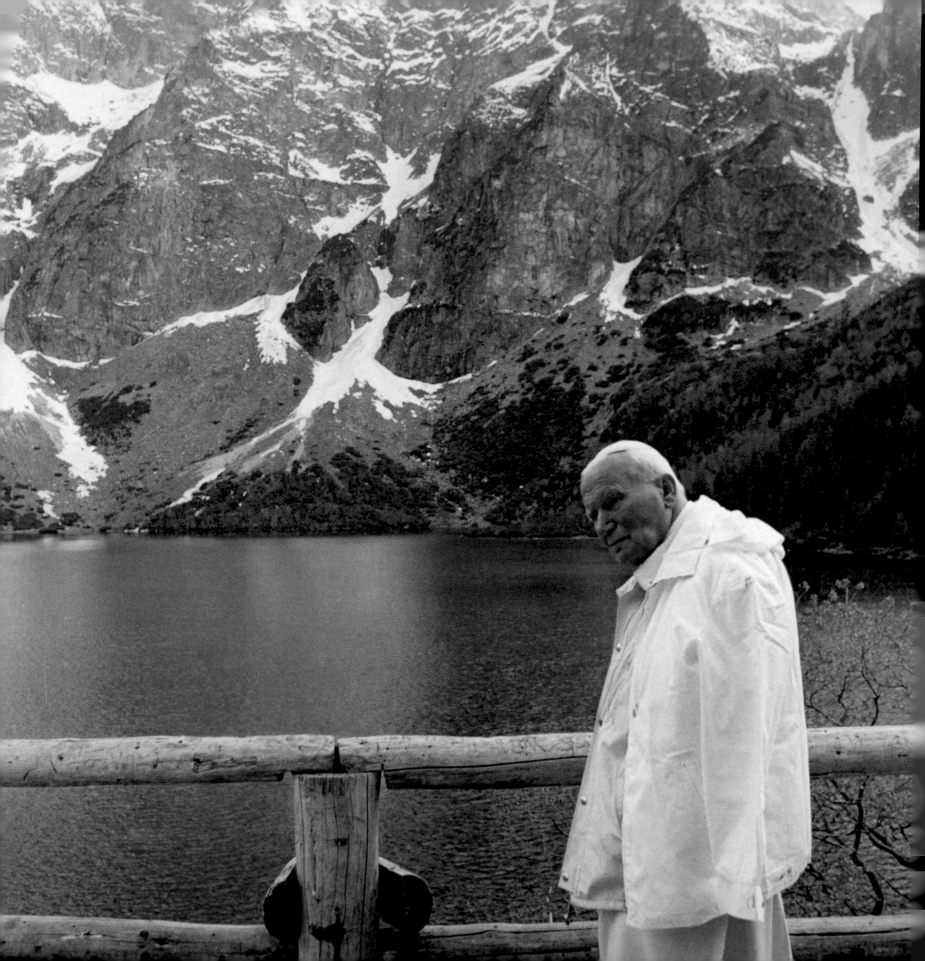

ENVIRONMENTAL ETHICS

WALT GRAZER

ope John Paul II is an inspiring example of someone who acts in the spirit of Saint Francis to "keep ever alive a sense of 'fraternity' with all those good and beautiful things which Almighty God has created" ("The Ecological Crisis: A Common Responsibility," Message for the 1990 World Day of Peace, December 8, 1989). John Paul II has an aesthetic appreciation for nature. He was an enthusiastic skier. He has often used his vacations and the *Angelus* prayer to offer homilies and commentary to evoke appreciation of creation and the moral obligation to care for it. In his view, nature is a sacramental window that reveals God's presence.

The environment is one of the first social questions Pope John Paul II cites in his first encyclical, *Redemptor Hominis* (1979). In his most extensive commentary on the environment, the 1990 World Day of Peace message, he observes that "World peace is threatened not only by the arms race, regional conflicts and continued injustices among peoples and nations, but also by a lack of due respect for nature." John Paul's reflections on Genesis and our sinful uses of creation provide the context for urging deeper respect for the order and harmony of God's creation.

Promoting and protecting human dignity lie at the heart of the Church's social ethic and Pope John Paul II's concern for the environment. This does not pit humans against nature. Rather, he calls us to be aware that humans are part of nature and should be willing to make sacrifices to live in solidarity with each other as a human family and with nature: "As one called to till and look after the garden of the world, man has a specific responsibility towards the environment in which he lives" (*Evangelium Vitae*, 1995).

Pope John Paul II's view of the environment as a moral concern "reveals the urgent need for a new solidarity, especially in relations between the developing nations and those that are already highly industrialized." This means that the "proper ecological balance will not be found without directly addressing the structural forms of poverty that exist throughout the world" (1990 World Day of Peace Message). For Pope John Paul II, there is a direct link between global economic development and environmental protection.

Given his deep commitment to ecumenical and interfaith endeavors, it is no wonder that Pope John Paul II also sees the environment as fertile ground for common efforts. On June 10, 2002, in the Ducal Palace of Venice, the Ecumenical Patriarch Bartholomew of Constantinople and Pope John Paul II signed a joint declaration of mutual concern urging the faithful to realize "more and more fully the divine purpose of creation."

Opposite: During his 1997 visit to Poland, the Pope takes time to walk in the Tatra Mountains.

The Pope speaks with Cardinal William Baum near the Reflecting Pool in Washington during his first visit to the United States in 1979.

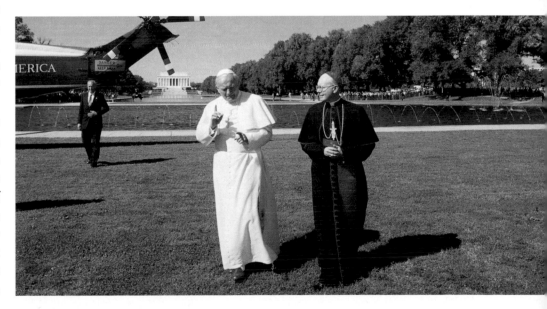

DIALOGUE WITH THE CULTURE

FATHER ARTHUR L. KENNEDY

f the sixteen documents that were promulgated by the Church at the Second Vatican Council, thirteen refer in some fashion to the importance of attending to the culture in which the Word of God is preached and celebrated, and in which the Church fulfills the mission given to it by Christ. While the *Constitution of the Church in the Modern World* contains a section (*Gaudium et Spes*, 53–62) that attends most fully to the Church's setting in culture, in no document is there any definition of what makes up a culture.

In its very founding the Church is, in part, bound to particular cultures, even as it transcends them. The modern attention to what makes a culture, and how it comes into existence or becomes extinct is a recent concern. One of the many gifts and achievements of Pope John Paul II has been his bringing the meaning of cultures to fuller clarity. He has done this not only for the Church but also for the whole of humanity. In his treatment of every concern of humanity and Church, all the components that constitute a culture are present. The geographies, races and languages, the histories and educational systems, social structures, economic and political order, and religious faith and belief are all grasped in Pope John Paul's sacramental vision of the mystery of human life that provides a coherent relationship that makes up the totality of human striving and seeking. Each of these components has its particular contribution to the whole and thus its proper place, but it is religious life and the focus on God that is the underlying vision

that shapes the details of the different components. For Christians, he says unceasingly, it is the life of Christ that will provide a right and just life for persons and the world that they are making. When one lives faithfully with one's brothers and sisters, the grace and love of Christ will give shape to human institutions.

He uses the terms "the dignity of man" and "solidarity" not just as words but as symbols that point to the fullness of human worth, good and order, brought into being by God's creation. In his encyclical *Veritatis Splendor*, he teaches of the need to use one's freedom properly in following the teachings of Christ, by which living one shapes "the culture of life." He warns that misplacing the various components of culture, such as putting race or economics above religious faith, creates ways of life that reveal "the culture of death."

It was in May 1982 that Pope John Paul II established the Pontifical Council for Culture for the purpose of bringing the saving truth of the Gospel to the world, and for creating a dialogue with people who have no belief, and increasingly with people of religions other than Christian or Jewish. By attending to what is held commonly by all peoples, namely their culture, it is hoped that the relations with others will develop in time and that the Church will have a role in that development. In March 1993, the Pope brought together the Council for Culture and the Council for Dialogue with Non-believers. Thus has he forged a legacy for the Church both in its self-understanding and in its relations with all human endeavors.

The Pope speaks with Mexican President Vicente Fox at a private audience at the Vatican, 2001.

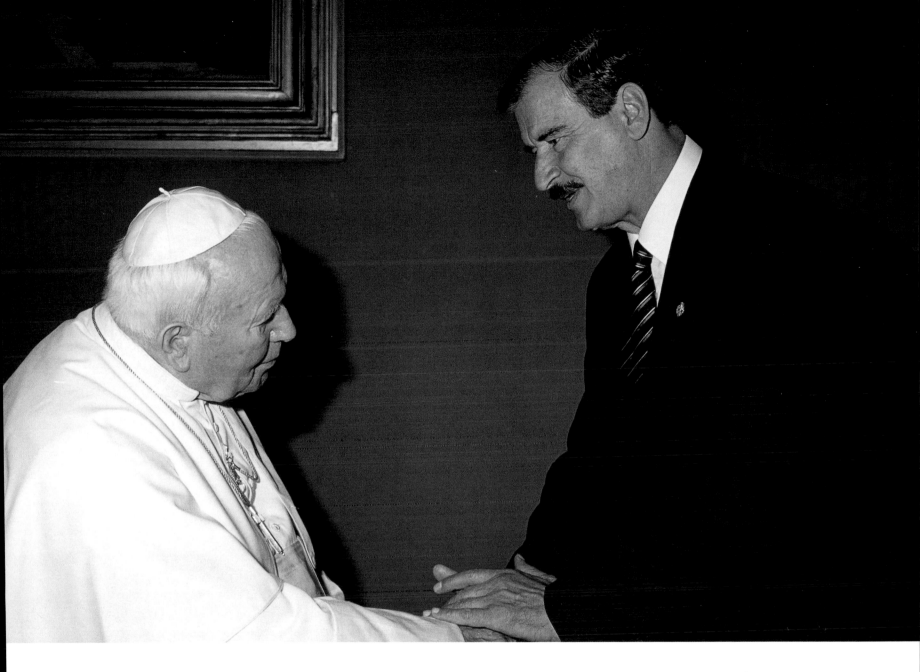

In order to evangelize effectively, it is necessary to adopt resolutely an attitude of exchange and of comprehension in order to sympathize with the cultural identity of nationalities, of ethnic groups, and of varied sectors of modern society.

JOHN PAUL II, *THE CHURCH AND CULTURE*,
AN ADDRESS TO THE MEMBERS OF THE PONTIFICAL
COUNCIL ON CULTURE, JANUARY 13, 1983

THE SIN OF RACISM

THOMAS SHELLABARGER

ohn Paul II has made very clear, "Racism is a sin that constitutes a serious offense against God." Unfortunately, racism continues to emerge in new and unexpected ways, always offending and degrading the human family. "To oppose racism we must practice the culture of reciprocal acceptance, recognizing in every man and woman a brother or sister with whom we walk in solidarity and peace" (*Angelus*, August 26, 2001).

Perhaps because he comes from "outside" Rome; perhaps because he came of age in an occupied country; for whatever reason, Pope John Paul II seems to know what it is like being different. Belonging to one family, the children of God, does not diminish the variety of people found within humanity.

The love Pope John Paul II has for humankind is reciprocated as many from every race and ethnic group—Christian or not—see him as their father. The Holy Father who has traveled more than any other pope always seems to recognize and celebrate the diversity of the human family. His numerous trips to Africa have allowed him to lift up the multifaceted nature of humankind as a great gift of life. Defending human life and promoting solidarity have become the hallmarks of his papacy.

While anticipating the "great Jubilee," Pope John Paul II at the beginning of his papacy wondered what mark the year 2000 would "leave on the face of human history or what it will bring to each people, nation, country and continent" (*Redemptor Hominis*, 1). But, as the twentieth century closed, humankind was confronting the phenomenon of globalization as well as the resurgence of aggressive nationalism, ethnic violence, and racial discrimination—all of which threaten human dignity and ultimately human life itself. The Holy Father concludes: "Every upright conscience cannot but decisively condemn any racism, no matter in what heart or place it is found" (*Angelus*, August 26, 2001).

When the Pope greeted America in St. Louis, Missouri, it was his fervent prayer that "Americans of every race, ethnic group, economic condition and creed" would resist the culture of death and choose to stand steadfastly on the side of life. "To choose life involves rejecting every form of violence: the violence of poverty and hunger; the violence of armed conflict; the violence of drug trafficking; the violence of racism…" (Opening Address, St. Louis, Missouri, January 26, 1999).

The Church must continue to teach and instill values that exalt human dignity and safeguard fundamental human rights. Catholics, Pope John Paul II has said, must work to ensure that no one is excluded from their communities and that people of all races and cultures feel the Church is their home (Remarks on International Day for the Elimination of Racial Discrimination, March 21, 2001). He asks believers to be a part of the transformation with a "conversion of heart, sensitization and formation" (*Angelus*, August 26, 2001).

The Pope believes that "the greatest homage which all the Churches can give to Christ on the threshold of the third millennium will be to manifest the Redeemer's all-powerful presence through the fruits of faith, hope and charity present in men and women of many different tongues and races who have followed Christ in the various forms of the Christian vocation" (*Tertio Millennio Adveniente*, 37).

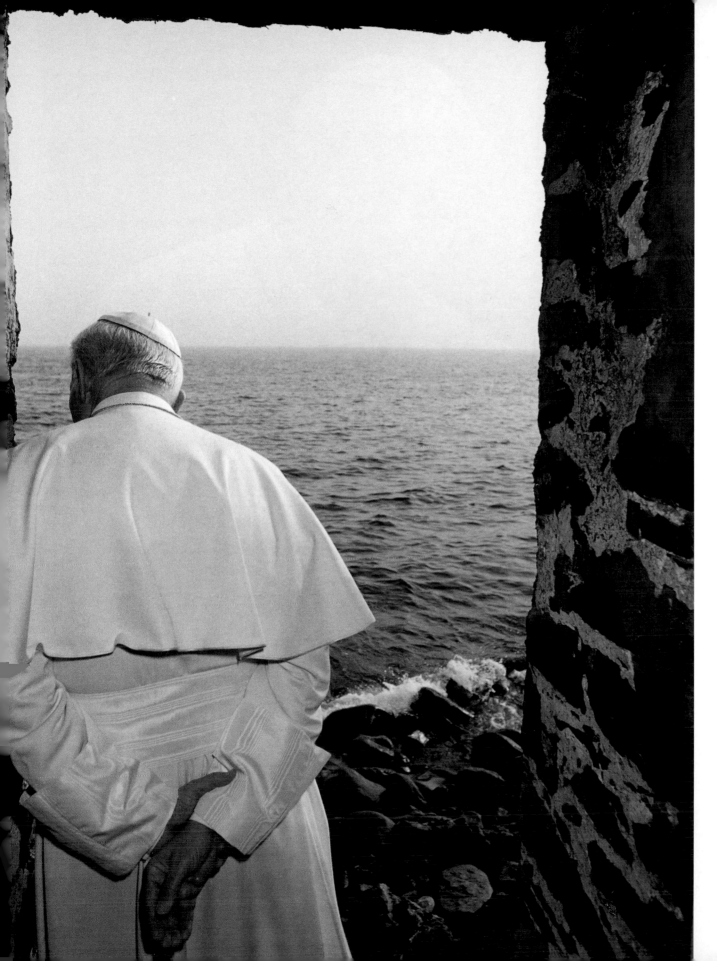

The Pope visits the "House of Slaves," February 2, 1992, on Goree Island, off the coast of Senegal, from which slaves were shipped to America.

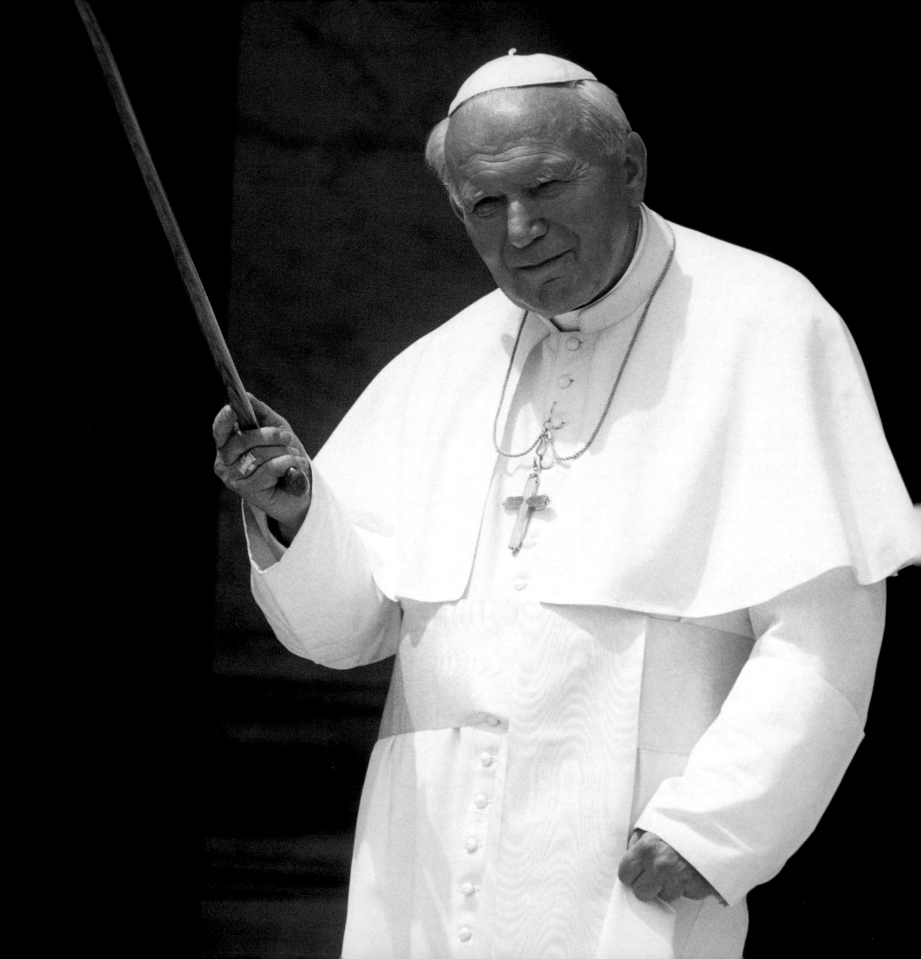

One Sudden, Brief Gesture–How Much It Bespoke

ARCHBISHOP EDWIN F. O'BRIEN, Archdiocese of the Military Services

EARLY into the new millennium, I attended a Wednesday Papal Audience, seated in the usual section for bishops: on stage to the right, seats facing center stage where the papal chair awaited its occupant. The Holy Father's walking abilities were becoming increasingly limited and I presumed he would enter the Audience Hall from the back by means of his moving platform.

Instead, a minute before the hour, the doors opened stage left, and so very slowly, John Paul II inched along by cane to the edge of the stage's entrance, visible only to us bishops facing directly into that ante-chamber.

The Pope paused as aides fell into proper formation. He handed off his cane and paused again. Then, the gesture: as if summoning every ounce of energy, he raised his fist-clenched arms just above his waist and pumped them once in a resolute and unmistakable "Let's go!" The signal was given. All his energies were summoned.

Lights flared, organ blared, a full hall roared. The bent-over man of iron, step by sure step, made his determined way to his Chair of Peter.

A life of total commitment continues. A life of heroic witness.

Opposite: The Pope gestures to onlookers during an audience in the Paul VI Audience Hall, October 6, 1998.

The Pope visits with Solidarity labor union leader Lech Walesa on the eve of the fall of Communism in 1989.

STANDING WITH THE WORKER

JOHN L. CARR

 or two decades, Pope John Paul II has affirmed, advanced, and applied Catholic Social Teaching on the dignity of work and the rights of workers. In his travels, words and witness, he has consistently called for greater economic justice and the recognition of the role of labor in society.

From his native Poland to the ends of the earth, John Paul insists that work is not a burden or penalty, but "expresses the human vocation to service and solidarity" (March 19, 1997). He maintains that "[H]uman work is a key, probably the essential key, to the whole social question" (*Laborem Exercens*, 3).

In *Laborem Exercens* (On Human Work), the Pope reaffirmed the right to employment, to just wages, and to choose to join a union. He has called for a priority of labor over capital. He has taught:

The obligation to earn one's bread by the sweat of one's brow also presumes the right to do so. A society in which this right is systematically denied, in which economic policies do not allow workers to reach satisfactory levels of employment, cannot be justified from an ethical point of view, nor can that society attain social peace (Centesimus Annus, 43).

A just wage is the concrete means of verifying the justice of the whole socioeconomic system and, in any case, of checking that it is functioning justly. It is not the only means of checking, but it is a particularly important one and, in a sense, the key means (Laborem Exercens, 19).

Moreover, he has also taught that workers have "the right to establish professional associations"; and trade unions have "the Church's defense and approval" (*Centesimus Annus*, 7). He continues, "The role of trade unions in negotiating minimum salaries and working conditions is decisive…" (*Centesimus Annus*, 15). Unions have a role, "not only in negotiating contracts, but also as 'places' where workers can express themselves. They serve the development of an authentic culture of work and help workers to share in a fully human way in the life of their place of employment" (*Centesimus Annus*, 15).

Affirming the role of unions, the Pope states, "The experience of history teaches that organizations of this type [unions] are an indispensable element of social life, especially in modern industrialized societies" (*Laborem Exercens*, 20). In his vision, unions help workers not simply "get more" for their work, but "be more"—more effective advocates of their own needs and more active participants in the common good of society.

Pope John Paul looks at economic life from the bottom up. How do economic choices touch the "least of these"(Mt 25)? In an age of growing globalization, the Holy Father contends that all economic life should be measured by how it protects the lives, dignity, and rights of workers and the vulnerable. At a time when workers are often treated as commodities, he has stood up for their dignity and rights in the shipyards of Poland, the *maquiladoras* of America, the sweatshops of the Far East, and the villages of Africa.

Pope John Paul II dons a hard hat and meets steel workers in Terni, Italy, on March 19, 1981.

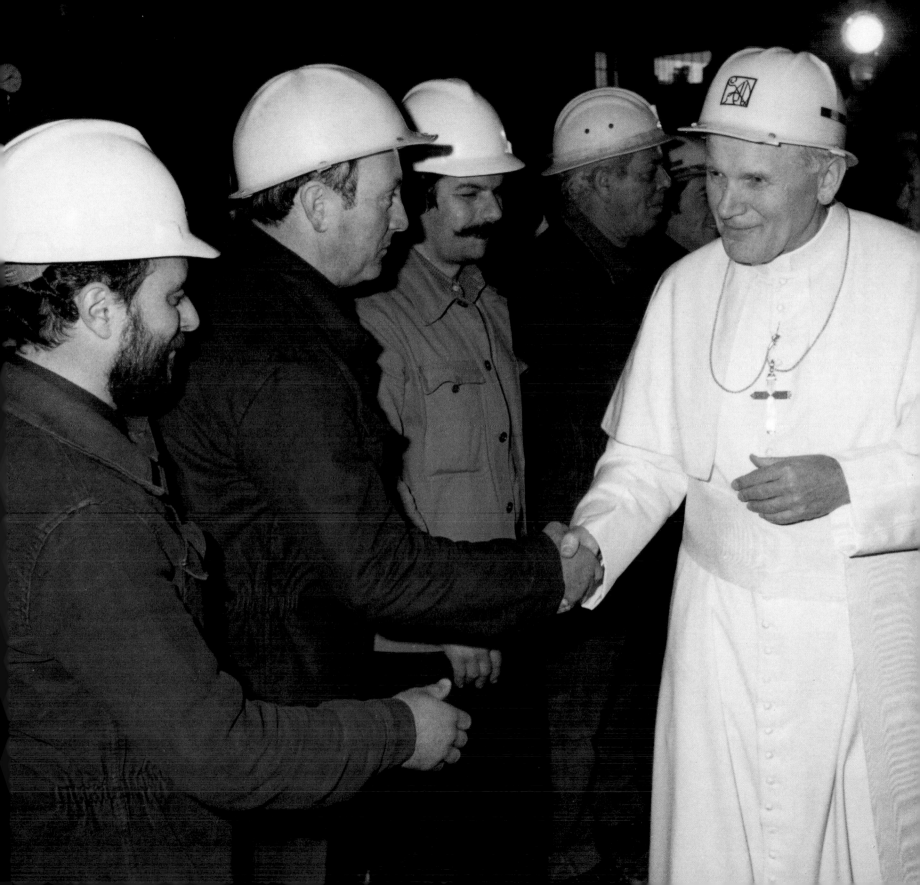

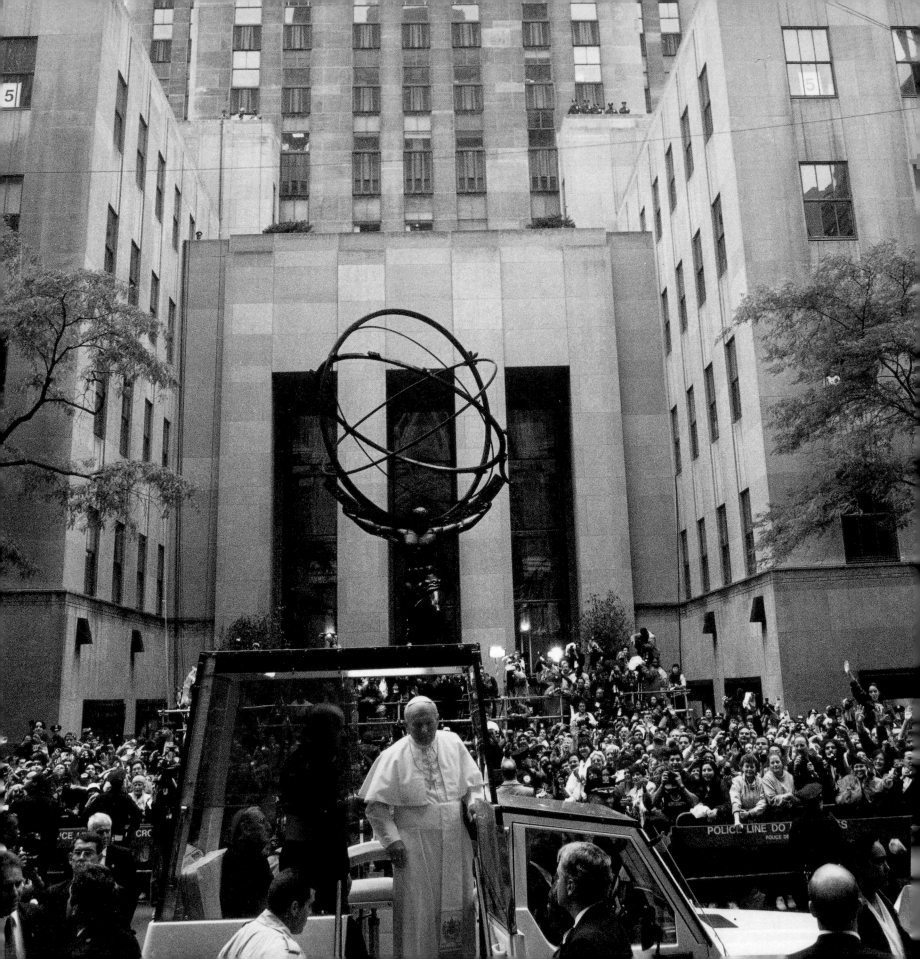

Like Christ and the Apostle in the Upper Room

CARDINAL WILLIAM H. KEELER, Archbishop of Baltimore

WHEN Pope John Paul II visited the United States in 1987, the major Christian ecumenical event on his itinerary took place in Columbia, South Carolina. The Holy Father had asked that the service be held in the South, of which he had heard much in visits from the bishops of the region. As Chairman of our Bishops' Ecumenical and Interreligious Affairs Committee, I had helped plan the program for the day.

At the home of the President of the University of South Carolina the Pope met first with the cheering students outside and then joined some thirty religious leaders upstairs, including two dozen heads of other Christian communities in the United States. Following formal addresses by the President of the National Council of Churches and the Holy Father, the leaders posed questions or made observations, with Orthodox Archbishop Iakovos presenting the first question.

The Holy Father listened closely, and Cardinal Iohannes Willebrands, President of the Council for Promoting Christian Unity, at his side, volunteered an answer to one of the questions. But the rest Pope John Paul answered personally, as he met with each of the interlocutors, recalled the issue they had raised and commented on it. When the signal was given to leave, the Holy Father asked all to sit while he observed, "We meet in an upper room that is like the Upper Room of the first Christian Pentecost. The Holy Spirit is here, reminding us that more binds us together than separates us."

As he left the room, Pope John Paul remarked to Cardinal Willebrands and to me that the event was remarkable and unlike other meetings he had had with church leaders in Old World countries.

Later, at the football field, as we waited to begin the ecumenical service, I turned to him and saw that he was completely absorbed in prayer. More than 60,000 people had assembled, at least 80 percent of them members of other Christian Churches, such as Southern Baptists, Methodists, Lutherans, and Episcopalians.

In his homily Pope John Paul II reflected on marriage and family life in the light of the Scripture readings that had been proclaimed. The congregation in the stadium responded enthusiastically, interrupting his message with applause a dozen times—the most moving display of this kind in his United States visit.

The Pope passes by Rockefeller Center in New York during his 1995 visit to the city, where he addressed the United Nations.

THE WHOLE HUMAN BEING

MONSIGNOR JOHN STRYNKOWSKI

During their fifth meeting, Pope John Paul II and Palestinian President Yasser Arafat discuss the Middle East peace process and tensions in Jerusalem, in 1996.

Opposite: Soon after his election, Russian President Vladimir Putin discussed Russia's ties with the West in an audience with Pope John Paul II, 2000.

For the Church the meaning of a human being is Christ. From the earliest days of the Church the fact of the Incarnation, of the Word becoming Flesh, meant that the way to understand the nature and destiny of human beings most fully is through Christ. In the twentieth century this principle was reiterated quite strongly by the Second Vatican Council through its "Pastoral Constitution on the Church in the Modern World." One of the principal architects of that document was the Archbishop of Krakow, Karol Wojtyla. Even as he had considerable influence on the formation of the Constitution (also known by its opening words in Latin, *Gaudium et Spes*), this document also influenced his subsequent ministry in Poland and then as Pope after his election in 1978.

The first encyclical of his pontificate was *Redemptor Hominis* (The Redeemer of Man), published March 4, 1979. One of its crucial and frequently quoted passages is as follows: "Man in the full truth of his existence, of his personal being and also of his community and social being ... is the primary route that the Church must travel in fulfilling her mission: he is the primary and fundamental way for the Church, the way traced out by Christ himself...."

The Pope frequently urges proclamation of the truth about human beings. This truth can already be glimpsed through human reason, the Pope has affirmed, but its fullness can be grasped only through Christ and faith. It is particularly incumbent upon the bishops to proclaim this truth in an age of moral relativism and the demeaning of human dignity through war, economic inequality and crimes against life.

The Pope has given further illumination to this truth through his development of the theology of the body, which views the human being holistically. This theology sees body and soul not as two separate entities but as two aspects of the individual interweaving in the mutuality of their actions and effects. Evil done to or by the individual affects the entirety of the human being. Thus too maleness and femaleness define human beings in their entirety and leads to the complementarity of man and woman and the fulfillment of each through the other in marriage.

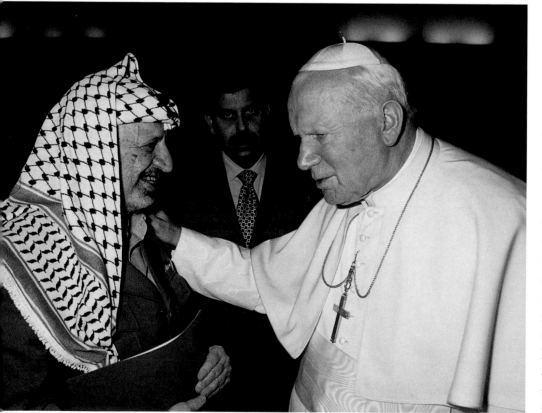

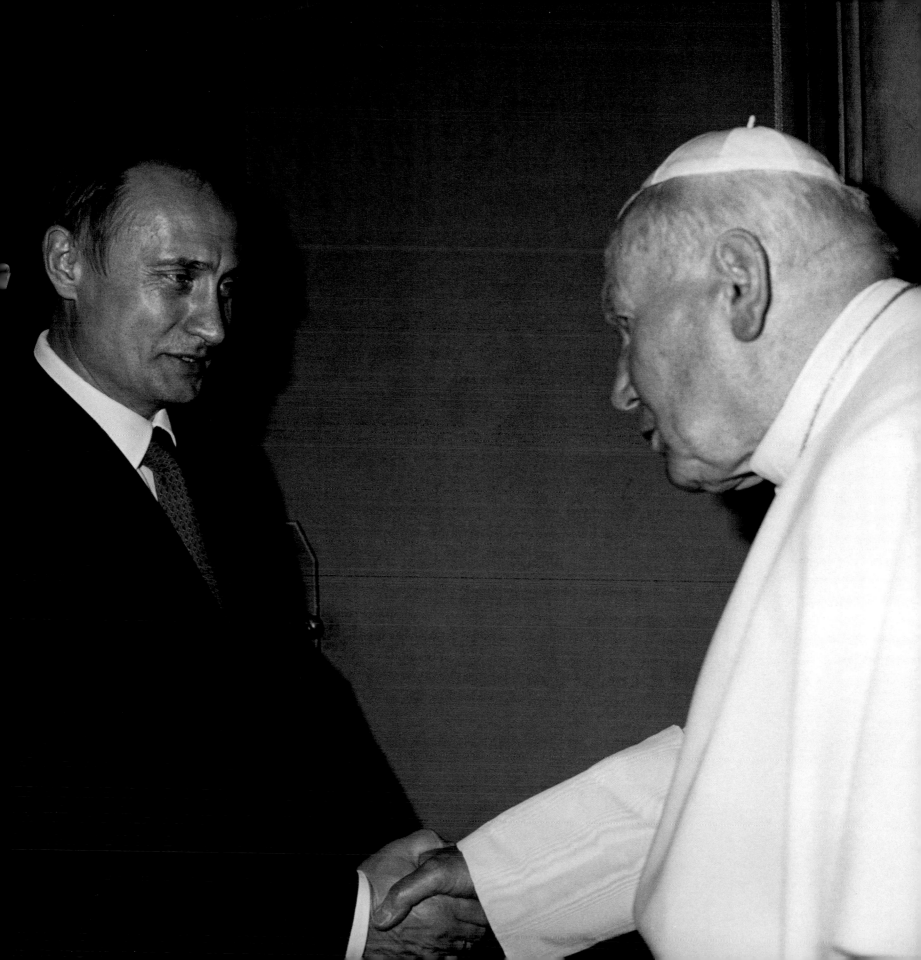

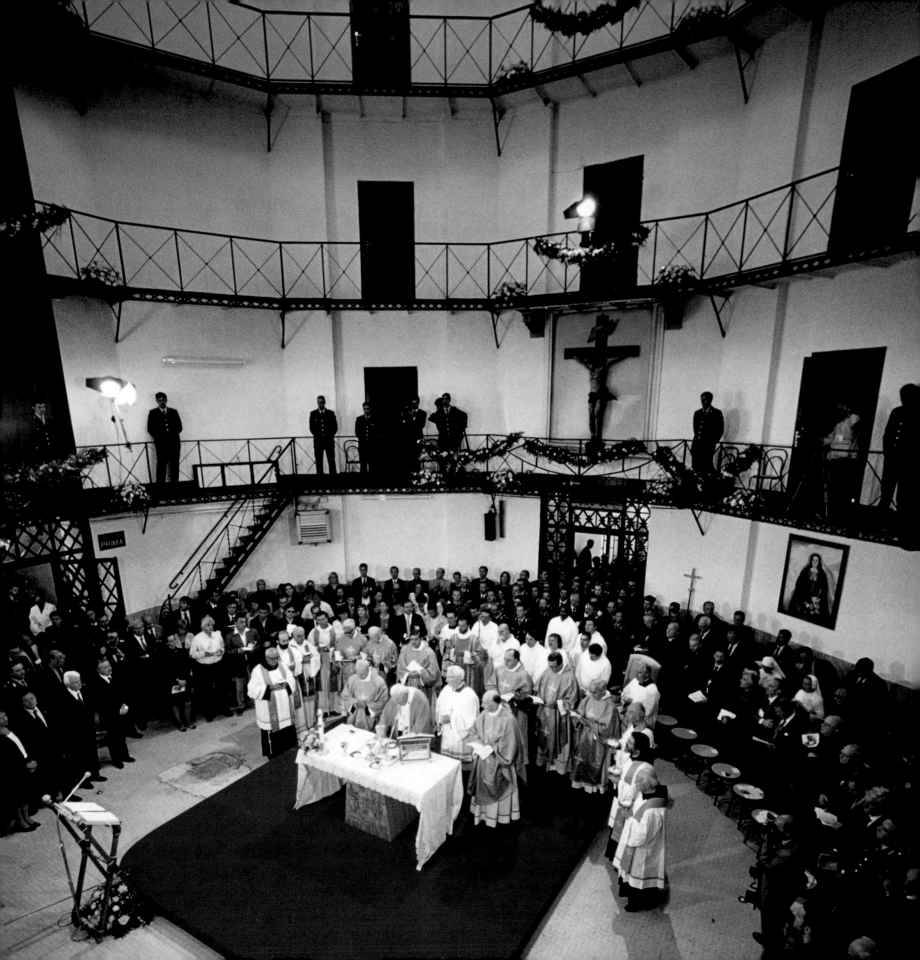

ABOLISHING THE DEATH PENALTY

ANDREW RIVAS

he new evangelization calls followers of Christ to be unconditionally pro-life: who will proclaim, celebrate and serve the Gospel of life in every situation" (*Evangelium Vitae*, 27). In this context, Pope John Paul II has been a powerful voice for ending the use of the death penalty as he insists that all human life is sacred, even the lives of those who have done great evil. "Modern society has the means of protecting itself, without definitively denying criminals the chance to reform. I renew the appeal I made most recently at Christmas for a consensus to end the death penalty, which is both cruel and unnecessary," he proclaimed in St. Louis in 1999. It was on this occasion that the Holy Father made a dramatic gesture when he appealed to the Governor of Missouri to spare the life of a convicted murderer and death row inmate; his scheduled execution was postponed because of the papal visit. This very personal appeal was a poignant reminder of how the Holy Father has made the struggle against the death penalty one of the defining aspects of his papacy. He has consistently appealed for the lives of death row inmates in the United States. He even asked for clemency for his own assailant.

Beyond his personal witness, Pope John Paul had left his mark on the treatment of the death penalty in Catholic teaching in his powerful encyclical *Evangelium Vitae*, which declares that the cases in which the death penalty could be applied "are rare, if not practically non-existent." In his homily to prisoners on the occasion of the Jubilee, July 7, 2000, John Paul said, "Punishment cannot be reduced to mere retribution, much less take the form of social retaliation or a sort of institutional vengeance." Punishment and imprisonment have "meaning" if "they serve the rehabilitation of the individual by offering those who have made a mistake an opportunity to reflect and to change their lives in order to be fully reintegrated into society."

In an age where respect for life is threatened in so many ways; by genocidal warfare, the relentless production and sale of arms, the wholesale destruction of unborn children, and the marginalization of the elderly and incurably ill, the Holy Father has steadfastly maintained that human life is a gift from God, and that no individual nor any government should destroy God's gift. Rather, all of us have the responsibility to protect human life from conception to natural death, even in the case where one life has taken another. The death penalty offers the tragic illusion that we can defend life by taking life.

In his recent message on the World Day of the Sick, held in Washington, the Holy Father calls recourse to the death penalty "unnecessary" and painfully reminds us that our "model of society bears the stamp of the culture of death, and is therefore in opposition to the Gospel message."

The Pope calls for repentance, forgiveness, and conversion while celebrating Mass at the Regina Coeli Prison, Rome's oldest prison and home to 900 inmates, Jubilee Day for Prisoners, July 9, 2000.

Following: The Pope stands atop Mount Nebo, Jordan, during his pilgrimage to the Holy Land, 2000.

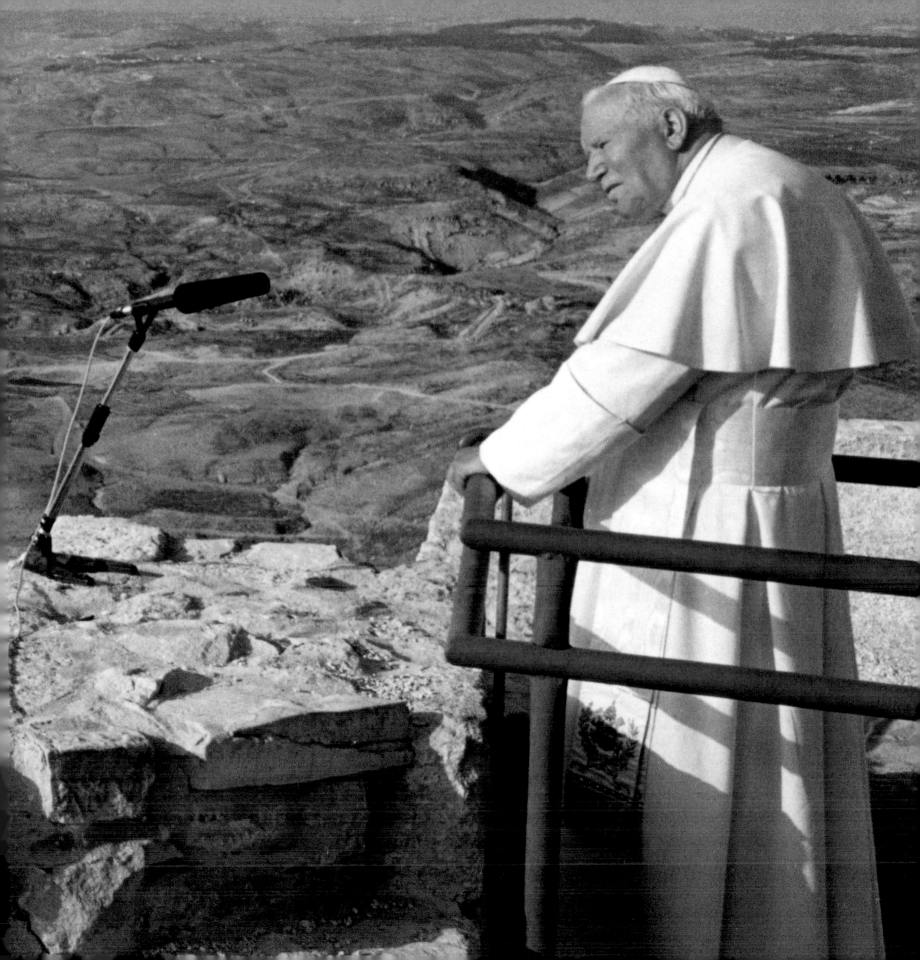

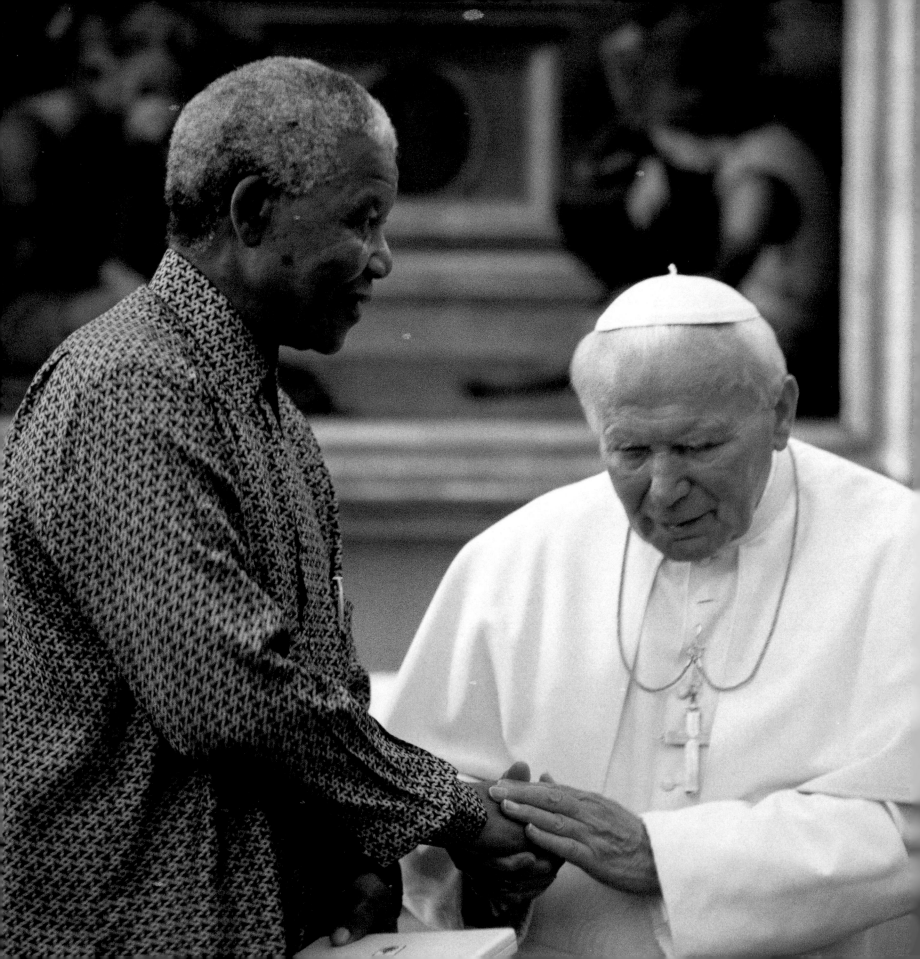

MODERN BIOETHICS

RICHARD DOERFLINGER

hen Karol Wojtyla became Pope John Paul II in October 1978, the first "test-tube baby" was three months old. Researchers had learned how to produce human life by joining sperm and egg in the laboratory without sexual union (*in vitro* fertilization). As we enter a new century, such technologies have led to debates about human embryo research, adoption of frozen embryos, human cloning, and genetic engineering of offspring.

The development of technology and the development of contemporary civilization, which is marked by the ascendancy of technology, demand a proportional development of morals and ethics. For the present, this last development seems unfortunately to be always left behind.

JOHN PAUL II, *REDEMPTOR HOMINIS*

These twenty-five years of John Paul II's pontificate have therefore coincided with a new age in mankind's power over human life at its foundations. And beginning with his first encyclical in 1979, *Redemptor Hominis* (Redeemer of Man), he called for careful assessment of such developments in light of the inherent dignity of the human person, insisting on the priority of "ethics over technology."

In a series of talks in the 1980s, the Holy Father surprised many with his basically positive judgments about the medical promise of genetics. As always, however, he distinguished valid use from dangerous abuse: Genetic engineering may bring cures and relieve human suffering, but must not be used to manipulate human life or to try to manufacture the "superior" human being.

In 1987, the Vatican reaffirmed the Church's rejection of *in vitro* fertilization—and of human cloning, then only a speculation. The new document, *Donum Vitae* (Gift of Life), warned prophetically against mistreating human embryos as mere objects of experimentation. But it left the door open to technologies to help couples have children without reducing procreation to a laboratory procedure.

In *Veritatis Splendor* (Splendor of the Truth) in 1993, John Paul II offered a profound critique of moral relativism and utilitarian thinking, which end by enslaving the vulnerable to the interests and whims of the strong. And in *Evangelium Vitae* (1995), he solemnly reaffirmed Church teaching against abortion, euthanasia and other attacks on human life, placing the defense of life at the center of the Church's witness: The "gospel of life" is an integral part of the Gospel.

Finally, by establishing the Pontifical Academy of Life in 1994, Pope John Paul II ensured that the Church would keep studying new developments in human cloning, stem cell research, care of the dying, and many other issues in bioethics. His lasting legacy is a Church unafraid to confront such issues, confident that it can make a distinctive contribution on behalf of the dignity of each and every human being.

South African President Nelson Mandela and the Pope shake hands during a private audience at the Vatican, June 18, 1998.

Respect for life requires that science and technology should always be at the service of man and his integral development. Society as a whole must respect, defend and promote the dignity of every human person, at every moment and in every condition of that person's life.

JOHN PAUL II, *EVANGELIUM VITAE*

CELEBRATING COMMON HERITAGE WITH THE JEWS

EUGENE FISHER

hile Blessed John XXIII launched the Second Vatican Council and Paul VI continued it, credit for pushing forward and making a part of the life of the Church vision of a radically new understanding of Jews and Judaism must go to John Paul II. When he grew up in Poland, many of Karol Wojtyla's childhood friends were Jews. Only one survived the Holocaust.

Beginning with his remarkable trip to Poland in 1979, the Pope has made Catholic-Jewish relations one of the hallmarks of his pontificate. At Auschwitz in 1979, he went first to the Jewish memorial and prayed there, then to the Polish memorial. Then left. No greater statement against Communism had ever been made. Communism's false "universalism" was defeated by the Pope's trenchant acknowledgment of Jewish suffering as a "saving warning" to all humanity.

In 1986, the Pope became the first Bishop of Rome to pray with Jews in their synagogue since Saint Peter, thus acknowledging the validity of Jewish prayer and the salvific reality of Judaism as a revealed religion. In a December 31, 1986, homily closing the end of the year, the pope himself noted the significance of this visit for his pontificate, the "one event which transcends the limits of the year... marked in centuries and millennia in the history of this Church. I thank Divine Providence that I was able to visit our 'elder brothers' in the faith of Abraham in their Roman synagogue." In 1987, the Pope became the first pope to meet with leaders of the world's largest Jewish community, declaring in Miami that "never again" can antisemitism sweep the Christian community.

The Pope also signed with Israel a "Fundamental Agreement" that validates the State and confirms the "religious attachment" between the People and State of Israel. In 1994, he hosted a memorial concert to the victims of the Shoah within the Vatican itself, initiating annual memorials there to coincide with the Jewish Remembrance Day, Yom Hashoah.

In the beginning of the Jubilee Year 2000, the Pope led the Catholic Church in a liturgy of repentance for its sins of the past millennium. One of the seven was the Church's centuries-long sin against the Jewish people, in its preaching and liturgy. This prayer of repentance in Saint Peter's in Rome was the same text that he placed in the Western Wall, Judaism's most sacred place, when he visited Jerusalem. In doing this he consoled the hearts of Jews not only in Israel but around the world and set the Catholic-Jewish relationship on firm footing of reconciliation for the centuries and millennia to come.

The Pope prays for Christian unity in the Garden of Gethsemane, Jerusalem, during his Jubilee pilgrimage to the Holy Land, in 2000.

Opposite: Israeli Prime Minister Yitzhak Rabin visits with the Pope at the Vatican, March 17, 1994.

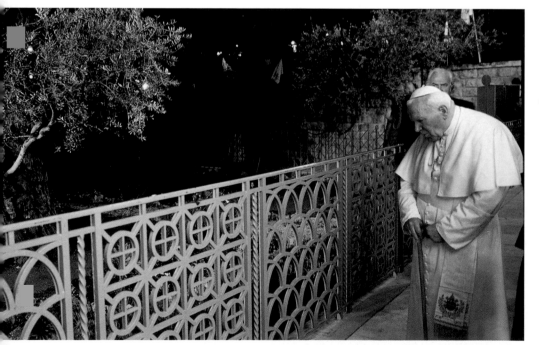

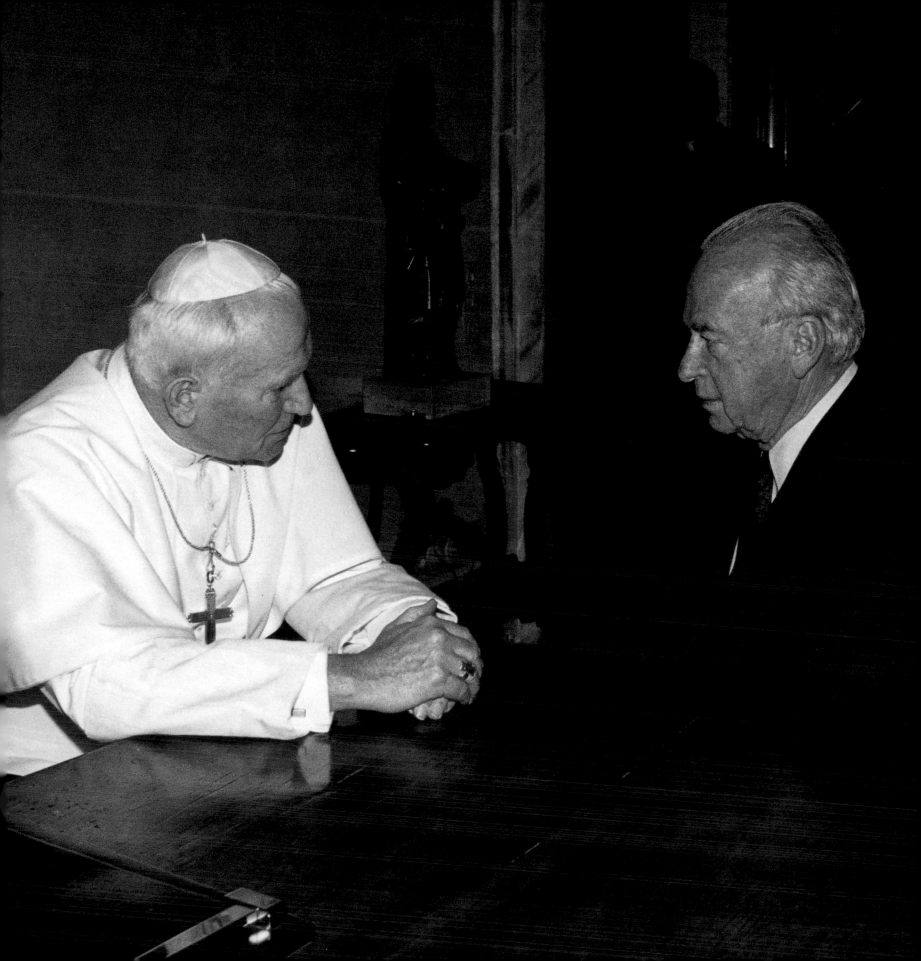

We are gathered this evening to commemorate the Holocaust of millions of Jews. The candles lit by the survivors are intended to show symbolically that this hall does not have narrow limits. It contains all the victims: fathers, mothers, sons, daughters, brothers, sisters, and friends. In our memory they are all present. They are with you. They are with us. We have a commitment, the only one, perhaps, that can give meaning to every tear shed by humanity and because of humanity to justify it. We have seen and we see peace derided, brotherhood mocked, harmony ignored, mercy scorned. Nevertheless, humanity is inclined to justice. Humanity is the only created being capable of conceiving it. To save humanity means satisfying the hunger and thirst of justice that resides within. This is our commitment after Auschwitz. We would risk causing the victims of the most atrocious deaths to die again if we do not commit ourselves, each according to his or her own capacities, to ensure that evil does not prevail over good as it did for millions of the children of the Jewish nation.

JOHN PAUL II, REFLECTIONS AT THE CONCERT
AT THE VATICAN COMMEMORATING THE SHOAH, APRIL 7, 1994

Pope John Paul II is greeted by Rabbi Elio Toaff, Chief Rabbi of Rome, during the Pope's landmark visit to the great Synagogue of Rome, where he referred to the Jewish people as the "elder brothers" of Christians, 1986.

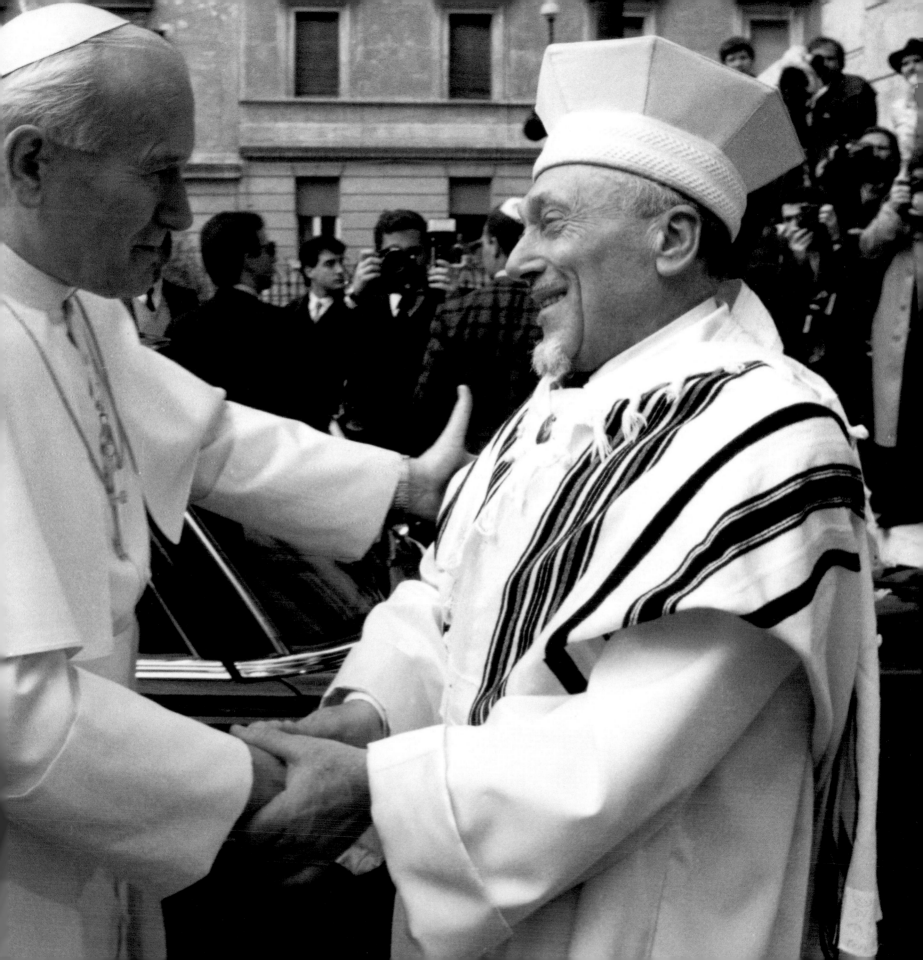

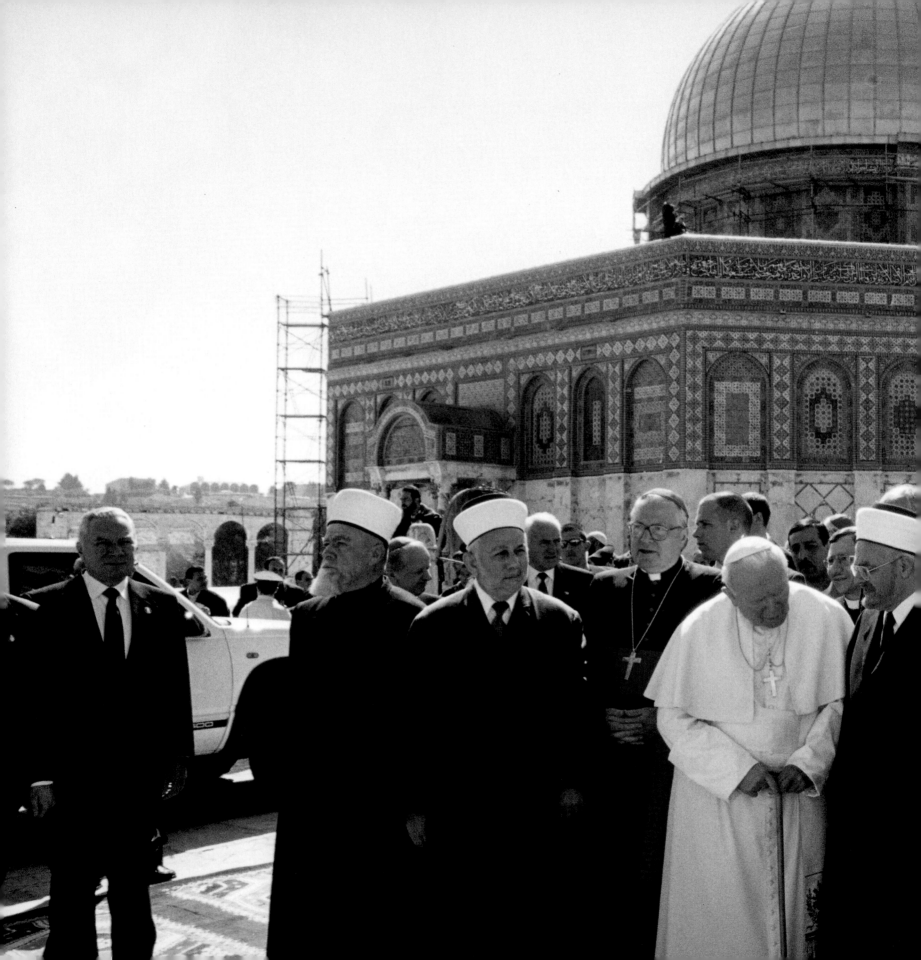

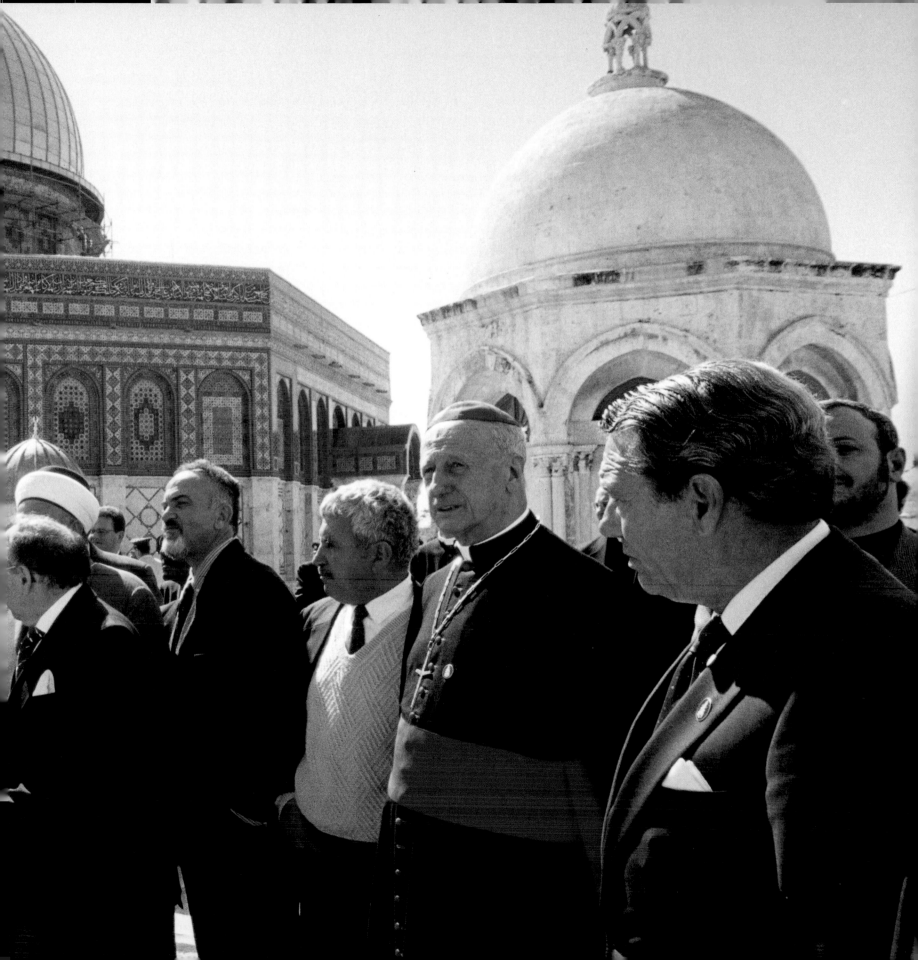

DIALOGUE WITH WORLD RELIGIONS

JOHN BORELLI

eeing the earth as a map of various religions was the fundamental impulse in the revision of the Church's self-awareness at the Second Vatican Council according to John Paul II. By giving example, he has championed the Council's positive approach to other religions and these other related achievements: a renewed understanding of the Church as a communion of people called by God into a dialogue of salvation, a fresh

In Christ, God calls all peoples to himself and he wishes to share with them the fullness of his revelation and love. He does not fail to make himself present in many ways, not only to individuals but also to entire peoples through their spiritual riches, of which their religions are the main and essential expression, even when they contain "gaps, insufficiencies, and errors."

JOHN PAUL II, *REDEMPTORIS MISSIO*

approach to Christian unity stressing dialogue and what already unites, a necessary emphasis on religious liberty, a reinvigorated involvement of the Church in dialogue with the world, and a redirection of missionary activity to include dialogue with religions and cultures.

For interreligious relations and dialogue, John Paul II has led in three principal ways: giving preeminent leadership as Pope, trusting the fundamental role of the Holy Spirit, and connecting this dialogue with the evangelizing mission of the Church. He laid out this agenda in his first encyclical (*Redemptor Hominis*, 1979), deepened the theological underpinnings in his encyclicals on mission (*Redemptoris Missio*, 1990) and ecumenism (*Ut Unum Sint*, 1995), and encouraged

contextual application in his exhortations following the special continental assemblies of the Synod of Bishops. Furthermore, John Paul II directed the Secretariat for Non-Christians, which Paul VI established (1964) to implement the Council's call for interreligious relations but which he renamed the Pontifical Council for Interreligious Dialogue (*Pastor Bonus*, 1988), to produce a detailed study on mission and dialogue (*Dialogue and Proclamation*, 1991).

Exemplary of his approach are the Assisi World Days of Prayers for Peace (October 27, 1986, and January 24, 2002). He invited others to join him in spiritual pilgrimage, to offer prayers, and to meditate together through mutual witness, being respectful of differences without compromise of essential teachings. These and the October 1999 interreligious assembly, his pilgrimages for the Jubilee Year 2000, and activities he hosted in Rome or during his travels have been ecumenical and interreligious occasions, witnessing a broad approach to evangelization, a commitment to peace and justice, and an understanding of the Church as the means of communion of all peoples with God.

The first Pope to visit a mosque, John Paul II has cited the Qur'an on several occasions and has received the public gratitude of notable Muslim leaders for his moral and spiritual leadership. He encouraged Christians to join Muslims in fasting and almsgiving during the Ramadan fast after September 11, 2001. Relations with Muslims have flourished for the Pontifical Council with several ongoing dialogues meeting each year and producing studies and public statements.

Encouraged by his leadership, United States bishops funded staff and activities in 1986 to implement their original intention after the

Council to have a national program for interreligious relations. With a significant increase in interreligious activities, the chairman of the Bishops' Committee on Ecumenical and Interreligious Affairs in 2000 appointed a Subcommittee on Interreligious Dialogue with five bishops as members and seven as consultants. Among its programs currently are three regional dialogues with Muslims meeting annually and preparing reports on revelation, violence and religion, marriage and family, and the spiritual life in contemporary society.

Christians and Muslims have many things in common, as believers and as human beings. We live in the same world, marked by many signs of hope, but also by multiple signs of anguish. For us, Abraham is a model of faith in God, of submission to his will and of confidence in his goodness. We believe in the same God, the one God, the living God, the God who created the world and brings his creatures to their perfection...

JOHN PAUL II, ADDRESS TO THE YOUNG MUSLIMS OF MOROCCO, AUGUST 19, 1985

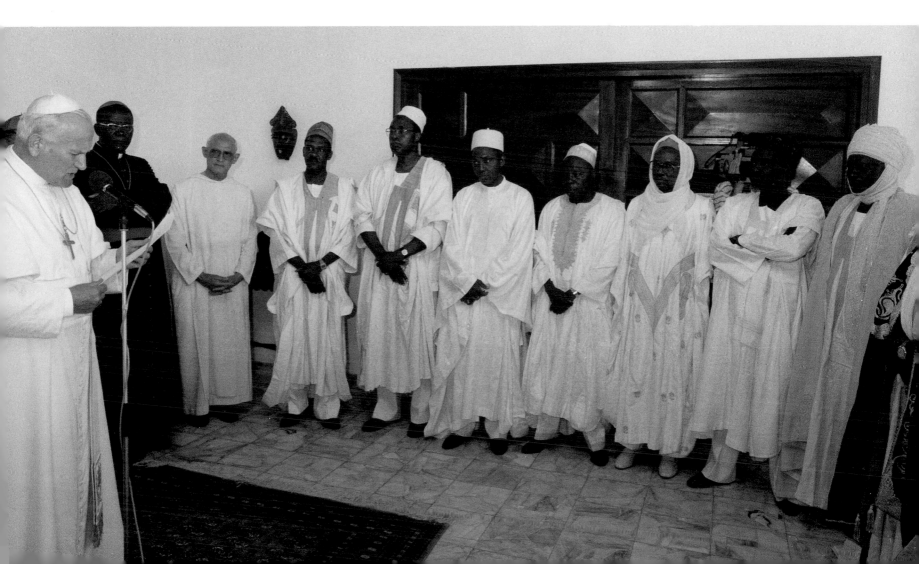

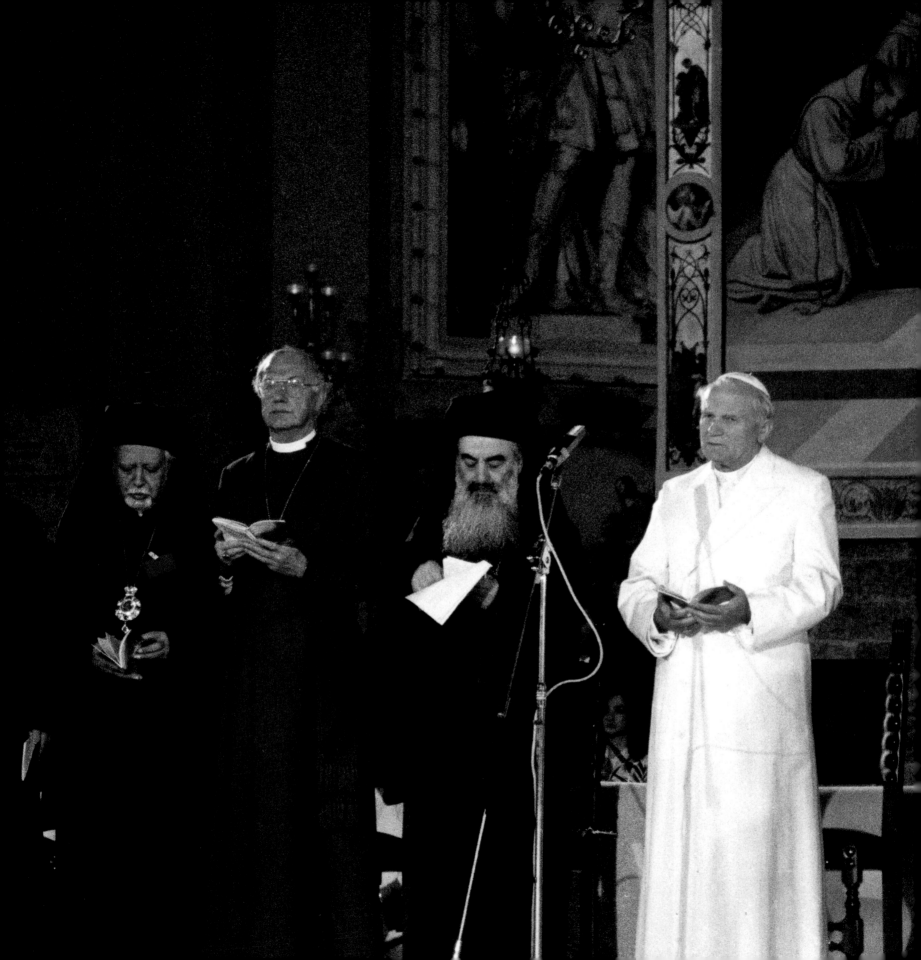

At the Interfaith Day of
Prayer for Peace, Assisi,
1986, the Pope stands
with, from left·
Bishop Gabriel of
Palmyra, representative
of the Greek Orthodox
Patriarch of Antioch,
Archbishop of Canterbury
Robert Runcie,
Archbishop Methodios
of Thyateira/Great Britain
and representative of the
Ecumenical Patriarch of
Constantinople,
the Dalai Lama,
the Venerable Maha
Ghosananda,
the Venerable Eui-Hyun
Seo of Korea, and
the Venerable Etai
Yamada of Japan.

EAST AND WEST, HEALING THE RIFT

FATHER RONALD ROBERSON, CSP

uilding on the legacy of Pope Paul VI, Pope John Paul II has spared no effort to heal the thousand-year-old rift between the Catholic and Eastern Orthodox Churches. One of his first trips outside Rome was to Istanbul, Turkey, to visit His Holiness Dimitrios I, the Ecumenical Patriarch of Constantinople, in November 1979. At the end of the visit the Pope and Patriarch announced the establishment of a theological dialogue between the Orthodox and Catholic Churches, the first official deliberations of this type since the end of the Council of Florence (1431–1445).

This visit to the first See of the Orthodox Church shows clearly the will of the whole Catholic Church to go forward in the march towards the unity of all, and also its conviction that the reestablishment of full communion with the Orthodox Church is a fundamental stage of the decisive progress of the whole ecumenical movement. It seems to me, in fact, that the question we must ask ourselves is not so much whether we can reestablish full communion, but rather whether we have the right to remain separated.

JOHN PAUL II, ISTANBUL, NOVEMBER 30, 1979

In the first decade of his papacy, John Paul emphasized the importance of the Byzantine tradition when he named Saints Cyril and Methodius co-patrons of Europe along with Saint Benedict in 1980, and issued an encyclical about them (*Slavorum Apostoli*) in 1985. In 1988, he released the Apostolic Letter *Euntes in Mundum Universum* for the millennium of the baptism of the ancestors of the Ukrainian, Belarusan and Russian people.

The Pope speaks with Ecumenical Patriarch Bartholomew I of Constantinople during his visit to Rome in 1995.

But in the 1990s relations with the Orthodox were going through a difficult period. Many Orthodox in Eastern Europe were suspicious of the Catholic Church, fearful that it would take advantage of the weakness of the Orthodox after years of Communist persecution to gain converts at their expense. With this in mind, John Paul has repeatedly assured the Orthodox of the Catholic Church's benevolent intentions. In June 1992 he approved the publication of principles and norms that called upon Catholics in the former Soviet Union to work closely with the Orthodox, and to help them in their struggle to revive after decades of persecution. In his Apostolic Letter *Orientale Lumen* (1995), the Pope wrote of the rich heritage of the Christian East that needs to be better understood and treasured by Roman Catholics. In his encyclical *Ut Unum Sint* (1995), the Pope wrote that "the Catholic Church desires nothing less than full communion between East and West."

Nevertheless, Orthodox uncertainties prevented the world-traveling Pope from visiting a predominantly Orthodox country for many years. The ice was broken only in May 1999 when he made a historic visit to Romania. This was followed by visits to Georgia in November 1999, to Greece in May 2001, to Ukraine in June 2001, and to Bulgaria in May 2002.

Even though the theological dialogue established in 1979 has been facing difficulties related to tensions in Eastern Europe since 1990, the Pope's recent visits to Orthodox countries have helped build up a greater sense of trust that will be essential if the goal of full communion is to be reached. During his twenty-five years as Pope, John Paul II has made an enormous contribution to that effort.

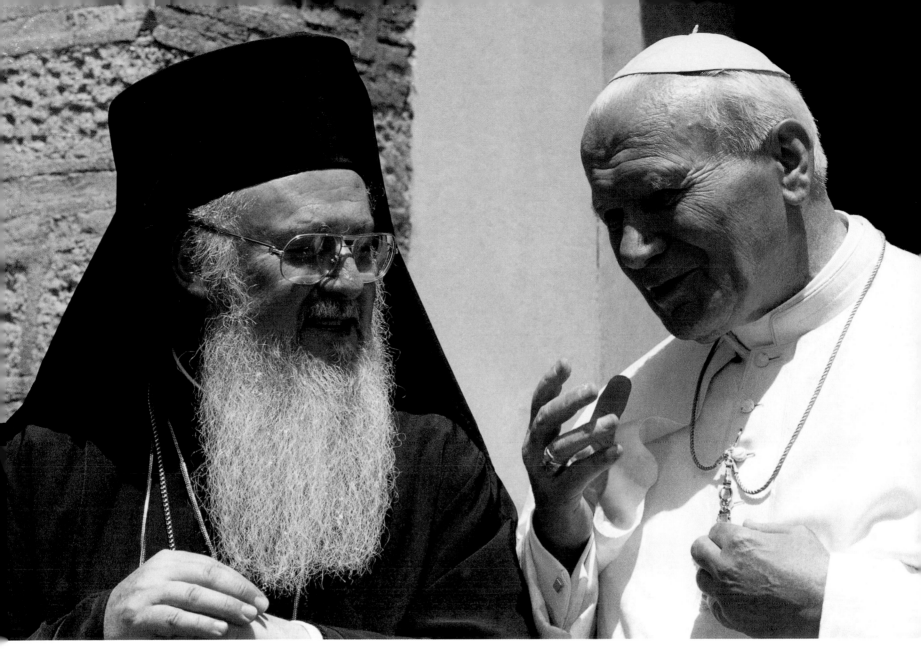

Your Beatitude, I have come here as a pilgrim to express the whole Catholic Church's affectionate closeness to you in the efforts of the bishops, clergy and faithful of the Romanian Orthodox Church as one millennium ends and another emerges on the horizon. I have come to contemplate the Face of Christ etched in your Church; I have come to venerate this suffering Face, the pledge to you of new hope.

JOHN PAUL II, ADDRESS TO PATRIARCH TEOCTIST OF
THE ROMANIAN ORTHODOX CHURCH, BUCHAREST, MAY 8, 1999

UNIFYING ALL CHRISTIANS

BROTHER JEFFREY GROS, FSC

The 1995 offer in the encyclical *Ut Unum Sint* (That All May Be One) to reform the papal office to better serve the cause of unity among Christians caught the imagination of Christians of all persuasions. However, there was much more in this encyclical, a high watermark in Catholic passion for ecumenism.

In each of the papal trips to the far ends of the globe Pope John Paul drew together Christian leaders to pray to God for their people, for Christian unity and for God's will for the future of the churches. During his pontificate dialogues with Anglicans and Lutherans have matured so that the churches were able to decide on agreements in faith.

Pope John Paul has followed closely dialogues with Methodists, Disciples, Baptists, Reformed churches and even seen the initiation of dramatic documents produced by Catholic scholars with their evangelical and Pentecostal colleagues.

He was the first pope since the Reformation to visit Canterbury Cathedral and the first ever to visit the churches in Scandinavia. When he visited the United States in 1987, the Billy Graham organization helped plan the ecumenical rally in the University stadium in South Carolina, where evangelicals, Protestants, Orthodox and Anglicans came together to give common witness to the Gospel.

His celebration of the Jubilee Year 2000 saw many breaks with long-standing Catholic practices and habits of mind: He inaugurated the year by opening the Holy Door at Saint Paul's with the help of a representative of the Eastern Orthodox Ecumenical Patriarch and George Carey, the Archbishop of Canterbury. On the first Sunday of Lent he publicly apologized for the failings of Catholics, among them failings against fellow Christians and the unity of the Church. He celebrated together with fellow Christians a commemoration of the witnesses to the faith of this century, from all Christian traditions.

During John Paul's tenure, he has blessed and encouraged local and national initiatives in bringing Christians together in prayer, common witness and in councils of churches. He has visited the World Council of Churches and encouraged its work. He has received ecumenical pilgrimages in Rome and welcomed heads of Protestant and Anglican churches from around the world.

Christians are closer together in their faith, mission and worship life than at any time in the last millennium. John Paul's continuous support of fellow Christian leaders, of ecumenical initiatives within his own Church, and of the patient and long-range theological efforts to resolve questions that have divided Christians for centuries, all place him among the pioneers of Christian unity.

A replica of the St. Louis arch was over the altar for the papal Mass in St. Louis in the America's Center, 1999.

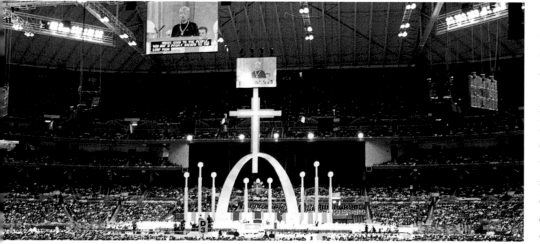

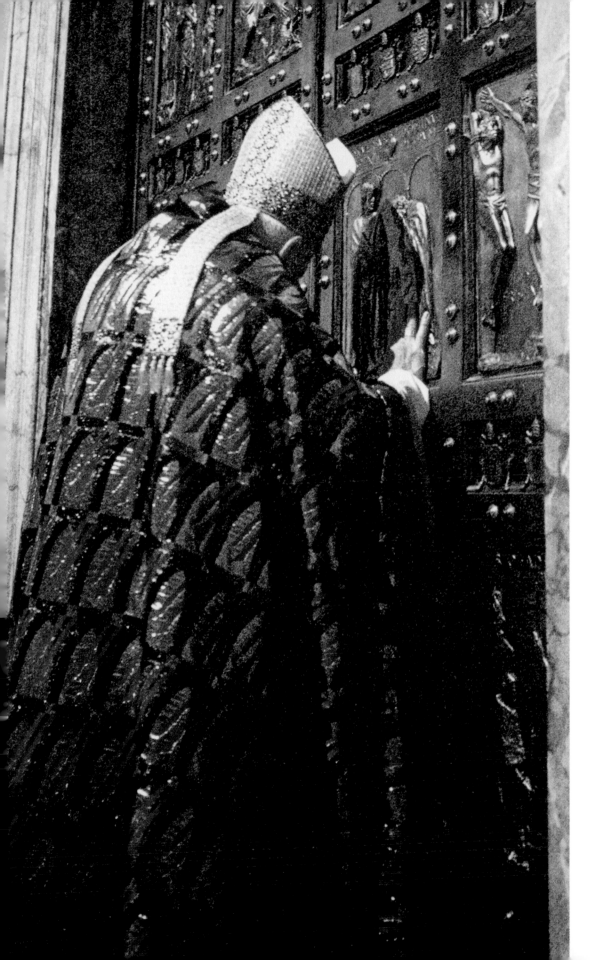

To believe in Christ means to desire unity; to desire unity means to desire the Church; to desire the Church means to desire the communion of grace which corresponds to the Father's plan from all eternity. Such is the meaning of Christ's prayer: "Ut Unum Sint" ["That they all may be one"].

JOHN PAUL II, *UT UNUM SINT*

The Pope opens the holy door in anticipation of the Jubilee Year, December 24, 1999.

Following:
Cardinal John O'Connor, Archbishop of New York, offers a gift to the Pope during his visit to St. Patrick's Cathedral in 1995.

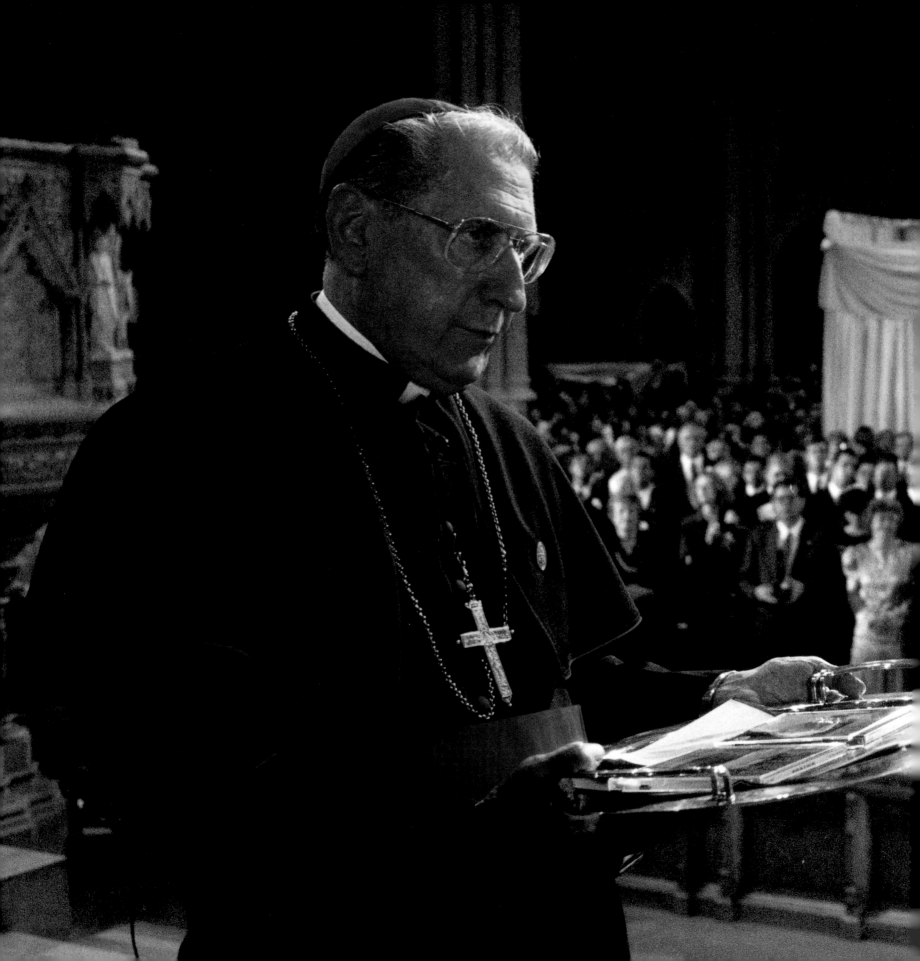

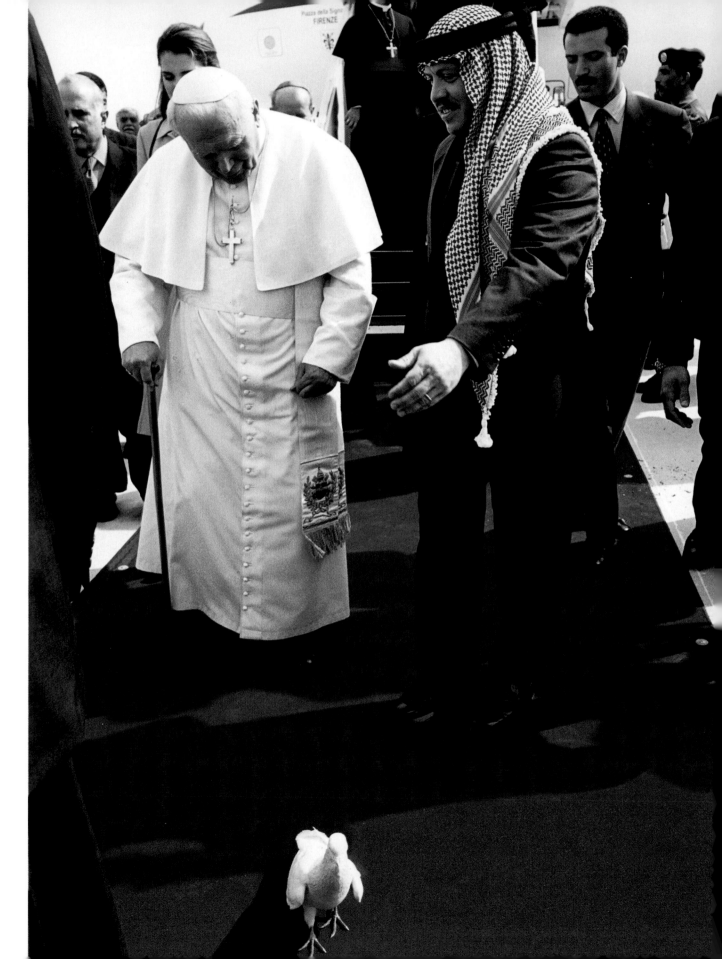

Pope John Paul II
commences his
pilgrimage to the
Holy Land by affirming
the Middle East peace
process in a visit to
Jordan, where
King Abdullah of Jordan
welcomed the Pope upon
his arrival at Amman's
Queen Alia Airport on
March 20, 2000.

Always the Personal Touch

CARDINAL FRANCIS GEORGE, OMI, Archbishop of Chicago

AT THE ceremony when I received the pallium as Archbishop of Chicago, Pope John Paul II told me that he wanted to talk to me. Anticipating some instructions about what he thought might be done, I went to his library prepared to listen. What I heard was a series of reflections on his relation to previous archbishops of Chicago, from Cardinal Meyer at the Second Vatican Council, to Cardinal Cody during the Pope's visit to Chicago in 1979, to Cardinal Bernardin and his pastoral projects. Still waiting for instructions, I heard him wish me good luck because there is much work to be done in a large archdiocese. The encounter reflected the Pope's personality and his approach: intensely personal, with a remarkable memory for names and details, encouraging and trusting, setting others free.

At the head of a table, the Holy Father is the gracious host. He enjoys his food and puts others at ease. With his penetrating glance singling out one or the other, he draws all into the conversation. Throughout, he is listening and teaching, himself a model for the strategy he believes should be the Church's approach to the world: proposing rather than imposing. This is a man who never fails to declare the truth, but always in love.

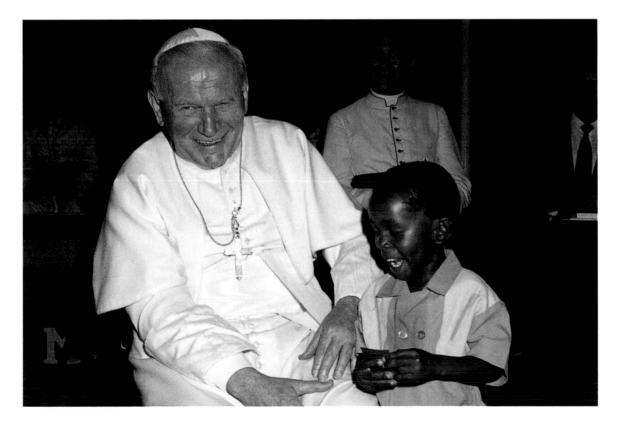

The Pope shares a laugh with a boy in Khartoum, Sudan, June 4, 1993, during his visit to Benin, Uganda, and Sudan.

When It Rains in the United States …

BISHOP ANTHONY M. PILLA OF CLEVELAND

President Ronald Reagan and his wife Nancy greet Pope John Paul II during a brief stop in Fairbanks, Alaska in 1984 during the papal visit to South Korea, Papua New Guinea, the Solomon Islands and Thailand.

AS AN OFFICER of the Bishops' Conference, one has the honor and the privilege of frequent meetings with the Holy Father. In those meetings you get a glimpse of his wisdom, insight, his keen intellect—and his delightful humor.

On one such occasion with the Holy Father, the officers engaged in some after-lunch conversation. One of the topics that was brought up was what we thought to be close scrutiny of everything that happens in the Church in the United States. The Holy Father was asked if there was a reason for such close scrutiny. His response was, "Well, when it rains in the United States, it's cloudy all over the world!"

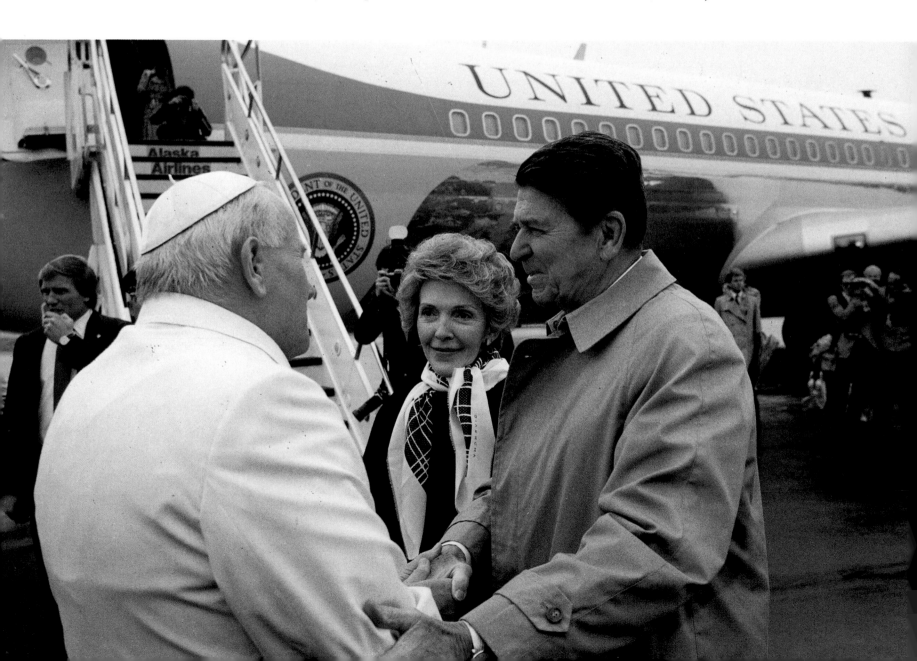

CATHOLIC SOCIAL TEACHING

JOHN L. CARR

ope John Paul II has effectively ended the debate about whether the social mission of the Church is integral or fringe, fundamental or marginal: that it has "permanent value" and is "genuine doctrine" which enables the Church to "analyze social realities, to make judgments about them and to indicate directions to be taken for the just resolution of the problems involved" (*Centesimus Annus*, 3, 5). By his words and witness, by his teaching and example, he has demonstrated that the Church's social teaching is at the heart of what it is to be a Catholic community of faith.

The scriptural and philosophical underpinnings of *Centesimus Annus* (1991), *Laborem Exercens* (1981) and *Sollicitudo Rei Socialis* (1987) make it absolutely clear that for Pope John Paul II, social teaching is not a theory, but above all else a basis and motivation for action. He has affirmed, built upon, and advanced the legacy of his predecessors —especially in areas of work and workers, war and peace, the role and limitations of markets and government. The theme of "solidarity" is a centerpiece of his papacy, reminding us again and again we are all members of one human family, sisters and brothers under one God.

No pope has more often or more consistently worked to defend life, promote justice, pursue peace, and apply these core principles to the pressing issues of our time—life and death, war and peace, economic justice and environment, debt and development. He has worked for peace in the Middle East and religious freedom and tolerance all around the world. He has strongly opposed abortion and euthanasia, cloning and capital punishment. He has called for debt relief and greater attention to HIV-AIDS.

The Holy Father admits there are limitations and dangers in how this teaching is applied. It cannot be used to justify violence and class struggle. It should not be misused for partisan political purposes. However, he is absolutely clear that the Church is called to defend life, promote justice and pursue peace.

Any believer who hears the teaching of John Paul II or watches his leadership understands with new clarity and urgency that the social mission of the Church is central to what Catholics believe and who they are.

Below: The Pope waves to crowds gathered for the second World Youth Day celebration in Buenos Aires, Argentina, 1987.

Following: The Pope enjoys a moment at the foot of the Golden Gate Bridge, San Francisco, 1987.

Essential Resources: The Pope celebrates Mass in Buenos Aires, Argentina, for the international World Youth Day, 1987.

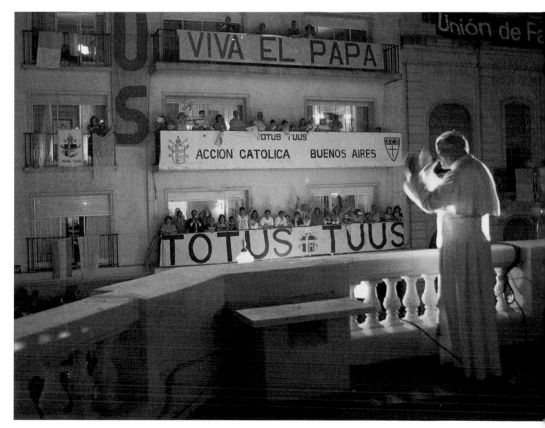

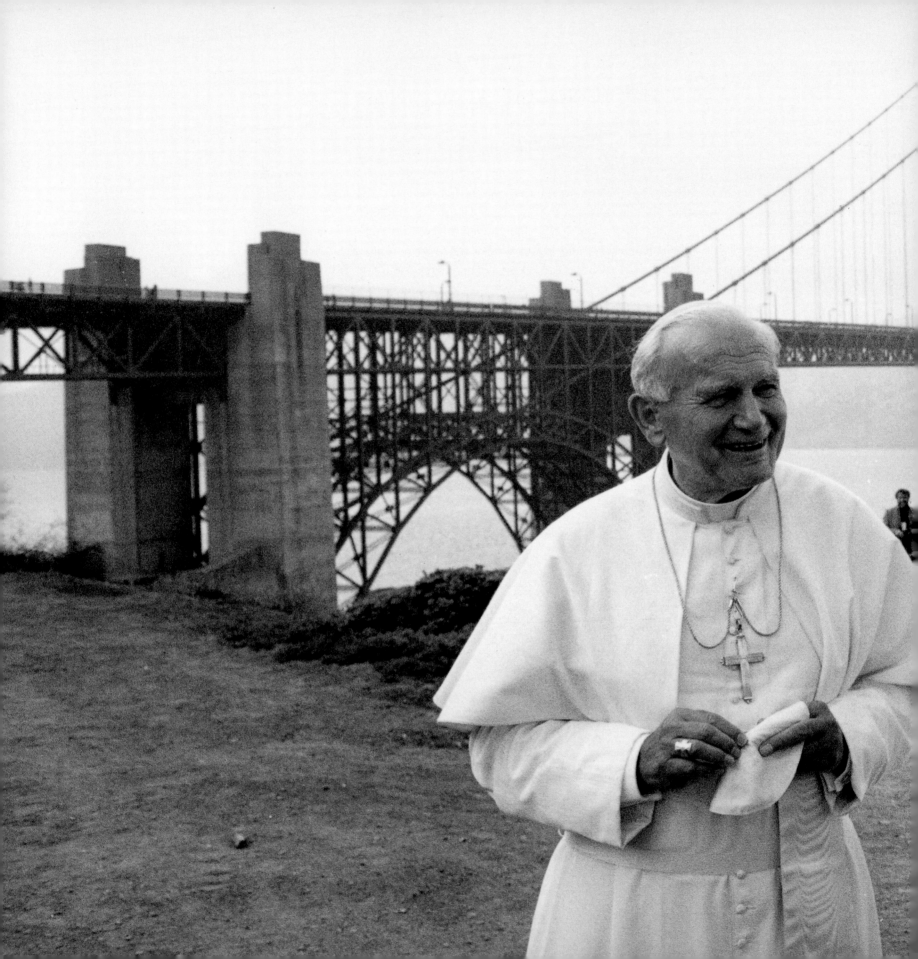

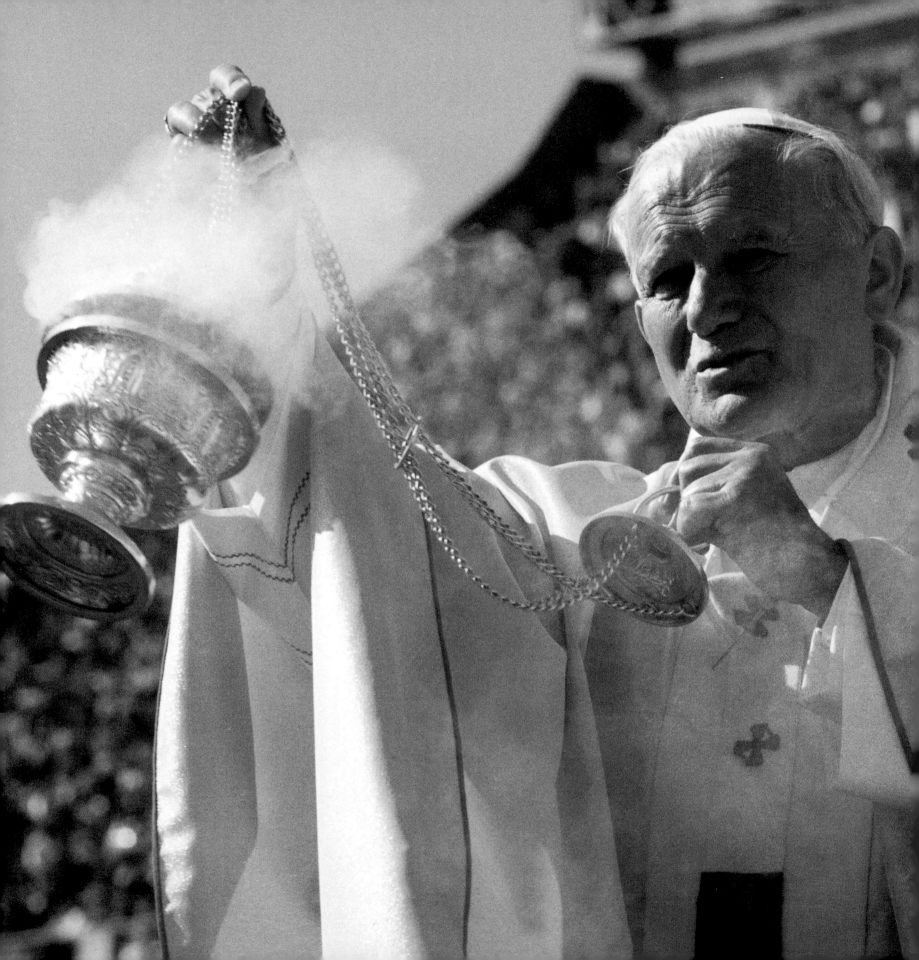

ESSENTIAL RESOURCES

---◆---

The Life and Ministry of Pope John Paul II

May 18, 1920
Karol Józef Wojtyla born in Wadowice, Poland.

June 20, 1920
Baptized in the Church of the Presentation of the Blessed Virgin Mary.

1929
His mother Emilia (née Kaczorowska) dies of kidney and heart failure.

1932
His brother Edmund, 15 years Karol's senior and a medical intern, dies of scarlet fever contracted from a patient.

1937
He and his father, also named Karol, move to Krakow; enrolls in department of philosophy, Jagiellonian University; joins the "Rhapsodic Theatre."

September 1, 1939
Nazis invade Poland; occupation forces university and theater to go underground; while studying underground, becomes stone cutter and assistant shot-firer in quarry.

1941
His father, who was a retired administrative officer and recruiter for the Polish army, dies; works in Solvay chemical plant unloading lime from railroad hoppers; tends boilers on night shift; active in UNIA (Christian underground).

1942
Begins studies for priesthood in Krakow's underground seminary.

1944
Disappears from job in Solvay; his name appears on Nazi's blacklist; he and other seminarians hide in home of Archbishop Adam Stefan Sapieha.

November 1, 1946
Ordained a priest; sent to Angelicum University in Rome.

1948
Assistant Pastor at the Church of the Assumption of Our Lady in Niegowic, and then Assistant Pastor of St. Florian's Church in Krakow.

1948
Earns doctorate in theology before Communists

abolish that department at Jagiellonian University; serves as student chaplain; joins faculty.

1953
Begins teaching as an Assistant Professor of Ethics and Moral Theology at Catholic University of Lublin.

1953
Becomes Assistant Professor at the Catholic University of Lublin and remains in this position until he becomes Pope.

September 28, 1958
Ordained auxiliary bishop of Krakow.

1962
Named *vicar capitular* (head of a diocese when a see is vacant, in this case because of a dispute with Polish government).

January 13, 1964
Appointed archbishop when Communist government lifts ban on such appointments.

1962–1965
Attends all sessions of the Second Vatican Council; contributes to conciliar document *Gaudium et Spes,* the Constitution on the Church in the Modern World.

June 26, 1967
Elevated to the College of Cardinals.

1972
His book, *Sources of Renewal,* reflecting his efforts to educate the people of his archdiocese on Vatican II, is published.

1978

October 16, 1978
Elected successor to Pope John Paul I, becoming the 264th Pope of the Catholic Church. He is the first non-Italian Pope since Adrian VI (1522–23), the first Polish Pope, and the youngest Pope since Pius IX (1846–78). He takes the name John Paul II.

October 22, 1978
Solemn inauguration of his ministry as Universal Pastor of the Church.

November 5, 1978
Visit to Assisi to venerate the tomb of St. Francis, patron of Italy, and to the basilica of Santa Maria Sopra Minerva to venerate the tomb of St. Catherine of Siena, patroness of Italy.

November 12, 1978
As bishop of Rome, John Paul II takes possession of St. John Lateran Basilica.

December 5, 1978
Begins his pastoral visits to the parishes in the diocese of Rome.

1979

January 24, 1979
Accepts the request for mediation in the border conflict between Argentina and Chile.

January 25, 1979
Begins first pastoral visit of John Paul II outside Italy: to the Dominican Republic, Mexico (for the Third General Conference of the Latin American Bishops, Puebla), with a stopover in the Bahamas (to Feb. 1).

March 4, 1979
First papal encyclical *Redemptor Hominis* (On the Redemption and Dignity of the Human Race), published March 15.

June 2, 1979
Second pastoral visit of John Paul II outside Italy: to Poland (June 2–10).

June 30, 1979
Celebration of the first consistory of his pontificate for the creation of 14 cardinals. (One additional cardinal was reserved *in pectore,* Chinese Ignatius Kung Pin-mei, whose appointment was published only in the consistory of June 28, 1991).

September 29, 1979
Third pastoral visit of John Paul II outside Italy: to Ireland, the United Nations and the United States (September 29–October 7).

October 2, 1979
Addresses the UN General Assembly in New York.

October 16, 1979
Post-Synodal Pastoral Exhortation *Catechesi Tradendae* (On Catechesis in Our Time), published October 25.

November 5, 1979
First Plenary Assembly of the College of Cardinals on the themes: the structure of the Roman Curia; the Church and culture; the financial situation of the Holy See (November 5–9).

November 28, 1979
Fourth pastoral visit outside Italy: to Turkey
(November 28–30).

1979
Diplomatic relations established with: Bahamas,
Grenada, Jamaica, and Mali.

1980

January 14, 1980
Opening of the Special Assembly for the Netherlands
of the Synod of the Bishops on: "The pastoral action
of the Church in Holland in the present situation"
(January 14–31).

April 4, 1980
Good Friday: John Paul II hears confessions of the
faithful for the first time in St. Peter's Basilica.

May 2, 1980
Fifth pastoral visit outside Italy: Zaire, Republic of
the Congo, Kenya, Ghana, Upper Volta, Ivory Coast
(May 2–12).

May 30, 1980
Sixth pastoral visit of John Paul II outside Italy: to
France (May 30–June 2).

June 2, 1980
Address to UNESCO in Paris.

June 21, 1980
Visit of President Jimmy Carter of the United States.

June 30, 1980
Seventh foreign pastoral visit: Brazil (June 30–July 12).

September 26, 1980
Fifth Ordinary General Assembly of the Synod of
Bishops on the theme: "The Role of the Christian
Family in the Modern World."

November 15, 1980
Eighth pastoral visit outside Italy: to West Germany
(November 15–19).

November 30, 1980
Second encyclical *Dives in Misericordia* (On the Mercy
of God), published December 2.

December 31, 1980
Apostolic Letter *Egregiae Virtutis* (Of Wondrous Virtue),
proclaiming Saints Cyril and Methodius, together with
Saint Benedict, co-patrons of Europe.

1980
Diplomatic relations established with: Greece,
Zimbabwe.

1981

February 8, 1981
John Paul II meets with Rome's Chief Rabbi Elio Toaff,
during his pastoral visit to the parish of Sts. Carlo e
Biagio in Catinari.

February 16, 1981
Ninth foreign pastoral visit: Pakistan, the Philippines,
Guam (USA), Japan, and Anchorage, Alaska
(February 16–27).

May 13, 1981
At 5:19 p.m. Turkish terrorist Mehmet Ali Agca makes
an attempt on the Pope's life while he is circling
St. Peter's Square in a jeep before his Wednesday
general audience. The Pope is brought to Gemelli
Hospital where he undergoes a six-hour operation.

May 17, 1981
The Holy Father recites the *Angelus* at Gemelli
Hospital: "Pray for the brother who shot me, whom
I have sincerely forgiven."

May 31, 1981
John Paul II creates the Council of Cardinals for the
Study of Organizational and Economic Problems of
the Holy See.

June 3, 1981
The Pope returns to the Vatican after 22 days of
recovery at Gemelli Hospital.

June 20, 1981
John Paul II is newly hospitalized for an infection.
On August 5 he undergoes a second operation; leaves
hospital definitively on August 14, returns to the
Vatican, then goes to Castelgandolfo on August 16.
He was in the hospital a total of 78 days between
May 13 and August 14.

July 13–14, 1981
First meeting of the Council of Cardinals for the
Study of Organizational and Economic Problems of
the Holy See.

September 14, 1981
Third encyclical *Laborem Exercens* (On Human Work).

November 22, 1981
Post-Synodal Apostolic Exhortation *Familiaris
Consortio* (On the Family), published on December 15.

December 12, 1981
John Paul II sends delegates from the Pontifical
Academy of Sciences to the presidents of the USA,
USSR, Great Britain, France, and to the UN, to explain
their document on the eventual consequences of the
use of nuclear arms in Europe and the world.

1981
Diplomatic relations established with: Dominica,
Equitorial Guinea, Singapore, Togo.

1982

January 6, 1982
Apostolic Letter *Caritatis Christi* (For the Love of
Christ) addressed to the Church in China.

February 12, 1982
10th foreign pastoral visit: Nigeria, Benin, Gabon and
Equatorial Guinea (February 12–19).

April 1, 1982
Receives credentials of the first British ambassador
to the Vatican since the reign of Henry VIII.

May 12, 1982
11th foreign pastoral visit: to Portugal, one year after
the assassination attempt in St. Peter's Square
(May 12–15).

May 28, 1982
12th foreign pastoral visit: to Great Britain
(May 28–June 2).

May 29, 1982
Joint statement of John Paul II and the Archbishop
of Canterbury, Dr. Robert Runcie, at the end of the
ecumenical celebration in the Anglican Canterbury
Cathedral. New Catholic-Anglican theological
commission is announced.

June 7, 1982
Meets US President Ronald Reagan for the
first time; they pledge to work for world peace
and justice.

June 11, 1982
13th foreign pastoral visit: to Argentina, in relation to
the war between Argentina and Great Britain
(June 11–12).

June 15, 1982
14th foreign pastoral visit: one-day trip to Geneva, Switzerland. John Paul II addresses the 68th session of the International Labor Conference.

August 2, 1982
The Holy See announces diplomatic relations with Denmark, Norway and Sweden.

August 29, 1982
15th foreign pastoral visit, and 28th within Italy: one-day trip to the Republic of San Marino and to Rimini, Italy.

September 15, 1982
Private meeting with Yasser Arafat on the prospects for peace in the Middle East. Renewed appeal for peace in Lebanon, after the murder of president-elect Bechir Gemayel.

October 31, 1982
16th foreign pastoral visit: to Spain, for the closure of the 4th Centenary of the death of St. Teresa of Avila (October 31–November 9).

November 23, 1982
Second plenary session of the College of Cardinals: principal topic is the reform of the Roman Curia (November 23–26).

November 26, 1982
John Paul II announces the Holy Year of Redemption: from Lent 1983 to Easter 1984.

1983

January 6, 1983
Papal Bull *Aperite Portas Redemptori* (Open the Doors to the Redeemer), announcing the Jubilee for the 1950th anniversary of the Redemption.

January 25, 1983
Pastoral Constitution *Sacrae Disciplinae Leges* (The Laws of Sacred Disciplines) promulgating the new *Code of Canon Law*.

February 2, 1983
Second consistory of John Paul II for the creation of 18 cardinals.

March 2, 1983
17th foreign pastoral visit: Lisbon, Portugal, and Central America— Costa Rica, Nicaragua, Panama, El Salvador, Guatemala, Honduras, Belize and Haiti (March 2–9).

March 24, 1983
Accepts credentials of the ambassador from Sweden, re-establishing diplomatic relations after 456 years.

March 25, 1983
Opening of the Holy Year of the Redemption (March 25, 1983–April 22, 1984).

March 25, 1983
Vatican announces that the Shroud of Turin has been bequeathed to the Pope by the deposed King Umberto, who died a week earlier.

June 16, 1983
18th pastoral visit outside Italy: to Poland (June 16–23).

August 14, 1983
19th foreign pastoral visit: Lourdes, France (August 14–15).

September 10, 1983
20th foreign pastoral visit: Austria (September 10–13).

September 29, 1983
Sixth Ordinary General Assembly of the Synod of Bishops on: "Penance and Reconciliation in the Mission of the Church" (September 29–October 29). At the final session Pope discloses his message to the heads of government of the United States and the Soviet Union calling for negotiations aimed at ending the arms race.

October 16, 1983
Act of entrustment and consecration of the world to the Mother of God by John Paul II, together with the cardinals and bishops participating in the Synod of Bishops.

November 5, 1983
Letter for the 500th anniversary of the birth of Martin Luther.

December 11, 1983
First papal visit to a Lutheran congregation, participating in a prayer service at the Evangelical Lutheran Church of Rome.

December 27, 1983
Visit to Rebibbia prison and meeting with Mehmet Ali Agca, the Turkish terrorist who made an attempt on his life on May 13, 1981.

1983
Diplomatic relations also established with: Belize, Nepal.

1984

January 10, 1984
Full diplomatic relations at the level of apostolic nunciature and embassy between the Holy See and the United States of America.

February 11, 1984
Pastoral Letter *Salvifici Doloris* (On the Christian Meaning of Suffering).

February 18, 1984
Agreement between the Holy See and the Italian Republic on the revision of the *Lateran Concordat*, new Concordat signed.

March 25, 1984
Apostolic Exhortation *Redemptionis Donum* (Gift of the Redemption) to all men and women religious, published on March 29.

April 20, 1984
Apostolic Letter *Redemptionis Anno* (Year of the Redemption), on the city of Jerusalem, sacred patrimony of all believers and crossroads of peace for the peoples of the Middle East.

May 2, 1984
21st pastoral visit outside Italy: South Korea, Papua-New Guinea, the Solomon Islands and Thailand, with a stopover in Alaska (May 2–12).

May 5, 1984
Apostolic Letter *Les Grands Mysteres,* on the situation in Lebanon.

June 12, 1984
22nd foreign pastoral visit: Switzerland (June 12–17).

September 3, 1984
Publication of the *Instruction on Certain Aspects of Liberation Theology* by the Congregation for the Doctrine of the Faith.

September 9, 1984
23rd foreign pastoral visit: Canada (September 9–20).

October 2, 1984
John Paul II tells the Pontifical Academy of Sciences that space belongs to all humanity and that satellites and other space vehicles should be regulated by just international agreements.

October 10, 1984
24th foreign pastoral visit: Zaragoza, Spain; Santo Domingo, Dominican Republic; and San Juan, Puerto Rico (October 10–12).

December 11, 1984
Publication of the Post-Synodal Pastoral Exhortation *Reconciliatio et Paenitentia* (Reconciliation and Penance).

1984
Diplomatic relations also established with: Saint Lucia, São Tomé and Principe, Seychelles, and the Solomon Islands.

1985

January 26, 1985
25th foreign pastoral visit: to Venezuela, Ecuador, Peru, Trinidad-Tobago (January 26–February 6).

February 11, 1985
John Paul II establishes Pontifical Commission for the Apostolate of Health Care Workers.

March 26, 1985
Apostolic Letter *To the Youth of the World* on the occasion of the United Nation's International Year of Youth.

March 30, 1985
First World Youth Day gathering, in Rome (March 30–31).

May 11, 1985
26th foreign pastoral visit: Netherlands, Luxembourg, and Belgium (May 11–21).

May 25, 1985
Third consistory for the creation of 28 new cardinals.

June 2, 1985
Fourth encyclical *Slavorum Apostoli* (The Apostles of the Slavs) in commemoration of the 11th centenary of the evangelization of Sts. Cyril and Methodius, published on July 2.

August 8, 1985
27th foreign pastoral visit: Togo, Ivory Coast, Cameroon, Republic of Central Africa, Zaire, Kenya, Morocco (August 8–19).

September 8, 1985
28th foreign pastoral visit: Liechtenstein.

November 17, 1985
Personal message to Presidents Ronald Reagan and Mikhail Gorbachev for the Geneva summit.

November 21, 1985
Third Plenary Meeting of the College of Cardinals on the reform of the Roman Curia (November 21–23).

November 25, 1985
Second Extraordinary General Assembly of the Synod of Bishops on: "The Twentieth Anniversary of the Conclusion of the Second Vatican Council" (November 25–December 8).

1985
Diplomatic relations established with: Liechtenstein.

1986

February 1, 1986
29th foreign pastoral visit: India (January 31–February 10).

April 5, 1986
Publication of the Instruction *Libertatis Conscientia* (On Christian Freedom and Liberation) by the Congregation for the Doctrine of the Faith.

April 13, 1986
Unprecedented visit to Rome's main synagogue, the oldest Jewish group in the Diaspora; prays with Rabbi Elio Toaff and Giacomo Saban, president of Rome's Jewish community.

May 18, 1986
Fifth papal encyclical *Dominum et Vivificantem* (Lord and Giver of Life), published on May 30.

July 1, 1986
30th foreign pastoral visit: to Colombia and Santa Lucia (July 1–8).

July 15, 1986
Publication of the new *Enchiridion Indulgentiarum* (Manual of Indulgences).

August 26, 1986
Apostolic Letter *Augustinum Hipponensem* for the 16th centenary of the conversion of St. Augustine.

October 4, 1986
31st foreign pastoral visit: France (East-Central region, October 4–7).

October 27, 1986
Attends the First World Day of Prayer for Peace which John Paul convened in Assisi with some 150 representatives of 12 world religions.

November 18, 1986
32nd foreign pastoral visit: to Bangladesh, Singapore, Fiji Islands, New Zealand, Australia and Seychelles (November 19–December 1).

1986
Diplomatic relations established with: Guinea, Guinea-Bissau, San Marino.

1987

January 13, 1987
Special audience with President of the Council of the People's Republic of Poland, General Wojciech Jaruzelski.

January 17, 1987
Private meeting with Jordan's King Hussein about the situation in the Middle East.

March 25, 1987
Sixth encyclical *Redemptoris Mater* (Mother of the Redeemer), describing the Virgin Mary's life as an image of obedience and a model of "femininity with dignity."

March 31, 1987
33rd foreign pastoral visit: to Uruguay, Chile, and Argentina: celebration in Buenos Aires of the Second World Youth Day (March 31–April 13).

April 30, 1987
34th foreign pastoral visit: to the Federal Republic of Germany (April 30–May 4).

June 6, 1987
Official visit of US President Ronald Reagan.

June 7, 1987
Solemn opening of the Marian Year (June 7– August 15).

June 8, 1987
35th pastoral visit outside Italy: Poland (June 8–14).

September 10, 1987
36th pastoral visit outside Italy: to USA and Canada (Fort Simpson) (September 10–21).

October 1, 1987
Seventh Ordinary General Assembly of the Synod of Bishops on: "The Vocation and Mission of the Lay Faithful in the Church and in the World."

December 3, 1987
His Holiness Dimitrios, Ecumenical Patriarch of Constantinople, visits John Paul II (December 3–7).

December 30, 1987
Seventh encyclical *Sollicitudo Rei Socialis* (On Social Concerns), published February 19, 1988. It criticized economic and political ideologies of the West and the East.

1988

March 3, 1988
First publication of the financial report of the Holy See (for the year 1986) and the estimated budget for the year 1988.

May 7, 1988
37th pastoral visit of John Paul II outside Italy: to Uruguay, Bolivia, Peru and Paraguay (May 7–18).

June 23, 1988
38th pastoral visit outside Italy: Austria (June 23–27).

June 28, 1988
Apostolic Constitution *Pastor Bonus* for the reform of the Roman Curia.

June 28, 1988
Fourth consistory for the creation of 24 cardinals.

July 2, 1988
Apostolic Letter *Ecclesia Dei* (Church of God), establishing a commission "to be instituted … to collaborate with the bishops, with the Departments of the Roman Curia… for the purpose of facilitating full ecclesial communion of priests, seminarians, religious communities or individuals until now linked to the Fraternity founded by Archbishop Lefevbre, who may wish to remain united to the Successor of Peter in the Catholic Church."

September 10, 1988
39th pastoral visit outside Italy: to Zimbabwe, Botswana, Lesotho, Swaziland, Mozambique (September 10–19).

September 30, 1988
Publication of the Apostolic Letter *Mulieris Dignitatem* (On the Dignity and Vocation of Women).

October 8, 1988
40th pastoral visit outside Italy: to the European Institutions at Strasbourg and to the dioceses of Strasbourg, Metz and Nancy, France (October 8–11).

December 30, 1988
Apostolic Exhortation *Christifideles Laici* (The Vocation and the Mission of the Lay Faithful in the Church and in the World).

1988
Diplomatic relations established with: Chad.

1989

March 8, 1989
Meeting of John Paul II and members of the Roman Curia with the metropolitan archbishops of the United States of America on the theme: "Evangelization in the Context of the Culture and Society of the United States with particular emphasis on the Role of the Bishop as Teacher of the Faith" (March 8–11).

April 28, 1989
41st pastoral visit outside Italy: Madagascar, Reunion, Zambia and Malawi (April 28–May 6).

May 27, 1989
Official visit of US President George H. W. Bush.

June 1, 1989
42nd pastoral trip outside Italy: Norway, Iceland, Finland, Denmark, Sweden (June 1–10).

July 17, 1989
Restoration of diplomatic relations between Poland and the Holy See.

August 19, 1989
43rd papal trip abroad: to Spain, for Fourth World Youth Day (August 19–21).

August 27, 1989
Apostolic Letter on the occasion of the 50th anniversary of the beginning of the Second World War.

September 7, 1989
Appeal to the followers of Islam in favor of Lebanon.

September 7, 1989
Apostolic Letter to all Bishops of the Catholic Church on the situation in Lebanon. World Day of Prayer for Peace in Lebanon.

September 29, 1989
Official visit of Archbishop of Canterbury Robert Runcie.

October 2, 1989
Joint statement of John Paul II and Archbishop Runcie.

October 6, 1989
44th foreign pastoral visit: Seoul (South Korea), Indonesia and Mauritius (October 6–16).

Deceimber 1, 1989
Official visit of President Mikhail Gorbachev of the USSR: marks the first time a Pope has met with the head of the Soviet government.

1990

January 25, 1990
45th pastoral visit outside Italy: to Cape Verde, Guinea Bissau, Mali, Burkina Faso, and Chad (January 25–February 1).

February 9, 1990
Holy See establishes diplomatic relations with Hungary.

March 15, 1990
Vatican announces the exchange of official representatives at the level of apostolic nuncio and special ambassador between the Holy See and the Soviet government.

April 21, 1990
46th pastoral visit outside Italy: Czechoslovakia (April 21–22)

May 6, 1990
47th pastoral visit outside Italy: to Mexico and Curacao (May 6–14).

May 25, 1990
48th pastoral visit outside Italy: to Malta (May 25–27).

September 1, 1990
49th pastoral visit outside Italy: to Tanzania, Burundi, Rwanda and Ivory Coast (September 1–10).

September 30, 1990
Eighth General Assembly of the Synod of Bishops on the theme: "The Formation of Priests in Circumstances of the Present Day" (September 30–October 28).

October 18, 1990
Promulgation of Code of Canons for Oriental Churches.

December 7, 1990
Eighth encyclical *Redemptoris Missio* (The Mission of the Redeemer), stressing the urgency of missionary evangelization.

1990
Diplomatic relations also established with: Bulgaria, Czech Republic, Romania, Saint Vincent and the Grenadines.

1991

January 15, 1991
Letter of John Paul II to US President George H. W. Bush and to President Saddam Hussein of Iraq, in an attempt to deter a Gulf War.

March 4–5, 1991
Meeting at the Vatican of episcopal representatives from the countries directly implicated in the Gulf War, including seven patriarchs.

April 4, 1991
Fourth Plenary Meeting of the College of Cardinals on the theme: "The Church facing the threat against human life and the challenge of the sects."

April 8, 1991
Meeting of the presidents of Episcopal Conferences (April 8–9), concerning the economic problems of the Holy See and the financial contribution of the bishops (Canon 1271, CIC).

May 1, 1991
Ninth encyclical *Centesimus Annus* (The Hundreth Year), commemorating 100 years of papal social teaching, beginning with Leo XIII's *Rerum Novarum* of 1891.

May 10, 1991
50th pastoral visit outside Italy: to Portugal (May 10–13).

June 1, 1991
51st pastoral visit outside Italy: to Poland (June 1–9).

June 28, 1991
Fifth consistory for the creation of 22 new cardinals. Cardinal Ignatius Kung Pin-Mei, named *in pectore* in 1979, made public.

August 13, 1991
52nd pastoral visit outside Italy: to Czestochowa, Krakow and Wadowice (Poland) for the 6th World Youth Day and to Hungary (August 13–20).

September 7, 1991
Holy See and Albania establish diplomatic ties.

October 5, 1991
Ecumenical prayer service at St. Peter's Basilica, on the occasion of the 6th centenary of the canonization of St. Brigit of Sweden. For the first time since the Reformation, two Lutheran bishops prayed in St. Peter's Basilica with the Pope, together with the Catholic bishops of Stockholm and Helsinki.

October 12, 1991
53rd pastoral visit outside Italy: to Brazil (October 12–21).

November 28, 1991
Special Assembly for Europe of the Synod of Bishops on the theme: "So that we might be witnesses of Christ who has set us free" (November 28–December 14).

December 12, 1991
Ecumenical prayer service in St. Peter's Basilica, on the occasion of the Special Assembly for Europe of the Synod of Bishops.

1991
Diplomatic relations also established with: Estonia, Latvia.

1992

January 12, 1992
Holy See announces its recognition of the sovereignty of Croatia and Slovenia.

February 8, 1992
Diplomatic relations with Croatia, Slovenia, Ukraine.

February 19, 1992
54th pastoral visit outside Italy: to Senegal, Gambia and Guinea (February 19–26).

March 11, 1992
Diplomatic relations with Kingdom of Swaziland.

April 4, 1992
Diplomatic relations with Mongolia.

April 7, 1992
Post-Synodal Apostolic Exhortation *Pastores Dabo Vobis* (Shepherds I Give You) published.

May 13, 1992
Institutes World Day for the Ill, to be celebrated annually on February 11.

May 23, 1992
Diplomatic relations with Armenia, Azerbaijan, Georgia and Moldova.

May 25, 1992
Visit to Pope by Anglican Archbishop of Canterbury George Carey.

June 1, 1992
Diplomatic relations with Republic of Nauru.

June 4, 1992
55th pastoral visit outside Italy: to Angola and São Tomé and Principe (June 4–10).

July 15, 1992
Holy Father undergoes colic resection surgery. His gallbladder is removed due to gallstones. John Paul II is released from Gemelli Hospital on July 28.

July 29, 1992
Holy See/Israel working commission formed.

August 1992
The Holy See and Kyrgyzstan establish diplomatic relations.

September 21, 1992
Diplomatic relations between Holy See and Mexico.

October 9, 1992
56th pastoral visit outside Italy: Santo Domingo, for the 5th centenary of evangelization of Latin America, and Fourth General Conference of the Latin American Episcopate (October 9–14).

October 17, 1992
Diplomatic relations with Kazakhstan, Uzbekistan.

November 11, 1992
Diplomatic relations with Belarus.

November 16, 1992
Apostolic Constitution *Fidei Depositum* (For New Catechism) is made public; *Catechism of the Catholic Church* presented in French edition.

December 7, 1992
John Paul II officially presents the *Catechism of the Catholic Church* to the College of Cardinals, the diplomatic corps, representatives from the Roman Curia, and to representatives of the doctrinal and catechetical commissions of episcopal conferences.

1992
Diplomatic relations also established with: Bosnia-Herzegovina, Switzerland.

1993

January 1, 1993
Holy See recognizes Czech Republic and Slovak Republic.

January 15, 1993
Motu Proprio Europae Orientalis, substituting a Permanent Interdicasterial Commission for the Church in Eastern Europe for the Pontifical Commission for Russia.

January 25, 1993
John Paul II announces new *Ecumenical Directory* for the application of the principles and norms of ecumenism.

February 3, 1993
57th pastoral visit outside Italy: to Khartoum, Benin, Uganda and Sudan (February 3–10). John Paul II announces that the Synod for Africa will be held in the Vatican in 1994.

April 25, 1993
58th pastoral visit outside Italy: to Albania. John Paul II ordains four bishops, restoring the hierarchy in a country that once declared itself officially atheist.

May 4, 1993
Pontifical Councils for Culture and for Dialogue with Non-believers are joined: new name is Pontifical Council for Culture.

May 25, 1993
Diplomatic relations with the Marshall Islands.

June 9, 1993
Patriarch of Ethiopian Orthodox Church His Holiness Abuna Paulos received by the Pope.

June 12, 1993
59th pastoral visit outside Italy: to Spain (June 12–17).

August 6, 1993
Tenth encyclical *Veritatis Splendor* (The Splendor of Truth); published October 5, 1993.

August 9–15, 1993
60th foreign pastoral visit: Jamaica, Mexico and Denver, for 8th World Youth Day.

September 4, 1993
61st pastoral visit outside Italy: to Lithuania, Latvia, Estonia (September 4–10). First ever visit by a pope to these countries.

November 11, 1993
Pope dislocates his right shoulder during a fall at the end of an audience in the Hall of Benediction. He spends one day at Gemelli Hospital; his shoulder is immobilized for one month.

December 26, 1993
Opening of the International Year of the Family of the Catholic Church.

December 30, 1993
Signing of the accord on basic principles regulating diplomatic relations between the Holy See and Israel.

1994

January 1, 1994
Motu Proprio Socialium Scientiarum Investigationes establishing Pontifical Academy of Social Sciences.

January 11, 1994
"Directives Concerning the Preparation of Seminary Educators" is released by Congregation for Catholic Education.

January 26, 1994
Diplomatic relations with Federated States of Micronesia.

February 2, 1994
Letter to Families, on the occasion of the International Year of the Family.

February 9, 1994
Motu Proprio Vitae Mysterium (The Mystery of Life) establishes Pontifical Academy for Life.

February 16, 1994
Diplomatic relations with Republic of Suriname.

March 3, 1994
Diplomatic relations with Hashemite Kingdom of Jordan.

March 5, 1994
Diplomatic relations with Republic of South Africa.

March 18, 1994
Letter of John Paul II to heads of states around the world and to the secretary general of the United Nations regarding the International Conference on Population and Development at Cairo, to be held in September 1994.

March 25, 1994
Diplomatic relations established with Cambodia.

April 7, 1994
Vatican concert for the commemoration of the Shoah, in the presence of John Paul II and Chief Rabbi of Rome, Elio Toaff.

April 10, 1994
Special Assembly for Africa of the Synod of Bishops on the theme: "The Church in Africa and Her Evangelizing Mission Towards the Year 2000: 'You Shall Be My Witnesses'" (April 10–May 8).

April 28, 1994
Holy Father falls, breaks femur. Goes to Gemelli Hospital the morning of April 29.

May 13, 1994
Holy Father institutes cloistered monastery within the Vatican.

May 22, 1994
Apostolic Letter to the bishops: *Ordinatio Sacerdotalis* (On Reserving Priestly Ordination to Men Alone).

June 2, 1994
Pope receives President Bill Clinton.

June 10, 1994
Diplomatic relations with Western Samoa.

June 13, 1994
Fifth plenary meeting of the College of Cardinals in preparation for the Jubilee of the Third Millennium.

June 15, 1994
Diplomatic relations at the level of apostolic nunciature and embassy between the Holy See and the State of Israel.

July 20, 1994
Diplomatic relations with Vanuatu.

July 24, 1994
Diplomatic relations with Kingdom of Tonga.

September 10, 1994
62nd pastoral visit outside Italy: to Zagreb, Croatia (September 10–11).

October 2, 1994
Ninth general assembly of the Synod of Bishops: "The Consecrated Life and Its Role in the Church and in the World" (October 2–29).

October 8, 1994
International Meeting of Families with the Holy Father honoring the International Year of the Family.

October 20, 1994
Publication of Pope John Paul's book *Crossing the Threshold of Hope*: 31 languages, 35 countries.

October 25, 1994
Beginning of working contacts of "permanent and official character" between the Holy See and the Palestine Liberation Organization, with a PLO office of representation to the Holy See and the nuncio of Tunisia responsible for contacts with the PLO.

November 10, 1994
Apostolic Letter *Tertio Millennio Adveniente* (As the Third Millennium Draws Near) to Bishops, Clergy and Lay Faithful on the Preparation for the Jubilee of the Year 2000.

November 26, 1994
Sixth consistory for the creation of 30 new cardinals from 24 countries.

December 13, 1994
Letter to Children in the Year of the Family.

December 21, 1994
Diplomatic ties established with Macedonia.

December 26, 1994
Pope John Paul II named Man of the Year by *Time Magazine*.

1995

January 11, 1995
63rd pastoral visit outside Italy: to Manila, the Philippines, for the celebration of 10th World Youth Day; to Port Moresby, Papua New Guinea; Sydney, Australia; and Colombo, Sri Lanka (January 11–21).

January 14, 1995
Message to Chinese Catholics, broadcast over *Radio Veritas* in Manila.

March 6–12, 1995
Holy See sends a delegation to the UN World Summit on Social Development in Copenhagen, Denmark.

March 25, 1995
Eleventh encyclical *Evangelium Vitae* (The Gospel of Life).

April 1995
Diplomatic relations with Kiribati.

May 2, 1995
Apostolic Letter *Orientale Lumen* for the centenary of *Orientalium Dignitas* of Pope Leo XIII.

May 8, 1995
Message on the Fiftieth Anniversary of the End of the Second World War in Europe.

May 20, 1995
Three-day pastoral visit to Czech Republic and Poland: 64th outside of Italy (May 20–22).

May 25, 1995
Twelfth encyclical *Ut Unum Sint* (That All May Be One).

May 26, 1995
Message to Gertrude Mongella, secretary general of UN's Fourth World Conference on Women, scheduled for September in Beijing, China.

June 3–4, 1995
Two-day trip to Belgium is 65th pastoral visit outside Italy: beatification of Father Damien de Veuster.

June 27, 1995
Ecumenical Patriarch Bartholomew I welcomed to Vatican.

June 29, 1995
Solemnity of Saints Peter and Paul, Apostles. Patriarch Bartholomew and the Holy Father give homilies in Saint Peter's Basilica, and sign Common Declaration. *Letter to Women* (made public on July 10).

June 30, 1995
66th pastoral visit outside Italy: Slovak Republic (June 30–July 3).

July 17, 1995
Theme announced for Jubilee Year 2000: "Jesus Christ—The Same Yesterday, Today, Always."

September 1995
Diplomatic relations with Namibia.

September 4–15, 1995
Holy See represented at the fourth UN Conference on Women, in Beijing, by Mary Ann Glendon of Harvard University, the first woman to head a Holy See delegation.

September 14, 1995
67th foreign pastoral visit: to Cameroon, Kenya, and South Africa for conclusion of Synod for Africa, September 14–20. In Yaoundé, Cameroon, the signing of the Post-Synodal Apostolic Exhortation *Ecclesia in Africa* (The Church in Africa), the first time a document is signed outside the Vatican.

October 4, 1995
68th pastoral visit outside Italy: to the USA (New York, Newark, Brooklyn, Baltimore). On Rome–NY flight, Pope crosses the 1 million kilometer mark (October 4–9).

October 5, 1995
Address to United Nations General Assembly, commemorating 50th anniversary of founding of UN.

November 26, 1995
Opening Mass in St. Peter's Basilica for Special Assembly for Lebanon of the Synod of Bishops (November 26–December 14).

December 1995
Diplomatic relations with Mozambique.

1995
Diplomatic relations also established with: Andorra, Eritrea.

1996

February 5, 1996
Departure for Latin America, 69th foreign visit: Guatemala, Nicaragua, El Salvador, Venezuela. Until February 12.

February 22, 1996
Apostolic Constitution *Universi Dominici Gregis* (On the Vacancy of the Apostolic See and the Election of the Roman Pontiff).

March 25, 1996
Post-Synodal Apostolic Exhortation *Vita Consecrata*.

April 14, 1996
One-day visit to Tunisia: 70th foreign trip.

May 17–19, 1996
71st trip abroad: to Slovenia.

June 1996
Diplomatic relations with Tajikistan established.

June 21–23, 1996
Departure for Germany, 72nd foreign trip.

July 1996
Diplomatic relations with Sierra Leone and Turkmenistan established.

September 6, 1996
Start of second papal trip to Hungary, and 73rd foreign apostolic visit. September 6–7.

September 19–22, 1996
Departure for France on 74th foreign trip.

October 8, 1996
Undergoes appendectomy at Gemelli Hospital. Returns to Vatican on October 15.

November 1, 1996
John Paul II marks 50 years of priestly ordination.

November 13, 1996
Address to World Food Summit at FAO headquarters, Rome.

November 15, 1996
Presentation of book, *Gift and Mystery: On the 50th Anniversary of My Priestly Ordination*.

November 19, 1996
Audience with President Fidel Castro of Cuba. Pope accepts invitation to visit in January 1998.

December 3, 1996
Message to the Church in China over Vatican Radio.

December 4–6, 1996
Visit by His Grace George Carey, Archbishop of Canterbury and Primate of the Anglican Communion.

December 6, 1996
Common Declaration signed by Pope, Anglican Primate.

December 10, 1996
Visit of His Holiness Karekin I Sarkassian, Supreme Patriarch and Catholicos of All Armenians.

December 13, 1996
Pope, Catholicos sign Common Declaration.

1997

January 14, 1997
Pope receives Lien Chan, vice president and prime minister of the Republic of China.

January 25, 1997
Meeting in Vatican with His Holiness Aram I, Catholicos of Cilicia of the Armenians. Signing of Common Declaration.

March 10, 1997
Holy See, Libya establish diplomatic ties.

March 12, 1997
Letter to UN Secretary-General Kofi Annan on situation in Zaire.

March 24, 1997
Vatican Web site debuts.

April 12–13, 1997
Two-day trip to Sarajevo: 75th foreign pastoral visit.

April 15, 1997
John Paul II welcomes UN Secretary General Kofi Annan.

April 25–27, 1997
Start of three-day pastoral visit to Czech Republic: 76th foreign trip.

May 10–11, 1997
Departure for two-day trip to Lebanon: 77th foreign pastoral trip.

May 31, 1997
Departure for Poland; until June 10. Pope's 78th foreign pastoral visit.

June 9, 1997
Diplomatic Relations with Cooperative Republic of Guyana.

June 26, 1997
Pope writes letters to Israeli Prime Minister Benjamin Netanyahu and to Yasser Arafat, president of the Palestinian Authority, in which he expresses concern for interrupted dialogue in Middle East peace process.

July 8, 1997
Holy See, Angola establish diplomatic relations.

July 17, 1997
Holy See approved as Observer to World Trade Organization.

July 18, 1997
Letter to Russian President Boris Yeltsin in which Pope expresses concern about a bill submitted to the Russian parliament "concerning freedom of conscience and religious associations."

July 22, 1997
Holy See signs United Nations conventional weapons ban.

August 21–24, 1997
Departure for Paris for 12th World Youth Day. This four-day trip is Holy Father's 79th foreign visit.

September 8, 1997
Apostolic Constitution *Laetamur Magnopere* (It Is a Cause of Great Joy) with which John Paul II promulgates the official Latin version of the *Catechism of the Catholic Church*.

October 2–5, 1997
Departure for four-day visit to Rio de Janeiro, Brazil, for Second World Meeting with Families. 80th foreign trip.

October 19, 1997
Pope proclaims Saint Therese of Lisieux, also known as Therese of the Child Jesus, Doctor of the Church. She is the 33rd person, the third woman (with St. Catherine of Siena and St. Teresa of Avila), and the youngest Doctor.

November 10, 1997
Holy See and Israel sign "Legal Personality Agreement."

November 16, 1997
Pope inaugurates Synod for America, presides at Eucharistic concelebration in St. Peter's Basilica (through December 12).

December 5, 1997
Holy See signs Convention banning land mines.

December 20, 1997
Papal letter to Cuban people on the occasion of Christmas and his forthcoming trip to their country.

1998

January 15, 1998
Communiqué announces Holy See-Palestinian Mixed Commission.

January 21–25, 1998
John Paul II's visit to Cuba, his 81st pastoral visit outside of Italy.

February 1, 1998
Holy Father visits Roman family in their home.

February 2, 1998
Pope John Paul presents new Apostolic Constitution *Ecclesia in Urbe* to Cardinal Ruini, vicar of Rome. Also, the celebration of the Second World Day for Consecrated Life.

February 15, 1998
Holy See nuncio to UN, Archbishop Renato Martino, conveys papal message to Secretary General Kofi Annan, encouraging him to undertake trip to Iraq to attempt to solve crisis developing there.

February 17, 1998
Holy See ratifies land mine convention.

February 21, 1998
Seventh consistory to create 20 new cardinals. Two additional cardinals held *in pectore*.

March 14, 1998
Pope signs Letter returning liturgical faculties to Syro-Malabar Church.

March 16, 1998
Presentation of Holy See document, "We Remember: A Reflection on the Shoah."

March 21–23, 1998
Holy Father leaves for Nigeria, 82nd foreign pastoral trip.

April 19, 1998
Opening of Synod for Asia (to May 14).

June 16, 1998
Pope receives UN Secretary General Kofi Annan. Holy See Permanent Observer to the United Nations, Archbishop Renato Martino, addresses the UN-sponsored conference in Rome for the establishment of an international criminal court.

June 19, 1998
Start of Pope's third trip to Austria: 83rd foreign apostolic visit. To June 21.

June 25, 1998
Presentation of Joint Declaration on Justification prepared by Pontifical Council for Promoting Christian Unity and Lutheran World Federation.

June 30, 1998
Publication of John Paul II's *Motu Proprio Ad Tuendam Fidem* (On Protecting the Faith).

July 7, 1998
Presentation of Apostolic Letter *Dies Domini* (On Keeping Holy the Lord's Day).

July 23, 1998
Publication of *Apostolos Suos* (His Apostles); Pope John Paul's Apostolic Letter issued *Motu Proprio On the Theological and Juridical Nature of Episcopal Conferences*. Dated May 21.

September 14, 1998
13th encyclical *Fides et Ratio* (Faith and Reason), published on October 15.

September 24, 1998
Holy See and Kazakhstan sign agreement on bilateral relations.

October 2, 1998
Departure for Croatia, 84th foreign pastoral visit (until October 4).

October 12, 1998
Diplomatic ties established between Holy See and Republic of Yemen.

November 22, 1998
Presides at the Special Assembly for Oceania of the Synod of Bishops (through Dec. 12.)

November 29, 1998
Proclamation of Bull of Indiction for the Holy Year 2000, during Mass in St. Peter's Basilica. Bull also sets forth the conditions for gaining the Jubilee indulgence.

1998
Diplomatic relations also established with: the Republic of Palau.

1999

January 22, 1999
Departs on 85th foreign pastoral visit, first to Mexico City for the formal close of the Synod for America and then on to St. Louis, Missouri. Signs and dates the Post-Synodal Apostolic Exhortation *Ecclesia in America* (The Church in America).

January 26, 1999
Meets President Clinton upon his arrival in St. Louis.

January 26, 1999
Presentation of new rite of exorcism of the Roman Book of Rites (from Congregation for Divine Worship and the Discipline of Sacraments).

January 28, 1999
Papal appeal for clemency saves life of prisoner Darrell Mease in United States.

March 1, 1999
Announcement that Pope has given permission to start the cause of beatification for Mother Teresa of Calcutta, dispensing from the norm which states that five years must pass between person's death and start of cause.

March 12, 1999
First bilateral accord between Holy See and Estonia is signed.

March 30, 1999
High level meeting in the Vatican studies the Kosovo crisis; includes ambassadors to the Holy See from NATO member countries and permanent members of the UN Security Council.

April 3, 1999
Pope John Paul's papacy, at 20 years and five months, becomes tenth longest in the history of the Church, surpassing Pope Leo III (795–816).

April 27, 1999
Pope writes UN Secretary General Kofi Annan on the eve of Annan's departure for Europe to seek peace in Yugoslavia.

May 7–9, 1999
Foreign pastoral visit to Romania is the Pope's 86th.

May 12, 1999
Anglican-Roman Catholic International Commission (ARCIC) document, "The Gift of Authority."

June 3, 1999
John Paul II receives UN Secretary General Kofi Annan.

June 5–17, 1999
Foreign pastoral visit to Poland is the Pope's 87th.

June 11, 1999
Warsaw, Poland: Pope's first-ever address to a Polish parliament.

June 12, 1999
Warsaw: Pope falls in nunciature, suffers cut on right temple.

June 15, 1999
Krakow: Pope, feverish, postpones day's engagements.

June 29, 1999
Holy Father's Letter on "Pilgrimages to the Places Linked to the History of Salvation" (published June 30). Patriarch Karekin I, Catholicos of all Armenians, dies. Pope's letter to patriarch, bearing the same date, is published July 8, day of funeral.

July 19 , 1999
Diplomatic Relations with the Lesser Antilles.

September 17, 1999
New *Enchiridion Indulgentiarum* (Manual of Indulgences) is presented.

September 19, 1999
One day apostolic trip to Slovenia, the Pope's 88th foreign pastoral visit.

October 1, 1999
Proclaims St. Edith Stein (Benedicta of the Cross), St. Bridget of Sweden, and St. Catherine of Siena as co-patronesses of Europe.

October 1–23, 1999
Presides over Second Special Assembly for Europe of the Synod of Bishops.

October 26, 1999
Publication of *The Letter of His Holiness John Paul II to the Elderly*.

October 31, 1999
Joint Declaration on the Doctrine of Justification signed in Augsburg, Germany, by representatives of the Catholic Church and World Lutheran Federation.

November 5–9, 1999
Leaves on 89th foreign pastoral visit to India and the Republic of Georgia.

November 23, 1999
Announcement that a joint team of Catholic and Jewish scholars will be formed to review published volumes of Church archival material covering the World War II period.

December 11, 1999
Inaugurates the completely restored Sistine Chapel.

December 24, 1999
John Paul II opens the Holy Door at St. Peter's Basilica, thereby beginning the Jubilee Year 2000.

2000

January 12, 2000
Diplomatic relations established with the State of Bahrain.

February 15, 2000
Basic Agreement is signed between the Holy See and the Palestinian Liberation Organization.

February 23, 2000
John Paul II presides over a Liturgy of the Word celebration in commemoration of Abraham. The event represented the first stage in the Pope's Jubilee Year pilgrimages to places linked with the history of salvation.

February 24–26, 2000
Foreign pastoral visit to Egypt, including Mount Sinai, is the Pope's 90th.

April 7, 2000
John Paul II receives UN Secretary General Kofi Annan.

March 7, 2000
Presentation of document by the International Theological Commission titled *Memory and Reconciliation: The Church and the Faults of the Past.*

March 20–26, 2000
Pilgrimage to the Holy Land, including Jordan, Israel, and the Palestinian Autonomous Territory, is the Pope's 91st foreign pastoral visit.

May 5, 2000
Three accords signed between the Holy See and Lithuania.

May 7, 2000
Pope presides at ecumenical celebration at the Colosseum for Witnesses to the Faith in the 20th Century.

May 12–13, 2000
Foreign pastoral visit to Fatima, Portugal, is the Pope's 92nd. Cardinal Secretary of State Angelo Sodano reads a text on the Third Secret of Fatima at the shrine on May 13, in anticipation of its publication in the near future.

May 20, 2000
Diplomatic relations established between the Holy See and Djibouti.

June 5, 2000
Audience for Russian President Vladimir Putin.

June 13, 2000
Mehmet Ali Agca, held in an Italian prison for the attempted assassination of John Paul II on May 13, 1981, is granted clemency by Italian President Carlo Ciampi, and extradited to his native Turkey.

June 15, 2000
Pope hosts lunch in Paul VI Hall for 200 poor and homeless as part of Jubilee Year celebrations.

June 26, 2000
Presentation of the Third Secret of Fatima.

July 9, 2000
Pope celebrates Mass in Rome's *Regina Coeli* prison as part of the Jubilee Day for Prisoners.

July 23, 2000
In reference to ongoing Middle East peace talks at Camp David, Maryland, the Pope repeats the Holy See's position that "only an internationally guaranteed special statute can effectively preserve the most sacred parts" of Jerusalem.

August 15, 2000
Celebration of the 15th World Youth Day in Rome.

September 5, 2000
Declaration *Dominus Iesus* "On the Unicity and Salvific Universality of Jesus Christ and the Church," prepared by the Congregation for the Doctrine of the Faith.

October 17, 2000
Visit of Queen Elizabeth II of England and Prince Philip, Duke of Edinburgh.

October 31, 2000
Proclamation of St. Thomas Moore as the Patron Saint of Statesmen and Politicians.

November 8, 2000
Karekin II, Catholicos of All Armenians, visits John Paul II. A joint communiqué signed November 11.

2001

January 6, 2001
Closing of the Holy Door to conclude the Great Jubilee of the Year 2000. The Apostolic Letter *Novo Millennio Ineunte* (At the Beginning of the Third Millennium) signed.

February 21, 2001
Eighth consistory for the creation of 42 new cardinals and publication of two cardinals named *in pectore* in 1998.

May 4–9, 2001
93rd foreign pastoral visit: to Greece, Syria and Malta in the footsteps of St. Paul the Apostle.

May 21, 2001
Sixth Extraordinary consistory of the College of Cardinals to reflect on the priorities of the Church in the Third Millennium.

June 23–27, 2001
Five-day visit to Ukraine is 94th foreign pastoral visit.

June 26, 2001
Papal message to UN Secretary General Kofi Annan for the UN special meeting on AIDS.

August 1, 2001
1000th General Audience.

September 22–27, 2001
Pastoral visit to Kazakhstan and Armenia is 95th foreign trip.

September 30, 2001
Tenth Ordinary General Assembly of the Synod of Bishops opens to discuss the theme "The Bishop: Servant of the Gospel of Jesus Christ for the Hope of the World." Concludes October 27.

November 18, 2001
Invitation to Catholics to fast on December 14 in response to the September 11 terrorist attacks. Leaders of the world's religions invited to a Day of Prayer for Peace at Assisi.

November 22, 2001
Apostolic Exhortation *Ecclesia in Oceania* (The Church in Oceania) signed; delivered to dioceses in Oceania by John Paul II via e-mail.

2002

January 23, 2002
Holy See consents to the "Convention on the Prohibition of the Development, Production and Stockpiling of Bacteriological and Toxin Weapons and on their Destruction."

January 24, 2002
Day of Prayer for Peace in the World at Assisi with members of other Churches and religious communities.

February 11, 2002
Elevated the four apostolic administrations of the Russian Federation to the rank of dioceses with a view to facilitating their pastoral activities.

February 20, 2002
The Pope decrees that, beginning in 2003, documents concerning Germany from the period 1922–1939 contained in the archives of the Section for Relations with States of the Secretariat of State and in the Secret Vatican Archives will be available for consultation.

February 28, 2002
Aleksander Kwasniewski, president of the Republic of Poland, received in audience.

March 3, 2002
Pope sends Assisi Decalogue for Peace to heads of state.

March 11, 2002
Pope receives members of the delegation of the Greek-Orthodox Church sent by His Beatitude Christodoulos, Archbishop of Athens and all Greece.

March 22, 2002
Third edition of the *Roman Missal* is presented.

March 25, 2002
Accord signed between the Holy See and the Republic of Albania regarding the regulation of reciprocal relations.

March 29, 2002
Pope John Paul's pontificate becomes the sixth longest in the history of the Church.

April 20, 2002
Declaration that the expulsion of Bishop Jerzy Mazur, SVD, from Russia represents a serious violation of the commitments undertaken by the Russian government.

April 23, 2002
Meeting of US Cardinals and the presidency of the US Conference of Catholic Bishops with members of the Roman Curia on the issue of sexual abuse of children by clergy. Pope declares there is "no place in priesthood for those who would harm the young." Meeting concludes April 24 with communiqué expressing solidarity with victims and pledging severity for offenders.

April 30, 2002
John Paul II names Cardinal Roger Etchegaray, president *emeritus* of the Pontifical Council for Justice and Peace, as his special envoy to Jerusalem amidst increasing Middle East violence.

May 2, 2002
Public release of the Apostolic Letter *Motu Proprio Misericordia Dei* (The Mercy of God) on certain aspects of the Celebration of the Sacrament of Penance.

May 10, 2002
Israeli Foreign Minister Shimon Peres visits Vatican.

May 22–26, 2002
Departs on a five-day pastoral visit to Azerbaijan and Bulgaria, his 96th foreign apostolic trip. The Catholic population of predominantly Muslim Azerbaijan numbers only 120 faithful, the smallest number of Catholics in a country visited by a Roman Pontiff; stays in a hotel, a papal first.

May 28, 2002
Receives President George W. Bush.

June 21, 2002
John Paul II receives the Archbishop of Canterbury, George Carey.

July 23, 2002
Departs on 97th apostolic trip outside of Italy, to Toronto for the World Youth Day, and subsequently to Guatemala City and Mexico City (July 31–August 1).

July 25, 2002
Signature of Accord between the Holy See and the Czech Republic on the regulation of reciprocal relations.

August 16–19, 2002
98th apostolic trip: to Poland.

October 12, 2002
Pope John Paul II and Patriarch Teoctist of the Orthodox Church of Romania sign a joint declaration.

October 16, 2002
Pope John Paul signs an apostolic letter dedicated to the Rosary, announces the addition of five new mysteries to this eight-century-old prayer, and declares October 2002 to October 2003 as the Year of the Rosary.

October 29, 2002
New Web site of the Vatican Apostolic Library presented.

October 31, 2002
John Paul II receives honorary Roman citizenship.

November 18, 2002
Diplomatic relations established between the Holy See and Qatar.

December 8, 2002
The revised "Essential Norms for Diocesan/Eparchial Policies Dealing with Allegations of Sexual Abuse of Minors by Priests or Deacons," presented by the US Conference of Catholic Bishops receives the recognition of the Holy See.

2002
Diplomatic relations also established with:
East Timor.

2003

January 16, 2003
"Doctrinal Note on the Participation of Catholics in Political Life," by the Congregation for the Doctrine of the Faith, is released.

February 6, 2003
Pope receives a delegation of the Serbian Orthodox Church.

February 10, 2003
Cardinal Roger Etchegaray, former president of the Pontifical Council for Justice and Peace, departs for Iraq as a special envoy of the Pope; meets with Iraqi President Saddam Hussein on February 15.

February 14, 2003
Audience for Tariq Aziz, vice prime minister of Iraq, regarding Iraq's compliance with United Nations resolutions and the threat of war with the United States.

February 18, 2003
Pope receives Kofi Annan, UN Secretary General.

March 5, 2003
Cardinal Pio Laghi, former apostolic nuncio to the United States and Pope John Paul II's personal envoy, meets with President George W. Bush to deliver a message from the Pope regarding the impending war with Iraq.

April 10, 2003
Series of Vatican Euro coins issued to commemorate the 25-year pontificate of Pope John Paul II.

April 17, 2003
Pope John Paul's 14th encyclical is published: *Ecclesia de Eucharistia* (Church of the Eucharist).

April 30*, 2003
Pope John Paul's papacy, at 24 years, six months, and eight days becomes the fourth longest in the history of the Church, surpassing that of Pope Pius VI (1775–1799).

May 3–4, 2003
Fifth pastoral visit to Spain, the 99th of his pontificate.

June 5–9, 2003
100th pastoral trip outside of Italy, to Croatia.

June 22, 2003
101st pastoral trip outside of Italy, to Bosnia.

* *This date is calculated from October 22, 1978, when Pope John Paul II's pontificate was formally inaugurated. Calculated from October 16, 1978, the date of his election as pope, John Paul became the fourth longest reigning pope on April 23, 2003.*

Adapted from materials prepared for John Paul II's pastoral visits to the United States in 1993 and 1995, from Vatican Information Service, and the Vatican Web site www.vatican.va.

Canonizations

1982

June 20, 1982
Crispin of Viterbo (1668–1750)

October 10, 1982
Maximilian Maria Kolbe, OFM (1894–1941)

October 31, 1982
Marguerite Bourgeoys (1620–1700)
Jeanne Delanoue (1666–1736)

1983

October 16, 1983
Leopold Mandic (1866–1942)

1984

March 11, 1984
Paula Frassinetti (1809–1882)

May 6, 1984
Andrew Kim and 102 Companions, Martyrs of Korea

October 21, 1984
Miguel Febres Cordero (1854–1910)

1986

April 13, 1986
Francis Anthony Fasani (1681–1742)

October 12, 1986
Giuseppe Maria Tomasi (1649–1713)

1987

October 18, 1987
Lawrence Ruiz (+1637)
Dominic Ibáñez de Erquicia, OP (1589–1633)
James Kyushei Tomonaga, OP, and
 13 Philippine Companions

October 25, 1987
Giuseppe Moscati (1880–1927)

1988

May 16, 1988
Martyrs of Paraguay:
 Roque González de Santa Cruz (1576–1628)
 Alfonso Rodríguez (+1628)
 Juan de Castillo, SJ (1596–1628)

June 11, 1988
Eustochia Smeraldo Calafato (1434–1485)

June 19, 1988
117 Martyrs of Vietnam (+1745–1862)

July 3, 1988
Simón de Rojas, O.SS. (1552–1624)
Rose–Philippine Duchesne (1769–1852)

October 2, 1988
Magdalen of Canossa (1774–1835)

December 11, 1988
Maria Rosa Molas y Vallvé (1815–1876)

1989

April 9, 1989
Clelia Barbieri (1847–1870)

November 1, 1989
Gaspar Bertoni (1777–1853)
Richard Pampuri, O.H. (1897–1930)

November 12, 1989
Agnes of Bohemia (1211–1282)
Brother Albert of Krakow (Adam Chmielowski)
 (1845–1916)

December 10, 1989
Mutien-Marie Wiaux, FSC (1841–1917)

1990

December 9, 1990
Marguerite d'Youville (1701–1771)

1991

November 17, 1991
Raphael Kalinowski, OCD (1835–1907)

1992

May 31, 1992
Claude La Colombière, SJ (1641–1682)

October 11, 1992
Ezequiel Moreno y Díaz (1848–1906)

1993

March 21, 1993
Mary of St. Ignatius (Claudine Thévenet) (1774–1837)
Sister Teresa de Jesus "de los Andes"
 (Juana Fernández Solar) (1900–1920)

June 16, 1993
Enrique de Ossó y Cercelló (1840–1896)

September 8, 1993
Saint Meinardo (1134/36–1196)

1995

May 21, 1995
Jan Sarkander (1576–1620)
Zdislava of Lemberk (1220–1252)

July 2, 1995
Martyrs of Kosice (+1619):
 Marek Krizin (1588–1619)
 Stefan Pongracz (1582–1609)
 Melichar Grodziecki, SJ (1584–1619)

December 3, 1995
Eugene de Mazenod (1782–1861)

1996

June 2, 1996
Jean-Gabriel Perboyre (1802–1840)
Egidio Maria of Saint Joseph
 (Francis Anthony Postillo) (1729–1812)
Juan Grande Román, O.H. (1546–1600)

1997

June 8, 1997
Hedwig, queen of Poland (1374–1399)

June 10, 1997
John of Dukla (1414–1484)

1998

October 11, 1998
Sister Teresa Benedicta of the Cross (Edith Stein)
(1891–1942)

1999

April 18, 1999
Marcellin Joseph Benoît Champagnat (1789–1840)
John Calabria (1873–1954)
Agostina Livia Pietrantoni (1864–1894)

June 16, 1999
Sister Kunegunda Kinga (1234–1292)

November 21, 1999
Brother Cyrill Bertrán and 8 Companions (+1934)
Inocencio de la Inmaculada (+1937)
Benedict Menni, OH (1841–1914)
Thomas of Cori, OFM (1655–1729)

2000

April 30, 2000
Mary Faustina Kowalska (1905–1938)

May 21, 2000
Cristóbal Magallanes Jara (1869–1927)
Román Adame Rosales
Rodrigo Aguilar Aleman
Julio Álvarez Mendoza
Luis Batis Sáinz
Agustín Caloca Cortés
Mateo Correa Megallanes
Atilano Cruz Alvarado
Miguel De La Mora De La Mora
Pedro Esqueda Ramírez
Margarito Flores García
José Isabel Flores Varela
David Galván Bermudes
Salvador Lara Puente
Pedro de Jesús Maldonado Lucero
Jesús Méndez Montoya
Manuel Morales
Justino Orona Madrigal
Sabas Reyes Salazar
José María Robles Hurtado
David Roldán Lara
Toribio Romo González

Jenaro Sánchez Delgadillo
Tranquilino Ubiarco Robles
David Uribe Velasco
José Maria de Yermo y Parres (1851–1904)
María de Jesús Sacramentado Venegas (1868–1959)

October 1, 2000
Augustine Chao (+1815) and 119 companions,
 Martyrs of China
María Josefa of the Heart of Jesus Sancho de Guerra
 (1842–1912)
Katharine Drexel (1858–1955)
Josephine Bakhita (1869–1947)

2001

June 10, 2001
Luigi Scrosoppi (1804–1884)
Agostino Roscelli (1818–1902)
Bernard of Corleone (1605–1667)
Teresa Eustochio Verzeri (1801–1852)
Rafqa Pietra Choboq Ar-Rayès (1832–1914)

November 25, 2001
Joseph Marello (1844–1895)
Paula Montal Fornés de San José de Calasanz
 (1799–1889)
Léonie Françoise de Sales Aviat (1844–1914)
Maria Crescentia Höss (1682–1744)

2002

May 19, 2002
Alphonsus de Orozco, OSA (1500–1591)
Ignatius of Santhià, OFMCap (1686–1770)
Humilis of Bisignano, OFM (Luke Anthony Pirozzo)
 (1582–1637)
Pauline of the Heart of Jesus in Agony
 (Pauline Amabilis Visenteiner) (1865–1942)
Benedicta Cambiagio Frassinello (1791–1858)

June 16, 2002
Padre Pio da Pietrelcina, OFMCap (Francisco Forgione)
 (1887–1968)

July 30, 2002
Pedro de San José de Betancourt (1887–1968)

July 31, 2002
Juan Diego Cuauhtlatohuac (1474–1548)

October 6, 2002
Josemaría Escrivá de Balaguer (1902–1975)

2003

May 4, 2003
Father Pedro Poveda Castroverde (1874–1936)
Father Jose Maria Rubio y Peralta, SJ (1864–1922)
Genoveva Torres Morales (1870–1956)
Angela of the Cross (Maria Guerrero Gonzalez)
 (1846–1931)
Maria Maravaillas de Jesus Pidal y Chico de Guzman
 (1891–1974)

May 18, 2003
Bishop Joseph Sebastian Pelczar (1842–1924)
Ursula Ledochowska (1865–1939)
Maria de Mattias (1805–1866)
Virginia Centurione Bracelli (1587–1651)

October 5, 2003
Bishop Daniele Comboni (1831–1881)
Father Arnold Janssen (1837–1909)
Father Joseph Freinademetz, SVD (1851–1908)

Beatifications

1979

February 24, 1979
Margaret Ebner (cult confirmed)

April 29, 1979
Francis Coll, OP
Jacob Desiré Laval

October 14, 1979
Henry de Ossó y Cervelló

1980

June 22, 1980
Joseph de Anchieta
Brother Peter of St. Joseph Betancur
Bishop Francis de Montmorency-Laval
Kateri Tekakwitha
Marie of the Incarnation (Marie Guyart)

October 26, 1980
Father Luigi Orione
Bartholomew Longo
Maria Anna Sala

1981

February 18, 1981
16 Martyrs of Japan:
 Lawrence Ruiz
 Anthony González
 Dominic Ibañez de Eriquicia
 Francis Shoyemon
 James Gorobiyoye
 Jordan Ansalone
 Lazarus of Kyoto
 Luke Alonso
 Marina of Omura
 Mary-Magdalen of Nagasaki
 Matthew Kohiyoye
 Michael de Aozaraza
 Michael Kurobioye
 Thomas Rokuzayemon
 Vincent Shiwozuka
 William Courtet

October 4, 1981
Maria Repetto
Bishop Alanus de Solminihac
Richard Pampuri

Mary of St. Ignatius (Claudine Thévenet)
Luigi Scrosoppi of Udine

1982

May 23, 1982
Peter Donders
Marie Rose Durocher
Brother André Bessette
Maria Angela Astorch
Marie Anna Rivier

October 3, 1982
Fra Angelico
Marie of the Cross (Jeanne Jugan)
Salvatore of Cappadocia, OFM (Salvatore Lilli)
 and 7 Armenian Companions

November 5, 1982
Sister Angela of the Cross
 (Maria Guerrero y González)

1983

January 25, 1983
María Gabriella Sagheddu

May 15, 1983
Bishop Luigi Versiglia
Callisto Caravario

June 20, 1983
Ursula Ledóchowska

June 22, 1983
Father Raphael (Josef Kalinowski)
Brother Albert (Adam Chmielowski), TOR

October 30, 1983
Jacob Cusmano
Jeremiah of Valachia (John Kostistk)
Father Dominic of the Most Blessed Sacrament
 (Dominic Iturrate Zubero)

November 13, 1983
María of Jesus Crucified (María Bouardy)

1994

February 19, 1984
Father William Repin and 98 Companions
 (Martyrs of Avrillé during French Revolution)
John Baptist Mazzucconi

September 11, 1984
Marie-Leonie (Alodie Virginia Paradis)

September 30, 1984
Frederick Albert
Clemente Marchisio
Isidore of St. Joseph (Isidore de Loor)
Rafaela Ybarra

November 25, 1984
Joseph Manyanet y Vives
Daniel Brottier
Sister Elizabeth of the Trinity (Elizabeth Catez)

1985

February 1, 1985
Mercedes of Jesus (Mercedes Molina)

February 2, 1985
Anna of the Angels (Anna Monteagudo)

April 14, 1985
Pauline von Mallinckrodt
Maria Catherine of St. Rose (Constance Troiani)

June 23, 1985
Benedict Menni
Peter Friedhofen

August 15, 1985
Sister Maria Clementine (Anuarite Nengapete)

September 22, 1985
Virginia Centurione Bracelli

October 6, 1985
Diego Luis de San Vitores
Joseph Maria Rubio y Peralta
Francis Gárate

November 3, 1985
Titus Brandsma

November 17, 1985
Pius of St. Aloysius Gonzaga (Luigi Campidelli)
Maria Theresa of Jesus (Caroline Gerhardinger)
Rafqa Petra Ar-Rayès

1986

February 8, 1986
Alphonsa of the Immaculate Conception
 (Anna Muttathupandatu)
Cyriac Elias Chavara

October 4, 1986
Anthony Chevrier

October 19, 1986
Teresa Maria of the Cross (Teresa Manetti)

1987

March 29, 1987
Martyrs of Guadalajara:
 María Pilar of St. Francis Borgia (Jacoba García)
 María of the Angels of St. Joseph
 (Marciana Valtierra Tordesillas)
 Teresa of the Child Jesus and St. John of the Cross
 (Eusebia Garcia y Garcia)
 Cardinal Marcellus Spinola y Maestre
 Manuel Domingo y Sol

April 3, 1987
Sister Teresa of Jesus "de los Andes"
 (Juana Fernández Solar)

May 1, 1987
Sister Teresa Benedicta of the Cross (Edith Stein)

May 3, 1987
Rupert Mayer

May 10, 1987
Peter Francis Jamet
Cardinal Andreas Carlo Ferrari
Benedicta Cambiagio Frassinello
Bishop Louis Moreau

June 10, 1987
Caroline Kózka

June 14, 1987
Bishop Michael Kozal

June 28, 1987
Archbishop George Matulaitis (Matulewicz)

October 4, 1987
Marcel Callo
Pierina Morosini
Antonia Mesina

November 1, 1987
Sister Blandina (Maria Magdalena Merten)
Ulricha (Francisca Nisch)
Brother Arnold (Jules Rèche)

November 22, 1987
George Haydock and 84 Companions, Martyrs of
 England, Scotland and Wales (1584–1689)

1988

April 17, 1988
John Calabria
Joseph Nascimbeni

April 24, 1988
Peter Bonilli
Gaspar Stangassinger
Father Francis Palau Y Quer
Savina Petrilli

September 3, 1988
Laura Vicuña

September 15, 1988
Joseph Gérard

September 25, 1988
Father Miguel Pro
Cardinal Joseph Benedetto Dusmet
Francis Fa'a di Bruno
Junipero Serra
Frederick Jansoone
Josepha Naval Girbés

October 16, 1988
Bernard Maria of Jesus (Cesare Silvestrelli)
Charles of St. Andrew (John Andrew Houben)
Honorat a Biala (Wenceslaus John Kozminski)

October 23, 1988
Bishop Nicolaus Stensen

November 20, 1988
Katharine Drexel
3 Missionary Martyrs of Ethiopia:
 Father Liberatus Weiss
 Father Samuel Marzorati
 Father Michele Pio

1989

April 23, 1989
Father Martin of St. Nicholas Lumbreras
Father Melchior Sánchez
Mother Maria of Jesus the Good Shepherd
 (Frances Siedliska)
Maria Margaret (Marianna Rosa Caiani)
Marie Catherine of St. Augustine
 (Marie Catherine Simon de Longpré)

April 30, 1989
Victoria Rasoamanarivo

May 2, 1989
Brother Scubilion (Jean-Bernard Rousseau)

June 18, 1989
Elizabeth Rienzi
Bishop Anthony Lucci

October 1, 1989
Passionist Martyrs of the Spanish Civil War:
 Father Niceforo of Jesus and Mary
 (Vicente Tejerina)
 José Estalayo Garcia
 Epifanio Sierra Conde
 Fulgencio Calvo Sanchez
 Abilio Ramos y Ramos
 Zacarias Fernandez Crespo
 Father Germano Perez Gimincz
 Father Felipe Valcabado Granada
 Brother Anacario Benito Nozal
 Brother Felipe Ruiz Fraile
 Maruilio Macho Rodriguez
 José Oses Sainz
 Julio Mediavilla Concejero
 José Ruiz Martínez
 Laurino Proano Cuesta
 Father Pedro Lergo Redondo
 Brother Benito Solana Ruiz
 Feliz Ugalde Iruzun
 Father Juan Pedro Bengoa Aranguren
 Brother Pablo Leoz Portillo
 Father Ildefonso Garcia Nozal
 Father Justiniano Cuesta Redondo
 Enfracio de Celis Salinas
 Tomas Cuartero Garcia
 Honorino Carracedo Ramos
 José Cuartero Garcia
Lorenzo Maria of St. Francis Xavier (Lorenzo Salvi)
Gertrude Caterina Comensoli
Frances Anne Carbonell

October 22, 1989
7 Martyrs from Thailand:
 Philip Siphong
 Sister Agnes Phila
 Sister Lucia Khambang
 Agatha Phutta
 Cecilia Butsi
 Bibiana Khampai
 Maria Phon
Marie of Jesus (Marie Deluil-Martiny)

October 31, 1989
Joseph Baldo

1990

April 29, 1990
9 Martyrs of Astoria during Spanish Civil War:
 Brother Cyrill Bertran (Juan Sanz Tejedor)
 Father Innocencio Inmaculada
 (Manuel Canoura Aranu)
 Adolf Seco Gutierrez
 Andrew Martín Fernandez
 Valdivieso Saez
 Julian Alfonsus Andrés
 Alfred Fernández Zapico
 Joseph López López
 Pius Bernabé Cano
Mercedes Prat y Prat
Brother James Hilarius (Emmanuel Barbal Cosan)
Filippo Rinaldi

May 6, 1990
Juan Diego
Three Child Martyrs (Cristopher, Anthony and John)
José Maria de Yermo y Parres

May 20, 1990
Pier George Frassati

October 7, 1990
Hannibal Maria Di Francia
Joseph Allamano

November 4, 1990
Marthe (Anna Le Bouteiller)
Louisa Montaignac de Chauvance
Maria of the Sacred Heart (Maria Schinina)
Elizabeth Vendramini

1991

April 21, 1991
Annunciata Cocchetti
Marie Thérèse of the Sacred Heart of Jesus
 (Marie Thérèse Haze)
Chiara Bosatta de Pianello

June 2, 1991
Bishop Joseph Sebastian Pelczar

June 5, 1991
Boleslawa Maria Lament

June 9, 1991
Rafael Melchior Chyliński

July 6, 1991
John Duns Scotus (decree on cult)

July 14, 1991
Bishop Edward Joseph Rosaz

August 13, 1991
Angela Salawa

October 18, 1991
Sister Pauline of the Heart of Jesus in Agony
 (Pauline Amabilis Visenteiner)

October 27, 1991
Adolph Kolping

1992

May 17, 1992
Josephine Bakhita
Josemaria Escrivá de Balaguer

June 21, 1992
Francis Spinelli

September 27, 1992
17 Irish Martyrs:
 Archbishop Dermot O'Hurley
 Bishop Patrick O'Healey, OFM
 Father Conrad O'Rourke, OFM
 Matthew Lambert
 Robert Meyler
 Edward Cheevers
 Patrick Cavanaugh
 Margaret Bermingham
 Maurice McKenraghty
 Brother Dominic Collins, SJ
 Bishop Conor O'Devany, OFM
 Patrick O'Loughbrain
 Father Peter Higgins, OP
 Bishop Terence Albert, OP
 Father John Kearney, OFM
 Father William Tirry, OSA
 Francis Taylor
Rafael Arnáiz Barón
Nazaría Ignacia of St. Teresa of Jesus March Mesa
Mother Francisca Salesia (Leonia Aviat)
Maria of the Heart of Jesus
 (Maria Josefa Sancho de Guerra)

October 25, 1992
122 Martyrs of Spanish Civil War:
 Braulius Maria Corres Díaz de Cerio
 Frederick Rubio Alvarez and 69 Companions
 Philip of Jesus Munárriz Azcona and
 50 Companions
Narcisa of Jesus Martillo Morán

November 22, 1992
Christopher Magellánes and 24 companions,
 Mexican martyrs
María de Jesús Sacramentado
 (María Venegas de la Torre)

1993

March 20, 1993
Maria of St. Cecilia of Rome (Dina Belanger)

March 20, 1993
John Duns Scotus (cult solemnly recognized)

April 18, 1993
Mother Angela Maria (Sophia Camilla Truszkowska)
Father Louis of Casoria (Arcangelo Palmentieri)
Sister Maria Faustina (Helena Kowalska)
Paula of St. Joseph of Calasanz (Paula Montal)

April 18, 1993
Stanislaus Kazimierczyk (cult solemnly recognized)

May 16, 1993
Maurice Tornay
Marie Louise of Jesus (Marie-Louise Trichet)
Columba Joanna Gabriel
Florida (Lucrezia Elena Cevoli)

September 26, 1993
Bishop Joseph Marello

October 10, 1993
Martyrs of Almeria, Spain:
 Bishop Diego Ventaja Milán
 Bishop Emmanuel Medina Olmos
 Brother Emigio Rodríguez
 Brother Amalio Mendoza
 Brother Valerio Bernardo Martinez
 Brother Evencio Ricardo Uyarra
 Brother Teodomiro Joaquin Säiz
 Brother Aurelio María Acebrón
 Brother José Cecilio Gonzalez
Victoria Diez y Bustos de Molina
María Francesca of Jesus (Anna Maria Rubatto)
Pedro Poveda Castroverde
Maria Crucified (Elizabeth Maria Satellico)

1994

April 24, 1994
Isidore Bakanja
Elizabeth Canori Mora
Joanna Beretta Mola

October 16, 1994
Nicholas Roland
Alberto Hurtado Cruchaga
María Rafols
Petra of St. Joseph (Anna Petra Perez Florida)
Josephine Vannini

November 5, 1994
Magdalena Catherine Morano

November 20, 1994
Hyacinthe Marie Cormier
Marie Poussepin
Agnes of Jesus Galand de Langeac
Eugénie Joubert
Claudius Granzotto

1995

January 17, 1995
Peter ToRot

January 19, 1995
Mary of the Cross (Mary Helen MacKillop)

January 21, 1995
Joseph Vaz

January 29, 1995
Rafael Guízar Valencia
Modestino of Jesus and Mary (Dominic Mazzarella)
Genoveva Torres Morales
Grimoaldo (Ferdinand Santamaria)

April 30, 1995
Bishop John von Tschiderer von Gleifheim

May 7, 1995
Maria Helena Stollenwerk
Maria of St. Joseph (Laura Alvorado Cordozo)
Giuseppina Bonino
María Domenica Brun Barbantini
Augustine Roscelli

June 4, 1995
Damien de Veuster

October 1, 1995
Carlos Eraña Guruceta
Fidel Fuido
Jesús Hita
Dionysius Pamplona
Father Emmanuel Segura
Brother David Carlos
Father Enrico Canadell
Father Faustino Oteiza
Florentino Felipe
Father Matteas Cardona
Father Fracesco Carceller
Ignazio Casanovas
Father Carlo Navarro
Father José Ferrer
Father Juan Agramunt
Father Alfredo Parte
Father John Baptist Souzy and 63 Companions
Father Peter Ruiz de los Paños y Angel and
 8 Companions
Mother Angela of St. Joseph (Francisca Martí) and
 16 Companions

Vincente Vilar David
Bishop Anselm Polanco Fontecha
Father Felipe Ripoll Morata
Father Pietro Casani

October 29, 1995
Sister Maria Theresa (Anna Maria Catherine Scherer)
Sister María Bernarda Butler
Marguerite Bays

1996

March 17, 1996
Bishop Daniel Comboni
Archbishop Guido Maria Conforti

May 12, 1996
Cardinal Ildefonso Schuster, OSB
Father Filippo Smaldone
Father Gennaro Maria Sarnelli
Mother Candida Maria of Jesus
 (Juana Josepha Cipitria y Barriola)
Sister Maria Raffaella Cimatti
Mother María Antonia Bandrés y Elósegui

June 23, 1996
Father Bernard Lichtenburg
Father Karl Leisner

October 6, 1996
Vincent Lewoniuk and 12 Companions
Edmund Ignatius Rice
Sister María Anna Mogas Fontcuberta
Maria Marcellina Darowska

November 24, 1996
Father Otto Neururer
Father Jacob Gapp
Catherine Jarrige

1997

May 4, 1997
Bishop Florentino Asensio Barrosa
Sister María Encarnación (Vicenta Rosal)
Father Gaetano Catanoso
Father Enrico Rebuschini
Ceferino Giménez Malla (first gypsy beatified)

June 6, 1997
Maria Bernardina Jablonska
Sister Maria Karlowska

August 22, 1997
Frederick Ozanam

September 27, 1997
Father Bartholomew Maria Dal Monte

October 12, 1997
Father Elías del Socorro Nieves
Father Domenic Lentini
Father John Piamarta
Sister Mary of Jesus
 (Emilie Van der Linden d'Hooghvorst)
Mother Maria Teresa Fasce

November 9, 1997
Bishop John Baptist Scalabrini
Bishop Vilmos Apor
María Vicenta of St. Dorothy Chávez Orozco

1998

March 15, 1998
Bishop Vincent Eugene Bossilkov
María of Mt. Carmel
 (Carmen Francisca Rosa Sallés y Baranqueras)
Sister Brigida of Jesus Morello

March 22, 1998
Father Cyprian Tansi

May 10, 1998
Father Nimatullah Youssef Kassab al-Hardini
Visitation Order Martyrs of the Spanish Civil War:
 Sister Maria Gabriela de Hinojosa Naveros
 Sister Josefa María Barrera Izaguire
 Sister Teresa María Cavestany y Anduaga
 Sister María Angela Olaizola Garagarza
 Sister María Engracia Lecuona Aramburu
 Sister María Inés Zudaire Galdeano
 Sister María Cecilia Cendoya Araquistain
Sister María Maravaillas de Jesus Pidal y
 Chico de Guzmán
Sister Maria Sagrario of St. Aloysius Gonzaga
 (Elvira Moragas Cantarero)
Sister Rita Dolores Pujatte Sánchez
Sister Frances of the Sacred Heart of Jesus
 (Aldea Araujo)

May 23, 1998
Father Secondo Pollo

May 24, 1998
Father John Maria Boccardo
Teresa Grillo
Teresa Bracco

June 21, 1998
Father Jacob Kern
Sister Maria Restituta (Helena Kafka)
Father Anton Maria Schwartz

September 20, 1998
Giuseppe Tovini

October 3, 1998
Cardinal Aloysius Stepinac

October 25, 1998
Father Antõnio de Sant'Anna Galvão
Father Faustino Míguez
Father Zeferino Agostini
Mother Theodore (Anna Thérésè Guérin)

1999

March 7, 1999
Vicente Soler and 6 Augustinian Recollect
 Companions
Father Manuel Martín Sierra
Father Nicolas Barré
Anna Schaeffer

May 2, 1999
Padre Pio of Pietrelcina (Francisco Forgione)

June 7, 1999
Father Stefan Wincenty Frelichowski

June 13, 1999
Archbishop Antony Nowowiejski
Henricus Kaczorowski
Anicetus Koplinski
Maria Anna Biernacka and 104 Companions
Sister Regina Protmann
Edmund Bojanowski

September 19, 1999
Bishop Anton Martin Slomsek

October 3, 1999
Father Ferdinando Maria Baccilieri
Father Edward Maria Joannes Poppe
Father Arcangelo Tadini
Mariano da Roccacasale
Diego Oddi
Nicola da Gesturi

2000

March 5, 2000
André de Soveral
Ambrósio Francisco Ferro and 28 Companions
Nicolas Bunkerd Kitbamrung
Maria Stella Mardosewicz and 10 Companions
Pedro Calungsod
Andrew of Phú Yên

April 9, 2000
Father Mariano de Jesus Euse Hoyos
Father Francis Xavier Seelos
Sister Anna Rosa Gattorno
Sister Maria Elizabeth Hesselblad
Sister Mariam Thresia Chiramel Mankidiyan

May 13, 2000
Jacinta and Francisco Marto of Fatima

September 3, 2000
Pope Pius IX (Giovanni Maria Mastai Ferretti)
Pope John XXIII (Angelo Giuseppe Roncalli)
Bishop Tommaso Reggio
Father William Joseph Chaminade
Columba Marmion

2001

March 11, 2001
Father José Aparicio Sanz and 232 Companions of
 the Spanish Civil War

April 29, 2001
Bishop Manuel Gonzalez Garcia
Marie-Anne Blondin
Caterina Volpicelli
Caterina Cittadini
Carlos Manuel Cecilio Rodriguez Santiago

May 9, 2001
Father George Preca
Ignatius Falzon
Sister Maria Adeodata Pisani

June 27, 2001
28 Ukrainian Martyrs:
 Mykola Carneckyj and 24 Companions
 Bishop Teodor Romza
 Father Omeljan Kovc
 Josaphata Hordashevska

October 7, 2001
Bishop Ignatius Maloyan
Nicholas Gross
Father Alfonso Maria Fusco
Father Tommaso Maria Fusco
Emilie Tavernier Gamelin
Eugenia Picco
Maria Euthymia Uffin

October 21, 2001
Luigi Beltrame Quattrocchi
Maria Corsini

November 4, 2001
Bishop Pavol Peter Gojdic
Father Metod Dominik Trcka
Bishop Giovanni Antonio Farina
Archbishop Bartolomeu Fernandes dos Mártires
Father Luigi Tezza
Paolo Manna
Gaetana Sterni
Maria Pilar Izquierdo Albero

2002

April 14, 2002
Father Gaetano Errico
Father Lodovico Pavoni
Father Luigi Variara
Sister Maria del Transito de Jesus Sacramentado
Bishop Artemide Zatti
Sister Maria Romero Meneses

May 26, 2002
Father Kamen Vitchev
Father Pavel Djidjov
Father Josaphat Chichkov

August 1, 2002
Juan Bautista
Jacinto de Los Angeles

August 18, 2002
Archbishop Sigmund Felinski
Father John Balicki
Father John Beyzym
Sister Santia Szymkowiak

October 20, 2002
Daudi Okelo
Jildo Irwa
Bishop Andrea Giacinto Longhin
Father Marcantonio Durando
Sister Mary of the Passion
 (Helene Marie de Chappotin de Neuville)
Sister Liduina Meneguzzi

2003

March 23, 2003
Father Pierre Bonhomme
Sister Dolores Rodriguez Sopena
Sister Maria Caridad Brader
Sister Juana Maria Condesa Lluch
Laszlo Batthyany-Strattmann

April 27, 2003
Father Giacomo Alberione
Father Marco d'Aviano
Maria Cristina Brando
Eugenia Ravasco
Maria Domenica Mantovani
Julia Salzano

June 6, 2003
Sister Marija of Jesus Crucified Petkovic

Journeys Outside of Italy

Numerals in gray denote numeric sequence of trips

1979

1 **January 25–February 1**
Dominican Republic, Mexico, with a stopover in the Bahamas

2 **June 2–10**
Poland

3 **September 29–October 7**
Ireland and the United States. The US leg of the trip began October 1.

4 **November 28–30**
Turkey

1980

5 **May 2–12**
Zaire, Congo, Kenya, Ghana, Upper Volta (now Burkina Faso) and Ivory Coast

6 **May 30–June 2**
France

7 **June 30–July 12**
Brazil

8 **November 15–19**
West Germany

1981

February 16–27
Philippines, Guam, and Japan, with stopovers of several hours in Pakistan and in Anchorage, Alaska

1982

February 12–19
Nigeria, Benin, Gabon, and Equatorial Guinea

May 12–15
Portugal (including Fatima)

May 28–June 2
Great Britain

June 10–13
Argentina (stopover in Rio de Janeiro, Brazil)

June 15
Switzerland

15 **August 29**
San Marino

16 **October 31–November 9**
Spain

1983

17 **March 2–10**
Costa Rica, Nicaragua, Panama, El Salvador, Guatemala, Belize, Honduras, Haiti (stopover in Lisbon, Portugal)

18 **June 16–23**
Poland

19 **August 14–15**
Lourdes, France

20 **September 10–13**
Austria

1984

21 **May 2–12**
South Korea, Papua New Guinea, Solomon Islands, Thailand (stopover in Fairbanks, Alaska)

22 **June 12–17**
Switzerland

23 **September 9–20**
Canada

24 **October 10–12**
Spain, Dominican Republic, Puerto Rico

1985

25 **January 26–February 6**
Venezuela, Ecuador, Peru, Trinidad and Tobago

26 **May 11–21**
Belgium, the Netherlands, Luxembourg

27 **August 8–19**
Togo, Ivory Coast, Cameroon, Central African Republic, Zaire, Kenya, Morocco

28 **September 8**
Liechtenstein

1986

29 **February 1–February 10**
India

30 **July 1–8**
Colombia, St. Lucia

31 **October 4–7**
France

32 **November 19–December 1**
Australia, New Zealand, Bangladesh, Fiji, Singapore, Seychelles

1987

33 **March 31–April 13**
Uruguay, Chile, Argentina

34 **April 30–May 4**
West Germany

35 **June 8–14**
Poland

36 **September 10–20**
United States and Canada

1988

37 **May 7–18**
Uruguay, Bolivia, Peru, Paraguay

38 **June 23–27**
Austria

39 **September 10–19**
Zimbabwe, Botswana, Lesotho, Swaziland, Mozambique, with a detour through South Africa

40 **October 8–11**
France

1989

41 **April 28–May 6**
Madagascar, Reunion, Zambia, and Malawi

42 **June 1–10**
Norway, Iceland, Finland, Denmark, Sweden

43 **August 19–21**
Spain

44 **October 6–16**
South Korea, Indonesia, East Timor, Mauritius

1990

45 **January 25–February 1**
Cape Verde, Guinea Bissau, Mali, Burkina Faso, Chad

46 **April 21–22**
Czechoslovakia

47 **May 6–13**
Mexico, Curacao

48 **May 25–27**
Malta

49 **September 1–10**
Tanzania, Rwanda, Burundi, Ivory Coast

1991

50 **May 10–13**
Portugal

51 **June 1–9**
Poland

52 **August 13–20**
Poland, Hungary

53 **October 12–21**
Brazil

1992

54 **February 19–26**
Senegal, Gambia, Guinea

55 **June 4–10**
Angola, São Tomé, Principe

56 **October 9–14**
Dominican Republic

1993

57 **February 3–10**
Benin, Uganda, Sudan

58 **April 25**
Albania

59 **June 12–17**
Spain

60 **August 9–16**
Jamaica, Mexico, United States
(World Youth Day held in Denver)

61 **September 4–10**
Lithuania, Latvia, Estonia

1994

62 **September 10–11**
Croatia

1995

63 **January 12–21**
Philippines, Australia, Papua New Guinea, Sri Lanka

64 **May 20–22**
Czech Republic, Poland

65 **June 3–4**
Belgium

66 **June 30**
Slovakia

67 **September 14–20**
Cameroon, Kenya, South Africa

68 **October 4–8**
United States

1996

69 **February 5–12**
Guatemala, El Salvador, Nicaragua, Venezuela

70 **April 14**
Tunisia

71 **May 17–19**
Slovenia

72 **June 21–23**
Germany

73 **September 6–7**
Hungary

74 **September 19–22**
France

1997

75 **April 12–13**
Sarajevo, Bosnia-Herzegovina

76 **April 25–27**
Czech Republic

77 **May 10–11**
Lebanon

78 **May 31–June 10**
Poland

79 **August 21–24**
France

80 **October 2–5**
Brazil

1998

81 **January 21–25**
Cuba

82 **March 21–23**
Nigeria

83 **June 19–21**
Austria

84 **October 2–4**
Croatia

1999

85 **January 22–25**
Mexico City, Mexico

January 26–27
St. Louis, Missouri

86 **May 7–9**
Romania

87 **June 5–17**
Poland

88 **September 19**
Slovenia

89 **November 5–9**
New Delhi, India, and Tbilisi, Georgia

2000

90 **Feb. 24–26**
Egypt

91 **March 20–26**
Jordan, Israel, Palestinian Autonomous Territory

92 **May 12–13**
Fatima, Portugal

2001

May 4–5
Athens, Greece

May 5–6
Syria

May 8–9
Malta

June 23–27
Ukraine

September 22–27
Armenia and Kazakstan

2002

May 22–26
Azerbaijan and Bulgaria

July 23–August 1
Canada, Guatemala, and Mexico

August 16–19
Poland

2003

May 3–4
Spain

June 5–9
Croatia

June 22
Bosnia

Visits to the United States

1979

October 1–7
Boston
New York, including the United Nations
Philadelphia
Chicago
Des Moines
Washington

1981

February 27
Stopover of several hours in Anchorage, Alaska

1984

May 12
Stopover of several hours in Fairbanks, Alaska

1987

September 10–19
Miami
Columbia, SC
New Orleans
San Antonio
Phoenix
Los Angeles
Monterey, CA
San Francisco
Detroit

1993

August 12–15
Denver (World Youth Day)

1995

October 4–8
Newark, NJ
New York, including the United Nations
Brooklyn, NY
Baltimore

1999

January 26–27
St. Louis

Pope John Paul II has traveled approximately 742,000 miles, according to an October 15, 2002, report from the Vatican Information Service marking the 24th anniversary of the Holy Father's election as Pope.

Encyclicals and Other Key Writings

Listed below, with brief descriptions, are all of Pope John Paul II's encyclicals through April 2003, followed by selected Apostolic Letters, Constitutions, Exhortations, and Motu Proprio.

Encyclicals

Redemptor Hominis, "The Redeemer of Man"
MARCH 4, 1979

The mystery of redemption and the situation of the redeemed person in the modern world are themes of the encyclical. Human rights and dignity, religious liberty and the quest for life's meaning in a world of technological and scientific breakthroughs are examined. The church's fundamental function in every age, Pope John Paul II states, is "to point the awareness and experience of the whole of humanity toward the mystery of God." Pope John Paul also describes the vital role of the Virgin Mary, calls for appreciation of priestly celibacy, and discusses the task of theologians.

Dives in Misericordia, "Rich in Mercy"
NOVEMBER 30, 1980

Pope John Paul II examines some of the "major anxieties of our time" and says that God's mercy is what is needed in the world "at this hour of history." There is a sense, he says, in which "mercy constitutes the fundamental content of the messianic message of Christ and the constitutive power of his mission."

Laborem Exercens, "On Human Work"
SEPTEMBER 14, 1981

Planned for the 90th anniversary of Pope Leo XIII's social encyclical, Rerum Novarum, this third encyclical says that the "church considers it her task always to call attention to the dignity and rights of those who work." The proper subject of work continues to be man, whether the economic system is capitalist or socialist, Pope John Paul II states. "It is always man who is the purpose of the work."

Slavorum Apostoli, "The Apostles of the Slavs"
JUNE 2, 1985

Coinciding with celebrations marking the 11th centenary of the death of Methodius, in this fourth encyclical, Pope John Paul II, the first Slavic pope, honors St. Cyril and St. Methodius, who in the ninth century brought the Gospel to the Slavic peoples of Eastern Europe. He notes that the brothers were "men of Hellenic culture and Byzantine training" who worked in a land which followed the Roman church. Thus they are "connecting links or spiritual bridges between the Eastern and Western traditions, which both come together in the one great tradition of the universal church."

Dominum et Vivificantem, "On the Holy Spirit in the Life of the Church and the World"
MAY 18, 1986

Against a materialism which accepts death as the end of human existence, Pope John Paul II writes in his fifth encyclical, the church proclaims the Holy Spirit, "the life which is stronger than death." Dialectical and historical materialism – the essential core of Marxism – is the system which has carried materialism to its "extreme practical consequences." This encyclical describes many "signs and symptoms of death" in the contemporary world. The conversion of the human heart, Pope John Paul II writes, "is brought about by the influence" of the Holy Spirit working through the conscience.

Redemptoris Mater, "The Mother of the Redeemer"
MARCH 25, 1987

"Mary belongs indissolubly to the mystery of Christ, and she belongs also to the mystery of the Church from the beginning, from the day of the Church's birth," Pope John Paul II writes in his sixth encyclical, written in connection with the Marian year which began on Pentecost Sunday, 1987. The encyclical addresses the Blessed Mother's "importance in relation to women and their status"; ecumenism and Mary; the relation of Mary and Jesus Christ; Mary's presence in the pilgrim church; Mary as a model of faith; and other questions.

Sollicitudo Rei Socialis, "The Social Concern of the Church"
DECEMBER 30, 1987 [ISSUED FEBRUARY 19, 1988]

Written to commemorate the 20th anniversary of Pope Paul VI's social encyclical, Populorum Progressio, Pope John Paul II's seventh encyclical, on social concerns, points to a widening gap between the world's rich and poor. It calls for recognition of the moral dimension of interdependence

along with a concept of development that is not merely economic. Pope John Paul reaffirms the continuity of church social teaching as well as its constant renewal.

Redemptoris Missio, "The Mission of Christ the Redeemer"

DECEMBER 7, 1990 [ISSUED JANUARY 22, 1991]

Pope John Paul II's eighth encyclical, subtitled "On the Permanent Validity of the Church's Missionary Mandate," stresses the urgency of missionary evangelization. The encyclical examines the new frontiers for missionary activity in modern cities or some traditionally Christian areas needing re-evangelization, while emphasizing the continued importance of a mission ad gentes—to the nations. Pope John Paul rejects any views of salvation and mission that would focus on humanity's earthly needs while remaining "closed to the transcendent." The relationship of missionary activity to ecumenism and interreligious dialogue, to the development of peoples, to situations in which Christians are the minority and to inculturation of the faith, along with the role of the communications media in evangelization, are among points discussed in the encyclical.

Centesimus Annus, "On the Hundredth Anniversary of Rerum Novarum"

MAY 1, 1991

This ninth encyclical was issued for the centenary of Pope Leo XIII's social encyclical Rerum Novarum. It was written in the wake of communism's collapse in Eastern Europe and looks to the new things (rerum novarum) influencing the social order. Pope John Paul II examines strengths and weaknesses of different forms of capitalism and the free market, and he takes up such themes as work, unions and wages, unemployment, profit, atheism, class struggle, freedom and private property.

Veritatis Splendor, "The Splendor of Truth"

AUGUST 6, 1993

In the 10th encyclical of his papacy, Pope John Paul II treats the foundations of moral theology—"foundations which are being undermined by certain present-day tendencies." Pope John Paul expresses concern that an "attempt to set freedom in opposition to truth, and indeed to separate them radically, is the consequence, manifestation and consummation of another more serious and destructive dichotomy, that which separates faith from morality." The encyclical reaffirms "the universality and immutability of the moral commandments, particularly those which prohibit always and without exception intrinsically evil acts." It expresses concern for helping present-day culture rediscover the bond between truth, freedom and the good.

Evangelium Vitae, "The Gospel of Life"

MARCH 25, 1995

Steps toward mobilizing a "new culture of life" are outlined in this 11th encyclical of Pope John Paul II. The fact that laws in many nations do not punish practices opposed to life, and even make them "altogether legal, is both a disturbing symptom and a significant cause of grave moral decline," he writes. Pope John Paul says that "no human law can claim to legitimize" abortion and euthanasia and that, through "conscientious objection," there "is a grave and clear obligation to oppose" laws that do so. He writes, "I confirm that the direct and voluntary killing of an innocent human being is always gravely immoral" (No. 57), and declares "that direct abortion, that is, abortion willed as an end or as a means, always constitutes a grave moral disorder" (No. 62). And, he says, "I confirm that euthanasia is a grave violation of the law of God" (No. 65).

Ut Unum Sint, "On Commitment to Ecumenism"

MAY 25, 1995

Ecumenism is not an "appendix" added to traditional church activity, but "an organic part of her life and work, and consequently must pervade all that she is and does," Pope John Paul II writes in his 12th encyclical, titled Ut Unum Sint. It examines the papacy's role as "visible sign and guarantor" of unity, acknowledging that the bishop of Rome "constitutes a difficulty for most other Christians, whose memory is marked by certain painful recollections." The encyclical discusses ecumenism's history, sacramental sharing, dialogue's nature, reception by the churches of dialogue-group agreements, common prayer, joint service, ecumenical translations of the Bible, doctrine, areas needing "fuller study before a true consensus of faith can be achieved" (No. 79) and other matters.

Fides et Ratio, "Faith and Reason"
SEPTEMBER 14, 1998

This 14th encyclical focuses on the "relationship between faith and philosophy." Pope John Paul II says it is his "task to state principles and criteria" necessary for restoring "a harmonious and creative relationship between theology and philosophy." The Church, he says, "has no philosophy of its own nor does she canonize any one particular philosophy in preference to others." Pope John Paul says: "The content of revelation can never debase the discoveries and legitimate autonomy of reason. Yet ...reason on its part must never lose its capacity to question and to be questioned." The encyclical examines the relationship of philosophy and God's word; metaphysics and theology; truth and freedom; human experience and philosophy; the ongoing value of philosophy in a scientific world and other topics.

Ecclesia De Eucharistia, "On the Eucharist in its Relationship to the Church"
APRIL 17, 2003

In this encyclical, issued on Holy Thursday, which commemorates the institution of the Eucharist, Pope John Paul II says that the Eucharist "stands at the centre of the Church's life," containing in itself the mystery of Christ's sacrifice on the cross and his rising from the dead. The encyclical contains a summary of the Church's Eucharistic doctrine. It reminds its readers of the importance of celebrating the Eucharist according to the norms of the Church, of the necessity of being in the state of grace to receive Communion, and of the impossibility of Eucharisitc sharing between the Catholic Church and those communities without the same Eucharistic theology or without a valid priesthood which is necessary for the Eucharist to be celebrated. Pope John Paul also offers a meditation on Mary as "woman of the Eucharist."

Apostolic Letters

Salvifici Doloris, "On the Christian Meaning of Human Suffering"
FEBRUARY 11, 1984

Pope John Paul II examines the meaning of personal suffering, as well as the Christian response to the suffering of others. The Gospel, Pope John Paul stresses, is "the negation of passivity in the face of suffering." He adds: "The World of human suffering unceasingly calls for, so to speak, another world: the world of human love; and in a certain sense man owes to suffering that unselfish love which stirs in his heart and actions."

Mulieris Dignitatem, "On the Dignity and Vocation of Women"
AUGUST 15, 1988

This letter, written on the occasion of the Marian year, represents Pope John Paul II's response to a recommendation of the 1987 world Synod of Bishops. Pope John Paul says that "both man and woman are human beings to an equal degree, both are created in God's image." He explores the attitude of Jesus toward women in the Gospels which show that "in the eyes of his contemporaries Christ became a promoter of women's true dignity and of the vocation corresponding" to it, the pope writes. Some of his themes include the exploitation of women, marriage, motherhood, the value of religious consecration, virginity, women who suffer, distinct feminine gifts and why women cannot be ordained to the priesthood.

Ordinatio Sacerdotalis, "On Reserving Priestly Ordination to Men"
MAY 22, 1994

Pope John Paul II says in this letter that, in granting admission to the ministerial priesthood, the church has always acknowledged as a perennial norm her Lord's way of acting in choosing the 12 men whom he made the foundation of his church. Because "in some places" women's ordination is thought to be still open to debate or that the "Church's judgment" on the matter has merely a "disciplinary force," Pope John Paul declares "that the Church has no authority whatsoever to confer priestly ordination on women and that this judgment is to be definitively held by all the Church's faithful." Pope John Paul says that "the fact the Blessed Virgin Mary ... received neither the mission proper to the apostles nor the ministerial priesthood clearly shows that the nonadmission of women to priestly ordination cannot mean that women are of lesser dignity, nor can it be construed as discrimination against them."

Orientale Lumen, The Light of the East
MAY 2, 1995

In this apostolic letter on the churches of the East, Pope John Paul II says, regarding the Orthodox churches, "We feel the need to go beyond the degree of communion we have reached." The letter acknowledges that with the fall of atheistic communism in Central and Eastern Europe "Christian brothers and sisters who together had suffered

persecution are regarding one another with suspicion and fear just when prospects and hopes of greater freedom are appearing." Pope John Paul comments that "the time has come to suffer, if necessary, in order never to fail in the witness of charity among Christians." Pope John Paul also discusses the East as a model for inculturation, monasticism; the need to improve "knowledge of one another." In addition to knowledge, he feels that "meeting one another regularly" is vital.

Laetamur Magnopere, "We Rejoice Greatly"
AUGUST 15, 1997

In this apostolic letter, promulgating the Latin "typical edition" of the Catechism of the Catholic Church—a task begun in 1986—Pope John Paul II says, "Catechesis will find in this genuine, systematic presentation of the faith and of Catholic doctrine a totally reliable way to present with renewed fervor each and every part of the Christian message to the people of our time."

Dies Domini, "On Keeping the Lord's Day Holy"
MAY 31, 1998

Pope John Paul II highlights "the duty to attend Sunday Mass," and he says "efforts must be made to ensure that the celebration has the festive character appropriate to the day commemorating the Lord's resurrection." Pope John Paul comments, "In considering the Sunday Eucharist more than 30 years after the council, we need to assess how well the word of God is being proclaimed and how effectively the people of God have grown in knowledge and love of sacred Scripture." The pope emphasizes that "the Mass in fact truly makes present the sacrifice of the cross." And, he says, the Eucharist's communal character "emerges in a special way when it is seen as the Easter banquet, in which Christ himself becomes our nourishment." Pope John Paul writes that "the Eucharistic celebration does not stop at the church door"; and he discusses Sunday assemblies without a priest, singing, the relations of Sunday to Sabbath, homilies, the sign of peace and other matters.

Novo Millennio Ineunte, "At the Beginning of the New Millennium"
JANUARY 6, 2001

This letter calls for pastoral planning by the church everywhere in which the universal call to holiness plays a key role and a spirituality of communion is accented. Examining the dimensions of "a spirituality of communion," including "the ability to see what is positive in others," Pope John Paul II says

a spirituality of communion means "resisting the selfish temptations which constantly beset us." Pope John Paul discusses celebration of the Eucharist, the sacrament of penance, ecumenism and interreligious dialogue, forms of prayer, the reading of Scripture, the new evangelization, inculturation, ecclesial movements, respect for life, and numerous other topics. Pope John Paul also writes: "We must learn to see [Christ] especially in the face of those with whom he himself wished to be identified: 'I was hungry and you gave me food'… By these words, no less than by the orthodoxy of her doctrine, the Church measures her fidelity."

Rosarium Virginis Mariae, "The Rosary of the Virgin Mary"
OCTOBER 16, 2002

This letter announced the start of a year of the rosary, running from October 2002 to October 2003. In it, Pope John Paul II recommends the addition of five new mysteries of the rosary—the mysteries of light—"to bring out fully the Christological depth of the rosary." These mysteries are: Christ's baptism; his self-revelation at Cana; his proclamation of the kingdom of God; his transfiguration; and his institution of the Eucharist. The apostolic letter includes numerous suggestions for praying the rosary in ways that foster contemplation of the mysteries of Christ.

Apostolic Constitutions

Sapientia Christiana, "Christian Wisdom"
APRIL 15, 1979

Establishes norms for ecclesiastical universities.

Sacrae Disciplinae Leges
JANUARY 25, 1983

Promulgates the revised Code of Canon Law.

Pastor Bonus, "The Good Shepherd"
JUNE 28, 1988

Establishes norms for the operation of the Roman Curia.

Ex Corde Ecclesiae, "Born from the Heart the Church"
AUGUST 15, 1990

Divided into two main parts, this apostolic constitution first discusses the Catholic university's identity and mission, and the second part is a presentation of general norms under seven headings for "all Catholic universities and

other Catholic institutes of higher studies throughout the world." The norms become effective the first day of the 1991 academic year.

Fidei Depositum, "Guarding the Deposit of Faith"
OCTOBER 11, 1992
Issued on the publication of the Catechism of the Catholic Church prepared following the Second Vatican Council.

Universi Dominici Gregis, "Shepherd of the Lord's Whole Flock"
FEBRUARY 22, 1996
Promulgates new norms for the election of a pope by a conclave of up to 120 cardinals not 80 years old "before the day of the Roman pontiff's death or the day when the Apostolic See becomes vacant."

Apostolic Exhortations

Catechesi Tradendae, "On Catechesis in Our Time"
OCTOBER 16, 1979
[It has become customary for the Pope to issue an apostolic exhortation after meetings of the Synod of Bishops. This is true of this document and the others listed below which follow synodal meetings.] Pope John Paul II's first apostolic exhortation was on catechesis or religious instruction. It followed on the fourth general assembly of the Synod of Bishops held in October, 1977, which Pope John Paul attended before his election. The exhortation emphasizes the "Christocentricity" of all catechesis and defined its aim as developing, "with God's help, an as yet initial faith, and to advance in fullness and to nourish day by day the Christian life of the faithful, young and old." Among the topics covered are the need for systematic catechesis, the content of catechesis and its integrity; suitable pedagogical methods; catechesis of various age groups and of the handicapped; catechesis and theology; and the responsibility of bishops, priests, men and women religious, lay catechists, schools, and families for catechesis.

Familiaris Consortio, "On the Role of the Christian Family in the Modern World"
NOVEMBER 22, 1981
This document was written after the 1980 international Synod of Bishops. Four general tasks of the family, discussed by the synod, are also discussed by Pope John Paul II: to form a community of persons; to serve life; to participate in society's development; and to share in the life and mission of the Church. Among the topics discussed are: the roles of women and of men in families, marriage as a sacrament, the rights of children and of the elderly, the role of parents in the education of children, family planning and birth control, prayer, marriage preparation, and the pastoral care of families after marriage, and other issues.

Reconciliatio et Paenitentia, "On Reconciliation and Penance"
DECEMBER 2, 1984
Writing after the 1983 Synod of Bishops, Pope John Paul II discusses, among other topics, the sacrament of penance; catechesis on reconciliation and penance; social sin; fasting and almsgiving; confessors; and the sense of sin and reconciliation within the church.

Christifideles Laici, "On the Lay Faithful in the Church and in the World"
DECEMBER 30, 1988
Writing after the 1987 world Synod of Bishops, Pope John Paul II says that the vocation and mission of the laity springs from baptism. The dignity of the laity, their participation in the Church's life as a communion, their coresponsibility in the Church's mission, their formation, roles of women and men, parish life, and associations of the laity are among points discussed.

Pastores Dabo Vobis, "On the Formation of Priests"
MARCH 25, 1992
Writing after the 1990 world Synod of Bishops, Pope John Paul II speaks of a scarcity of priestly vocations in parts of the world and calls for direct preaching on the mystery of vocation; analyzes factors within society that hinder vocations, while also pointing to factors that "offer favorable conditions for embarking" on a vocation; reaffirms the value of priestly celibacy in the Western Church; discusses major and minor seminaries, cooperation with the laity, how movements and lay associations foster vocations, affective maturity among priests, ongoing formation, older priesthood candidates, roles of laity and women in priestly formation, among other topics.

Ecclesia in Africa
SEPTEMBER 14, 1995
Writing after the spring 1994 Special Assembly for Africa of the Synod of Bishops, Pope John Paul II notes that the synod "clearly showed that issues in Africa such as increasing

poverty, urbanization, the international debt, the arms trade, the problem of refugees and displaced persons, demographic concerns and threats to the family, the liberation of women, the spread of AIDS, the survival of the practice of slavery in some places, ethnocentricity and tribal opposition figure among the fundamental challenges." Christian-Muslim relations, inculturation of faith, formation of the laity, priestly formation and numerous other topics concerning the agents and structures of evangelization are discussed. Returning repeatedly to a human rights theme, he says "the winds of change are blowing strongly in many parts of Africa, and people are demanding ever more insistently the recognition and promotion of human rights and freedoms."

Vita Consecrata, "On the Consecrated Life and Its Mission in the Church and in the World"
MARCH 25, 1996
Writing after the October 1994 world Synod of Bishops, Pope John Paul II examines the evangelical counsels of chastity, poverty and obedience; new and old forms of consecrated life; religious garb; the founding charisms of institutes; women; initial and ongoing formation of consecrated persons; community life; authority's role; the relationship of religious superiors and bishops, and their need for ongoing dialogue; roles within the local church; cooperation with the laity; issues related to participation in ecclesial movements; roles of priests and brothers in mixed institutes, promotion of vocations; the prophetic character of consecrated life; the ecumenical contribution consecrated institutes can make; their role in education, including colleges and universities; service of the poor; and many other concerns.

Ecclesia in America
JANUARY 22, 1999
Writing after the Fall 1997 Special Assembly for America of the Synod of Bishops, Pope John Paul II says that in America "areas in which it seems especially necessary to strengthen cooperation are the sharing of information on pastoral matters, missionary collaboration, education, immigration and ecumenism." Pope John Paul focuses in a special way on new evangelization called for by "the new and unique situation in which the world and the church find themselves at the threshold of the third millennium, and the urgent needs which result. Pope John Paul examines many issues of church life - for example, spirituality and conversion; Scripture study, popular piety and inculturation of the

Gospel; the role of bishops, priests, deacons, those in the consecrated life and lay people, the need to foster priestly vocations, youth ministry, ecumenism and parish renewal. He applies church social teaching to numerous challenging social issues such as corruption, the drug trade, the environment, the arms race, globalization, Third World debt and torture, and he focuses on the human rights of all, from the unborn to the aged.

Ecclesia in Asia
NOVEMBER 6, 1999
Writing after the Spring 1998 Special Assembly for Asia of the Synod of Bishops, Pope John Paul II focuses on how the church's mission of evangelization can be carried out in Asia, where nearly two-thirds of the world's population lives and where, with the exception of the Philippines, Christianity is a minority religion. Pope John Paul says that "there can be no true evangelization without the explicit proclamation of Jesus as Lord" and that "proclamation that respects the rights of consciences does not violate freedom, since faith always demands a free response on the part of the individual." He also discusses inculturation; church social teaching; poverty and oppression; economic growth; the arms race; government corruption; religious freedom; the formation of evangelizers; basic ecclesial communities; interreligious dialogue; ecumenism; priests; consecrated life; the laity, and numerous other concerns.

Ecclesia in Oceania
NOVEMBER 22, 2001
Pope John Paul II wrote this exhortation in response to the Special Assembly of the Synod of Bishops for Oceania in the Fall of 1998. In it Pope John Paul says that the need for a new evangelization "is the first priority for the church in Oceania" and "the time is ripe for a re presentation of the Gospel to the peoples of the Pacific." The apostolic exhortation discusses the effects of modernization in Oceania; the role of catechists; ecumenism and interreligious understanding; fundamentalism; church social teaching; the sanctity of life; sexual abuse by some clergy and religious; indigenous peoples; the importance of Scripture; liturgy; women's roles; the roles of priest and deacons; the consecrated life; the laity and other matters.

Ecclesia in Europa
JUNE 28, 2003
The Second Special Assembly for Europe of the Synod of Bishops (October 1 to 23 1999) was the last of a series of

continental Synods celebrated in preparation for the Jubilee Year 2000. In this apostolic exhortation, Pope John Paul II emphasizes the theme of Jesus Christ as "our hope" and the "gospel of hope," often citing the Book of Revelation. The Pope addresses the challenges and signs of hope for the Church in Europe. Pope John Paul also discusses the urgent need for proclamation of the gospel of hope, dialogue with other religions, the evangelization of culture, the necessity to "pay particular attention to the multifaceted world of the mass media," liturgy, giving new hope to the poor, the challenge of unemployment, the pastoral care of the sick, marriage and the family, service to the Gospel of life, and immigration. In the last chapter, Pope John Paul discusses the new face of Europe as the European Union and European institutions expand. He calls on those drawing up the future European constitution to "include a reference to the religious and in particular the Christian heritage of Europe." After discussing "the Church for the new Europe," Pope John Paul closes the exhortation with an "entrustment to Mary."

Motu Proprio

Ecclesia Dei
JULY 22, 1988

[The words motu proprio *can be translated "on his own initiative." They refer to documents originating with the pope himself, usually embodying some form of executive action.]* In this document Pope John Paul II urged followers of the schismatic French Archbishop Marcel Lefebvre to remain "united to the vicar of Christ in the unity of the Catholic Church," cautioning that "everyone should be aware that formal adherence to the schism is a grave offense against God and carries the penalty of ex-communication decreed by the church's law." Pope John Paul also established a commission to facilitate the full ecclesial communion of those who have been "until now linked" to Lefebvre's society and said that "respect must everywhere be shown for the feelings of all those who are attached to the Latin liturgical tradition, by a wide and generous application" of Vatican directives for use of the Tridentine Mass.

Ad Tuendam Fidem,
To Protect the Faith
MAY 18, 1998

With this letter, Pope John Paul II made an addition to canon law to include the second clause in the profession of faith published in 1989 by the Holy See's Congregation for the Doctrine of the Faith concerning teachings proposed "definitively." The letter underlines the assent required when dealing with church teaching proposed definitively, and it provides for applying penalties to those who deny definitive teachings.

Apostolos Suos, On the Theological and Juridical Nature of Episcopal Conferences
MAY 21, 1998

Pope John Paul II affirms the importance of national and regional conferences of bishops called for by the Second Vatican Council. The letter discusses collegiality; the individual bishop's role; membership in bishops' conferences and their procedures. Part of it is devoted to the doctrinal competence of bishops' conferences stating that unanimous doctrinal declarations by a conference oblige the faithful of that territory "to adhere with a sense of religious respect to that authentic magisterium of their own bishops." If there is not unanimity, a *recognitio* or approval by the Holy See is necessary before the faithful of that territory would be obliged to adhere to a doctrinal declaration.

Misericordia Dei, On Certain Aspects of the Celebration of the Sacrament of Penance
MAY 2, 2002

Pope John Paul II stresses that general absolution is "exceptional in character" and the "the church has always seen an essential link between the judgment entrusted to the priest in the sacrament and the need for penitents to name their own sins, except where this is not possible." Pope John Paul appeals to bishops and priests "to undertake a vigorous revitalization of the sacrament of reconciliation." Pope John Paul clarifies the nature of the conditions in which general absolution may be used.

Complete Writings by Category

Apostolic Constitutions

Ecclesia in Urbe, "The Church in the City" (January 1, 1998)

Universi Dominici Gregis, "Shepherd of the Lord's Whole Flock" (February 22, 1996)

Fidei Depositum, "Guarding the Deposit of Faith" (October 11, 1992)

Ex Corde Ecclesiae, "Born From the Heart of the Church" (August 15, 1990)

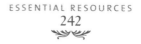

Pastor Bonus, "The Good Shepherd" (June 28, 1988)

Divinus Perfectionis Magister, "The Divine Teacher of Perfection" (January 25, 1983)

Sacrae Disciplinae Leges, promulgates the revised *Code of Canon Law* (January 25, 1983)

Magnum Matrimonii Sacramentum, "The Great Sacrament of Matrimony" (October 7, 1982)

Sapientia Christiana, "Christian Wisdom" (April 15, 1979)

Apostolic Exhortations

Ecclesia in Europa (June 28, 2003)

Ecclesia in Oceania (November 22, 2001)

Ecclesia in Asia (November 6, 1999)

Ecclesia in America (January 22, 1999)

Vita Consecrata, The Consecrated Life (March 25, 1996)

Ecclesia in Africa (September 14, 1995)

Pastores Dabo Vobis, "I Will Give You Shepherds" (March 25, 1992)

Redemptoris Custos, "The Guardian of the Redeemer" (August 15, 1989)

Christifideles Laici, "On the Lay Faithful in the Church and in the World" (December 30, 1988)

Reconciliatio et Paenitentia, "Reconciliation and Penance" (December 2, 1984)

Redemptionis Donum, "The Gift of Redemption" (March 25, 1984)

Familiaris Consortio, "On the Role of the Christian Family in the Modern World" (November 22, 1981)

Catechesi Tradendae, "On Catechesis in Our Time" (October 16, 1979)

Apostolic Letters

Rosarium Virginis Mariae, "The Rosary of the Virgin Mary" on the Most Holy Rosary (October 16, 2002)

Misericordia Dei on certain aspects of the celebration of the Sacrament of Penance (May 2, 2002)

Apostolic Letter to the Catholic People of Hungary for the conclusion of the "Hungarian Millennium" (July 25, 2001)

On the 1700th Anniversary of the "Baptism of Armenia" (February 17, 2001)

Novo Millennio Ineunte, "At the Beginning of the New Millennium" (6 January 2001)

300th Anniversary of the Union of the Greek Catholic Church of Romania with the Church of Rome (20 July 2000)

Inter Munera Academiarum, "Among the Functions of Academies" (January 28, 1999)

Dies Domini, "On Keeping the Lord's Day Holy" (May 31, 1998)

Divini Amoris Scientia, "The Science of Divine Love" (October 19, 1997)

Laetamur Magnopere, "We Rejoice Greatly" (August 15, 1997)

Operosam Diem, "The Laborious Day" (December 1, 1996)

Apostolic Letter for the 350 Years of the Union of Uzhorod (April 18, 1996)

Apostolic Letter for the Fourth Centenary of the Union of Brest (November 12, 1995)

Orientale Lumen, "The Light of the East" (May 2, 1995)

Tertio Millennio Adveniente, "With the Coming of the Third Millennium" (November 10, 1994)

Ordinatio Sacerdotalis, "On Reserving Priestly Ordination to Men" (May 22, 1994)

Apostolic Letter for the organization of the ecclesiastical jurisdictions in Poland (March 25, 1992)

Apostolic Letter for the Fifth Centenary of the Evangelization of the New World (June 29, 1990)

Apostolic Letter for the Centenary of the "Opera di San Pietro Apostolo" (October 1, 1989)

Apostolic Letter on the Situation in Lebanon (September 7, 1989)

Apostolic Letter on the Occasion of the Fiftieth Anniversary of the Beginning of World War II (August 27, 1989)

Vicesimus Quintus Annus, "The Twenty-Fifth Year" (December 4, 1988)

Mulieris Dignitatem, "On the Dignity and Vocation of Women" (August 15, 1988)

Euntes In Mundum Universum, "Go into the Entire World" (January 25, 1988)

Duodecim Saeculum, "The Twelfth Century" (December 4, 1987)

Spiritus Domini, "The Spirit of the Lord" (August 1, 1987)

Sescentesima Anniversaria, "The Six Hundredth Anniversary" (June 5, 1987)

Augustinum Hipponensem, "Augustine of Hippo" (August 28, 1986)

Dilecti Amici, "Dear Friends" (March 31, 1985)

Les Grands Mystères, "The Great Mysteries" (May 1, 1984)

Redemptionis Anno, "The Year of Redemption" (April 20, 1984)

Salvifici Doloris, "On the Christian Meaning of Human Suffering" (February 11, 1984)

A Concilio Constantinopolitano I, "From the Council of Constantinople" (March 25, 1981)

Egregiae Virtutis, "Of Wondrous Virtue" (December 31, 1980)

Sanctorum Altrix, "The Sustainer of Saints" (July 11, 1980)

Amantissima Providentia, "The Most Beloved Providence" (April 29, 1980)

Patres Ecclesiae, "The Fathers of the Church" (January 2, 1980)

Rutilans Agmen, "The Shining Throng" (May 8, 1979)

Encyclicals

Ecclesia de Eucharistia, "On the Eucharist in its Relationship to the Church" (2003)

Fides et Ratio, "Faith and Reason" (14 September 1998)

Ut Unum Sint, "On Commitment to Ecumenism" (25 May 1995)

Evangelium Vitae, "The Gospel of Life" (25 March 1995)

Veritatis Splendor, "The Splendor of Truth" (6 August 1993)

Centesimus Annus, "On the Hundredth Anniversary of *Rerum Novarum"* (1 May 1991)

Redemptoris Missio, "The Mission of Christ the Redeemer" (7 December 1990)

Sollicitudo Rei Socialis, "The Social Concerns of the Church" (30 December 1987)

Redemptoris Mater, "The Mother of the Redeemer" (25 March 1987)

Dominum et Vivificantem, "On the Holy Spirit in the Life of the Church and the World" (18 May 1986)

Slavorum Apostoli, "The Apostles of the Slavs" (2 June 1985)

Laborem Exercens, "On Human Work" (14 September 1981)

Dives in Misericordia, "Rich in Mercy" (30 November 1980)

Redemptor Hominis, "The Redeemer of Man" (4 March 1979)

Letters

Apostolic Letter in the form of *Motu Proprio Misericordia Dei* on certain aspects of the celebration of the Sacrament of Penance (May 2, 2002)

Sacramentorum Sanctitatis Tutela, "The Defense of the Holiness of the Sacraments" *(January 10, 2002)*

Proclamation of St. Thomas More as Patron of Statesmen and Politicians (October 31, 2000)

Proclamation of the Co-Patronesses of Europe (October 1, 1999)

Apostolos Suos, "On the Theological and Juridical Nature of Episcopal Conferences" (May *21, 1998)*

Ad Tuendam Fidem, "To Protect the Faith" (May *18, 1998)*

Stella Maris, "The Star of the Sea" *(January 31, 1997)*

Apostolic Letter *Motu Proprio* promulgation of the definitive Statute establishing the Labour Office of the Holy See (September 30, 1994)

Vitae Mysterium, "The Mystery of Life" (February 11, 1994)

Socialium Scientiarum, "On the Social Sciences" (January 1, 1994)

Inde a Pontificatus, "Already from the Beginning of the Pontificate" (March 25, 1993)

Europae Orientalis, "Eastern Europe" (January 15, 1993)

Ecclesia Dei, "Church of God" (July 2, 1988)

Sollicita Cura, "Solicitous Care" (December 26, 1987)

Quo Civium Iura, "How the Rights of Citizens" (November 21, 1987)

Dolentium Hominum, "On Suffering People" (February 11, 1985)

Tredecium Anni, "Thirteen Years" (August 6, 1982)

Familia a Deo Instituta, "The Family Instituted by God" (May 9, 1981)

Glossary

Apostle
Literally, "one sent." Refers to the twelve men chosen by Christ to be the bearers of his teachings to the world, and also, in a broader sense, to other important early evangelizers such as St. Paul.

Apostolic
Refers to what derives in some way from the tradition of preaching and teaching passed down in the Church from the Apostles.

Apostolic Camera
A "chamber" or office in the Roman Curia headed by the Chamberlain *(Camerlengo)* of the Holy Roman Church, whose chief responsibility is the administration of the Church during the interim between the death of a pope and the election of a successor. Cardinal Eduardo Martinez Somalo is currently Chamberlain of the Holy Roman Church.

Apostolic Constitution
This is a solemn, papal document with legislative authority dealing with important matters of faith or Church life affecting the whole Church or a sizable part of it. An apostolic constitution was used to promulgate the revised Code of Canon Law in 1983.

Apostolic Exhortation
This is a papal document that, while not legislative in nature, promotes Church teaching. Examples include exhortations issued by the pope following a Synod of Bishops.

Apostolic Letter
An apostolic letter is a papal letter usually sent to a particular group of persons, for example, a group of bishops, rather than to the entire Church. It is not a legislative text.

Apostolic Nunciature
The offices of the Holy Father's representative to the Church in a country and then to the government in that country.

Apostolic Succession
The handing on of apostolic preaching and authority from the Apostles to the Church through their successors, the bishops.

Beatification
A declaration by the pope that a person who died a martyr or practiced Christian virtue to a heroic degree is "blessed" and holy and thus worthy of honor and imitation by the faithful. This is the step prior to canonization, in which a person is declared to be a saint.

Bishop
Bishops are the successors to the Apostles. Together they form the college of bishops, of which the head is the Bishop of Rome, the pope, as the successor to St. Peter. Each diocesan bishop has the responsibility of pastoral care for a particular church (a diocese) and also, as a member of the college of bishops, for the universal Church.

Camerlengo (Chamberlain)
1) The Chamberlain of the Holy Roman Church is a cardinal with special responsibilities, especially during the time between the death of one pope and the election of his successor; among other things, he safeguards and administers the goods and revenues of the Holy See and heads particular congregations of cardinals for special purposes.

2) The Chamberlain of the College of Cardinals has charge of the property and revenues of the College and keeps the record of business transacted in consistories.

Canon Law
The rules (canons or laws) which provide the norms for good order in the visible society of the Church. Those canons that apply universally are contained in the Codes of Canon Law. The most recent Code of Canon Law was promulgated in 1983 for the Latin (Western) Church and in 1991 for the Eastern Church (The Code of Canons of the Eastern Churches).

Canonization
The process by which the Church declares a person to be a saint and puts forward this person as worthy of veneration by the universal Church.

Cardinals, College of
The College of Cardinals is made up of the cardinals of the Church, almost all bishops, who have been appointed to advise the pope and to assist in the governance of the Church. Upon the death of the pope, the College elects a new pope.

Catechesis
Religious instruction and formation in the faith.

Cathedral
The major church in an archdiocese, diocese, or eparchy. It is the seat of the local bishop.

Catholic
Greek word for "universal." First used in the title Catholic Church in a letter written by St. Ignatius of Antioch to the Christians of Smyrna about 107 A.D.

Church
1) The universal Church that is spread throughout the world

2) the local Church is that of a particular locality, such as a diocese. The Church embraces all its members—on earth, in heaven, in purgatory.

Collegiality
Refers to the fact that the whole college of bishops, headed by the pope, shares responsibility and authority for the teaching, sanctification and government of the Church.

Conclave
The private assembly of cardinals who elect a pope. Electors must be under the age of 80. For an election there must be a two-thirds majority. If a two-thirds majority has not been reached after 30 ballots, election is by an absolute majority.

Consecrated Life
A permanent state of life recognized by the Church, entered freely in response to the call of Christ to perfection, and characterized by the profession of the evangelical counsels of poverty, chastity, and obedience.

consistory
An assembly of cardinals presided over by the pope.

Curia
The personnel and offices through which 1) the pope administers the affairs of the universal Church (the Roman Curia), or 2) a bishop administers the affairs of a diocese (diocesan curia).

Deacon/diaconate
Deacons serve in the ministry of the liturgy, of the word, and of charity. The diaconate is the first order or grade in ordained ministry. Any man who is to be ordained to the priesthood must first be ordained as a transitional deacon. The Permanent Diaconate is for men who do not plan to become ordained priests and is open to both married and unmarried men.

Diocese
A particular church, a fully organized ecclesiastical jurisdiction under the pastoral direction of a bishop as local Ordinary, with the cooperation and assistance of the priests and deacons.

Ecumenism
Promotion of the restoration of unity among all Christians, the unity which is a gift of Christ and to which the Church is called by the Holy Spirit. For the Catholic Church, the Decree on Ecumenism of the Second Vatican Council provides a charter for ecumenical efforts.

Encyclical
A pastoral letter on an important matter addressed by the pope to the whole Church and even to the whole world. Among the most famous encyclicals have been Pope Leo XIII's *Rerum Novarum* and Pope John XXIII's *Pacem in Terra*.

Eparchy
In the Eastern Catholic Churches, a particular church governed by a bishop; equivalent to the term "diocese" used in the Latin Church.

Episcopal
Of or pertaining to a bishop or bishops. From the Greek *episkopos*, "bishop."

Hierarchy
Refers to the differentiation of various offices of ministry in the Church (deacon, priest, bishop) and their ordering relative to one another. The term is also commonly used to refer to the order of bishops alone.

Holy Father
A title of the pope, an adaptation of the Latin title *Beatissimus Pater*, "Most Blessed Father."

Holy See
Refers to the pope, who occupies the chair or seat of Peter as bishop of Rome, and to the various officials and bodies of the Church's central administration—the Roman Curia—which act in the name and by authority of the pope.

Instruction
A document to explain implementation of a Church law, which can be issued by the relevant authority in a particular matter, such as the pope or a bishop.

Keys, Power of the
Spiritual authority and jurisdiction in the Church, symbolized by the keys of the Kingdom of Heaven that Christ entrusted to St. Peter.

Lay ministries
These are ministries within the Church that are carried out by laypersons. Included are altar servers, extraordinary ministers of Holy Communion, and lectors.

Lectionary
The book that contains all the readings from the Scriptures for use in the celebration of the liturgy.

Liturgy
The public worship and prayer of the Church.

Liturgy of the Word
That part of the celebration of the Mass when the Scriptures are proclaimed and reflected upon. On Sundays and major feasts, there are three readings:

1) Old Testament selection

2) New Testament selection (from the Epistles)

3) The Gospel reading

Liturgy of the Eucharist
The part of the celebration of the Mass when the gifts of bread and wine are prepared and offered to the Father. Through the Eucharistic prayer proclaimed by the priest, the bread and wine become the body and blood of Christ and are then received by the people.

Magisterium
The official teaching office of the Church.

Mary
The mother of Jesus Christ and thus bearer of the title "Mother of God." From apostolic times, the faithful have accorded to Mary the highest forms of veneration (as opposed to adoration or the worship given to God alone). She is celebrated throughout the year and in devotions such as the rosary and litany and is hailed the patroness of many countries, including the United States.

Mass
The common name for the Eucharistic liturgy of the Catholic Church. Synonyms: Eucharist, Eucharistic celebration.

Miracles, apparitions
Generally 'miracle' is used to refer to physical phenomena that defy natural explanation, such as medically unexplainable cures. An 'apparition' is a supernatural manifestation of God, an angel or a saint to an individual or a group of individuals.

Mitre
A headdress worn at some liturgical functions by bishops, abbots, and, in certain cases, other ecclesiastics.

Motu Proprio
Coming from the Latin phrase meaning "of his own initiative," a *motu proprio* is an apostolic letter which is legislative in nature and addressed to the entire Church, often treating an administrative matter. Recently the Pope issued a *motu proprio* amending church law in the matter of certain serious offenses including clerical sexual abuse.

Papabile
Informal terms referring to someone who appears to be a likely candidate for election to the papacy.

Papal infallibility
In fulfillment of Christ's promise to sustain his Church, the Holy Spirit is at work in the Church to preserve the Church from error in its definitive teachings on faith and morals. In extraordinary circumstances, as defined by the First Vatican Council, the pope exercises the gift of infallible teaching that has been given to the entire Church.

Papal Representatives
The three types of representatives of the Roman Pontiff are:

1) Legate—An individual appointed by the pope to be his personal representative to a nation, international conference, or local church. The legate may be chosen from the local clergy of a country.

2) Apostolic Nuncio—In the United States, the papal representative is sent by the pope to both the local church and to the government. His title is Apostolic Nuncio. Although he holds the title of ambassador, in US law he is not accorded the special privilege of being the dean of the diplomatic corps.

3) Permanent Observer to the United Nations—The Apostolic See maintains permanent legates below the ambassadorial level to represent its interests at several world organizations. Since the papal representative does not enjoy the right to vote at the United Nations, his title there is that of Observer.

Papal Secretariat of State
The Secretariat of State provides the pope with the closest possible assistance in the care of the universal Church. It consists of two sections:

1) The Section for General Affairs assists the pope in expediting daily business of the Holy See. It coordinates curial operations; prepares drafts of documents entrusted to it by the pope; has supervisory duties over the *Acta Apostolicae Sedis, Annuario Pontificio,* the Vatican Press Office and the Central Statistics Office.

2) The Section for Relations with States (formerly the Council for Public Affairs of the Church, a separate body) handles diplomatic and other relations with civil governments. Attached to it is a council of cardinals and bishops.

The current officers of the Secretariat of State: Cardinal Angelo Sodano, Secretary of State; Most Rev. Leonardo Sandri, Deputy for General Affairs; Most Rev. Jean-Louis Tauran, Secretary for Relations with States.

Pontiff
A title of the pope, from the Latin term for "chief priest." The pope is the Supreme Pontiff (*Pontifex maximus*).

Pope
A title (from Greek *pappas*, "father") used for the Bishop of Rome, who has jurisdiction over the Church throughout the world.

Primacy
Papal primacy refers to the pope's authority over the whole Church.

Province
1) A territory comprising one archdiocese called the metropolitan see and one or more dioceses called suffragan sees. The head of an archdiocese, an archbishop, has metropolitan rights and responsibilities over the province.

2) A division of a religious order under the jurisdiction of a provincial superior.

Roman Curia
The official collective name for the administrative agencies and courts, and their officials, who assist the pope in governing the Church. Members are appointed and granted authority by the pope.

Rome, Diocese of
The City of Rome is the diocese of the pope, as the Bishop of Rome.

Rosary
A prayer of meditation primarily on events in the lives of Mary and Jesus, repeating the "Our Father" and "Hail Mary". It is generally said on a physical circlet of beads.

Sacramentary
The book used by the celebrant, containing all the prayers for the liturgy of the Mass.

Second Vatican Council
A major meeting of the bishops of the world convened by Pope John XXIII to bring about a renewal of the Church. It was in session from 1962 to 1965 and produced important documents in liturgy, ecumenism, communications and other areas.

See
Another name for diocese, eparchy, or archdiocese. From the Latin *sedes*, "seat," referring to the seat or chair of the bishop.

Seminary
An educational institution for men preparing for holy orders.

Synod
A gathering for deliberation on particular matters.

Urbi et Orbi
A Latin phrase meaning "To the City and to the World." It is used to describe certain solemn papal blessings, and by extension the messages that accompany them. A pope gives his blessing *urbi et orbi* at Christmas and Easter and at his first public appearance after he is elected pope.

Vatican Congregation
A Vatican body which is responsible for an important area in the life of the Church, such as worship and sacraments, the clergy, and saints' causes.

Zucchetto
Skull cap worn by the pope (white); bishops (purple); and cardinals (red).

Contributors

John Borelli

Associate Director, USCCB Secretariat for Ecumenical and Interreligious Affairs; holds a doctorate in theology and the history of religions from Fordham University. He is editor with John H. Erickson of The Quest for Unity: Orthodox and Catholics in Dialogue and a frequent contributor to scholarly journals, including Ecumenical Trends, Buddhist-Christian Studies, The Living Light, Mid-stream, and the Journal of Ecumenical Studies. He is a consultor to the Holy See's Pontifical Council for Interreligious Dialogue, a member of the International Buddhist-Christian Theological Encounter Group and an adviser to the Monastic Interreligious Dialogue. He staffs the USCCB's three regional dialogues with Muslims, its dialogue with Buddhists, and the Anglican-Roman Catholic Consultation in the USA.

Father Edward J. Burns

Executive Director, USCCB Secretariat for Vocations and Priestly Formation; is a priest of the Diocese of Pittsburgh and holds master of theology and master of divinity degrees from Mt. St. Mary's Seminary, Emmitsburg, MD. He is a member of the National Catholic Educational Association Seminary Department Board and serves as a consultant to the NCEA Seminary Department, the Midwest Association of Theology, the East Coast Rectors Association and the Association of Academic Deans.

John Carr

Secretary, USCCB Department of Social Development and World Peace; holds a bachelor's degree from the University of St. Thomas and an honorary doctor of law degree from Barry College. He was director of the White House Conference on Families in 1979-80, and director of the National Committee for Full Employment in the late 70s. He has written on Catholics and political responsibility, housing and mediating structures and often speaks on the mission and message of Catholic Social Teaching and the moral dimensions of key public issues.

Beverly A. Carroll

Executive Director, USCCB Secretariat for African American Catholics; holds a master's degree in organization development from Towson State University and is a member of the Advisory Committee for the Xavier Institute for Black Catholic Studies, the National Black Catholic Congress Board of Trustees, the National Association of Black Catholic Administrators, the National Black Sisters Conference and the Provincial African American Committee of the Holy Name Province of Franciscans. She is author of The Cypress Will Grow, a video and resource book for evangelization, and producer of several videos, including If Rivers Could Speak and Unraveling the Evangelical Cord.

Mark E. Chopko

General Counsel, USCCB; holds a law degree from Cornell University and is an expert on church-state relations. He is a member of the Board of Scholars of the DePaul Law School's Center for Church-State Studies, the American Corporate Counsel Association, and the National Council of Churches Religious Liberty Committee. Among his publications are Faith and the Law—Public Lives, Private Virtue (Texas Tech Law Review).

Cathleen Cleaver

Director of Planning and Information, USCCB Secretariat for Pro-Life Activities; holds a law degree from Georgetown University. She is the former Chief Counsel of the House Constitution Subcommittee. Her professional experience spans the fields of communication, public policy and law. As a co-host of the cable TV program, "Law Notebook," she provided a weekly commentary on cutting-edge legal and legislative issues. She has appeared on PBS's "Firing Line" and CNN's "Crossfire," among other programs. She has published scholarly legal articles on constitutional issues and has filed "friend of the court" briefs with the US Supreme Court. She also has testified as a legal expert in hearings before congres-ional committees in the US House and Senate.

Ronaldo Cruz

Executive Director, USCCB Secretariat for Hispanic Affairs; holds a bachelor of arts degree from the University of Arizona, Tucson, and a master of social work degree from Arizona State University, Tempe. He is the winner of the Midwest Regional Conference for Hispanic Ministry Award for Leadership in 2000; the 1999 St. Martin de Porres National Award for Promoting Dialogue Between African Americans and Hispanic Americans from the National Association of Building Bridges in Black and Brown, Detroit; and the 1998 St. Ezequiel Moreno National Award from the Cursillo of New York City. He is on the Board of Directors of the Mexican American Cultural Center in San Antonio and the National Catholic Association of Diocesan Directors for Hispanic Ministry.

Deacon William T. Ditewig

Executive Director, USCCB Secretariat for the Diaconate; is a deacon of the Archdiocese of Washington, and holds a Ph.D. in ecclesiology from The Catholic University of America. He has authored two books, Leading Our Children to God: A Faith Guide for Catholic Parents, and Lay Leaders: Resources for a Changing Parish, both published by Ave Maria Press. He has also been published in several journals, including The Jurist, Deacon Digest, and Diaconate, and he is a contributor to the New Catholic Encyclopedia. He contributed to and was on the editorial board of the National Directory for the Formation, Ministry and Life of Permanent Deacons in the United States. He is a member of the government board of the International Diaconate Center, and a member of the Catholic Theological Society of America.

Richard M. Doerflinger

Deputy Director, USCCB Secretariat for Pro-Life Activities; holds a master of arts in divinity degree from the University of Chicago and has pursued doctoral studies at the University of Chicago and The Catholic University of America. He is an adjunct fellow in bioethics and public policy at the National Catholic Bioethics Center. He frequently writes and

speaks on euthanasia, assisted suicide, embryo experimentation and reproductive technologies. He has been published in such periodicals as National Catholic Bioethics Quarterly, Kennedy Institute of Ethics Journal, Hastings Center Report, Linacre Quarterly, and Duquesne Law Review.

Eugene J. Fisher

Director of Catholic-Jewish Relations, USCCB Secretariat for Ecumenical and Interreligious Affairs; holds a doctorate in Hebrew culture and education from New York University and is a member of the Society of Biblical Literature; Catholic Biblical Association; National Association of Professors of Hebrew; Biblical Archaeology Society; American Academy of Religion, Fellowship of Reconciliation; Christian Study Group on Judaism and the Jewish People; The National Institute on the Holocaust; Center for Holocaust Studies, Churches' Center for Theology and Public Policy; the Vatican Commission for Religious Relations with Jewish People; and the National Association of Ecumenical Officers. He is a Contributing Editor to the New Catholic Encyclopedia (Second Edition, 2003) and represents the Holy See at international dialogues. He has published over 20 books and 300 articles, and has been honored for his work by institutes for Jewish-Christian Studies of Muhlenberg College, Notre Dame College, the National Jewish Chautauqua Society, the Tanenbaum Center in New York and the Ecumenical Institute in Detroit. In 1995, he was winner of a Best Book Award from the National Jewish Book Council.

Mark Franken

Executive Director, USCCB Migration and Refugee Services; holds a bachelor's degree in applied behavioral science from National-Louis University. He is a member of the Governing Board of the International Catholic Migration Commission; a board member of the Center of Migration Studies; and a founding member of Refugee Council USA.

Sheila Garcia

Assistant Director, USCCB Secretariat for Family, Laity, Women and Youth; holds a bachelor's degree from Ohio University and a master's degree in theology from the DeSales School of Theology. She has written on topics related to women for such publications as *Liguorian, Spiritual Life* and *Catholic Woman*.

Walter E. Grazer

Director, Environmental Justice Program of the USCCB Department of Social Development and World Peace; holds a master's degree in international affairs from George Washington University and master of social work degree from Virginia Commonwealth University. He is co-editor with Father Drew Christiansen, SJ, of And God Saw That It Was Good: Catholic Theology and the Environment.

Brother Jeffrey Gros, FSC

Associate Director, USCCB Secretariat for Ecumenical and Interreligious Affairs; is a member of the De LaSalle Christian Brothers and holds a doctorate in systematic theology from Fordham University. He is editor of The Search for Visible Unity; co-editor with Joseph Burgess of Building Unity and Growing Consensus; and co-editor with Ellen Wondra and Rozanne Elder of Common Witness to the Gospel. He is a member of the Catholic Theological Society of America, the College Theological Society, the National Association of Evangelicals, and the North American Academy of Ecumenists.

Sister Amy Hoey RSM

Project Coordinator, Lay Ecclesial Ministry, USCCB Secretariat for Family, Laity, Women and Youth; is a member of the New Hampshire Regional Community of the Sisters of Mercy of the Americas and holds a doctorate in English. She has held regional and national leadership positions in her religious community and has been a Sister of Mercy for 52 years. She was awarded the Guadium et Spes Award from the National Association of Lay Ministers in 2000.

Father John E. Hurley, CSP

Executive Director, Secretariat for Evangelization; is a Paulist Father. He has a bachelor of arts degree in religious education from The Catholic University of America, a master of divinity degree from the Washington Theological Union, and a doctor of ministry degree from the Jesuit School of Theology in Berkeley. He served as founding director of the Paulist Center for Catholic Evangelization in Portland, Oregon, from 1978–1984.

Father Arthur L. Kennedy

Executive Director, USCCB Secretariat for Ecumenical and Interreligious Affairs; is a priest of the Archdiocese of Boston and holds a license in theology from the Pontifical Gregorian University, Rome, and a doctorate in systematic theology from Boston University. He has published essays on literature, theology, philosophical anthropology, the role of Catholic universities and religious education. He has engaged in various ecumenical and interreligious dialogues, participating in both the academic and pastoral dimensions. He served on the boards of ecumenical councils in Minnesota, and of the Jay Phillips Center for Jewish-Christian Learning at the University of St. Thomas.

Father J. Cletus Kiley

Director, USCCB Secretariat for Priestly Life and Ministry; is a priest of the Archdiocese of Chicago and holds a doctorate in ministry from the University of St. Mary of the Lake, Mundelein, Illinois, a master's degree in spirituality from the University of San Francisco and a master of divinity degree from Mundelein Seminary, Mundelein. Father Kiley has spoken and written widely on priest personnel issues. Father Kiley recently served as the USCCB General Secretary's Deputy for the Protection of Children and Youth, assisting in the development of the National Review Board and the Office of Child and Youth Protection. He serves as a member of the Board of Directors of the Center for the Protection of Workers' Rights and the Board of Directors of the National Interfaith Committee on Worker Justice. He is a past president of the National

Association of Church Personnel Administrators and was recently honored with the President's Award from the National Association for the Continuing Education of Roman Catholic Clergy.

Father Daniel J. Kutys

Deputy Secretary for Catechesis, USCCB Department of Education; is a priest of the Archdiocese of Philadelphia and holds a master of divinity degree from St. Charles Seminary, Philadelphia. He has broad experience in pastoral work and religious education.

Father John Langan, SJ

A priest of the Detroit Province of Jesuits; holds a doctorate in philosophy from the University of Michigan and graduate degrees in theology from Woodstock College and in Classics from Loyola University, Chicago. He is a professor at Georgetown University, where he is the Joseph Cardinal Bernardin Professor of Catholic Social Thought, a senior research scholar in the Kennedy Institute of Ethics, and a member of the core faculty in the School of Foreign Service. He has lectured and written extensively on the ethics of war and peace, human rights, business ethics, and Catholic social teaching. He is currently vice president of the Society for Christian Ethics and will serve as president in 2004.

Monsignor Francis J. Maniscalco

Director, USCCB Department of Communications; is a priest of the Diocese of Rockville Centre, New York, and holds a doctorate in church administration and a master's degree in religious studies from Fordham University. He has written and spoken extensively on the Church and the mass media, and for eight years was editor of the Long Island Catholic, a weekly newspaper with a circulation of 130,000. He is a member of the Catholic Academy for Communications Arts Professionals and the Catholic Press Association, and is President of the Interfaith Broadcasting Commission.

H. Richard McCord

Executive Director, USCCB Secretariat for Family, Laity, Women, and Youth; holds a master's degree from Princeton Theological Seminary and a doctorate in education from the University of Maryland. He is the recipient of the Gaudium et Spes Award from the National Association for Lay Ministry in 2000 and the National Recognition Award from the National

Association of Catholic Family Life Ministers in 1993. He has written extensively in Catholic periodicals and contributed chapters to Vatican II: The Continuing Agenda, Families and Communities in Partnership, Using a Family Perspective, and Why We Serve.

Sister Glenn Anne McPhee, OP

Secretary for Education, USCCB Department of Education; is a member of the Dominican Sisters of Mission San Jose. She has a bachelor of arts degree in history and political science from Holy Names College, a master of arts degree in educational administration from Loyola Marymount University, and has done postgraduate work at the University of San Francisco (USF). She is a member of the National Catholic Educational Association, the Chief Administrators of Catholic Education, the National Association of Secondary School Principals, and the Council for American Private Education. Her awards include the Outstanding Leadership Award from the Institute for Catholic Educational Leadership, and the University of San Francisco's Distinguished Lecturer Award, and she has served as adjunct professor of educational leadership at USF.

Monsignor James P. Moroney

Executive Director, USCCB Secretariat for the Liturgy; is a priest of the Diocese of Worcester, Massachusetts, and has pursued theological and liturgical studies at the Pontifical Gregorian University, Rome; the Pontifical Liturgy Institute at Saint Anselmo's; and The Catholic University of America. In 1999, he was appointed by Pope John Paul II as a consultant to the Congregation for Divine Worship and the Discipline of the Sacraments and serves as an advisor to the Vox Clara Committee of that same congregation.

Gerard F. Powers

Director, USCCB Office for International Justice and Peace; holds a law degree and a master's degree in theology from the University of Notre Dame. He has been an adjunct professor of ethics and international law at the National Law Center of George Washington University and the Washington College of Law. He is co-editor with Father Drew Christiansen, SJ and Robert Hennemeyer of Peacemaking: Moral and Policy Challenges for a New World. He also is author of numerous articles on religious liberty, religion and

conflict in Bosnia and Northern Ireland, economic sanctions and the ethics of war and peace.

Andrew Rivas

Policy Advisor, Nonviolence, Agriculture, Environmental Issues, USCCB Office of Domestic Social Development; holds a bachelor's degree from the University of California at Los Angeles and a Juris Doctor degree from the Columbus School of Law, The Catholic University of America.

Father Ronald G. Roberson, CSP

Associate Director, USCCB Ecumenical and Interreligious Affairs; is a Paulist Father and holds a doctorate in Oriental Ecclesiastical Sciences from the Pontifical Oriental Institute, Rome. He has written extensively on ecumenism and Catholic-Orthodox relations in scholarly journals and frequently lectures on related topics.

Sister Maureen Shaughnessy, SC

General Superior of the Sisters of Charity of St. Elizabeth; holds a master's degree in religious education from LaSalle University, Philadelphia, and has done post-graduate studies at Columbia University's Teachers' College. She is a member of the National Conference of Catechetical Leadership, the National Catholic Educational Association, and the American Association for Adult Continuing Education and the Religious Education Association. She is co-author of Sadlier Publishing's Mary's Journey Program and was a member of the writing committee for Serving Life & Faith, the USCCB Department of Education document on adult religious education and the American Catholic community. She frequently speaks on religious education.

Thomas Shellabarger

Policy Adviser, Urban Issues, Economic Issues, USCCB Department of Domestic Social Development; holds a bachelor's degree from the University of Michigan and has done graduate work at Florida Atlantic University.

Monsignor John J. Strynkowski

A priest of the diocese of Brooklyn, New York; holds a doctorate in sacred theology from the Pontifical Gregorian University, Rome. He has taught in seminaries in the United States and Rome and has been published

in several periodicals and journals including The Jurist, Origins, Priests and People, The Tablet (London) and Marriage Studies. He is a member of the Catholic Theological Society of America and the Roman Catholic-Methodist Dialogue and Roman Catholic-Polish National Catholic Dialogue in the United States.

John Thavis

Catholic News Service, Rome Bureau Chief; holds a bachelor's degree from St. John's University, Collegeville, Minnesota. He has worked in the Rome Bureau since 1983 and as bureau chief since 1996. He has been honored by the Catholic Press Association for his coverage of the Vatican and the humanitarian crisis in Yugoslavia in 1999. His other writings include a guide book on Rome. He has traveled with Pope John Paul II on 26 trips to more than 50 countries.

Ana Villamil

Associate Director, USCCB Secretariat for Family, Laity, Women and Youth; holds a bachelor's degree in mechanical engineering from the University of Notre Dame, a master of business administration degree from the Wharton Business School, University of Pennsylvania, a master's degree in space technology from the Florida Institute of Technology, and a master of divinity degree from the Washington Theological Union. She is on the board of directors for Community of Hope, a non-profit Washington group that assists low income and homeless families transition to self-sufficiency, and has written on lay ministry for several publications.

Father Robert J. Vitillo

Executive Director, USCCB Catholic Campaign for Human Development; is a priest of the diocese of Paterson, New Jersey, and holds a master's degree in social work from Rutgers University, where he also pursued doctoral studies in social work. He has worked with Caritas Internationalis, the worldwide confederation of Catholic Church-sponsored social service and development organizations in 190 countries. He has served as a consultant with UNICEF and the National Council for Adoption and as the international delegate of Caritas Internationalis at United Nations headquarters and at the World Bank. He holds a Certificate in Emergency Management Training for Refugee Situations from the Office of the United Nations High Commissioner for Refugees and has written widely on the Church's social mission, HIV/AIDS, child protective services, adoption, human trafficking, and refugee and migration issues. He is a member of the National Association of Social Workers, the Academy of Certified Social Workers, and Catholic Charities USA. He serves as the president of the board of directors of the National Catholic AIDS Network; and sits on the boards of directors of the National Council for Adoption, the Council on Accreditation of Services to Children and Families, and the Magnificat Global Health Foundation. He is co-chair of the Caritas Internationalis Task Force on HIV/AIDS.

Sister Mary Ann Walsh, RSM

Deputy Director for Media Relations, USCCB Department of Communications; is a member of the Albany Regional Community of the Sisters of Mercy of the Americas; holds a master's degree in English from the College of St. Rose and a master's degree in pastoral counseling from Loyola College of Maryland. She has prepared media relations strategies and spoken on media topics for Unda-USA, the Society for Professional Journalists, and Virginia State Press Association. She also was producer of the award-winning video, Five Extraordinary Days, about World Youth Day '93. She has been honored for her work by several groups, including the New York State Bar Association, New York Press Association, the Colorado Chapter of the Public Relations Society of America, Catholic Press Association, and Unda-USA, now known as the Catholic Academy for Communications Arts Professionals.

Acknowledgments

Credit for this tribute to Pope John Paul II goes to many people at the Holy See and in the United States. Deepest thanks go to the wonderful photographers at the Vatican newspaper, *L'Osservatore Romano*, whose work graces these pages, especially Arturo Mari, who has photographed the Pope from the day he was elected onwards. Marjorie Weeke, a veteran assistant to journalists from around the world, also deserves profound thanks for the many hours she spent searching through the *L'Osservatore Romano* photo archives for just the right pictures, and Father Georgio Bruni, OSB, head of the *L'Osservatore Romano*'s Photo Service, who facilitated Marjorie's efforts.

Deepest gratitude to the United States Conference of Catholic Bishops, especially the Committee on Communications, headed by Bishop Joseph A. Galante, who, through its Catholic Communication Campaign, provided wonderful moral and financial support for all efforts. Especially to be noted is Monsignor Francis J. Maniscalco, the USCCB Director of Communications. He helped bring this project into being and see it through to completion. Others deserving mention by name include *Catholic News Service*, especially Thomas N. Lorsung, editor in chief; John Thavis, head of the *Catholic News Service* Rome Bureau, whose biographical essay proved to be both factual and poetic; the staff of *Origins, Catholic News Service*'s treasured documentary service; and the *Catholic News Service* library. The staff of the communications department must also be commended, especially David Early, who compiled much of the resource material, and Soren Johnson, who wrote captions and pursued background for both copy and photos. Thanks also to the essayists of the USCCB whose work is included here, especially Monsignor John Strynkowki, who headed the Secretariat for Doctrine and Pastoral Practices, and his staff, and Father Robert Vitillo, head of the Catholic Campaign for Human Development. Both priests have been extraordinary colleagues and went far beyond what might rightly be expected of them, writing several essays and offering guidance throughout.

Personal reflections submitted by a number of active bishops of the USCCB and others associated with the Conference have added to the uniqueness of this book, for which we are very grateful. Regretfully, space limitations precluded publishing all the moving reflections that were or could be provided by members, retired members or staff of the USCCB.

Special thanks also to Ruder Finn Design, whose exquisite work here speaks for itself, and RF Binder, which provided extraordinary help in coordinating all our efforts. Among those derserving special note are David Finn, Franklin Walton, Lisa Gabbay, Meghan Dotter and designers Timothy Samara and Winnie Chang.

Thanks also to Sheed & Ward for believing in this book from the beginning. A special thanks goes to Jeremy Langford, Sheed & Ward's editorial director, who worked in close collaboration with the USCCB and Ruder Finn Design on everything from photo selections to coordinating schedules and staff to copyediting and proofreading. Thanks also to Father Kenneth O'Malley, C.P., Director of the Bechtold Library at Catholic Theological Union, for fact checking and indexing. And to Richard Weisenseel for thoroughly proofreading the book.

To these people and the many more who contributed to this work, many, many thanks.

Sister Mary Ann Walsh, RSM

Sister Mary Ann Walsh, RSM

The Pope leads the recitation of the Rosary in the Paul VI Audience Hall while a visiting child investigates a microphone, February 7, 1998.

Page 256: The Pope watches a fireworks display from his window overlooking St. Peter's Square as thousands celebrate the new millennium.

Index

INDEX OF DOCUMENTS

INDEX OF PHOTOS

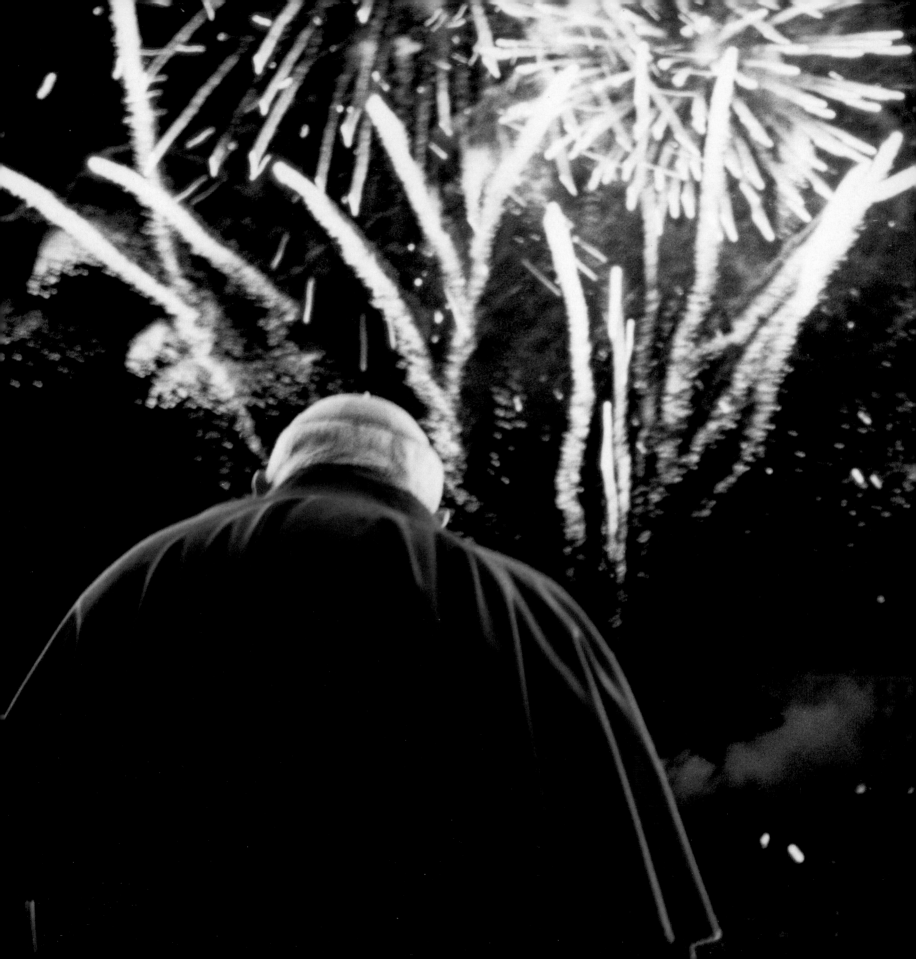